ARTISTS OF THE OLD WEST

ARTISTS OF T

A CHANTICLEER PRESS EDITION

JOHN C. EWERS

HE OLD WEST

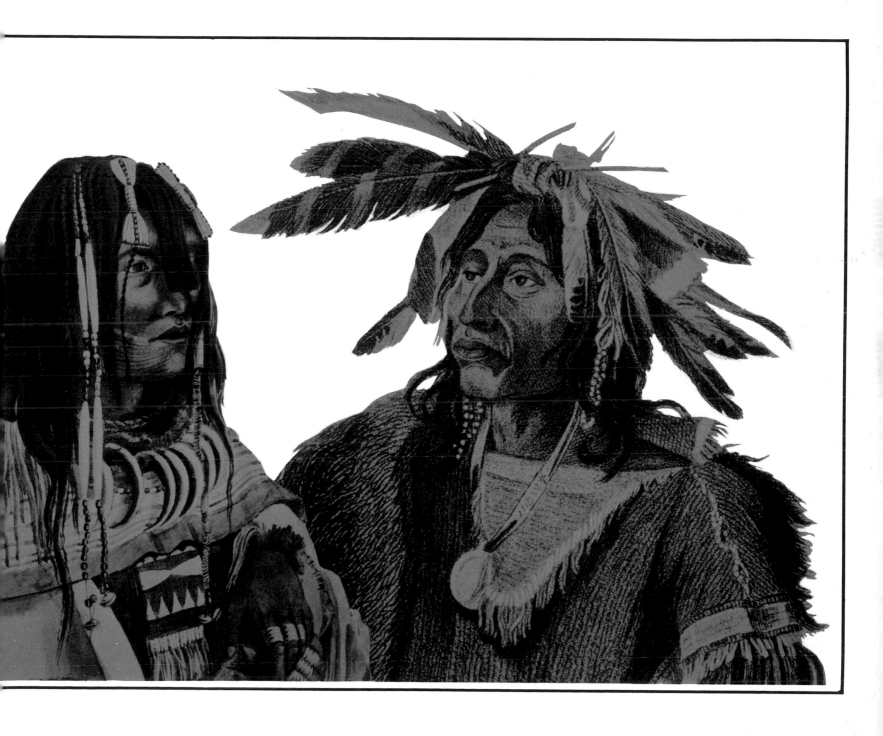

DOUBLEDAY & CO., GARDEN CITY, NEW YORK

To Diane

Who shares her father's enjoyment
of the history and art
of the Old West.

Title page: Composite of detail from
"Wolf Child, a Piegan Warrior" by Karl
Bodmer, Joslyn Art Museum and
Northern Natural Gas Company, Omaha
(left), and detail from "Big Soldier,
Teton Sioux Chief," by Karl Bodmer,
Smithsonian Institution (right).
Opposite: Study for Rifleman in
"Shooting for the Beef" by George
Caleb Bingham, St. Louis Mercantile
Library Association, St. Louis, Missouri.
Overleaf: Detail from "Chippeway
Canoe" by Peter Rindisbacher, U.S.
Military Academy Museum, West
Point.

This book is fully protected by
copyright under the terms of the
International Copyright Union.
Permission to use portions of this book
must be obtained in writing from the
publisher.

ISBN: 0-385-0 4474-7
Library of Congress Catalog
Card Number: 65-20054

Planned and produced by
Chanticleer Press, New York

Printed by Amilcare Pizzi, S.p.A.,
Milan, Italy
Published by Doubleday & Company,
Inc., Garden City, New York. Enlarged
edition, 1973. Original edition, 1965.

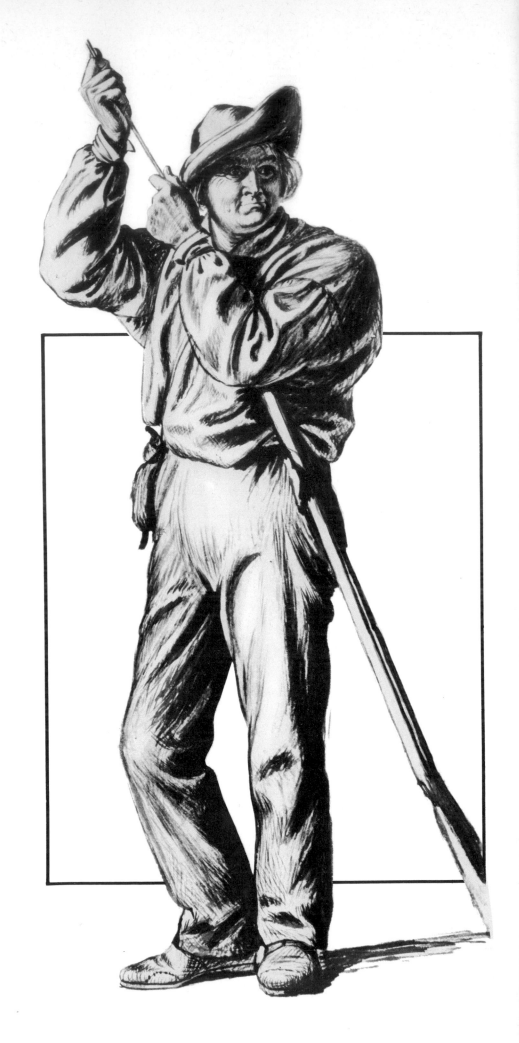

CONTENTS

THE ARTIST AS EXPLORER AND HISTORIAN 7
INTRODUCTION

IN THE WAKE OF LEWIS AND CLARK 10
CHARLES WILLSON PEALE AND CHARLES B. J. F. DE SAINT-MÉMIN

FIRST ARTISTS IN THE GREAT AMERICAN DESERT 22
TITIAN RAMSAY PEALE AND SAMUEL SEYMOUR

PORTRAYING PLAINS INDIANS FOR POSTERITY 32
CHARLES BIRD KING AND JOHN NEAGLE

YOUNG ARTIST ON THE RED RIVER OF THE NORTH 44
PETER RINDISBACHER

HUNTING INDIANS WITH A PAINTBRUSH 53
GEORGE CATLIN

MASTER DRAFTSMAN ON THE UPPER MISSOURI 76
KARL BODMER

AMONG THE MOUNTAIN MEN 98
ALFRED JACOB MILLER

AMONG THE FUR TRADERS
AT THE MOUTH OF THE YELLOWSTONE 118
RUDOLPH FRIEDERICH KURZ

LIFE ON THE MISSOURI FRONTIER 132
GEORGE CALEB BINGHAM

IN THE CALIFORNIA MINES *142*
CHARLES NAHL AND THOMAS A. AYRES

BROTHERS AMONG THE SOUTHWEST INDIANS *154*
EDWARD M. AND RICHARD H. KERN

ARTIST AND TRAIL BLAZER IN THE NORTHERN ROCKIES *172*
GUSTAVUS SOHON

SCENES OF ROCKY MOUNTAIN GRANDEUR *182*
ALBERT BIERSTADT AND THOMAS MORAN

ARTISTS OF THE PLAINS INDIAN WARS *198*
THEODORE R. DAVIS AND FREDERIC REMINGTON

A MONTANA COWBOY
PORTRAYS THE PASSING OF THE OLD WEST *220*
CHARLES M. RUSSELL

ACKNOWLEDGMENTS *237*

BIBLIOGRAPHY *238*

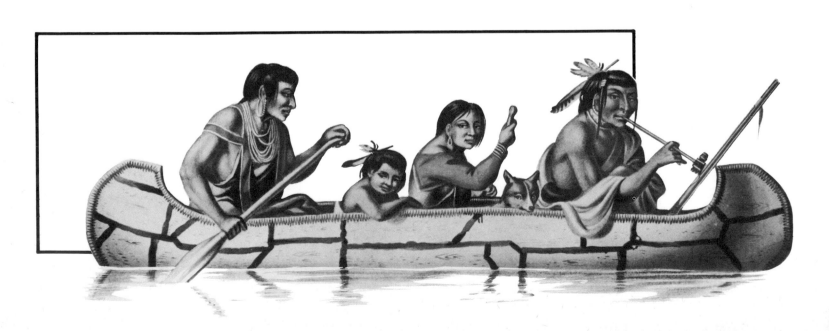

THE ARTIST AS EXPLORER AND HISTORIAN

To the pioneer artists who explored the plains and the mountains of the trans-Mississippi West and drew and painted what they saw in that vast region we are indebted for a vivid and colorful record of what the Old West was like. Yet so rapidly was the West transformed from unknown Indian country into a settled region that artists had little time to prepare their pictorial record. Within ninety years of the Louisiana Purchase in 1803 the West of the Indian buffalo hunters, of the Rocky Mountain trappers and fort-based Indian traders, the overland trails, the California Gold Rush, the Plains Indian Wars, and the open range cowboys had passed into history.

During the early decades of the nineteenth century interest in Western exploration was most intense in the nation's political capital, Washington, and in the country's intellectual capital, Philadelphia. In the latter the flourishing arts and sciences complemented one another in the search for truth. Acute observation and detailed recording of man and nature motivated both artists and scientists. In the graphic arts these aims found expression in realistic portraiture and literal renderings of topography, plants, birds and animals. Conscious distortion or failure to record the distinctive features of nature would have been as abhorrent to the artist as to the natural scientist.

Charles Willson Peale, a founder of the country's first art academy and art school, and proprietor of the Philadelphia Museum, possessed both artistic talent and scientific curiosity. He was equally interested in the Western Indians who visited Philadelphia and in the natural history specimens collected by Lewis and Clark. His contemporaries, Saint-Mémin, King, and Neagle, also produced likenesses of Plains Indians who visited Washington and Philadelphia, but did not go West themselves.

Titian Peale (son of Charles) and Samuel Seymour of Philadelphia were the first official artists to accompany a United States government exploring expedition onto the plains. Their field sketches on the Long Expedition of 1819–20—of wildlife and Indians, as well as the first

views of the Rocky Mountains and the valleys of the Missouri, Platte and Arkansas Rivers—were literal transcriptions of nature.

The same desire to communicate accurately what they saw and experienced in the West dominated the works of other pioneer artists of the West prior to 1890. Indians were amazed at the realism of George Catlin's and Karl Bodmer's works, and some primitive Mandan artists tried to follow their example. Hazard Stevens praised the "expressive likeness" of Gustavus Sohon's portraits. Charles Nahl's pictures of life in the California mines appealed first to the miners themselves. Remington was beloved by the frontier soldiers whom he portrayed, and Russell's range life scenes were admired by Montana cowboys because they accurately portrayed the life they knew.

Whatever the age of these artists, they shared a youthful love of adventure, physical courage, and enthusiasm. In the rugged West they found a challenge to their talents which the more genteel and familiar surroundings of civilized life did not offer them. Whether they were self-taught or thoroughly trained by the best European teachers, the Western scene inspired them to create their most significant works.

That Indians should bulk large in the works of these artist-explorers is not surprising. Red men were a vital and striking part of the Western scene. The Plains Indians especially appealed to artists as examples of primitive man living in a state of nature. Their strong, handsome features, proud and dignified bearing, and gaily decorated dress costumes made them attractive subjects for portraiture. Their prowess as big-game hunters, horsemen and warriors, and their exotic dances and savage rituals had dramatic appeal. The artists hastened to record the characteristic features of Indian life before it was erased by the advance of civilization. The nineteenth-century draftsmen and painters helped to make the Plains Indians of buffalo days the best-known primitive people in the world. To this day most Americans and Europeans think of Indians as these artists pictured them.

It was a painter of Indians, George Catlin, who, in 1841, first suggested the creation of a national park to preserve both the Plains Indians and the buffalo from extermination. No serious consideration was given to this revolutionary idea at that time. However, the works of later artists—Thomas A. Ayres, Albert Bierstadt, and Thomas Moran—aroused American appreciation of the unique beauty of Western wilderness areas, and helped to prevent their desecration or exploitation. They thus encouraged the preservation of select portions of the

West through the establishment of the world's first system of national parks for the enjoyment of all future generations.

A marked decrease in drawn or painted portraits followed the introduction of the camera into the West in the 1850's. Competition from the camera also may have encouraged Bierstadt and Moran to idealize rather than to copy slavishly the Western landscape. Nevertheless, they and other artists of the second half of the century knew that the black-and-white pictures created by the slow-shuttered camera of their time could not reveal the brilliant colors of nature or record the rapid movement of men and animals.

Realistic, storytelling action became a hallmark of the works of Frederic Remington and Charles M. Russell. In the face of the art critics' insistence that painting should offer more than an illustrator's detailed representation of dramatic and colorful episodes, they persisted in trying to recreate a life that was gone forever. Their works have become increasingly popular among Old West enthusiasts whose judgments of drawings and paintings are strongly influenced by their interest in historical subject matter.

Even so, detailed realism is not enough. The student of Western history should learn to distinguish between the primary pictorial document which the artist created from his own firsthand knowledge of his subject and the spurious realism of the historical reconstruction. In the works of Russell and Remington, and indeed in those of Catlin and Miller a half-century earlier, we find some of both. Only when we apply the same tests of validity to a drawing or painting that a historian uses in evaluating written documents can we fully appreciate the contributions to history of the artist who portrayed vividly and accurately what he saw with his own eyes. The best of such painters were both fine artists and reliable historians.

IN THE WAKE OF
LEWIS
AND
CLARK

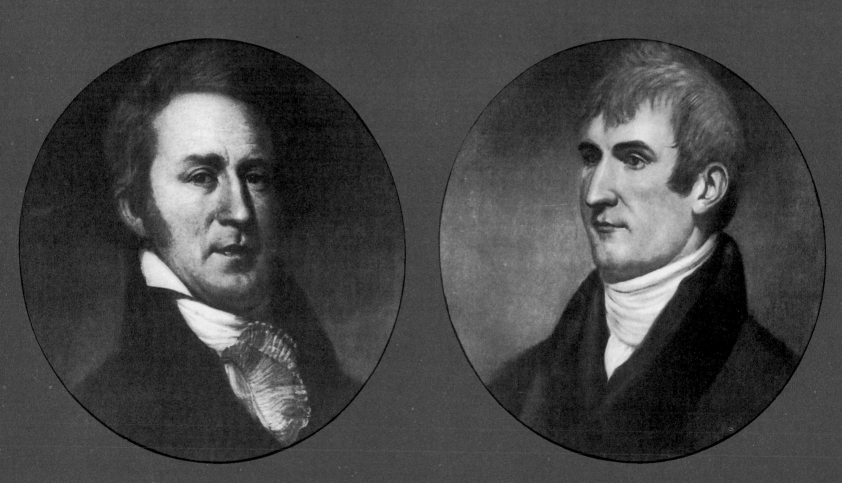

Charles Willson Peale and Charles B.J.F. de Saint-Mémin

In the little town of Washington on the banks of the Potomac the twenty-seventh anniversary of American independence was celebrated with an unusual patriotic fervor. On the morning of July 4, 1803, the *National Intelligencer* proclaimed in bold type the signing of a treaty with France which ceded to the United States "the whole of Louisiana." Immediately this was the talk of the capital city of some 4,500 people. When the members of Captain Andrews' Company of Militia of the City of Washington gathered for their Fourth of July dinner, they raised their glasses in response to a new toast: "May the cession of Lousiana be the guarantee of permanent peace in America." Then they endorsed this noble sentiment with nine rousing cheers.

Never before had one nation bought from another such a huge block of real estate. The price agreed upon far exceeded this young nation's treasury receipts for an entire year. Just how much of a bargain was the Louisiana Purchase?

Louisiana was a vast region in the very heartland of the North American continent. It included all the lands west of the Mississippi drained by that great river. Yet in the 121 years since Robert Cavelier, Sieur de La Salle, had claimed and named Louisiana in honor of his French king, no one had followed the mighty Mississippi and its lengthy western tributaries to their sources. The true boundaries of "Louisiana" remained unknown.

Officials of the American government knew that French and Spanish traders had obtained valuable furs from numerous Indian tribes in the interior of this vast wilderness. But the names, numbers and locations of few of those tribes were known in the United States. Lacking knowledge of the geography, resources, and the fertility of the soil in Louisiana, no one could have prophesied that this region ever would support a sizeable population of civilized men and women.

From beyond the Mississippi had come strange stories of active volcanoes, burning subterranean fires, and a great mountain of salt, more than a hundred miles long and forty-five wide, far up the muddy Missouri. There were rumors of a nation of white Indians who lived high up that river, spoke Welsh, and possessed a culture far richer than that of their red-skinned neighbors. And even Thomas Jefferson, who had won recognition as an amateur scientist, and who had been fascinated by finds of mammoth remains in New York and Kentucky, was inclined to credit Indian tales that this huge beast still survived in the remote wilderness. What other wonders might be discovered in this immense, unexplored region?

No man of his time had been more fascinated by the mysteries of the trans-Mississippi West than had Thomas Jefferson. For more than twenty years prior to the Louisiana Purchase he had advocated sending an expedition from the Mississippi River to the Pacific in the interest of both science and commerce. The fact that Louisiana still belonged to a foreign power did not prevent him from recommending such an exploration to Congress in a confidential message on January 18, 1803. Nor did it deter Congress from granting President Jefferson secret authority thirty-eight days later to proceed with his project.

Jefferson had long before decided upon his private secretary and fellow Virginian, Meriwether Lewis, as the best man to lead this exploration. He knew that Lewis was not a trained scientist. But he was confident of Lewis' ability to command a small force of enlisted men, to deal successfully with strange Indians, and to recognize anything new to mineralogy, botany, or zoology that he would observe.

William Clark. C.W.Peale. 1810. Oil. Independence National Historical Park, Philadelphia (left)

Meriwether Lewis. C.W. Peale. 1807. Oil. Independence National Historical Park, Philadelphia (right)

11

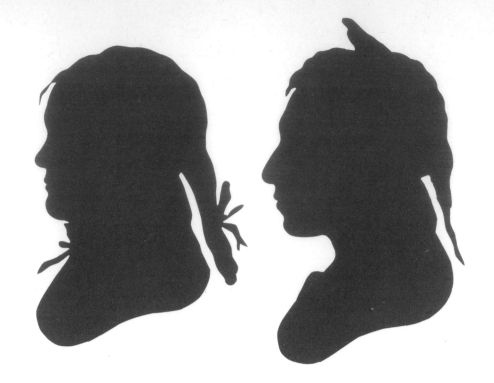

Paul Chouteau, Osage Interpreter. C.W. Peale. 1806. Silhouette. Smithsonian Institution (near right)

Pagesgata, a Pawnee Indian. C.W. Peale. 1806. Silhouette. Smithsonian Institution (far right)

During the spring of 1803, Lewis journeyed to Pennsylvania to receive instructions from Andrew Ellicott, the noted land surveyor in Lancaster, on the best methods of taking observations, calculating locations, and mapping; to purchase scientific instruments and other equipment for the expedition, and to obtain the advice of Philadelphia's leading scientists on recording field observations and collecting specimens in natural history.

Before news of the successful negotiation of the Louisiana purchase reached Washington, Jefferson had given Lewis comprehensive instructions, and Lewis had written to his old friend, William Clark, inviting him to join the expedition as co-leader. The acquisition of Louisiana relieved the planners of this expedition of the embarrassment of pretending that its destination was the Upper Mississippi rather than the far-off Pacific coast by way of the Missouri and Columbia Rivers.

In his instructions to Lewis, Jefferson emphasized the necessity for treating all Indian tribes in the most conciliatory manner. Furthermore, he wrote: "If a few of their influential chiefs, within practicable distance, wish to visit us, arrange such a visit with them, and furnish them with authority to call on our officers, on their entering the U.S. to have them conveyed to this place at public expense."

Captain Lewis lost little time in beginning to carry out this part of his instructions. Early in the spring of 1804, even before the Lewis and Clark Expedition left its winter camp opposite the mouth of the Missouri River, a party of twelve Osage chiefs and two boys left St. Louis for the nation's capital. They were escorted by Jean Pierre Chouteau, a member of the most prominent family in St. Louis, one which had been especially successful in trade with the Osage Indians.

On July 12th, President Jefferson greeted this first group of Indian leaders from west of the Mississippi to visit their Great White Father. "My children," he said, "I receive you with great pleasure at the seat of the government of the seventeen United nations, and tender you a sincere welcome."

Jefferson was impressed by both the appearance and the importance of the Osage chiefs. To his Secretary of the Navy he wrote, "They are the finest men we have ever seen. They have not yet learnt the use of spiritous liquors." And he hastened to add, "The truth is they are the great

White Hair, Head Chief of the Great Osages. Saint-Mémin. 1804. Crayon. The New-York Historical Society (opposite)

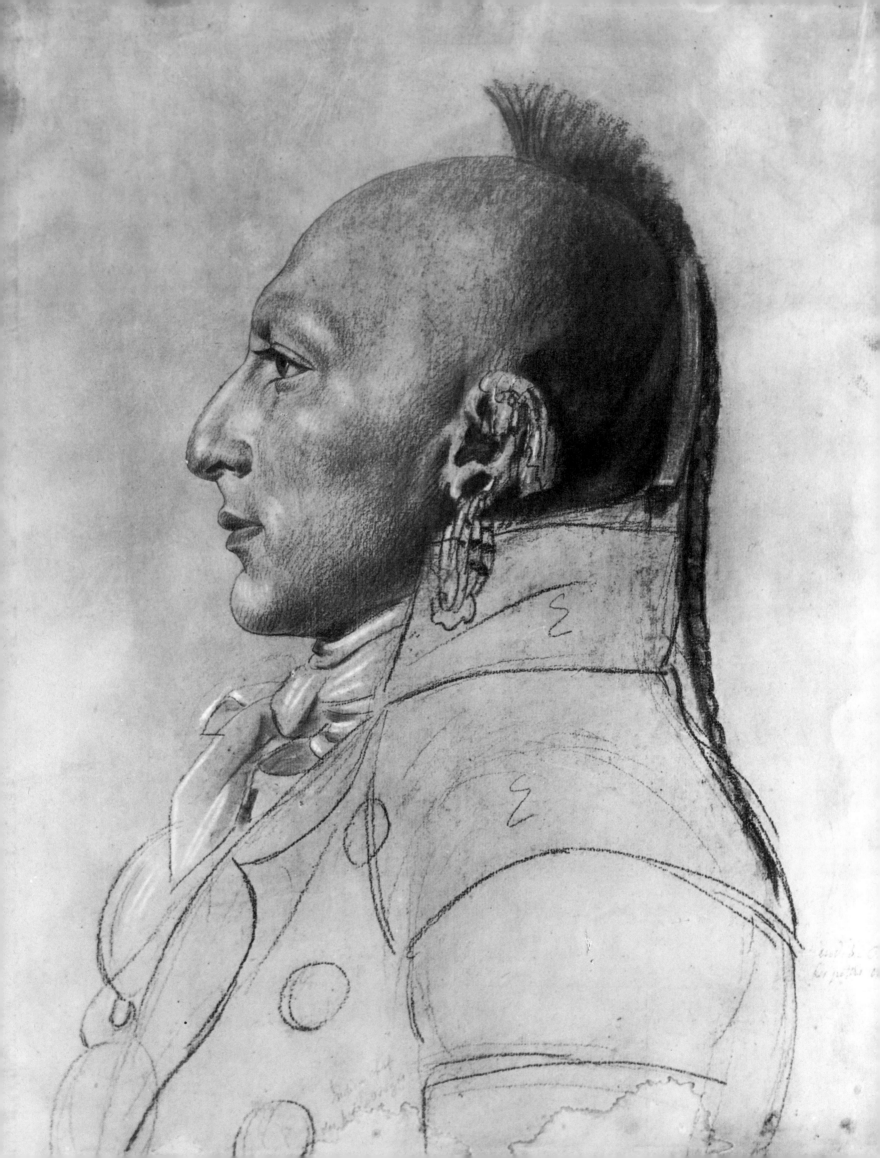

nation South of the Missouri, their possessions extending thence to the Red river, as the Sioux are great North of that river. With these two powerful nations we must stand well, because in their quarter we are miserably weak."

To impress these visitors with the power of the United States, Jefferson escorted them to the Navy Yard to see three frigates. The Indians heard the ships' guns fired and saw their signal flags hoisted. The red men showed not the least sign of emotion. Nevertheless, they showed their gratitude for the attentions given them in Washington by offering their own entertainment—a lively and colorful series of Osage war dances—in an open air performance. More than half of the city's population came to watch the painted, feathered, breechclouted dancers. The principal chief sat beside the President, with the other heads of government and their elegantly dressed ladies in the audience.

From Washington these Indians were taken on a tour of the larger cities—Baltimore, Philadelphia, and New York. In New York the Tammany Society entertained them in its wigwam. They saw an elaborate display of fireworks, and received a bible from the New York Missionary Society. And their performance of Osage war dances was another dramatic success.

Wherever these Indians traveled they were objects of great curiosity. Their leader, White Hair (Pahuska), Head Chief of the Great Osages, was especially popular. "Their King," reported the *American Citizen*, "is upward of six feet in stature, proportionately well made, with a large Roman nose, and dignified in his port. Perhaps no one brought up in savage life has ever been known to unite with the same ease, politeness and nobleness of manners." Proudly he wore his blue officer's uniform with its gold epaulets, the gift of the United States. Gracefully he doffed his hat and bowed to admiring spectators.

At some time during this eastern tour, most probably during his stay in Washington, White Hair sat for his portrait by Charles Balthazer Julien Févret de Saint-Mémin. The huge Indian must have contrasted sharply with the short, plump, bald-headed artist. Saint-Mémin was a member of the lesser French nobility, and a former colonel in the royal army. He had fled to the United States as a refugee from the French Revolution. As a youth Saint-Mémin had enjoyed drawing and painting as a hobby. In America he turned to art for his livelihood, and achieved a considerable success making and engraving inexpensive portraits in Philadelphia, Washington, Baltimore and other eastern communities. Among his hundreds of sitters were Washington and Jefferson.

To aid him in securing a likeness rapidly, Saint-Mémin employed a wooden-framed drawing device of a type invented by Louis Chrétien about 1787. With this physiognotrace, as the machine was known, he quickly traced an exact, life-size profile of his sitter on a large sheet of tinted paper. Then he finished the portrait in black and white crayon.

In this manner Saint-Mémin executed the earliest known portraits of Plains Indians. Five of his life-size profile portraits of Osage Indians have been preserved. Saint-Mémin's reputation as an artist has suffered from his own declaration that he depended upon a mechanical instrument for the essential outline of his sitter's features. Nevertheless, his Osage portraits reveal fine draftsmanship in his modeling of the heads. There is no better rendering of the Plains Indian physical type, with its combination of prominent cheekbones, bold nose, heavy jaw, and thin lips, than Saint-Mémin's portrait of the chief of the Little Osages who visited Washington in 1804.

Chief of the Little Osages. Saint-Mémin. 1804. Crayon. The New-York Historical Society

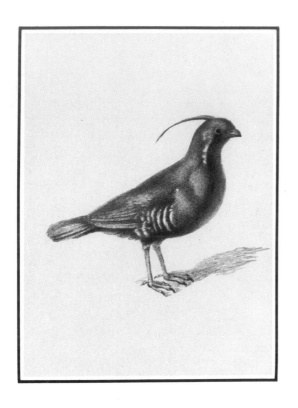

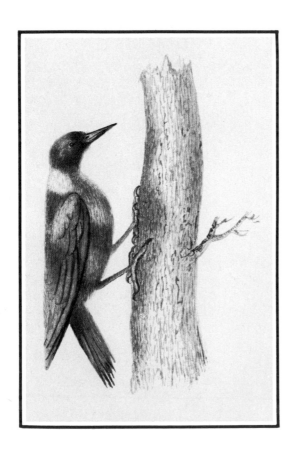

Lewis' Mountain Quail and Woodpecker (from birds collected by Lewis and Clark). C.W. Peale. Undated. Drawings. American Philosophical Society, Philadelphia (left)

"Fisher" (thought to be drawn by C.W.Peale for Meriwether Lewis' proposed account of the Lewis and Clark explorations). Undated. Drawing. American Philosophical Society, Philadelphia

Some of the foreign diplomats in Washington at that time complained that President Jefferson showed greater deference to the savage chiefs than to prominent representatives of the great European nations. But Sir Augustus J. Foster, of the British legation, was as fascinated by the red men as was the American president. Saint-Mémin executed watercolor portraits of four of the Osage visitors for him. The most striking of these is the likeness of a young Osage warrior dressed in paint and hair roach, and wearing long bone hair pipes. Perhaps this young man was costumed for one of the dances white audiences so enjoyed.

When the traveling Osages returned home that fall with their presents and superior airs, they aroused the envy and enmity of neighboring tribesmen. From many different tribes, Indian chiefs, who had never seen a white man's town, came to St. Louis eager to make the long trek eastward to see their Great White Father. American officials selected twenty-seven Indians from twelve tribes and started them on their way to Washington in October 1805. They received the same warm welcome from President Jefferson as had their predecessors, and they too were escorted on a tour of eastern cities.

In Philadelphia they visited Charles Willson Peale's museum in the State House (Independence Hall) to see the country's finest collection of birds and animals, as well as about 80 portraits of American heroes

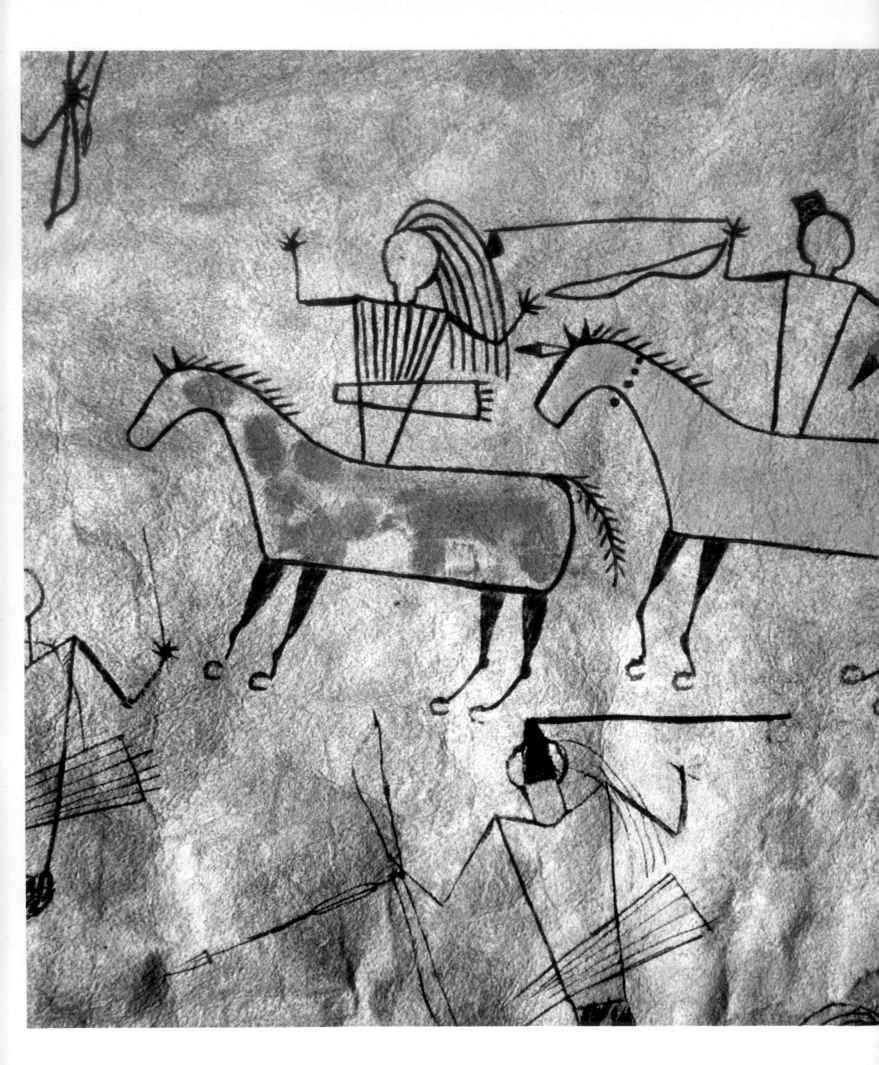

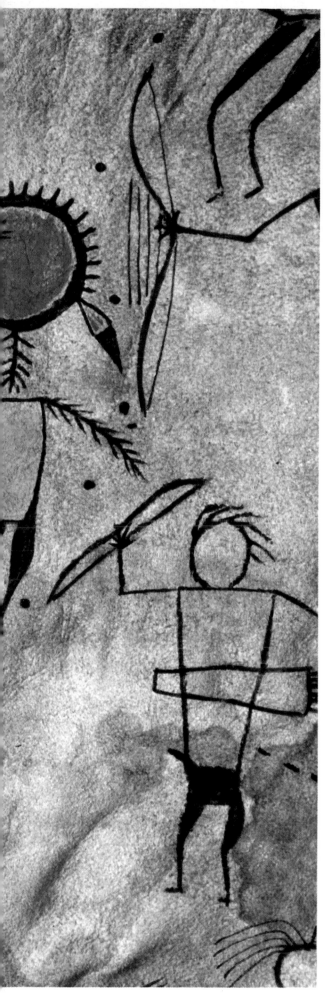

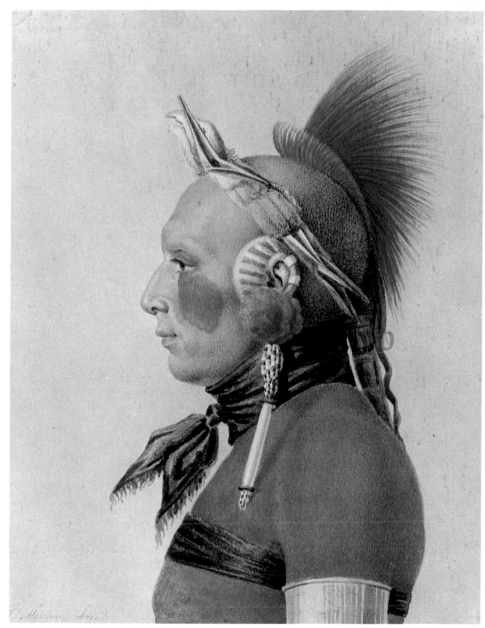

*A*n Osage Warrior. Saint-Mémin.
*1804. Watercolor. Henry Francis du Pont
Winterthur Museum (above)*

*Detail from a Mandan Indian Painting of
a Battle with Enemy Tribesmen (on a
buffalo robe collected by Lewis and
Clark). Peabody Museum of Archaeology
and Ethnology, Harvard University (left)*

painted by Peale. Peale cut silhouettes of nearly 12 of the Indians and sent them to his friend President Jefferson with the comment, "Some of these savages have interesting characters by the lines of their faces."

Employing a version of the physiognotrace invented by John Isaac Hawkins of Philadelphia only four years earlier, Peale quickly traced a profile in reduced size onto a sheet of white paper folded into four layers. Then he adroitly cut four identical silhouettes from the paper. Finally he mounted each silhouette on black paper.

Thousands of these "blockheads," as Peale's children referred to the silhouettes, were made of visitors to Peale's popular museum during the first decade of the nineteenth century. Perhaps none were more historic than the earliest known likenesses of men from several Western tribes which Peale sent to the President. With these were silhouettes of the Indians' interpreters, Joseph Barron, and Paul Chouteau. The latter, a mixed-blood, later became an Osage chief. They included the profiles of two young men from the Republican Pawnee village far up the Platte River. These two were returned to their homes by Lieutenant Zebulon Montgomery Pike, during the summer of 1806, on his way to explore the southwestern portion of newly acquired Louisiana. Pike found that the Pawnee chiefs regarded these young men as "boys of no importance to the tribe," unworthy of the attentions given them in Washington.

Early in October 1805, Jefferson eagerly examined the first shipment of scientific specimens from the Upper Missouri sent back by the Lewis and Clark exploring party. From their winter quarters near the Mandan Villages in present North Dakota they had dispatched a varied collection shortly before they pushed on toward the Pacific. Some of the animal skins had been badly damaged in nearly six months' travel down the Missouri and Mississippi to New Orleans and on to Baltimore by sea. But fortunately one of the buffalo robes was received in good condition. On it was painted an Indian artist's record of a battle between Mandan and enemy tribesmen about 1797. Its crudely drawn human figures, with featureless, knoblike heads and linear arms and legs, revealed the child-like character of the arts among these most sophisticated Indians on the Upper Missouri. This primitive work was more tribal history than art.

Four live magpies and a lively prairie dog came through unscathed. There were also horns, skins, and skeletons of larger mammals. Jefferson promptly forwarded the zoological specimens to Charles Willson Peale, the artist who doubled as a natural scientist, for study and display. Upon receipt of these rare additions to his museum, Peale wrote to the President. "Everything that comes from Louisiana must be interesting to the public." No less interesting to botanists were the samples of Mandan and Arikara tobacco, and the quick-ripening corn these northernmost Plains Indian farmers had developed to enable them to harvest a crop in a short growing season.

Through the long months that followed, nothing was heard from Lewis and Clark. Then, on September 21, 1806, the travelers returned safely to St. Louis. They had crossed the Rockies, descended the Columbia, and reached the Pacific. They had brought back notebooks filled with observations on the geography, natural resources, and the Indian tribes of the region—some of which had never before seen a white man.

No modern astronaut returning from outer space has received a more heroic welcome than did the leaders of that first official United States exploring venture into the Western wilderness. Jefferson praised their "addition to knolege (sic) in every department" and prophesied "the world will find that these travellers have well earned its favor."

The artist, Saint-Mémin, was on hand to trace their heroic profiles. He also drew a full-length portrait of Captain Lewis clad in the handsome ermine-trimmed shirt that he had received from the Shoshoni chief, Cameahwait, west of the Rocky Mountains. Lewis gave this shirt to Charles Willson Peale who exhibited it on a wax figure of the explorer to symbolize peace and friendship between Indians and whites. As soon as the famous explorers could visit Philadelphia, Peale painted their portraits in oils for his gallery of American heroes.

In the late winter of 1807, Lewis was appointed Governor of Louisiana Territory, and Clark had the double honor of becoming Superintendent of Indian Affairs for Louisiana and Brigadier General of Militia. To Lewis also fell the task of preparing for publication the scientific record of the exploration. A prospectus for this work promised three volumes, the second of which was to contain "plates illustrative of the dress and general appearance of such Indian nations as differ materially from each other; of their habitations; their weapons and habiliments used in war; their hunting and fishing apparatus, &c." The third volume was to be even more profusely illustrated with engravings of "every subject of natural history which is entirely new. . . ."

Lewis must have intended to publish several of Saint-Mémin's portraits of members of Indian deputations from the West, for he paid that artist $83.50 for likenesses of the Indians he deemed worthwhile. But Charles Willson Peale, whose museum housed many of the Indian artifacts and zoological specimens obtained by Lewis and Clark, was to be the principal illustrator. A few of Peale's drawings, including finely executed renderings of birds and a lizard, are preserved in the American Philosophical Society in Philadelphia. Peale's drawing of a small mammal, designated "a fisher," may have been made for Lewis' work.

A series of misfortunes prevented the realization of Lewis' ambitious plans for a comprehensive, illustrated report. He had made little or no progress in writing the text before his untimely death on October 18, 1809. Clark knew his own literary limitations, and so turned over the writing of the narrative to Nicholas Biddle of Philadelphia.

Ten years after Lewis and Clark embarked on their voyage of discovery there appeared the *History of the expedition under the Command of Captains Lewis and Clark, to the sources of the Missouri, thence across the Rocky Mountains and down the River Columbia to the Pacific Ocean. Performed during the years 1804–5–6* (Philadelphia, 1814). Its two volumes included Biddle's narrative and six excellent maps, but *no* illustrations.

So it was that during the decade following the acquisition of Louisiana the record by artists of that immense wilderness was a meagre one. It is easy for modern critics to deplore Jefferson's failure to send an able artist with the Lewis and Clark expedition. But Jefferson was too aware of the dangers of that long trek through an unknown Indian country to send a trained scientist, a doctor, or an artist with that hardy company of soldier-explorers.

Nevertheless, the first pictorial records of the Western wilderness may be numbered among the indirect results of the Lewis and Clark explorations. Saint-Mémin and the elder Peale never set foot on land west of the Alleghenies. Yet they came to know fragments of the early West in the forms of Indian diplomats and scientific novelties sent east by Lewis and Clark. And they drew what they knew of the West with a realism rarely equalled by later artists who saw with their own eyes the broad and varied landscape beyond the Mississippi.

FIRST ARTISTS IN THE GREAT AMERICAN DESERT

Titian Ramsay Peale and Samuel Seymour

Early in December 1818, seventy-seven-year-old Charles Willson Peale visited Secretary of War John C. Calhoun. Peale knew that the War Department was sending a strong expedition more than two thousand miles up the Missouri River to build a military post at the mouth of the Yellowstone. The post would help Americans to compete with the British for the lucrative trade in furs with the Indians who hunted on both sides of the international boundary in that remote region. Furthermore, he had heard that Calhoun planned to send a small party of trained scientists in the footsteps of the soldiers and under the direction of Major Stephen H. Long, topographical engineer. Peale recognized this exploration as an exciting challenge to men of science. At his age he could not volunteer for service in the wilderness. But he could participate vicariously if he could secure a post for his son, Titian, and persuade the War Department to deposit the collections made by the explorers in his Philadelphia Museum.

Titian Ramsay Peale was but nineteen years old at that time. As a boy he had shown little interest in formal schooling. Yet Titian, like his father, loved both natural history and art. Literally brought up in his father's museum, he had displayed a talent for drawing animals. His earliest known animal picture is an undated watercolor of a pair of grizzly bears collected in the West by Lieutenant Zebulon Pike and presented as live cubs to the elder Peale by President Jefferson in 1807. These unusual pets grew up in the Peale household until they became so ferocious they had to be killed. Then they were mounted for museum exhibition. Since the age of fourteen Titian had worked in the museum, demonstrating remarkable skill in preparing animals for display. He had earned the respect of the leading zoologists of his time. Thomas Say had chosen him to prepare the colored illustrations for the prospectus of his pioneer monograph, *American Entomology*, and Titian's accurate renderings of butterflies had helped the scientist to find a publisher for that expensive work. Titian was only eighteen when he was elected to the Academy of Natural Sciences of Philadelphia. He had recently

returned from a short but successful collecting trip in Florida and Georgia.

Soon after his father's visit to the Secretary of War, Titian was appointed assistant to his good friend, Thomas Say, who had been chosen as naturalist for the expedition up the Missouri. Titian's older half-brother, Rembrandt, one of the country's leading artists, advised him:

I suspect you will be the only Draughtsman. I therefore recommend you to practise immediately sketching from nature. I know how well you draw when you have the object placed quietly before you, but if you practise sketching from human figures as well as animals and trees, hills, cataracts, etc., you will be able to present us with many a curious representation. . . . Make drawings of the Indians in their warrior dresses; these will be infinitely more interesting than if made from the dresses put on white men afterwards. Give us some accurate drawings of their habitations. I have never seen one that was decently finished.

Even before the expedition departed Charles Willson Peale grasped the opportunity to paint oil portraits of Major Long and the scientists of his staff for his gallery of American heroes. Proudly he portrayed his young son, Titian, wearing the specially designed uniform of an expedition naturalist.

Major Long's orders called upon him to:

explore the Missouri and its principal branches, and then, in succession Red River, Arkansa, and Mississippi, above the mouth of the Missouri . . . to acquire as thorough and accurate knowledge as may be practicable, of a portion of our country which is daily becoming more interesting, but which is as yet imperfectly known.

Plains Indian Bowman on a Running Horse. T.R.Peale. 1819–20. Pencil and watercolor. American Philosophical Society, Philadelphia

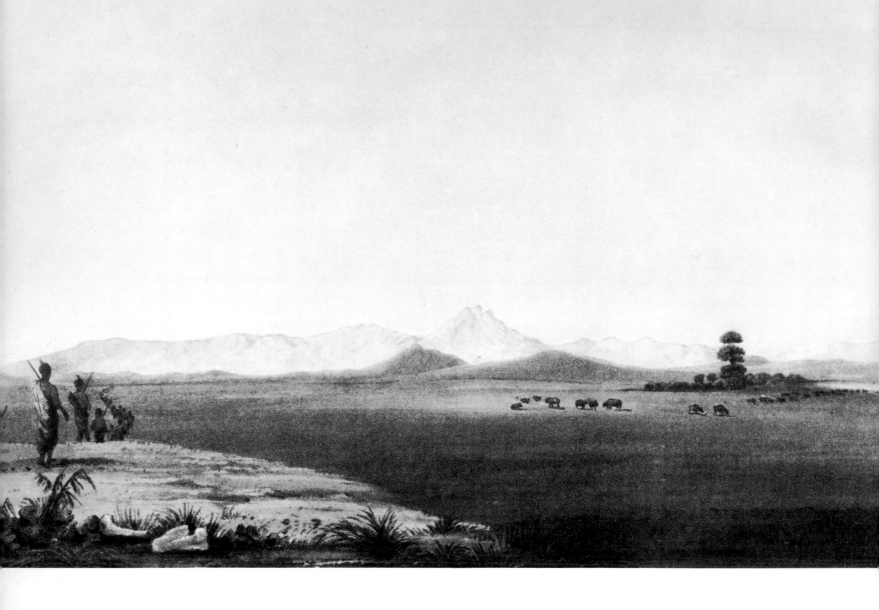

On March 31, 1819, Major Long defined Titian Peale's duties on the forthcoming expedition. "Mr. Peale will officiate as assistant naturalist. . . . His services will be required in collecting specimens suitable to be preserved, in drafting and delineating them, in preserving the skins, &c, of animals, and in sketching the stratifications of rocks, earths, &c, and presented on the declivities of precipices."

Although Titian was to serve as both naturalist and scientific illustrator, an older man, Samuel Seymour, had been recruited as painter for the expedition. Unfortunately, little is known of the background of this first official painter for a Western exploring expedition. He was said to have been born in England, but to have been an engraver and painter in Philadelphia for about twenty years. Seymour's duties were to "furnish sketches of landscapes, whenever we meet with any distinguished for their beauty or grandeur," and "to paint miniature likenesses, or portraits if required, of distinguished Indians, and exhibit groups of savages engaged in celebrating their festivals, or sitting in council, and in general illustrate any subject, that may be deemed appropriate to his art."

At Pittsburgh the Long Expedition, as it is commonly known, boarded the *Western Engineer*, a vessel designed for service on the treacherous Missouri, known for its snags and sand bars. Her bow cannon and four howitzers would protect her passengers from Indian attacks. Her bow, carved in the figure of a large serpent with waste smoke escaping through its mouth, would make an awesome impression upon the red men of the Upper Missouri, who had never seen a steamboat.

Prairie Chicken.
T.R.Peale. 1819–20. Pencil.
American Philosophical
Society, Philadelphia

istant View of the Rocky Mountains. Seymour. June 30, 1820. Engraving made after the first sketch of this range. 1823. Rare Book Division, New York Public Library (left)

Detachment of the Long Expedition at the Encampment of Kiowa and Allied Indians on the Arkansas River. Seymour. July 1820. Watercolor. Beinecke Rare Book and Manuscript Library, Yale University (below)

On June 22, 1819, fifteen years after the Lewis and Clark expedition had begun its tedious ascent of the Missouri, the *Western Engineer* entered the muddy waters of that great river. American settlements had spread up the river banks as far as Fort Osage, near present-day Independence, Missouri. By the time the scientists reached this last outpost of the frontier they had exchanged their handsome uniforms for the more practical frontiersman's garb of buckskin hunting shirt, leggings, and moccasins.

From Fort Osage, Thomas Say led a detachment of ten men, including Peale and Seymour, overland to visit the Kansa Indians on the Kansas River. Those Indians cordially welcomed the explorers to their village and feasted them on jerked buffalo meat and boiled corn. But after leaving the Kansas they were overtaken by a large war party of Pawnees, who stole their horses and forced them to return to the Kansa village. Hardly had they retired that evening in the large lodge set aside for them, when a party of shouting Indians, armed with bows, arrows, and lances, rushed into their dimly lighted quarters. Their visitors turned out to be Kansa dog dancers who had come to entertain them. Seymour sketched the scene—red men howling and dancing about the central fireplace to the accompaniment of a drum and rattles. Thus he created the first field drawing of a Plains Indian dance group in action, and the earliest picture of the interior of a lodge of a farming tribe on the Great Plains.

After Say's overland party rejoined their comrades aboard the *Western Engineer* at the mouth of Wolf River, the steamer moved up the Missouri. On September 21st, she anchored about five miles south of the Council Bluff where Lewis and Clark had parleyed with the Oto and

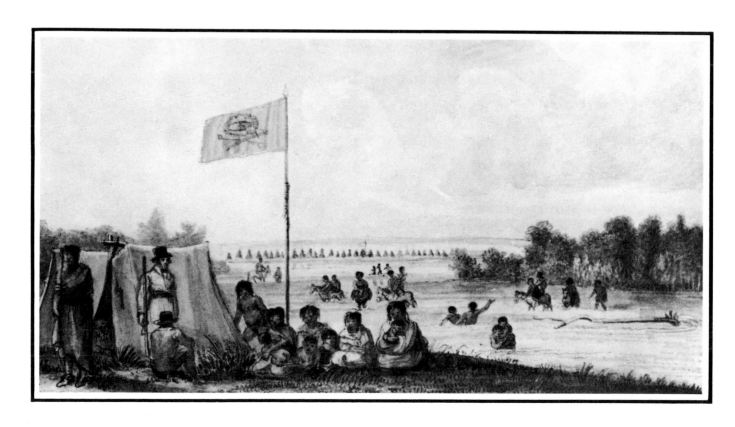

Missouri chiefs on August 3, 1804. There, on a narrow, well-timbered plain, sheltered from the cold northwest winds by bluffs two hundred feet high, Long's men built log cabins for their winter quarters, which they named Engineer Cantonment. Titian Peale sketched this rude field station near the present city of Omaha, Nebraska. In the foreground of this picture appears the *Western Engineer*, the first steamboat to ascend the Missouri beyond the mouth of the Platte.

Early in October, Major Benjamin O'Fallon, William Clark's nephew, and Indian Agent for the Missouri tribes, met the Oto and Missouri, and shortly thereafter, the three Pawnee tribes in formal councils at or near the white men's camp. Seymour pictured both of these councils in watercolors. His view of the Pawnee council shows Indians sitting on rude benches in a large semicircle facing the visiting army officers and a military band. Sentinels in dress uniforms walk behind the benches. One of the Indian leaders has stepped forward to speak for his people. An American flag flies from a conspicuous pole. In this council the Pawnees agreed to restore much of the property they had stolen from Say's party near the Kansa village and promised that the offenders would be whipped.

In October, Major Long returned to Washington, leaving Thomas Say in charge of the field station, "to examine the country, visit the neighboring tribes, procure animals &c." Throughout the winter and spring of 1819–20, Peale collected and prepared specimens of birds, mammals, reptiles, fishes, and insects, many of them new to science. Peale caught new species of fishes through holes in the ice of a nearby pond, trapped a coyote, and shot other mammals. He was primarily responsible for keeping the camp supplied with fresh meat. On February 22, 1820, Peale and the interpreter, John Dougherty, returned from a hunt near the Sioux River on which they had killed a dozen buffalo. During that hunt Peale must have drawn from life the first of many pictures that have depicted buffalo grazing on the plains. His finished watercolor is simply captioned, *Bulls. Febr. 1820*. Peale's field sketches in the vicinity of Engineer Cantonment also included birds, fishes, and delicately colored watercolors of insects.

Nor did Peale and Say neglect to study the Indians of the region. With Dougherty's assistance Say gathered a wealth of information on the customs of the Omaha Indians and their neighbors—their hunts, warfare, political organization, religious beliefs, and daily life. It probably was in November 1819, when a group of Sioux visited Engineer Cantonment, that Peale executed the first known white artist's picture of the conical, buffalo hide-covered tipi, typical home of the nomadic Plains tribes.

On May 28, 1820, Major Long returned from the East with discouraging news. An economy-minded Congress had disallowed further exploration of the Upper Missouri. Four days later he issued instructions for "an excursion by land to the source of the river Platte, and thence by way of the Arkansa and Red Rivers to the Mississippi." Indians and traders in the vicinity of Engineer Cantonment tried to dissuade the explorers from moving westward. They said the country through which they must pass was without wood or water, and was infested with hostile Indians. Nevertheless, Long's little party of twenty men set out on June 6, 1820. Each man rode a horse, and their entire equipment, including small presents for Indians, was carried on the backs of eight pack horses. Following an old Indian trace they rode west to the Pawnee villages on the Loup Fork of the Platte.

*B*lacktail Deer,
Summer Hair. T.R.Peale.
1820. Watercolor. Ameri-
can Philosophical Society,
Philadelphia

The Pawnees received them hospitably. But Long Hair, friendly chief of the Grand Pawnees tried to keep them from proceeding. The indomitable Major discounted Long Hair's warnings, believing the Pawnees did not want them to pass through their hunting grounds, and coveted all of the Indian presents the white men had. Finally convinced that he could not shake the explorers' determination, Long Hair told them, "You must have long hearts, to undertake such a journey with so weak a force; hearts that would reach from the earth to the heavens."

Recruiting two French traders as guides and interpreters, the little party left the Pawnee villages on June 12th. Following the trail taken by Pawnee war parties against mountain Indians who hunted buffalo on the high plains, the expedition moved about twenty-five miles a day, resting only on Sundays.

On June 22nd, the party reached the forks of the broad and shallow Platte. Ahead lay the hunting and battle grounds of the Pawnees and the roving Cheyennes, Arapahoes, Kiowas and Comanches. As they pushed on up the south fork of the Platte they found great herds of buffalo crossing that river and moving southward, and began to see grim evidence of bitter intertribal battles.

On the night of June 27th, they encamped in a grove of cottonwood trees near an abandoned fort that had been hastily built by a Loup Pawnee war party returning from a raid on the Comanches the previous spring. It was simply a circle of logs little more than waist high, and they were to see many such defensive works during the next two months. Peale's watercolor of this fort shows a semicircle of buffalo skulls in the foreground marked with thirty-six red lines to indicate the number of Pawnee warriors. It also shows one of the two sticks which the Pawnees had placed upright in the ground. A few hairs were tied in each of two parcels to the end of each stick, showing that the Pawnee warriors had taken four enemy scalps.

Next day the explorers began to see herds of wild horses, which ran off in fright when the animals scented the approaching humans.

After traveling nearly a month over monotonous plains, the expedition came in sight of the Rocky Mountains. On that day, June 30, 1820, Samuel Seymour drew the first picture of the Rockies, including Longs Peak (rising 14,255 feet), later named after his commanding officer. Apparently this historic view of the front range was executed from a point near present Fort Morgan, Colorado, about one hundred miles east of the mountains.

Cheered by this sublime sight, the party pressed forward, hoping to spend the Fourth of July in the mountains. Yet Independence Day arrived and the Rockies were still some distance away. Major Long issued a gill of whisky to each man of his party. Captain Bell, official journalist for the expedition, was inspired to write in his entry for that day: "We are where imagination only has traveled before us—where civilization never existed—and yet we are within the limits of our country."

The expedition camped near the mouth of Platte Canyon (near present Waterton, Colorado), and Seymour sketched the area where the Platte River descends from the mountains. Moving southward, the party crossed the dividing ridge between the drainage basins of the Platte and Arkansas.

Between July 12th and 14th, Edwin James and two enlisted men made the first ascent of Pikes Peak and visited the now famous Manitou Springs. In the neighborhood of the Rockies, Say and Peale collected

specimens of mountain fauna—birds, reptiles, and small mammals.

On the morning of July 19th, the explorers reluctantly turned their backs on the Rockies and began their long march homeward. Dr. James probably expressed the emotions of all the easterners in that party when he wrote: "More than one thousand miles of dreary monotonous plain lay between us and the enjoyments and indulgences of civilized countries. This we were to traverse in the heat of summer, but the scarcity of game about the mountains rendered an immediate departure necessary."

They had traveled through Indian country for six weeks without seeing an Indian. Then, on July 21st, they met a young Kiowa Apache who was eloping with the wife of another Indian. He told them that the nomadic tribes of the Arkansas Valley had been raiding the Spaniards on Red River far south of their usual haunts. But they were returning, and the whites knew they could not avoid meeting sizable groups of these warlike Indians.

Nevertheless, Long did not hesitate to divide his party into two detachments. Two days later, on July 28th, Captain Bell, leading one group of twelve men down the Arkansas came upon a camp of nearly five hundred Indians. The whites approached the red men cautiously, carrying a white flag bearing paintings of a sword and pipe and the hand of a white man shaking that of an Indian. Happily the red men received them as friends. The explorers pitched their tents across the Arkansas from the large Indian encampment. Samuel Seymour pictured the scene next morning when Kiowa, Kiowa Apache, Cheyenne, and Arapaho chiefs crossed the river to confer with Captain Bell. The artist's small watercolor conveys the essential elements of this meeting—the white men's flag of peace flying over two small tents, and the chiefs with Captain Bell in the foreground, while Indians ford the shallow river from their tipi encampment on the far shore, some of them bringing meat to trade for trinkets.

During their next three week's march down the Arkansas Valley, Bell's men met three war parties: a small, outward-bound Arapaho group, a larger number of Cheyenne warriors returning from a successful raid on the Pawnees, and a bedraggled Comanche war party with their wounded, returning from a fight with the Otos in which they had been beaten. If Seymour sketched any of these parties, the drawings are not known to have been preserved.

After crossing the Arkansas, Major Long's detachment entered Spanish territory to explore the valley of the Red River. With him went Titian Peale and eight other men. On July 31st, a member of this party killed a black-tailed deer. That night, by the light of a large fire, Peale made a drawing of this previously undescribed but common mammal of the West. Later Peale executed a finished watercolor of black-tailed deer.

On August 9th, Long's party met a band of Kiowa Apache, who told the white men they were on Red River about ten days' march upstream from the Wichita Indian grass lodge villages. But as the explorers followed the nearly dry bed of this river, they encountered no more Indians. Not until they had traveled an estimated 796 miles down this stream and found that it entered the Arkansas, did Long realize that the river was not the Red but the Canadian.

Keenly disappointed, Long led his detachment eastward down the Arkansas. On September 12th, they came upon a trader, the first white man they had met in more than three months. Next day they reached Fort Smith, the westernmost military post on the Arkansas, and were reunited with Bell's detachment. After a week's rest, Seymour and Peale

Titian Ramsay Peale in the Uniform of a Long Expedition Naturalist. C.W.Peale. 1819. Oil. Maryland Historical Society

A Pair of Grizzly Bears (bears presented to Peale's museum by President Jefferson). T.R.Peale. Undated. Watercolor. American Philosophical Society, Philadelphia (below)

accompanied Long to Cape Girardeau on the Mississippi, and early in November these first white artists on the Western plains sailed down the river en route home by way of New Orleans.

In his official report Major Long presented a discouraging picture of the lands he and his men had traversed from Engineer Cantonment on the Missouri to the Rocky Mountains and eastward, via the Arkansas and its tributaries to Fort Smith. He declared the whole region to be "almost wholly unfit for cultivation, and uninhabitable by a people depending upon agriculture for their subsistence." He prophesied that "the scarcity of wood and water, almost uniformly prevalent, will prove an insuperable obstacle in the way of settling the country." He termed the region extending five to six hundred miles eastward of the Rocky Mountains the "Great American Desert," and so designated it on the official map of his exploration.

No wonder the general public, accustomed to glowing tales of the wonders of the West, was disappointed by his appraisal. Nevertheless, the contributions to knowledge made by Long's Expedition were considerable, especially in Say and Peale's field of zoology. It deposited more than seventy-five specimens in Charles Willson Peale's museum, along with 120 drawings of mammals, birds, fishes, reptiles, insects, shells, and plants by Titian Peale.

In his two volume work, *Account of an Expedition from Pittsburgh to the Rocky Mountains performed in the years 1819 and 1820 . . . under the command of Major Stephen H. Long* (published in Philadelphia in 1823), Edwin James declared that Peale had executed "122 sketches of which twenty-one only were finished, the residue being merely outlines of quadrupeds, birds, insects, etc." He credited Samuel Seymour with 150 landscape views, of which sixty were finished. The atlas accompanying James's work offered only a very small sample of the artists' contribution to the exploration. Six of the eight plates in the American edition were landscapes by Seymour. Five other Seymour scenes appeared in the English edition. Thus less than five percent of the drawings made on the Long Expedition were published.

The less than a dozen of Seymour's watercolors that have survived in the original or as engraved reproductions are documents of true historical significance. They are small in scale, and most of them are rather colorless, yet they reveal that artist's efforts to picture the Western scene as faithfully as his talents would permit.

Fortunately, nearly fifty of Titian Peale's watercolors and pencil sketches have been preserved in the American Philosophical Society in Philadelphia. They include the earliest known white artist's portrayal of Plains Indian warriors and buffalo hunters on horseback, as well as the first representations of such typical wildlife of the Great Plains as the antelope, the prairie chicken, and the grasshopper. Titian Peale's primary interest in zoology is manifest. His art was disciplined by the demands of scientific illustration. His finished watercolors, particularly his groupings of some of the larger mammals in settings suggesting their natural habitats, seem stiff and labored—like some of the wild animal groups prepared by taxidermists for museums before taxidermy itself became an art. In later years better draftsmen and painters would portray the wild animals of the Plains and the Rockies in violent action more convincingly than Peale rendered some of them at rest. Since Titian Peale was a pioneer in his field, perhaps we should expect to find some of the crudities that typify pioneer efforts. Nevertheless, some of his hasty pencil sketches have both freshness and charm.

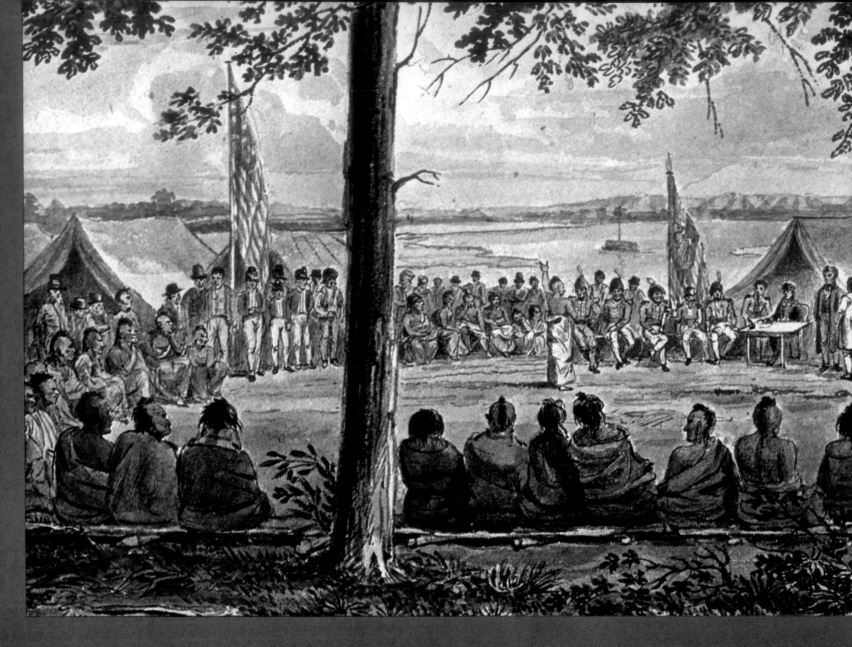

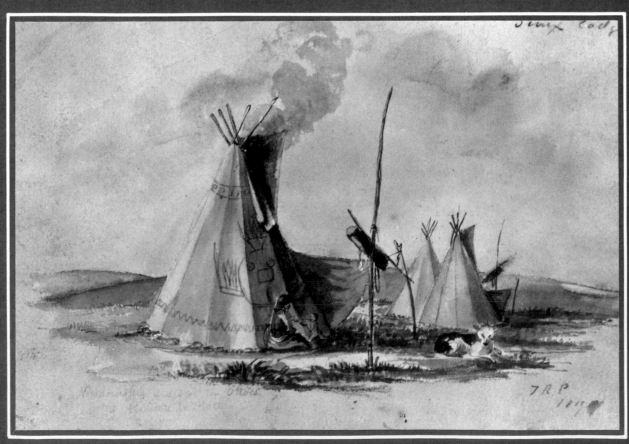

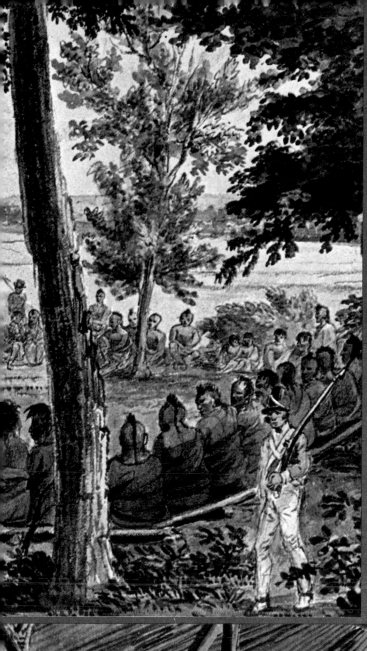

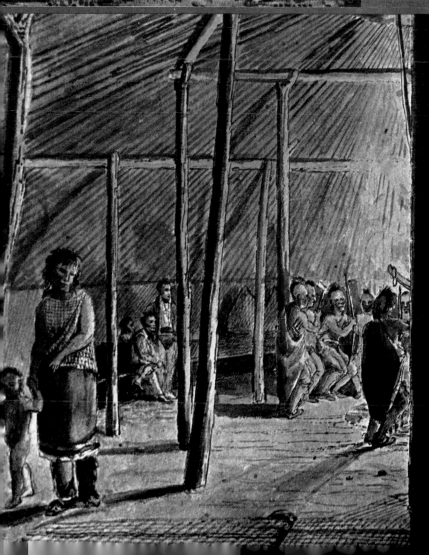

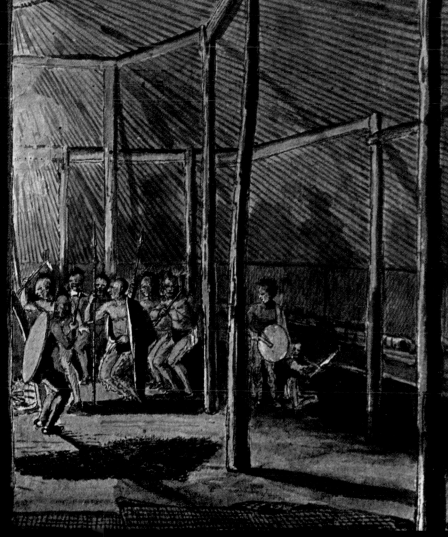

Pawnee Indian Council. Seymour. October 1819. Watercolor. Beinecke Rare Book and Manuscript Library, Yale University (left)

"Sioux Lodges, 1819." (The earliest known picture of Plains Indian tipis.) T.R.Peale. Watercolor. Miss Ida Edelson, Philadelphia (bottom left)

Dog Dance in a Kansa Indian Lodge. Seymour. August 1819. Watercolor. Beinecke Rare Book and Manuscript Library, Yale University (bottom right)

PORTRAYING PLAINS INDIANS FOR POSTERITY

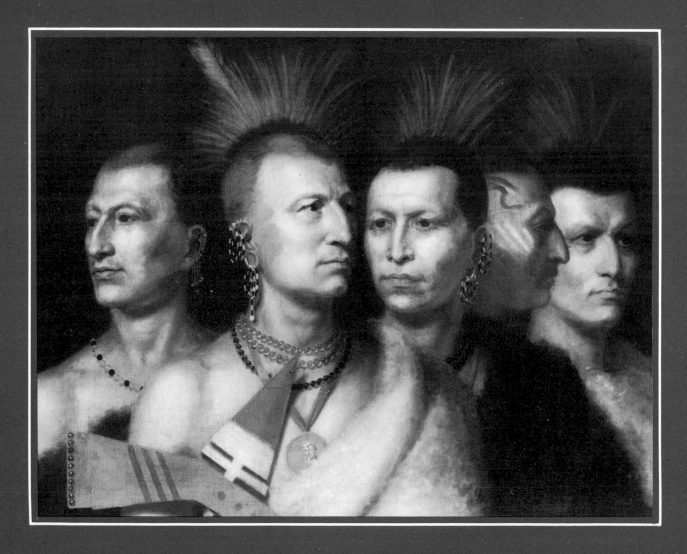

Charles Bird King and John Neagle

*Young Omawhaw,
War Eagle, Little Missouri
and Pawnees. King. 1821.
Oil. Smithsonian Institution*

Among Samuel Seymour's duties for the Long Expedition had been that of painting "miniature likenesses, or portraits, if required, of distinguished Indians." He saw prominent chiefs and warriors of more than ten tribes during his year west of the Mississippi. He may have attempted other Indian portraits, but only three of them, pictured side by side on a small sheet of paper, are still extant. These Indians are identified only by tribe as *Kaskaia, Shienne Chief, Arrapaho.* Doubtless they were leaders of the Kiowa Apache, Cheyenne, and Arapaho portions of the camp met by Captain Bell's detachment of Long's Expedition on the Arkansas River in July 1820. These are of interest as the earliest known portraits of Indians of those Western tribes. But the faces are so small and so crudely drawn, and the costuming so lacking in detail that this picture tells us very little about these people. If we judge Seymour's ability from this example alone, we must conclude that he had little real talent for portraiture.

Within two years of the return of the Long Expedition, however, a number of the distinguished Indians they had met in the valleys of the Missouri and the Platte were pictured by more able portraitists.

In the early fall of 1821, Major Benjamin O'Fallon, Indian Agent for the Missouri River tribes, visited the Kansa, Oto and Missouri, Omaha, and the three Pawnee villages, recruiting Indian leaders for a visit to the Great White Father in Washington. He found it impossible to convince some of the proud chiefs that it would be worth their while to make a long trek that would keep them away from home for half a year. Long Hair, the aged and astute head chief of the Grand Pawnees, a tribe of four thousand, regarded himself as the most important leader of the greatest people in the world. Why should *he* condescend to travel more than a thousand miles to visit President Monroe, a man who had fewer wives, owned fewer horses, and had not taken as many scalps as had he, Long Hair of the Grand Pawnees? Long Hair expressed his willingness to live at peace with the Americans, but he flatly refused to visit their great chief in Washington.

The Indian Agent, however, was able to persuade prominent members of all seven tribes to join him on his journey. There were sixteen Indians in his party when he reached the capital city. The *National Intelligencer* heralded their arrival in its issue of November 30, 1821: "Their object is to visit their Great White Father, and learn something of that civilization of which they have hitherto remained in total ignorance." The reporter revealed his own ignorance of these Indians and their grassy homelands by adding: "These red men of the forest who now visit us are completely in a state of nature."

Government officials in 1821 followed much the same pattern of entertaining and impressing Indian visitors with the dense population, military strength and good will of the United States as had been employed in receiving the first Indian delegation from Louisiana a generation earlier. The Indians were shown the navy yards, arsenals, and fortifications. They were taken on the grand tour of Baltimore, Philadelphia, and New York. The *New York American* of December 15th pronounced these Indians "fine specimens of the native race of this continent, uncorrupted by all the civilization the Indian has been capable of acquiring—its vices." After their return to Washington these chiefs painted their faces, stripped to their red flannel breech-clouts, gave their war whoops, and displayed their war dances to a fascinated audience of more than six thousand in front of the President's house.

At President Monroe's formal New Year's reception they were

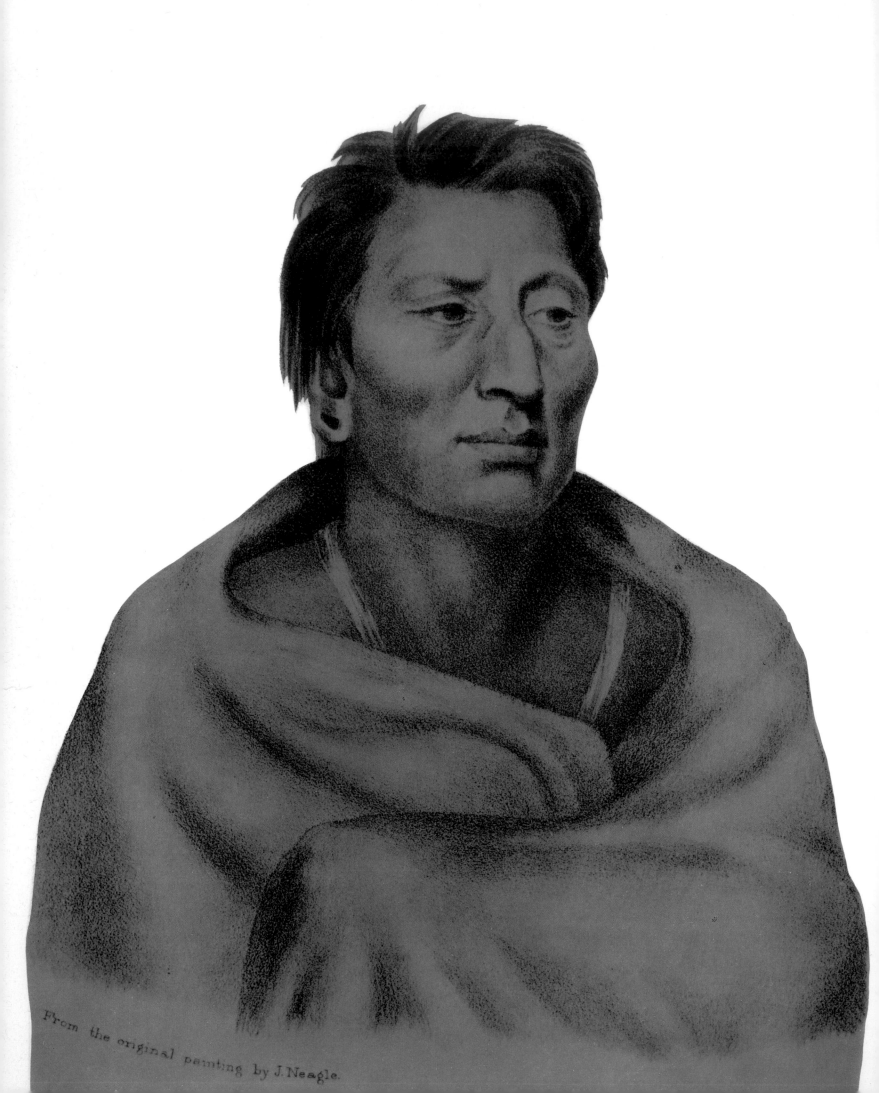

From the original painting by J. Neagle.

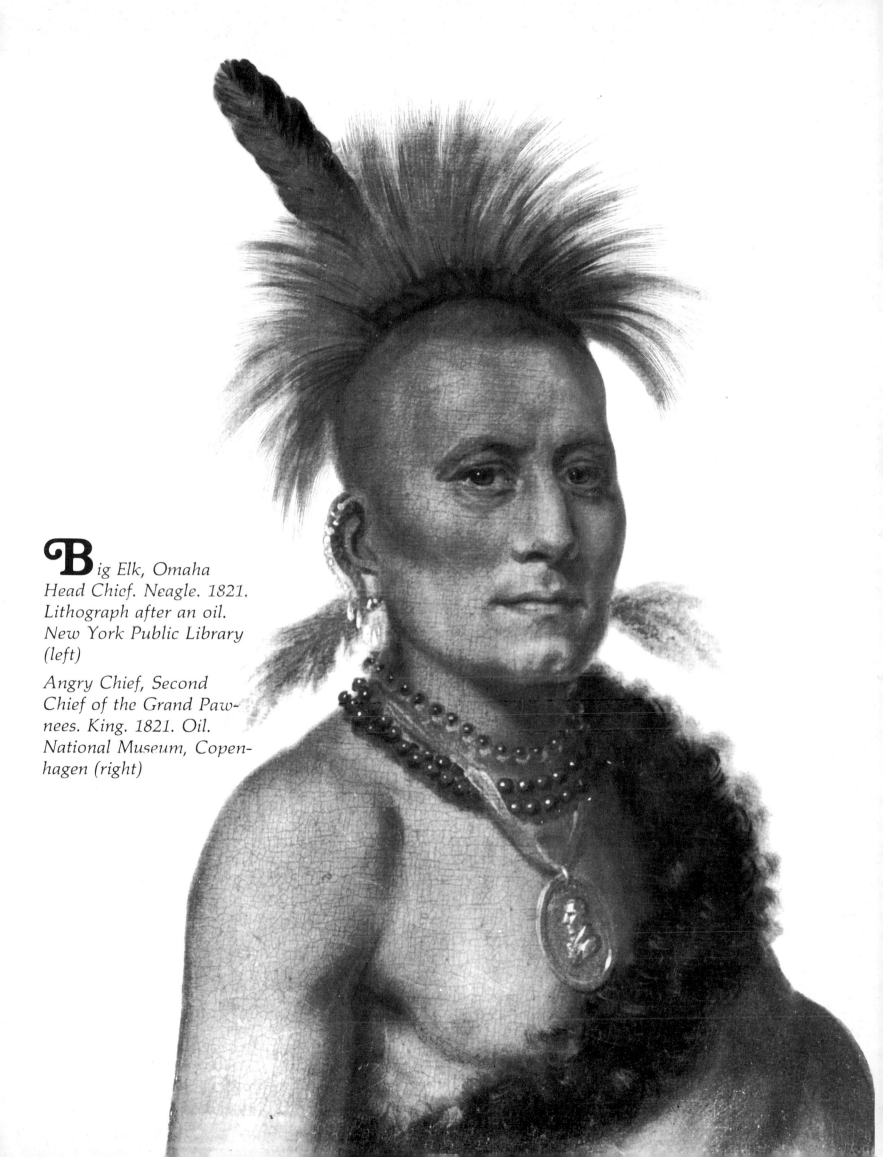

Big Elk, Omaha Head Chief. Neagle. 1821. Lithograph after an oil. New York Public Library (left)

Angry Chief, Second Chief of the Grand Pawnees. King. 1821. Oil. National Museum, Copenhagen (right)

introduced to their Great White Father. In reporting this social event next day the *Washington Gazette* observed:

. . . during this ceremony their demeanor was respectful and dignified; their countenance inquisitive and interesting; three of them were attired in buffalo robes, embellished with a variety of painted figures, birds, horses, etc. The little Pawnee had a headdress of feathers, descending like wings to the waist, the O'Mahas chief wore silver bracelets, the Kansas was wrapt in his blanket, the Otos and Missouris were in buffaloe. On their faces red paint was laid from the eyebrows to the cheek bones.

No resident of Washington was more keenly attracted by the appearance of these visitors than was the polished gentleman-artist, Charles Bird King. Born in Newport, Rhode Island, in 1785, King's early interest in painting had been encouraged by some of the leading artists of his day. Samuel King of Newport, instructor of Allston and Malbone, was his first teacher. He later studied under Edward Savage in New York, and spent seven years in London, where he roomed with Thomas Sully and had the advantage of Benjamin West's instruction. Returning to America in 1812, King practiced his art in Philadelphia for four years, before moving to Washington and achieving a reputation as a painter of prominent Americans of his time.

It probably was in his studio on Twelfth Street that King painted a striking portrait of a group of five of the younger members of the 1821 Indian delegation, which he titled *Young Omawhaw, War Eagle, Little Missouri, and Pawnees.* In this studio composition King defined the facial features of these virile, proud warriors with a sureness that was lacking in Seymour's feeble efforts in the field.

Thomas L. McKenney, Superintendent of Indian Trade, commissioned King to paint portraits of at least eight members of this delegation to decorate the walls of his offices in Georgetown. The artist was reputed to have received four hundred dollars from government funds for these half-length likenesses on wooden panels.

Three of King's portraits were of members of the small Oto tribe, which lived with the remnants of the Missouri Indians on the Platte River near its mouth. Together the Oto and Missouri numbered less than eight hundred individuals. Thomas Say had found their second chief, Prairie Wolf (Shaumonekusse) to be "one of the most brave and generous warriors of the Missouri valley." King painted this man clad in a buffalo-horned headdress and a necklace of grizzly bear claws, his muscular body partially covered by his trade blanket. His expression may show something of that "eminently witty" quality which Say had observed was "strongly indicated by his well-marked features." Good-natured this man may have been, but on the Plains he was renowned for the war honors he earned in conflicts with five enemy tribes and the Spaniards. He had led the small Oto force that had soundly whipped the Comanche war party Captain Bell's detachment of the Long Expedition had met carrying their wounded homeward on the Arkansas in the late summer of 1820. His daring feats in warfare against the much more numerous Comanches had won him the nickname of "Ietan" (Comanche) among his own people.

Prairie Wolf was the only man of the 1821 delegation to bring his wife to Washington with him. This young woman, Eagle of Delight (Hayne Hudjihini), was showered with presents during her eastern tour. Probably the figured cloth waist and the four necklaces she wore when she posed for Charles Bird King were a few of these gifts from admiring whites. Eagle of Delight died soon after her return home, and her hus-

White Plume, Head Chief of the Kansa. King. 1821. Oil. The White House Collection, Washington, D.C.

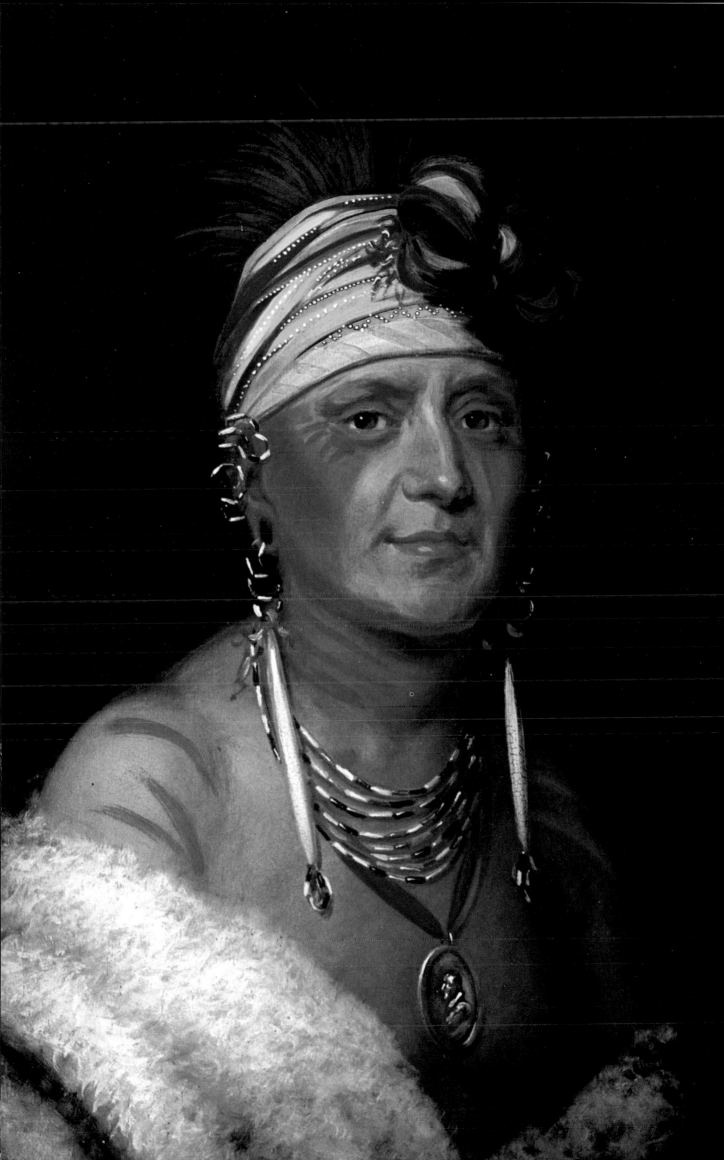

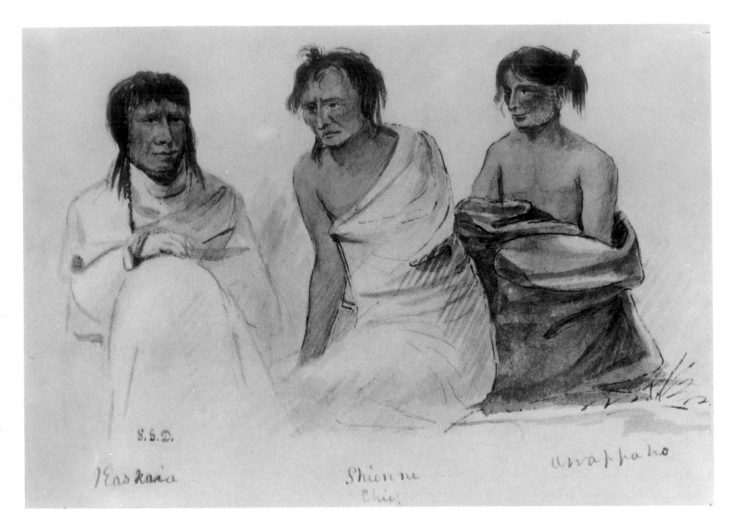

band had the end of his handsome nose bitten off by his brother in a drunken carouse. He served as head chief of his tribe for nearly fifteen years, finally losing his life in a fight at a trading post in 1837.

The oldest member of the 1821 delegation was White Plume (Monchansia), a chief of the Kansa tribe of some eighteen hundred people. Members of the Long Expedition had recognized him as a man "apparently destined to become the leader of the nation." King's portrait reveals a dignified, keen-eyed, handsome man without marked Indian features. The portrait does not suggest the corpulency for which White Plume was known in subsequent years when he became the Kansa head chief and followed a friendly policy toward Americans.

Big Elk (Ongpatonga) was the most distinguished member of the delegation. He had been head chief of the Omaha tribe for several years before the Long Expedition became well acquainted with him through his frequent visits to Engineer Cantonment. They observed that Big Elk was "more distinguished for his intellect than for any martial qualities." He also impressed the whites with his oratorical skills. In seeking favors from the Americans, in the field as well as in Washington, he stressed the point that no one of his nation had ever "stained his hands with the blood of the white man." He claimed that his own attachment for the whites was so strong that "he should, at a future day, be a white man himself." King's portrait of Big Elk may show this chief's "commanding presence," but it mercifully fails to illustrate the Long Expedition's

Kiowa Apache, Cheyenne, and Arapaho. Seymour. 1820. Sepia field sketch. Beinecke Rare Book and Manuscript Library, Yale University

further observation that his face was "much pitted with smallpox."

King portrayed three Pawnee members of this visiting Indian group. One of them was Peskalechaco, an active young warrior of the Republican Pawnees. His buffalo robe, draped over his right shoulder, bears rude paintings which doubtless recorded some of his exploits in war. Five years later he lost his life fighting enemy raiders who were discovered in the act of stealing horses from his village.

The second chief of the Grand Pawnees, when the Long Expedition visited their village in 1820, was Angry Chief (Sharitarish). He welcomed the whites on their arrival and assembled thirty or more young warriors to entertain them with a series of dances. This ambitious younger man coveted Long Hair's position as tribal head chief. When Long Hair refused to go to Washington, Angry Chief went in his stead and learned how wrong Long Hair had been in underestimating the numbers and power of the Americans. Old Long Hair died soon after Angry Chief's return from the East. Angry Chief succeeded him but lived to enjoy his high office for only a few months. King's portrait shows this determined young man proudly wearing his presidential medal on his bare chest.

The popular hero of the delegation was a young man, Generous Chief (Petalesharo), son of Knife Chief, the principal chief of the Skidi Pawnees, by whose name the son was also known. From time immemorial the Skidi Pawnees had offered a human sacrifice to the morning star each spring in order to insure the success of their crops of corn, beans, and pumpkins. The victim was always a prisoner of war, and usually a pure young woman. She was treated kindly by her captors and kept in ignorance of her fate until the morning she was led, painted from head to foot in sacred red and black colors, to a scaffold in the center of the village, tied to the crossbars, and, just as the morning star appeared in the sky, killed by a medicine arrow shot through her heart. American traders and officials, horrified by the cruelty of this ceremony, had urged the Skidi Pawnees to abandon it, but the powerful and fanatical priests of the tribe claimed that a calamity would befall their people if the morning star ceremony was not performed in its traditional fashion.

In 1818, a young Comanche woman was chosen for the Skidi sacrifice. The victim had been led to the scaffold and her arms and feet tied, when Petalesharo, respected son of the head chief, rushed from the crowd of spectators, quickly untied the prisoner, carried her to two horses which he had made ready, and rode swiftly away with her. When they were beyond danger of pursuit, Generous Chief gave the girl food and freed her. Then he returned to the village. So swift and unexpected had been his action that there had been no opposition. Nor did the priests wreak vengeance upon the bold liberator.

While the Indians were in Washington the story of Petalesharo's heroic deed was published in the *National Intelligencer.* The act appealed to the humane sentiments of Christians and the romantic imaginations of young women. Overnight the young redskin became something of a national hero. This hero worship was climaxed when the young ladies of Miss White's Seminary presented the embarrassed man with a silver medal on which was incised a picture of his rescue of the Comanche maiden and the inscription, "To the Bravest of the Brave."

Charles Bird King pictured Petalesharo as an earnest young man with exceedingly handsome features framed by the weasel-skin pendants of a magnificent eagle-feather war bonnet. Perhaps the artist could not resist idealizing the likeness. Certainly the portrait of Petalesharo painted by the young Philadelphia artist, John Neagle, during the delegation's

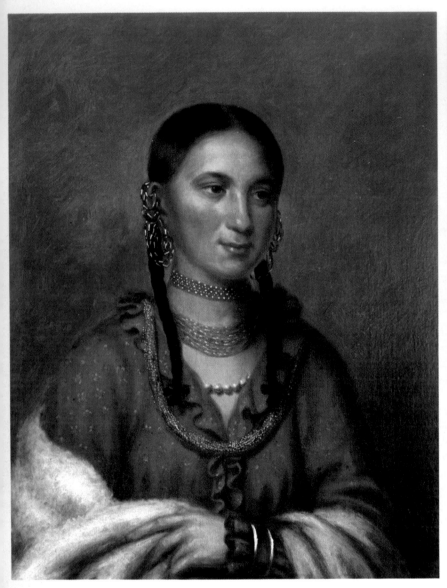 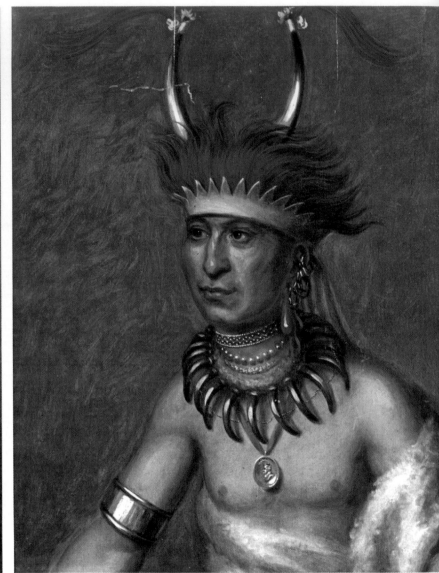

Eagle of Delight, Wife of Prairie Wolf. King. 1821. Oil. The White House Collection, Washington, D.C. (left above)

Prairie Wolf, Oto Indian Second Chief. King. 1821. Oil. The White House Collection, Washington, D.C. (right above)

Petalesharo, Skidi Pawnee Hero. King. 1821. Oil. The White House Collection, Washington, D.C. (opposite)

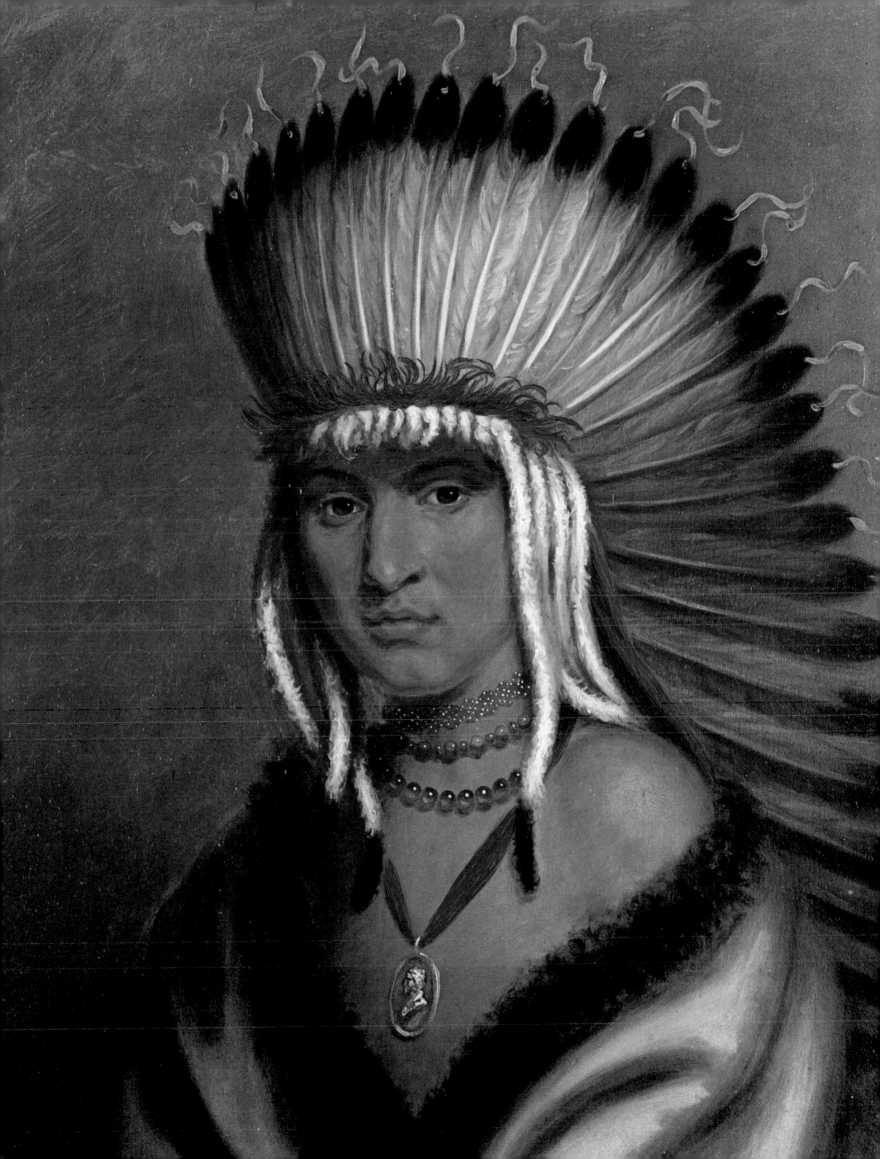

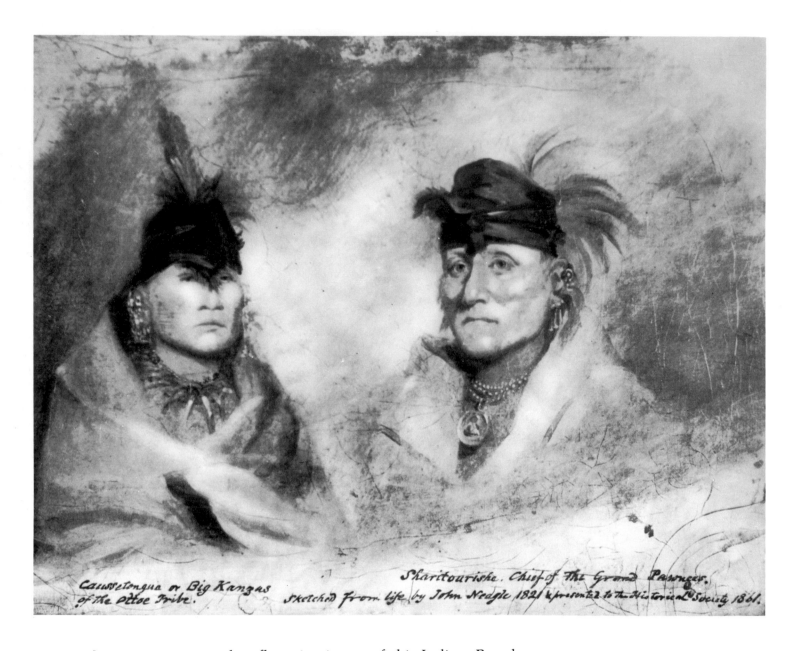

Caussetongua or Big Kanzas of the Otoe Tribe. Sharitourishe, Chief of the Grand Pawnees. Sketched from life by John Neagle 1821 & presented to the Historical Society 1861.

visit to that city, presents a less flattering image of this Indian. But the story of the young man's heroism had not been widely publicized at the time he posed for Neagle. Neagle's portrait of Petalesharo (identified by his father's name, Knife Chief) may also be the first of the countless pictures of North American Indians wearing a feather bonnet and trailer.

Neagle also executed portraits of at least three other members of the delegation, Big Elk, Angry Chief, and Big Kansa of the Oto tribe. Four of this artist's Indian portraits were exhibited at the Annual Exhibition of the Pennsylvania Academy of Fine Arts in the spring of 1822. At the time he executed these portraits, twenty-five-year-old John Neagle had been painting professionally for only three years, but he was a thoroughly trained, ambitious, extremely rapid worker, on his way to becoming Philadelphia's best portrait painter in the pre-Civil War years. Neagle may have been attracted to Indians by the fact that he was swarthy of complexion, with keen black eyes, black straight hair, and had an Indian-like facial expression himself. He was proud of his Indian-like appearance.

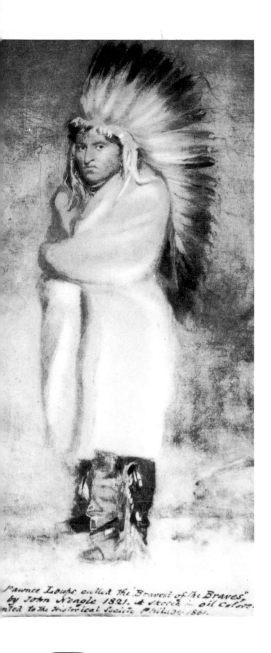

Pawnee Loups called the "Bravest of the Braves" by John Neagle 1821. A sketch in oil colors. ...ted to the Historical Society. Philada 1861.

Big Kansa (Oto) and Angry Chief (Pawnee). Neagle. 1821. Oil. Historical Society of Pennsylvania (left)

Petalesharo, also known as the Knife Chief. Neagle. 1821. Oil. Historical Society of Pennsylvania (above)

Charles Bird King's portraits of the 1821 delegation comprise the first series of oil paintings of prominent Indians of the West. Although King painted many portraits of politically and socially prominent whites, and many Indians from the woodland tribes, these pictures of Western Indians remained the most popular of his works. Some of them he copied and recopied four or more times and a few of these replicas were sent abroad to Denmark and to England.

Furthermore, these paintings formed the nucleus of the famous National Indian Portrait Gallery of nearly 150 portraits of Indian visitors to Washington in the years 1820–1837. Secretary of War James Barbour credited Thomas McKenny with conceiving "the expediency of preserving the likenesses of some of the most distinguished among this most extraordinary race of people." And Barbour approved of the project because he believed that "this race was about to become extinct, and that a faithful resemblance of the most remarkable among them would be full of interest in after times."

When that indefatigable commentator on American customs, Frances Trollope, saw the growing collection in 1832, she wrote:

The bureau for Indian affairs contains a room of great interest; the walls are entirely covered with original portraits of all the chiefs who from time to time, have come to negotiate with their great father, as they call the President. These portraits are by Mr. King, and . . . are excellent likenesses, as are all the portraits I have ever seen from the hands of that gentleman.

In 1858, the National Indian Portrait Gallery was transferred to the Smithsonian Institution where these paintings remained on exhibition until a fire destroyed many of them on January 15, 1865. Although nearly all of the original portraits were lost in that fire, King's likenesses of Indians are preserved in replicas in museum collections from Oklahoma and Nebraska to Denmark, as well as in faithful and colorful lithographs illustrating the series of biographical sketches in Thomas McKenney's and James Hall's three-volume work, *History of the Indian Tribes of North America*. Published in Philadelphia in 1836–44, this king-size work became a landmark in American Indian studies largely because of its exquisite portraits. Its handsome plates (19¼ × 13¼ inches) are still coveted collector's items.

In the year 1839, Dr. Samuel George Morton of Philadelphia published *Crania Americana*, the pioneer scientific study of the physical characteristics of North American Indians. A lithographic reproduction of John Neagle's portrait of the Omaha chief, Big Elk, served as the frontispiece for this great work. Dr. Morton explained his selection of this subject thus: "Among the multitude of Indian portraits . . . I know of no one that embraces more characteristic traits than this, as seen in the retreating forehead, the low brow, the dull and seemingly unobservant eye, the large aquiline nose, the high cheek bones, full mouth and chin and angular face."

This combination of physical traits was most commonly found among the Indians of the Great Plains. And it was through the works of such portrait painters as Charles Bird King* and John Neagle that the image of the Plains Indian came to symbolize the American Indian par excellence in the minds of civilized men and women everywhere.

*In 1963, five replicas by Charles Bird King of his portraits of Plains Indians of that 1821 delegation to Washington were presented to Mrs. John F. Kennedy for the White House Collection.

YOUNG ARTIST ON THE RED RIVER OF THE NORTH

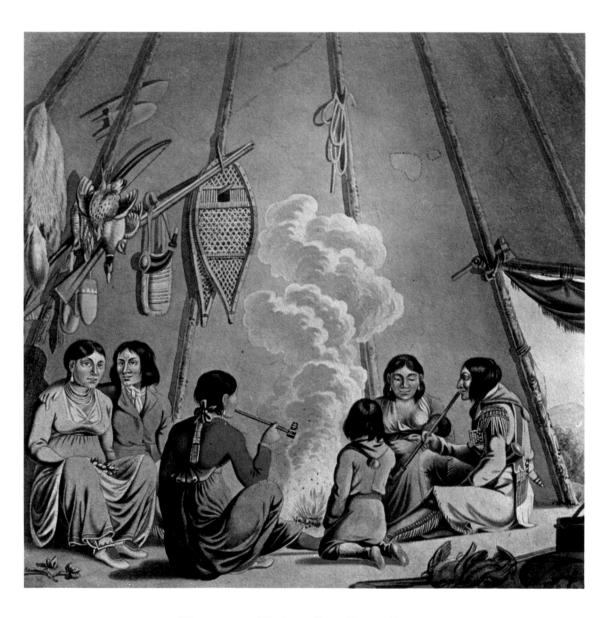

Peter Rindisbacher

One of the strangest real estate deals in the history of the American West was made in London during the summer of 1811: the Hudson's Bay Company granted some 116,000 square miles of prairie land to Lord Thomas Douglas, fifth Earl of Selkirk, in exchange for ten shillings and his promise to settle a thousand families on that land within ten years. Selkirk's grant extended from Lake Winnipeg southward through the valley of the Red River of the North to the watershed which separated the drainage basin of Hudson Bay from that of the Missouri River. It included parts of the present states of North Dakota and Minnesota and the Canadian provinces of Manitoba and Saskatchewan. This was the hunting grounds of the Chippewa, Cree, Assiniboine, and Sioux Indians. The only white men in the territory were fur traders of the Hudson's Bay Company and their bitter Northwest Company rivals from Montreal.

The Hudson's Bay Company expected that this colony would supply cheap agricultural products to feed its hungry canoemen and the traders who manned its far-flung posts in the northwestern wilderness. Lord Selkirk hoped the new colony would attract large numbers of ambitious families from the overpopulated centers of the Old World. In the first two years he settled a number of Scotch families on his grant. But the Northwest Company traders and their Indian allies challenged the right of Selkirk and the Hudson's Bay Company to establish a settlement of whites on Indians' land.

In 1817 Selkirk induced a number of discharged mercenaries from the De Meuron regiment—which had served the British in America during the War of 1812—to move west and to help bring peace to his turbulent settlement. He also made a treaty with the Indians promising them one hundred pounds of tobacco annually for the right to colonize part of their lands. By the summer of 1818, Lord Selkirk's Red River Colony, as it was commonly known, had become a polyglot community of 151 Scotch, 45 De Meurons (mostly Germans and Swiss), and 26 French Canadians, living in fifty-seven houses. There were also some former Hudson's Bay Company employees who had brought their Indian wives and mixed-blood children to settle down after their retirement from the fur trade.

By 1821, Selkirk's Red River Colony was still far short of its promised one thousand families. But Selkirk's European agent was extravagantly singing the praises of the Red River Valley to industrious families in Switzerland. It mattered not that some of these good people believed he was describing the Red River of Louisiana, where they might find homes in a warm climate among prosperous French settlers; the smooth-talking agent recruited fifty-seven families, promising each a home and one hundred acres of land to be paid for in five or more years with only five hundred bushels of wheat from their own farms.

In the spring of 1821, the Swiss immigrants and their possessions were loaded on barges at Basle. They sailed down the Rhine and boarded the Hudson's Bay Company's ship *Wellington* for a fourteen-week voyage to the west coast of Hudson Bay. When they left Europe they numbered 171 people; six children were born on the way.

Among these immigrants was Peter Rindisbacher, a forty-one-year-old veterinary surgeon, with his wife and six children. His second son, Peter, a lad of fifteen years, had been born in the canton of Berne, April 12, 1806. Young Peter had never shown any interest in farming. But he loved to draw and paint. At the age of six he had copied pictures and he had made drawings in his schoolbooks until his father gave him paper

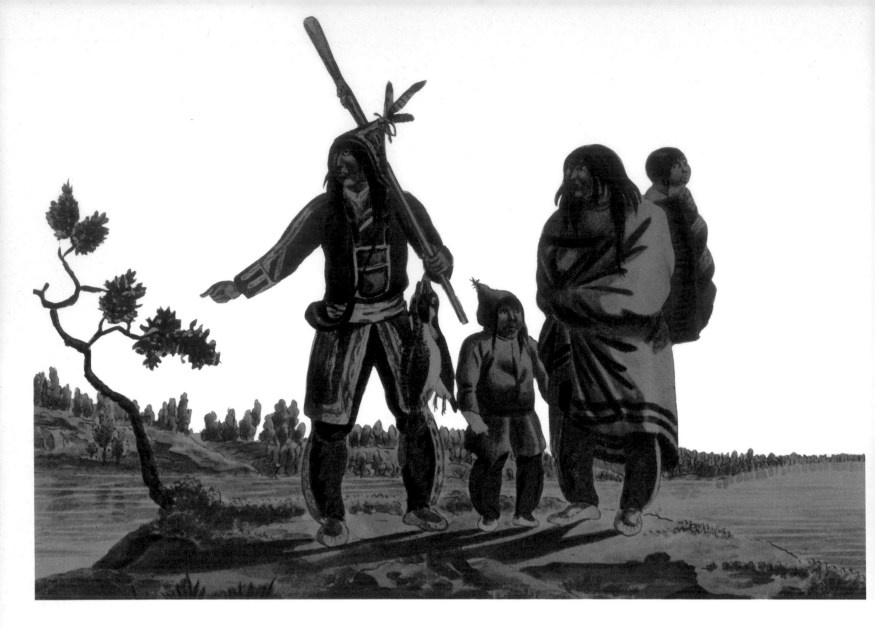

and paints. In his twelfth year he received his only known formal art instruction when the painter, Jacob S. Weibel, invited him on a trip to the Bernese Alps.

During the long sea voyage to Hudson Bay the boy artist made numerous pencil sketches of memorable sights—huge icebergs, Eskimos in small boats and kayaks, and other arctic scenes. After the Swiss landed at York Factory, the Hudson's Bay Company's port on the shore of Hudson Bay, he continued to record aspects of the new land. One of his first sketches ashore pictured a Cree Indian family near York Factory—perhaps the first of the many red men Peter Rindisbacher was to meet in America.

From York Factory the Swiss immigrants traveled up the Hayes River and across Lake Winnipeg, a hazardous wilderness journey. One man and six children died before they reached the boundary of the Selkirk Colony. Peter Rindisbacher pictured their arrival. His watercolor bears the caption, *Arrival at the mouth of Red River in North America, 47N, and welcome from the Sautaux Indians, Nov. 1, 1821, after a river and sea voyage of 4836 English miles.* Chief Peguis of the Chippewas, a staunch friend of the Red River settlers, welcomed his Swiss neighbors-to-be to his camp and supplied them with fresh and dried salmon.

Few pioneers were more poorly prepared for the rigors of frontier life than were these Swiss immigrants. Among them were clockmakers, musicians, a schoolmaster, a dentist, and an apothecary; men of skill in civilized pursuits, who were forced to adjust to the most primitive

A Hunter and Family of Cree Indians at York Factory. Rindisbacher. 1821. Watercolor. Public Archives of Canada (above)

Fort Gibraltar at the Junction of Red and Assiniboine Rivers. Rindisbacher. Winter 1821–22. Watercolor. Public Archives of Canada (top right)

46

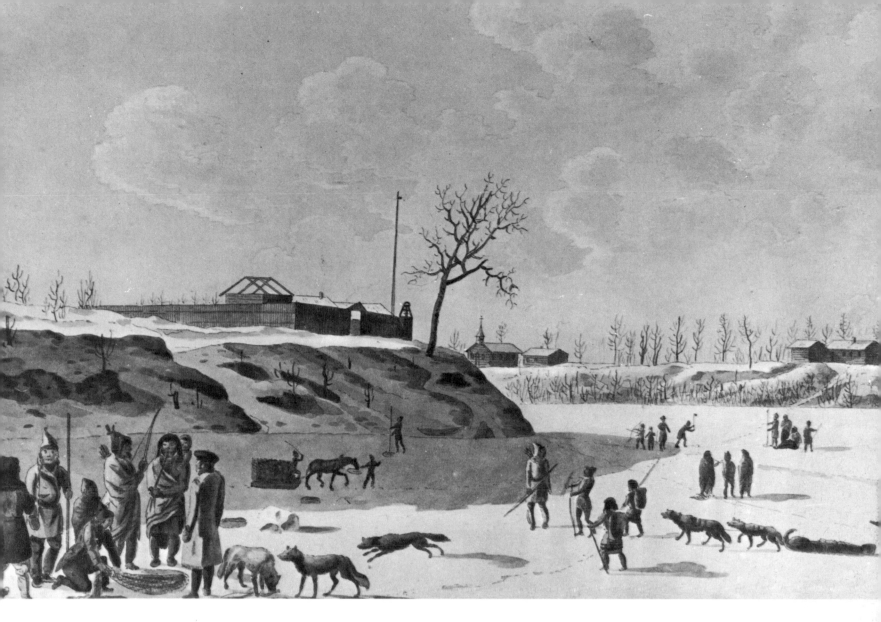

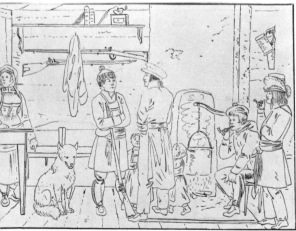

Colonists on the Red River of the North. Rindisbacher. Undated. Pen and ink. Public Archives of Canada

living conditions. Rindisbacher's watercolor of the junction of the Assiniboine and Red rivers, as it appeared during his first winter in the West, shows Indians and whites walking and sledding on the thickly frozen river. In the left background appears old, wooden Fort Gibraltar, where the settlers purchased their meagre supplies. Among the earlier settlers, the De Meuron soldiers were especially happy to see the Swiss maidens, some of whom they courted and married. But most of the Swiss were compelled to move to the open buffalo plains to obtain meat to carry them through their first winter in the New World.

During his residence of nearly five years in the Red River Colony young Rindisbacher made the most of his opportunities to draw and paint the diverse peoples of that region and their varied summer and winter activities. His sketches portray the distinctive dress of the Swiss, De Meuron, Scotch and French Canadian settlers, Hudson's Bay men, and the Indians in garments of animal skins or trade cloth and ornaments of trade beads and metal.

In the Red River region the Chippewas of the Woodlands mingled with the Assiniboines and Crees of the Great Plains and all of these tribes joined in conflict with the aggressive Sioux. Rindisbacher's drawings depict on the one hand the bark-covered homes, birchbark canoes, and fishing activities of the Chippewas, and on the other the Plains Indians' skin-covered tipis, buffalo hunting, and use of horses.

Rindisbacher executed the earliest known pictures of tipi interiors, although he tended to show more foundation poles than were commonly

Chippeway Canoe. Rindisbacher. Undated. Watercolor. U.S. Military Academy Museum, West Point (below)

Murder of David Tulley and Family by Sisseton Sioux. Rindisbacher. Undated. Watercolor. U.S. Military Academy Museum, West Point (right)

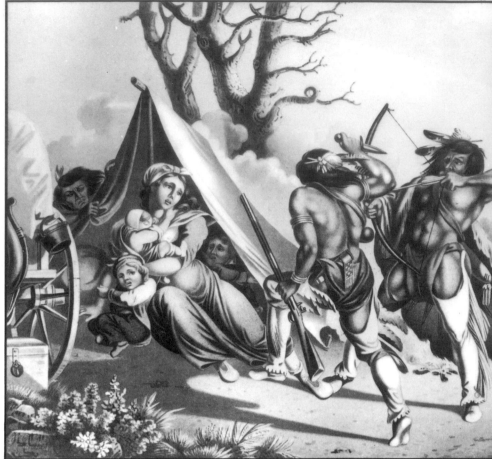

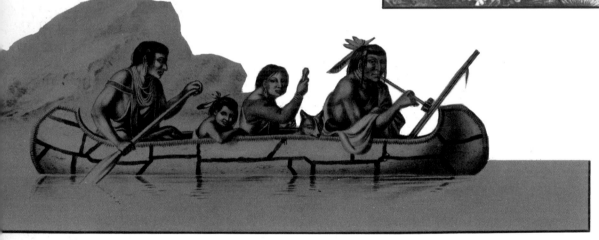

Drunken Frolic amongst the Chippeways and Assiniboines. Rindisbacher. Undated. Watercolor. U.S. Military Academy Museum, West Point (right)

employed by the Indians. He may have been the first artist to picture the A-shaped travois drawn by Indian dogs, and the use of snowshoes and toboggans by Indians west of Hudson Bay. His lively watercolor, *A Drunken Frolic Among the Chippeways and Assiniboines*, portrays, against a background of tipis and a long, arched, Chippewa bark-covered dwelling, one of the most sordid aspects of the fur trade. When the Indians brought their winter's catch of furs to the trading posts in spring the traders usually gave them kegs of rum. Orgies often followed in which some of the Indians drank themselves into a stupor, while others fought in brawls that too frequently ended in murder.

Another of young Peter's scenes portrays the murder of the family of David Tully, Scotch settlers, by the Sisseton Sioux in 1823. Others show an Indian in the act of scalping his red-skinned enemy in battle, and a warrior returning to his tipi, scalp trophy in hand. Thus Rindisbacher showed the seamy as well as the pleasant side of life in this primitive region in the early 1820's.

Some of Rindisbacher's most popular scenes were of Indian buffalo hunts. One of these shows Assiniboine hunters on snowshoes, accompanied by their excited, barking, lean dogs, approaching a herd of buffalo. In this early spring hunt the snow is sufficiently frozen to bear the weight of the men, but the heavy buffalo break through the snow's crust and cannot run. Another scene depicts Indians creeping up on the buffalo in the dead of winter and killing several beasts without disturbing the entire herd. A third watercolor shows Indians on horseback, armed with bows and arrows, running buffalo in warmer weather. Perhaps Peter's veterinarian father imparted to his talented son some of the knowledge of animal anatomy clearly revealed in the boy's renderings of buffalo, dogs, and horses in violent action.

Apparently Rindisbacher first drew each subject in pencil and later rendered many of the same scenes in watercolor. He soon found that other colonists wanted copies of his graphic representations of the wildlife and scenery around them. Among his early patrons were the Church of England clergyman, the sheriff, and the Governor of the Red River Colony, Captain Andrew Bulger. Gradually the young artist's reputation spread among the officials of the great Hudson's Bay Company, and he found a modest market for his works that helped to augment his family's meagre income. By 1824, James Hargrave, accountant at Fort Garry, was receiving orders for Rindisbacher's watercolors. George Barnston wrote from York Factory requesting *Plains Indian on horseback shooting an enemy, traveling in winter with an Indian guide before the sled*, and buffalo hunting scenes "in which," he said, "I think the young lad excells." Among other purchasers was William Smith, Secretary of the Hudson's Bay Company in London.

About 1825, a set of six colored lithographs was published in London

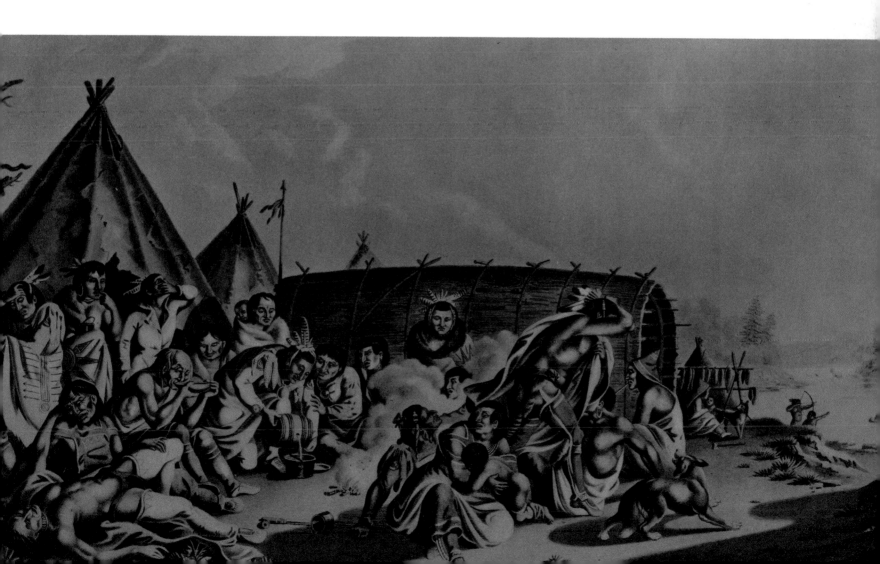

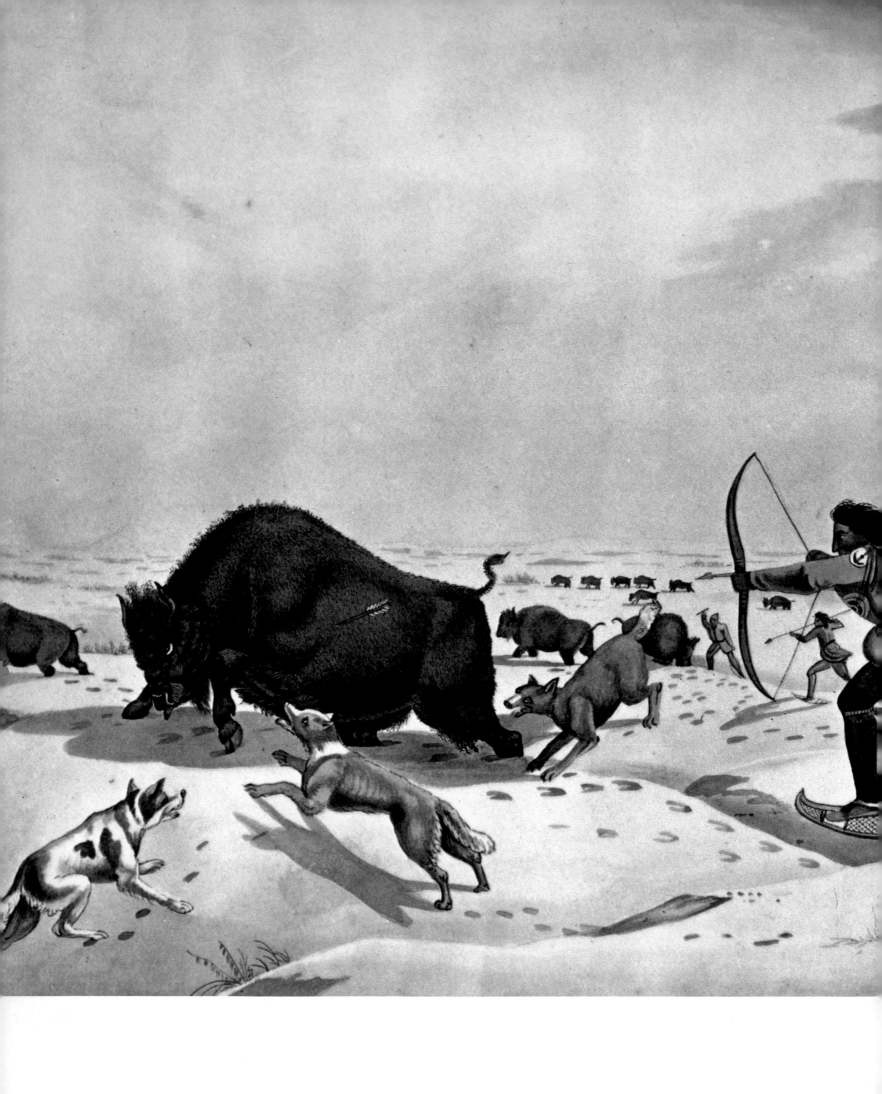

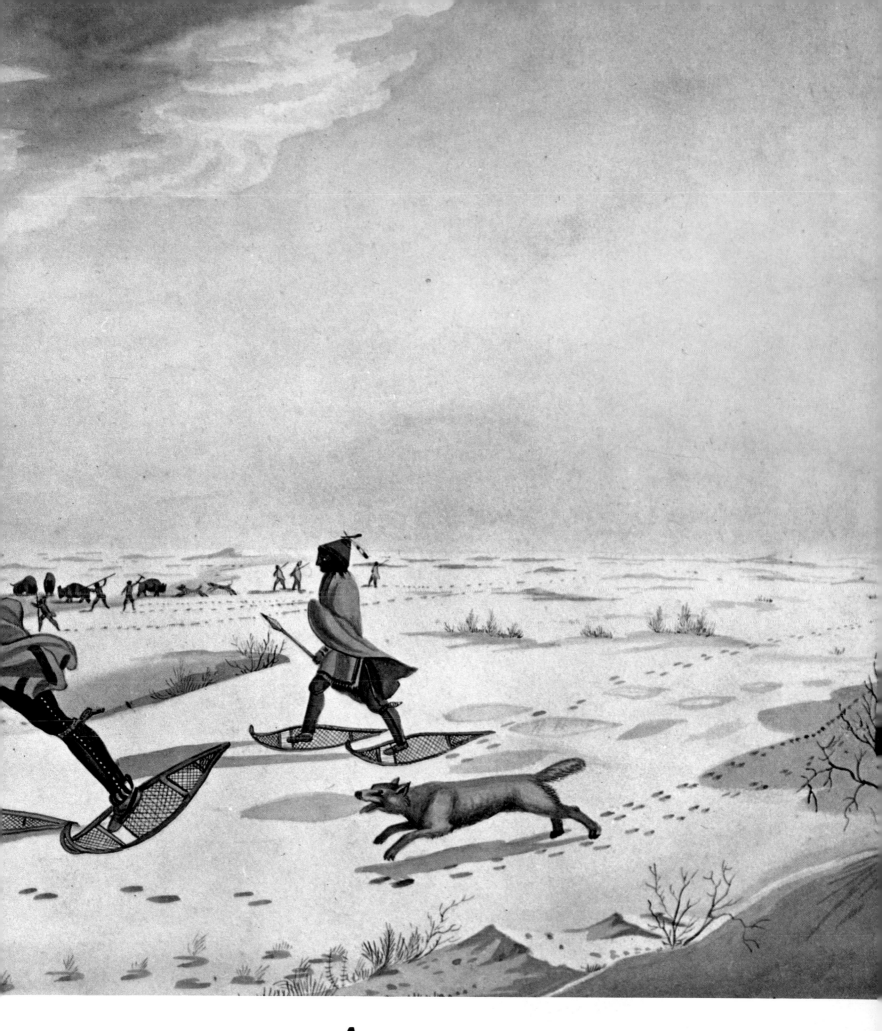

*A*ssiniboine Buffalo Hunt on Snowshoes. Rindisbacher.
*Undated. Watercolor. Peabody Museum of Archaeology and
Ethnology, Harvard University*

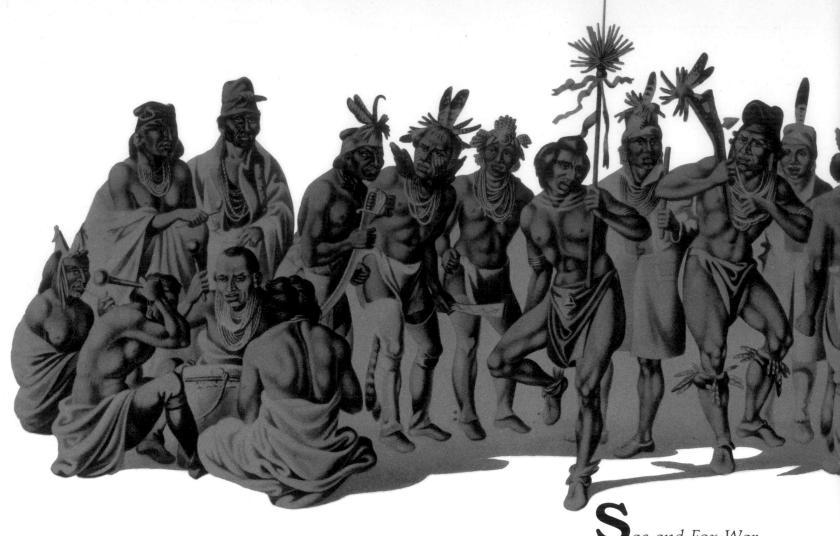

with the title *Views of Hudson's Bay. Taken by a Gentleman on the spot in the years 1823 and 1824*. There can be little doubt that the original drawings on which these prints were based were by Peter Rindisbacher. They portrayed the governor of the Red River Colony traveling in a light canoe in summer and in a dog cariole in winter, as well as his meetings with delegations of Indians. H. Jones, an English artist, copied them, incidentally substituting the face of Robert Pelly, who succeeded Bulger as governor, for that of his predecessor.

Heavy snows buried the Red River Valley during the winter of 1825–26. The buffalo drifted far to the west, and the storms continued so that hunters could not follow them. The colonists were reduced to eating their horses and dogs to keep alive. Whole families died of starvation and exposure. When the thick river ice broke up in May, the Red and Assiniboine valleys were flooded. As the onrushing river ice, augmented by rains and high winds, spread over the valley, most of the settlers' homes were swept away. Only one life was lost, but the settlers were wiped out.

The Swiss settlers, who never happily adjusted to the primitive conditions of life during their four and a half years on the Red River, then abandoned the colony and moved southward into the United States. Several Swiss families settled in the lead-mining region of Wisconsin. Among those who found homes at Gratiot's Grove in this area was Peter Rindisbacher.

Although he continued to draw and to paint during his three years' residence in Wisconsin, relatively few of Rindisbacher's pictures of this

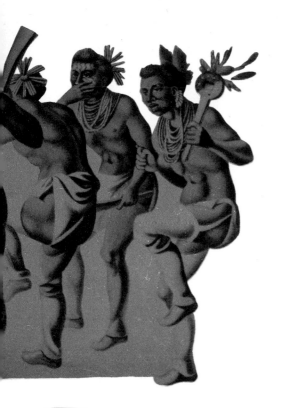

period are known. Among them were a half-length portrait of Isaac Winnesheek, son of a Winnebago chief, a Winnebago war dance, a full-length portrait of the Sauk and Fox chief, Keokuk, and a war dance by men of that tribe. These subjects were drawn for Caleb Atwater, one of the United States Commissioners at a treaty made at Prairie du Chien with the Winnebago and neighboring tribes of Wisconsin and Illinois in the summer of 1829. Atwater paid the artist $130 for these paintings and some sketches of wildlife. He was particularly pleased with Rindisbacher's ability to obtain likenesses of Indians. The *Sac and Fox War Dance* became one of Rindisbacher's most popular subjects, and he copied it several times.

In 1829, Peter Rindisbacher moved to St. Louis. In his studio on Locust Street between Main and Second, he sought to make a living by executing miniature portraits and landscapes "at reasonable prices." At that time a new periodical, *The American Turf Register and Sporting Magazine*, published in Baltimore, was actively soliciting contributions on sports and games in the "Far West." Its December 1829 issue offered an article on American Indian horsemanship which was illustrated by Rindisbacher's picture, *Sioux Warrior Charging*. The editors and readers of that national magazine liked Rindisbacher's work. Nine of his pictures of wild birds, animals, and hunting scenes in the West were reproduced in later issues. His second contribution, *Buffalo Attacked by a Band of Prairie Wolves*, was printed along with a letter from an unnamed friend stationed at Jefferson Barracks near St. Louis, expressing his appreciation of the artist's talents:

His portfolio contains many fine efforts. The Indian dance is without fault; and of itself, sufficient to establish a reputation. The buffalo chase is pronounced true to nature by all who can estimate its merits. He is very happy in his landscapes; and when time and opportunity shall permit him to spread the magnificent west before the admirers of the grand and picturesque, his sketches from Hudson's Bay to St. Louis, will no doubt, secure him a lasting reputation.

Unfortunately, Peter Rindisbacher died at the age of twenty-eight, just as he was beginning to achieve national recognition. On August 15, 1834, two days after his death, *The Missouri Republican* of St. Louis solemnly observed: "Mr. Rindisbacher had talents which gave every assurance of future celebrity. . . . He possessed a keen sensibility and the most delicate perception of the beautiful."

Rindisbacher's contribution to the pictorial history of the West rests primarily upon his accurate portrayal of the life of white settlers and Indians in the neighborhood of the Red River Colony in the early 1820's. He was also the first artist to depict life on the northern plains in winter. The nearly one hundred examples of his pencil drawings and watercolors that have survived testify to his remarkable youthful talent and to his maturing abilities during his thirteen years in the West. Over the years, as he copied and recopied his earlier works and undertook new subjects, his skill as a watercolorist developed. The series of eighteen watercolors in the Military Academy Museum at West Point are thought to have been executed toward the end of Rindisbacher's career. They combine fine draftsmanship with the full-colored rendering of humans and animals as solid yet rounded, three-dimensional forms. The figures are accurate in detail, and the elements of each picture are organized into an appealing and decorative composition.

Buffalo Attacked by Prairie Wolves. Rindisbacher. Undated. Lithograph after drawing. "American Turf Register and Sporting Magazine," April 1830 (below)

Lith. of Endicott & Swett.

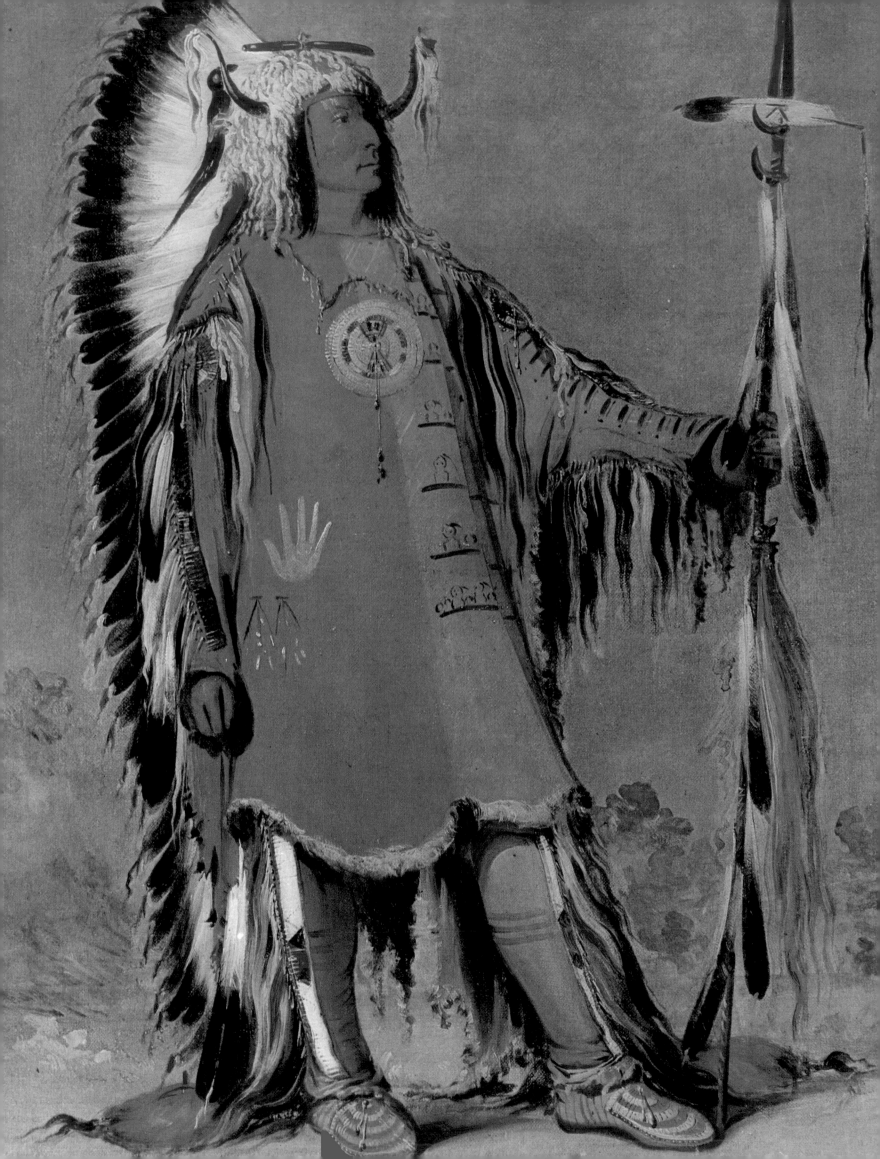

HUNTING INDIANS
WITH
A PAINTBRUSH

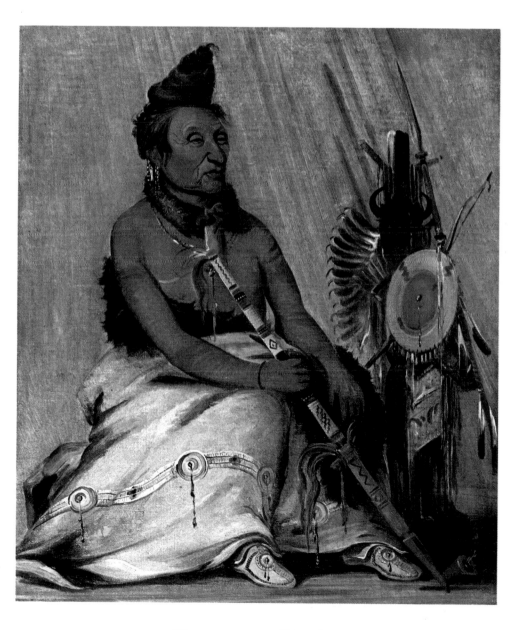

George Catlin

In the spring of 1830, a slight, wiry man in his middle thirties, bearing a long tomahawk scar on his left cheek, appeared in St. Louis carrying a letter of introduction to General William Clark, Superintendent of Indian Affairs for the Western portion of the United States. As a soldier, explorer, and Indian administrator, Clark had known many colorful characters, but he had never met a man quite like this intensely enthusiastic stranger from Pennsylvania. He was George Catlin. Armed with pencils and paintbrushes he had come West to hunt wild Indians.

Catlin was gifted at making friends quickly and easily. Born in Wilkes-Barre, Pennsylvania, July 26, 1796, and brought up in Broome County, New York, he had heard many romantic and exciting stories of the Indians of that region when it had been a frontier settlement. His mother had been captured by Indians in the bloody Wyoming Valley Massacre of 1778. That tomahawk scar on his cheek was the relic of a boyhood accident. While playing Indian with his friends, a tomahawk thrown by one of them had glanced off a tree and struck him in the face.

George had taken a long time to find himself. As a boy he had loved the out-of-doors. Hunting and fishing attracted him much more than did schoolbooks. Nevertheless, when he was twenty-one, his father, a lawyer, persuaded him to attend law school. The next year he passed his bar examinations and began to practice law in Lucerne, Pennsylvania. But he had become more interested in drawing and painting than in courtroom procedures. He sold his law books, abandoned his legal career, and moved to Philadelphia to devote his life to art.

By dint of hard work Catlin taught himself to paint both miniatures and large oil portraits. In 1824, he won election to the select company of the Pennsylvania Academy of Fine Arts. Four years later the American Academy of Fine Arts exhibited twelve of his works, including a full-length portrait of De Witt Clinton, Governor of New York. But opportunities to paint fine ladies and prominent gentlemen failed to satisfy Catlin's yearning for some challenging project to which he could dedicate his life.

Then one day Catlin saw a delegation of Indians from the "wilds of the Far West" passing through Philadelphia. He was intrigued by the possibilities of portraying "man in the simplicity and loftiness of his nature, unrestrained by the disguises of art." Believing that the Western tribes were doomed to destruction by bayonet, whisky, and disease as the white man's frontier moved Westward, Catlin vowed that "nothing short of the loss of my life shall prevent me from visiting their country, and becoming their historian."

Before he was financially able to travel to the Western Indian country Catlin gained experience painting Indian portraits among the reservation tribes nearer home. His earliest known Indian subject, an unfinished portrait of the Seneca orator, Red Jacket, was dated *Buffalo, 1826*. In 1829, he painted Iroquois Indians in western New York. The following winter he pictured two Mohawks, and an Ottawa visitor to Niagara Falls.

The frontier was moving rapidly Westward. Some tribes from the eastern forests had voluntarily crossed the Mississippi. The Indian Removal Act of 1830 was forcing many other woodland tribes to migrate onto the grasslands beyond the great river. Catlin believed he had to hurry if he was to record the Plains Indians before they were corrupted by the vices of civilization.

General Clark helped to introduce Catlin to the Indians West of the Mississippi. But for nearly two years after their first meeting Catlin

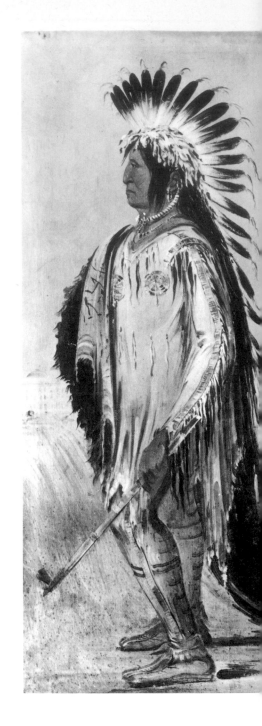

*M*ato-tope (Four Bears), Second Chief of the Mandans. Catlin. 1832. Oil. Smithsonian Institution (preceding page 54)

Black Moccasin, Aged Hidatsa Chief. Catlin. 1832. Oil. Smithsonian Institution (preceding page 55)

The Light, an Assiniboine Indian, on His Way to and Return from Washington. Catlin. 1832. Oil. Smithsonian Institution

traveled among the tribes whose chiefs had been to Washington and had been painted in the East by Charles Bird King and others. In July 1830, he accompanied Clark to Prairie du Chien to negotiate treaties with the Iowa, Missouri, Oto, Omaha, Sauk and Fox, and the eastern bands of Sioux. That fall he was at Cantonment Leavenworth (present Fort Leavenworth, Kansas), then the most remote military post on the Missouri, portraying tribesmen who had migrated from east of the Mississippi—the Delaware, Kaskaskia, Kickapoo, Peoria, Potawatomi, Shawnee and Weah. Later that year he painted tribal leaders among the Kansa on Kansas River. In the spring of 1831, Catlin rode with Indian Agent John Dougherty to the earthlodge villages of the Pawnees on the Platte, visited by his friend Titian Peale eleven years earlier, to record the likenesses of more than a dozen warriors.

In the fall of 1831, a small delegation of magnificent Assiniboine, Plains Cree, Plains Ojibwa, and Yanktonai Sioux from the mouth of the Yellowstone, two thousand miles up the Missouri, appeared in St. Louis. They were the first members of those remote tribes to be recruited for a trip to Washington. Catlin was the first artist to portray these proud, handsome men, clad in their porcupine-quilled and painted skin shirts and elaborate hair and neck ornaments. These were the noble red men Catlin had been seeking. They had never before seen a white man's town. As he painted their portraits that fall, Catlin must have longed to visit the unspoiled tribes that produced such heroes.

Catlin grasped an opportunity to travel up the Missouri aboard the American Fur Company's new steamboat *Yellowstone* in the spring of 1832. It was to be the first steamboat to ascend the Missouri to Fort Union, the company's four-year-old post at the mouth of the Yellowstone, more than a thousand miles beyond the farthest point reached by Major Long's *Western Engineer*.

Among his fellow passengers were the homeward-bound Indians whose portraits Catlin painted while they were en route to Washington the previous fall. He hardly recognized The Light, handsome son of an Assiniboine chief, resplendent in a colonel's uniform trimmed with gold lace and huge epaulettes, his head covered with a plumed beaver hat, his feet encased in high-heeled boots which made him "step like a yoked hog." Impressed by this transformation of a noble red man, Catlin painted a dual portrait, contrasting The Light's dignified and comfortable appearance in his Indian garb while on his way to Washington with his ridiculous discomfort in the tight-fitting chief's uniform President Jackson had bestowed upon him in the capital.

On May 23rd, Catlin reached Fort Tecumseh (shortly to be renamed Fort Pierre), the principal trading post for the Western Sioux, at the mouth of the Teton River, three hundred miles above the mouth of the Platte. William Laidlaw, veteran Sioux trader in charge of that post, helped Catlin quickly make friends with the Indians in some six hundred buffalo-hide tipis near the fort. During the ensuing two weeks, Catlin compiled the first pictorial field record of the warlike Western Sioux. In one painting he depicted the excitement of a Sioux scalp dance by members of a successful war party, shouting and brandishing their weapons, while dancing around their women folk who display enemy scalps dangling from upraised poles. In another he pictured a Sioux brave, wearing only a breechclout, undergoing the self-torture of the sun dance.

Catlin induced a number of prominent Sioux to stand or sit for their portraits clad in their finest garments. Amazed at Catlin's ability to

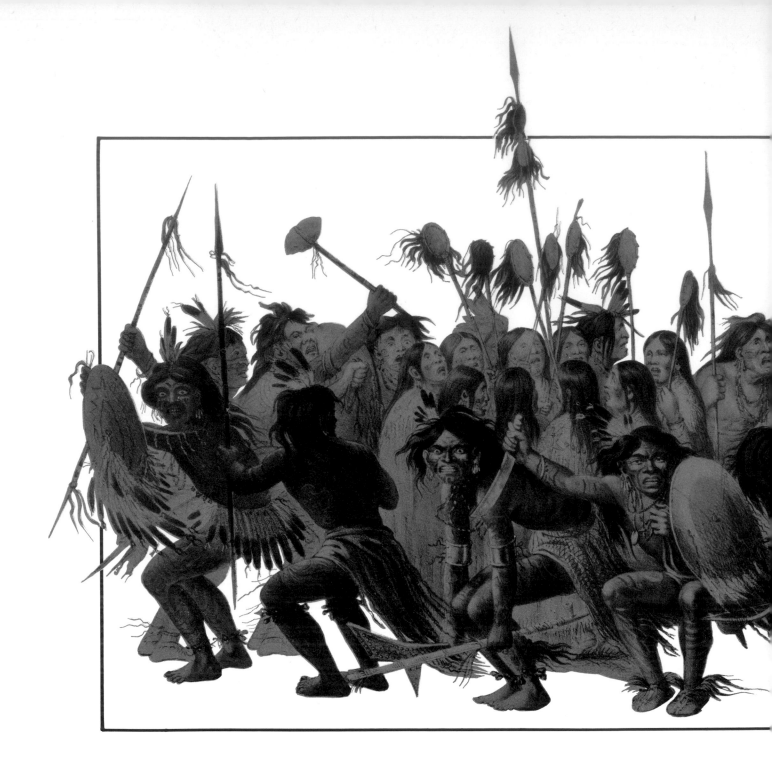

transfer the image of a human being to canvas, the superstitious Sioux looked upon him as a medicine man of unique powers. During his last day at Fort Pierre, Catlin was completing his portrait of Little Bear, a Hunkpapa warrior, when The Dog, an ill-tempered chief of a rival band, seeing the three-quarter-view picture, taunted the sitter with being but half a man. Little Bear called The Dog a coward, and in the fight that followed Little Bear was killed. The camp was thrown into confusion. The "great medicine painter" hastily packed his colors, brushes, and canvas and withdrew to the safety of the fort. He was happy to embark on the *Yellowstone* next morning and to leave the turbulent Sioux behind.

It probably was from the deck of the steamer that Catlin executed a distant view of a band of nomadic Sioux on the march, moving their folded tipi covers, lodge poles, and all their possessions with the aid of horses and strong dogs harnessed to the A-shaped drags known to the

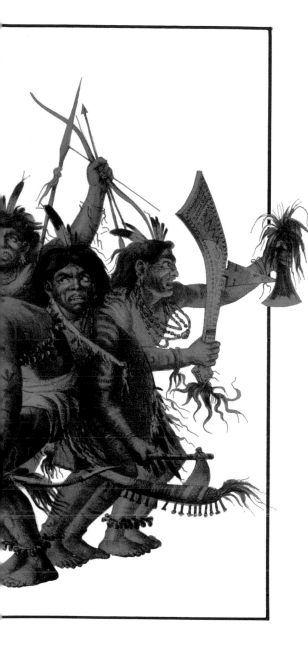

French traders as travois. Catlin was the first of many artists to picture this method of moving camp.

The steamboat passed the two palisaded villages of the Arikara Indians some four hundred miles above Fort Pierre. Residents of these villages had welcomed Lewis and Clark and feasted them in their earth-lodges on corn and buffalo meat in 1804 and 1806. But one of their beloved chiefs had died during a visit to Washington, and since that time the Arikaras had caused the whites so much trouble that traders called them "the horrid tribe." Weeks later, in the Mandan villages, Catlin painted their head chief, Bloody Hand, who had killed an American trader near the door of his trading post.

Four hundred miles farther upstream the steamboat reached its destination, Fort Union at the mouth of the Yellowstone. Kenneth McKenzie, in charge of this post, introduced Catlin to the leaders of several tribes who visited there that summer. He allowed Catlin to use the upper room of one of the fort's corner bastions for his portrait studio. Seated on the breech of a twelve-pound cannon, intended to

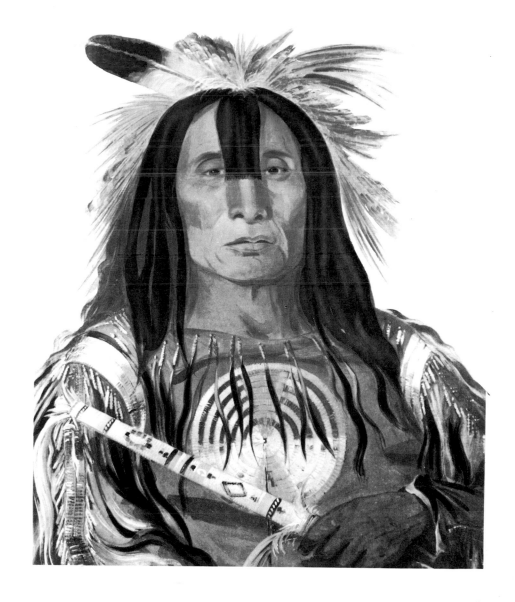

Sioux Scalp Dance. Catlin. 1844. Lithograph. Rare Book Division, New York Public Library (above)

Buffalo Bull's Back Fat, Head Chief of the Blood Tribe of Blackfeet. Catlin. 1832. Oil. Smithsonian Institution (right)

*S*ioux Indians Moving
Camp. Catlin. 1852. Pencil.
Rare Book Division, New
York Public Library

defend the fort against Indian attacks, Catlin executed the earliest known portraits of Blackfoot and Crow Indians.

For a quarter-century after Lewis and Clark the three Blackfoot tribes had opposed the incursion of American trappers around the Missouri headwaters. Twice they had forced the Americans to abandon the present Montana region. Not until two winters prior to Catlin's visit was McKenzie successful in opening peaceful trade with these aggressive red men. One of the artist's Blackfoot subjects was Eagle Ribs, a renowned Piegan warrior, who openly boasted of the eight scalps he had taken from white trappers, and who decorated the seams of his shirt and leggings with hair from the heads of both his Indian and white enemies.

The Crow Indians from the middle Yellowstone valley were traditional enemies of the Blackfoot and had been uniformly friendly to the whites, although McKenzie had yet to build his first trading post in their country. Catlin considered Crow men the handsomest, most elegantly dressed Indians he had seen, and he regarded young Two Crows as a fine example of the Crow physical type.

While at Fort Union, Catlin had numerous opportunities to observe the nomadic Indians, armed with bows and lances, riding out to hunt buffalo, and he himself was invited to participate in such a chase. Probably his best known and most popular oil paintings of Plains Indian buffalo hunts were based upon these observations.

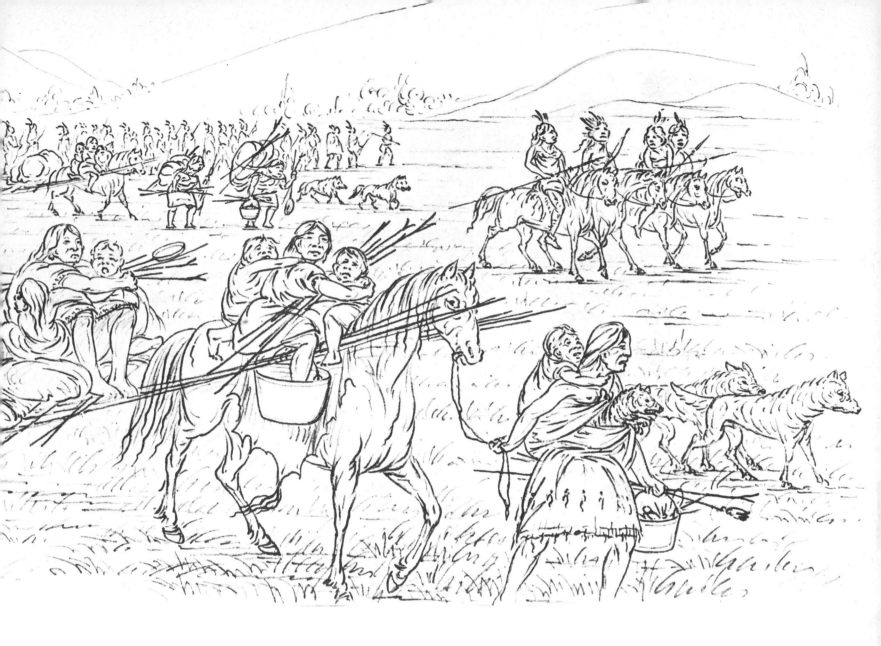

Catlin also saw a Blackfoot medicine man, clad in the whole skin of a grizzly bear, attending a dying man of his tribe who had been shot in a fight with a Cree Indian. The artist purchased the entire outfit of this native doctor, and years later drew a revealing sketch showing that Indian's bedside manner in the presence of a crowd of awed redskins, who placed their hands over their mouths to hide their amazement.

From Fort Union, Catlin descended the Missouri in a skiff accompanied by two trappers, Ba'tiste and Bogard, who amused him with many tall tales of the Upper Missouri. They stopped frequently so that Catlin could make quick sketches or small oil paintings of wildlife or eroded bluffs. They subsisted largely upon the game they killed on shore. A week's travel brought them to Fort Clark, the American Fur Company's post for the Mandan and Hidatsa trade, about two hundred miles below Fort Union. The factor, James Kipp, who had traded with these tribes for a decade, invited Catlin to stay at the fort while he painted in the Indian villages nearby.

Catlin worked feverishly during the next few days. One of his scenes was a "bird's-eye-view" of a large Mandan village on the Missouri below Fort Clark. From a position atop one of the earth-covered dwellings, he managed to show the greater part of this town of more than a thousand inhabitants, its palisade, the circular ceremonial structure in the center of the closely-grouped houses, and the scarecrow-like sacrificial poles topped with human effigies of trade cloth.

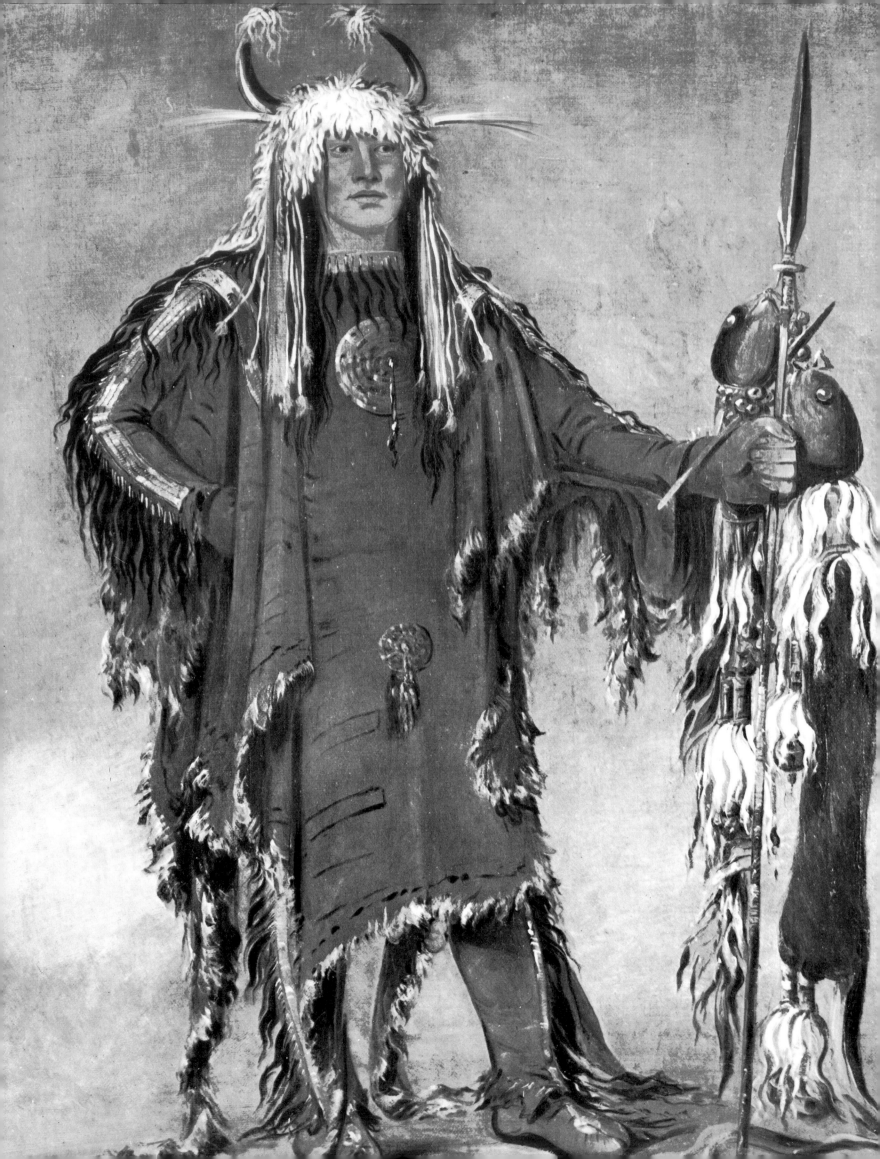

Catlin became very friendly with Four Bears, handsome second chief and outstanding warrior among the Mandans, who feasted the artist in his lodge on buffalo ribs, marrow fat, and a pudding of prairie turnips flavored with buffalo berries. Catlin painted two portraits of Four Bears. One shows the Indian full-length, magnificently costumed in a horned bonnet and quill-decorated shirt, leggings and moccasins. Crude pictographic figures painted on the shirt recorded Four Bears' conquests of his enemies, and a silhouetted human hand testified that he had killed an enemy in hand-to-hand combat. This painting has been reproduced many times as a symbol of the historic Indians of the Great Plains. Four Bears was to Catlin an Indian of heroic stature, "the most extraordinary man, perhaps, who lives to this day, in the atmosphere of Nature's noblemen."

Accompanied by trader Kipp, Catlin witnessed and sketched the Mandan Okipa, the tribe's most elaborate religious ceremony, dramatizing their mythological explanation of the creation of the earth and all life as well as their traditions of Mandan history. At the conclusion of this four-day ritual Catlin set up his easel in a Mandan earthlodge, using the central roof opening as his skylight, and transferred from his sketchbook to canvas the strange scenes he had witnessed. The most dramatic of these oil paintings shows young men undergoing the excruciating self-torture on the second day of the ritual. Two skewers were inserted under the skin of the back or breasts of each man. He was raised by cords that were fastened to these skewers and then passed over a roof timber in the ceremonial lodge; he remained suspended in mid-air until he lost consciousness. Catlin rendered this scene in all its gruesome detail.

Everything about the Mandan way of life interested Catlin. He painted their horse racing and games, their dances and burial customs. He thought the Mandans so far advanced beyond the other Upper Missouri tribes in "manners and refinements" that they must be "an amalgam of natives with some civilized race." His admiration for this tribe exceeded even the high regard for these people evident in the journals of Lewis and Clark.

Actually Mandan culture differed little from that of the Hidatsa Indians (Catlin's "Minnatarres"), a neighboring farming people, with whom the artist was not so well acquainted. He did visit the Hidatsa earthlodge village on Knife River and painted portraits of several members of the tribe. One is a likeness of Black Moccasin, an aged and nearly blind chief, whom Lewis and Clark had known as a friendly and vigorous leader twenty-eight years earlier. Black Moccasin recalled, with pleasure, the visit of "Red Hair" (Clark) and "Long Knife" (Lewis) as he sat for his portrait.

A band of Crow Indians were visiting their relatives the Hidatsa, while Catlin was in the latter's village, and the artist witnessed their superb horsemanship. The Crows were the wealthiest and most expert horsemen among the Upper Missouri tribes. The portrait Catlin made of He-Who-Jumps-Over-Everyone depicts an affluent Crow warrior riding a spirited horse. Both are decked out in the most elegant trappings. This painting shows the Plains Indian horseman at his best. Few men of other tribes could afford such a display of wealth.

Continuing their long downstream journey, Catlin and his two trapper companions reached Fort Pierre on August 14th, rested a day, and were off again on their way to St. Louis. From time to time they stopped long enough for Catlin to sketch quickly, with paints and brushes, some

Eagle Ribs, a Piegan Blackfoot Warrior. Catlin. 1832. Oil. Smithsonian Institution

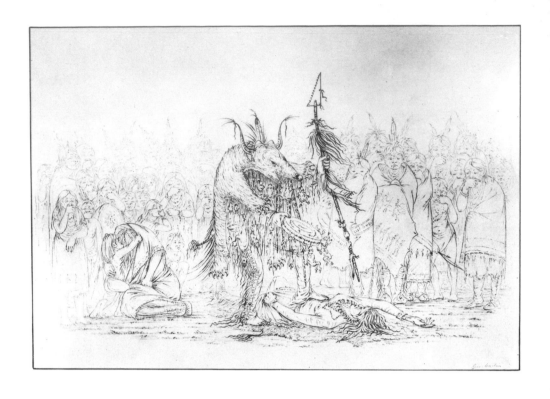

landscape or historic site. One of the latter was a distant view of the grave of Sergeant Charles Floyd atop a green hill overlooking the muddy Missouri. Floyd was the only man lost by Lewis and Clark, and he had died of an illness called bilious colic.

No one in St. Louis could have viewed the many paintings Catlin had made that summer with greater appreciation than old General Clark. Catlin had followed the course taken by Lewis and Clark for two thousand miles up the Missouri, and he had brought back a pictorial record of the country and its Indians that no one on that expedition had had the skill to attempt.

Catlin had performed prodigious tasks in that summer of 1832. During eighty-six days on the Upper Missouri between Fort Pierre and Fort Union, he had averaged eighteen miles of travel per day. He had participated in buffalo hunts, observed Indian councils, dances, games, and religious ceremonies, and he had talked with the men of the American Fur Company, gathering material for a series of letters to the New York *Commercial Advertiser*, which he later expanded into the greater part of a two-volume book. He also created more than 135 pictures: some 66 Indian portraits, 36 scenes of Indian life, 26 landscapes, and at least 8 hunting scenes. Only a man roused to a feverish pitch of creativity could have performed all those tasks in so short a time. There must have been days when Catlin painted half a dozen pictures, employing a pictorial shorthand which would enable him to complete the paintings in his studio at a later date.

During the following year Catlin busied himself in filling-in the backgrounds of his portraits, finishing his many scenes, and readying his paintings for exhibition in the Indian Gallery that had been his dream.

In the spring of 1834, Catlin was back on the plains, eager to paint more Indians. Secretary of War Cass had granted him permission to accompany the newly formed Dragoons on their first expedition into Indian country. From Fort Gibson, the westernmost military post on the

Blackfoot Medicine Man Treating His Patient near Fort Union. Catlin. Summer 1852. Pencil. Rare Book Division, New York Public Library (above)

Two Crows, a Handsome Young Man of the Crow Tribe. Catlin. 1832. Oil. Smithsonian Institution (right)

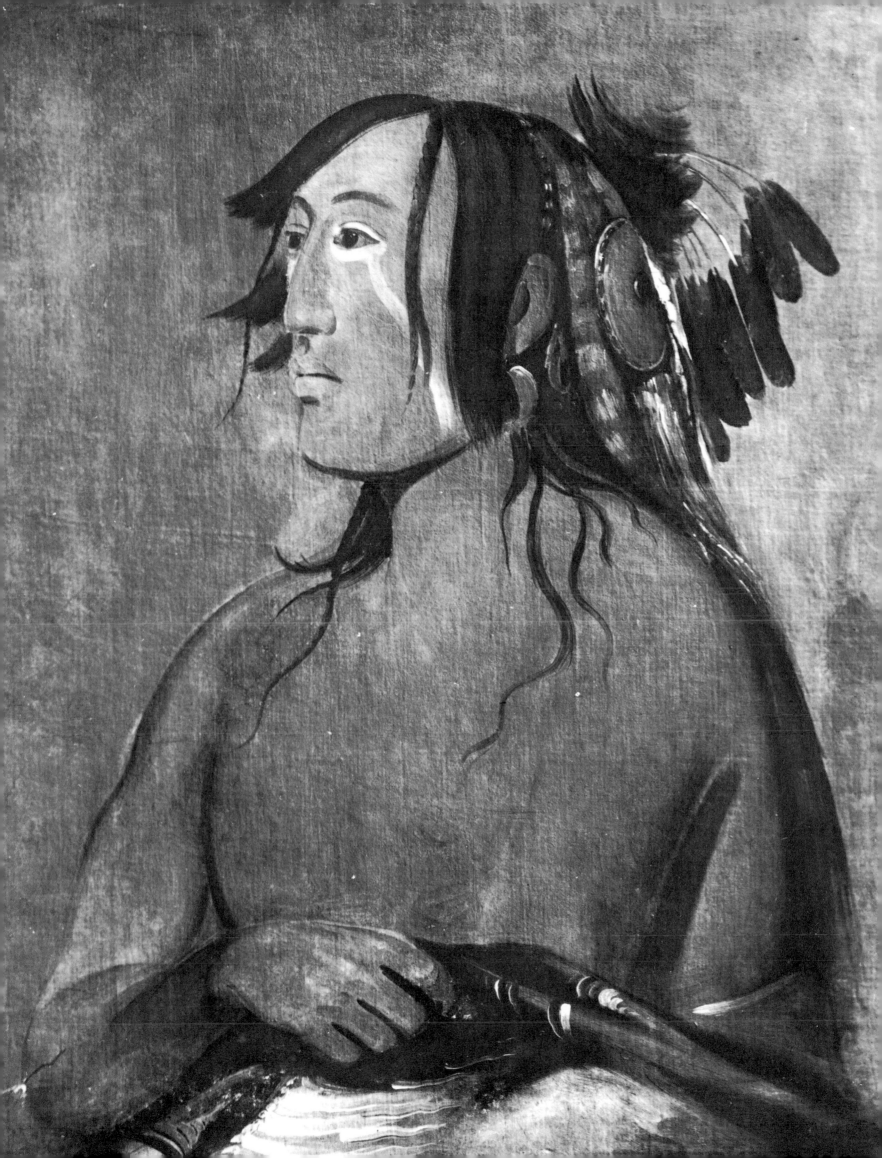

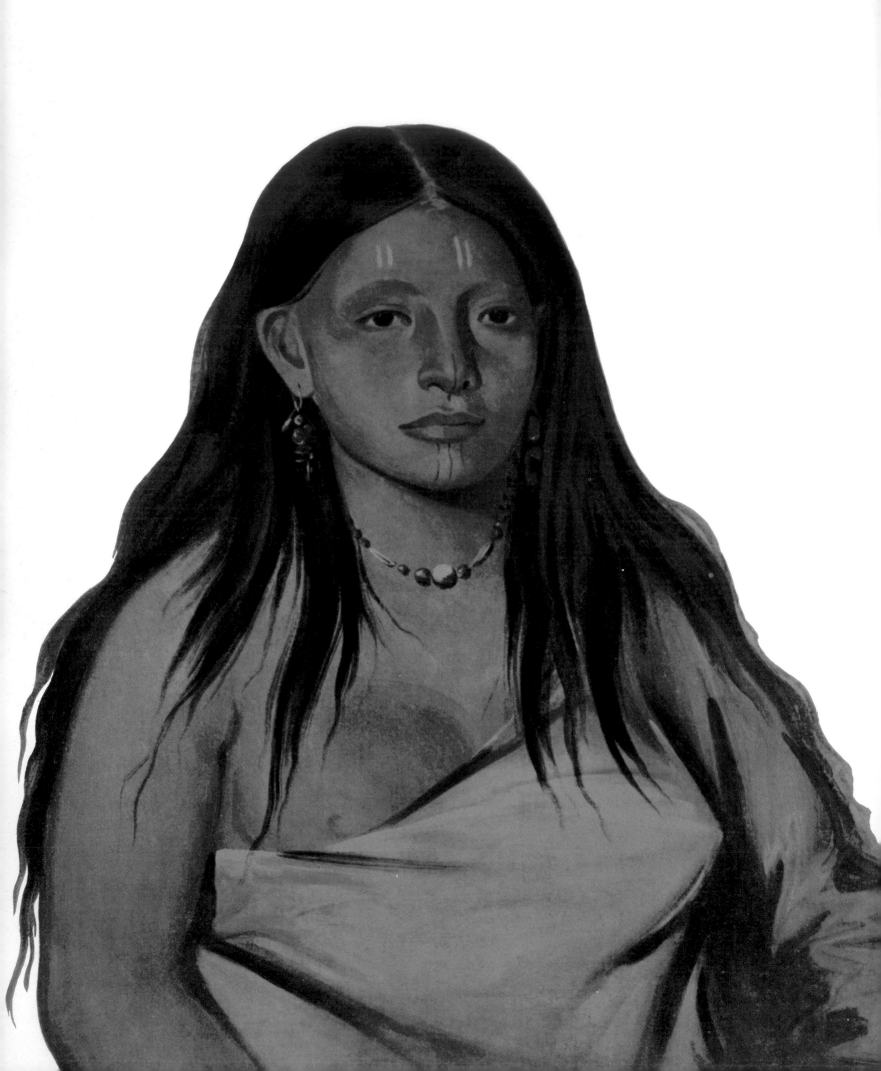

Arkansas, they would ride into the territory of the wild and little-known Comanche and Wichita tribes. Reaching Fort Gibson two months before the expedition got under way, Catlin spent the interval painting Cherokees, Creeks, and Seminoles, Indians who had been forced to move out of the Southeast. The cloth garments of modified white-men's patterns worn by these semi-civilized tribes contrasted sharply with the primitive dress of the traditional occupants of the Western grasslands.

Secretary Cass considered it important to the peace of the frontiers that a "respectable force" be sent to impress the wandering and restless tribes of the southern plains with the power of the United States. When the Dragoons left Fort Gibson on June 15th, some five hundred strong, they were bound for Comanche and Wichita villages "somewhere on the headwaters of the Red River." Catlin executed portraits of two teen-age girls, a Kiowa and a Wichita, captured by the Osages, whom the Dragoons were to return to their own people.

As they moved across the treeless plains in the summer heat, many of the soldiers wilted. By the time they reached the mouth of the False Washita, 220 miles west of Fort Gibson, eighty-six of them were down with bilious fever. There, Colonel Henry Dodge selected some 250 of the most daring and fit men to continue to march westward. Leading a packhorse laden with his canvas and gear, Catlin rode with them.

No one in the party could be sure how the warlike Comanches would receive this drastically reduced force. On July 14th, the Dragoons encountered a large party of Comanche buffalo and wild horse hunters. It was a great relief to the whites when, after some indecision, Little Spaniard, a Mexican who had become a leader among these Indians, rode forward with a white flag of peace and offered his hand in friendship. Catlin pictured this dramatic meeting between the Dragoons and Comanches.

Two days later, about ten miles north of present Fort Sill, Oklahoma, the Dragoons reached a great Comanche village of six to eight hundred tipis around which thousands of fine horses grazed. Catlin became so sick with "fever and ague" that he could not ride on to the Wichita villages with the Dragoons. But during the two weeks he remained in the Comanche village he managed to paint the earliest known scenes of Comanche daily life. One of them depicts a large portion of the great encampment with women in the foreground dressing buffalo hides and drying meat.

Catlin found Comanche men hard-faced and short. He noted that they were awkward afoot, but "in racing horses and in riding, they are not equalled by any other Indians on the continent." Cavalry officers stationed at frontier posts in later years wrote of the Comanches as the finest horsemen in the world. Catlin illustrated the skill they displayed in a sham battle put on for their white visitors. His painting shows participants protecting themselves by slipping to the off side of their horses and discharging their arrows from under the animal's neck, while riding at full speed. The feat was more effective for show than an actual battlefield maneuver.

Accompanied by leading chiefs of the Comanche, Kiowa, and Wichita tribes, the Dragoons marched back to Fort Gibson in less than three weeks. During the last eight days of this journey Catlin was so ill that he was delirious and had to be carried in a baggage wagon.

The expedition reached Fort Gibson two months after their departure. More than one hundred of their number had died of sickness. Yet they had accomplished their mission of establishing peaceful relations

Wichita Girl, Captive of the Osages. Catlin. 1834. Oil. Smithsonian Institution

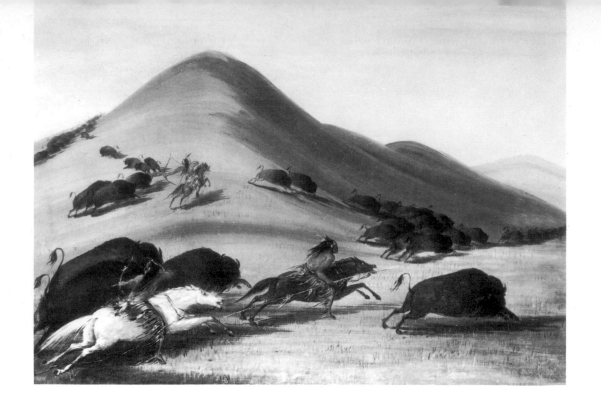

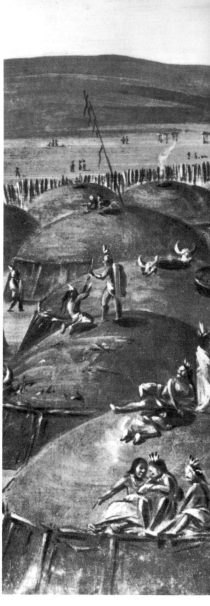

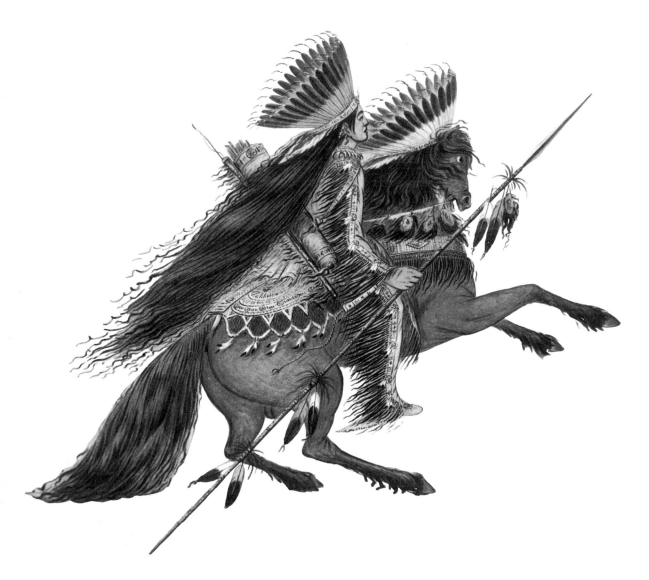

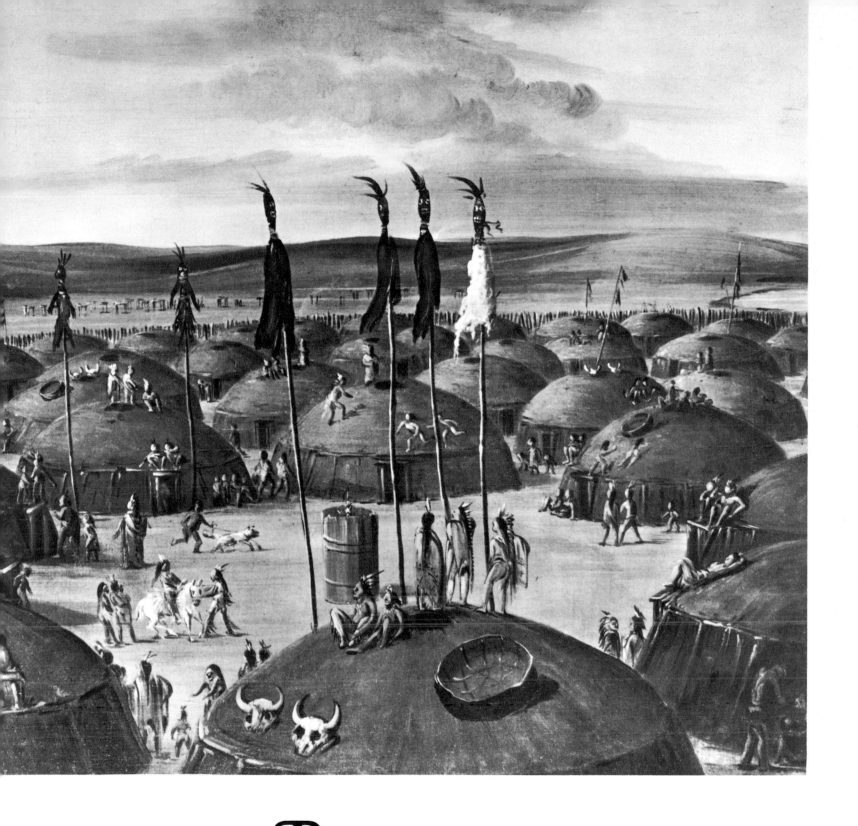

Bird's-Eye-View of a Mandan Village. Catlin. 1832. Oil. Smithsonian Institution (above)

Buffalo Hunt with Bows and Arrows. Catlin. 1832. Oil. Smithsonian Institution (top left)

He-Who-Jumps-Over-Every-One, a Crow Indian on Horse-back. Catlin. 1832. Watercolor. Museum of the American Indian. Heye Foundation, New York (bottom left)

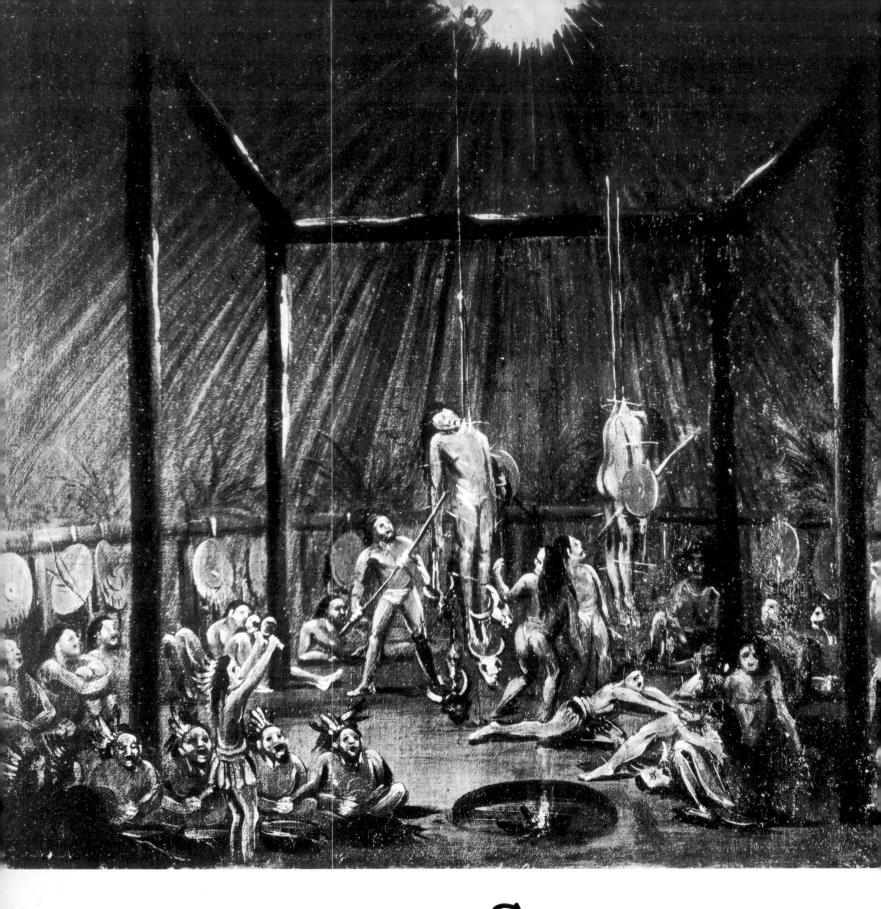

S*elf-Torture in the Mandan Okipa Ceremony. Catlin. 1832. Oil. University Museum, University of Pennsylvania (above)*

Comanche Indian Sham Battle. Catlin. 1834. Oil. Smithsonian Institution (top right)

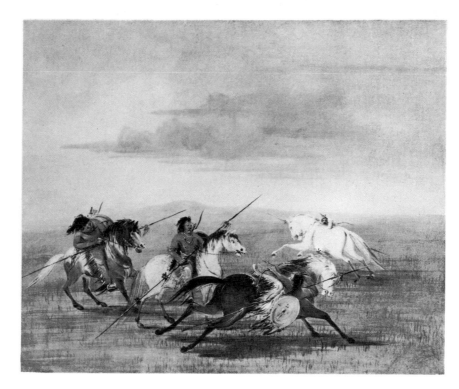

with the most warlike tribes of the southern plains. Catlin too, in spite of his illness, had scored a success in picturing the remote tribes of this region, who were even less known to Americans than had been the Indians of the Upper Missouri in 1832. Some of Catlin's portraits of tribal leaders may have been painted at Fort Gibson after his recovery rather than in their own country.

In 1804, Lewis and Clark had learned that the fine red stone pipe bowls smoked by the Missouri Valley tribes had come from a quarry far to the eastward. Thirty-two years later George Catlin visited that quarry in present-day Pipestone County, Minnesota, to picture the Indians' quarrying operation and to obtain samples of the stone. Dr. Charles Thomas Jackson of Boston, a leading mineralogist, examined the stone, pronounced it "a new mineral compound" and named it "catlinite" in honor of the artist.

No earlier painter of the West and its Indians so effectively publicized his work on both sides of the Atlantic as did George Catlin. He began exhibiting his Indian paintings in Pittsburgh in 1833, and thereafter showed them in other midwestern river towns. When he opened his large one-man show in New York in 1837, it was such a success that he had to move it to larger quarters at the Stuyvesant Institute on Broadway. Later he exhibited his Indian Gallery to large crowds in Washington, Philadelphia, and Boston. Newspapers were extravagant in their praise of Catlin's success in bringing the Wild West to civilization for everyone to see. Indeed some of them wrote of the artist as a genius. The *United States Gazette* declared that "perhaps no one since Hogarth has had, in so high degree, the facility of seizing at the moment the true impression of a scene before his eyes, and transferring it to the canvas."

In the fall of 1839, Catlin packed up his Indian Gallery and sailed for England. He opened in London's Egyptian Hall and continued to exhibit in England for nearly five years. Then, in 1845, he moved his exhibition to Paris. Undoubtedly the high-water mark of Catlin's artistic career was reached when he was invited to exhibit his collection in the

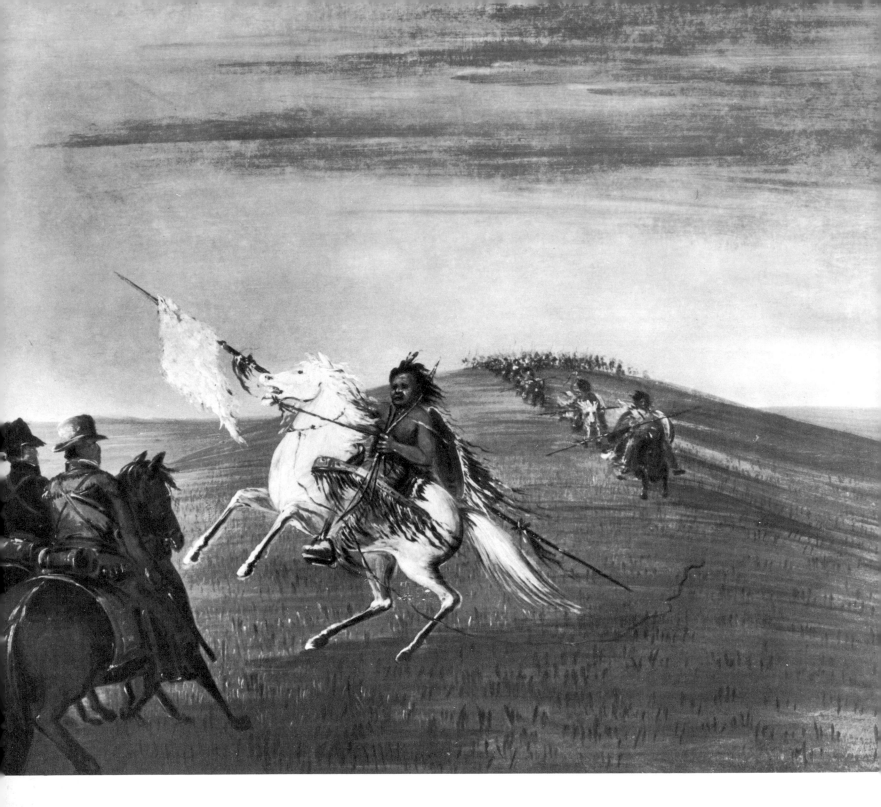

world-famous Louvre in a special showing for King Louis Philippe and his guests.

Meanwhile Catlin was gaining a reputation as an author. In 1841, his first and most famous book, *Letters and Notes on the Manners, Customs and Condition of the North American Indians*, was published in London at his own expense. It was illustrated with 312 small steel engravings, most of which were linear simplifications of his original oil paintings. Three years later he published *Catlin's North American Indian Portfolio*, a handsome collection of twenty-five large, colored lithographs of his most popular paintings. Thousands of people who never saw an original Catlin work of art gained a graphic impression of the American West through the words and pictures of his books.

A majority of the paintings from Catlin's original Gallery are pre-

Comanche Indians Meeting the United States Dragoons. Catlin. 1834. Oil. Smithsonian Institution

served in the Smithsonian Institution. However, during the 1850's, when Catlin was badly in need of money, he copied and recopied his own works in pencil, watercolors, and oils. Consequently many renderings of the same subject, in Catlin's own hand, may be found in other museums and libraries, some of them more carefully delineated than the hastily executed original paintings.

George Catlin has been a subject of controversy in American art for generations. He was self-taught, and his style bears little resemblance to that of other artists of his own or earlier periods. He was at his best as a portrait painter, and he possessed an uncommon gift for defining the character of an Indian's face with a few deft strokes. He was usually more interested in achieving a good likeness of an Indian than in the detailed rendering of his costume and accessories.

On the other hand, Catlin never quite mastered the human figure, so that he was less successful in his full-length portraits. This deficiency. along with a lack of understanding of perspective, is evident in his scenes of Indian life. But he never hesitated to record action quickly, so that such scenes possess an admirable freshness and directness.

This same boldness of execution, together with simplicity of form and color, characterized Catlin's Western landscapes. On some occasions he took liberties with a scene, as in his view of the pipestone quarry; here he exaggerated the height of the distant quartzite ledge and moved the boulders known as Three Maidens far to the left of their actual location in order to bring these landmarks into the picture. Nevertheless, many of Catlin's rapidly executed landscapes manage to convey a vivid impression of the bigness of the West—the breadth of the plains, the distance to the horizon, the vastness of the sky.

A critical examination of Catlin's paintings reveals that they vary greatly in ethnological significance as well as in artistic quality. Some contain questionable or erroneous elements; others exaggerate the size of objects. But many of them are remarkably accurate even in minor details. It is apparent that each Catlin painting must be appraised on its merits, and that the best of them are very good indeed.

A year before his death Catlin expressed the modest hope that viewers of his pictures would "find enough of historical interest excited by faithful resemblance to the physiognomy and customs of these people, to compensate what might be deficient in them as works of art." Most viewers of Catlin's work are willing to judge it on these terms—as faithful pictorial documents of the Old West and of Indian life.

That Catlin's work had a strong influence upon other artists of the mid-nineteenth century cannot be doubted. His success in the West stimulated other artists to go there. His paintings provided source materials for less adventurous artists who attempted to picture the Wild West in the safety of their big city studios, among them Felix O.C. Darley, commonly recognized as the outstanding American illustrator of his time. One of Darley's pictures of a buffalo hunt is frankly labeled "after Catlin."

Recent appraisals of Catlin's work tend to support the prophecy of Joseph Henry, Secretary of the Smithsonian Institution, shortly after Catlin's death on December 23, 1872: "His paintings will grow in importance with advancing years."

Broken Arm, a Plains Cree Leader. Catlin. 1831. Oil. Smithsonian Institution (overleaf, left)

Mint, a Mandan Indian Girl. Catlin. 1832. Oil. Smithsonian Institution (overleaf, right)

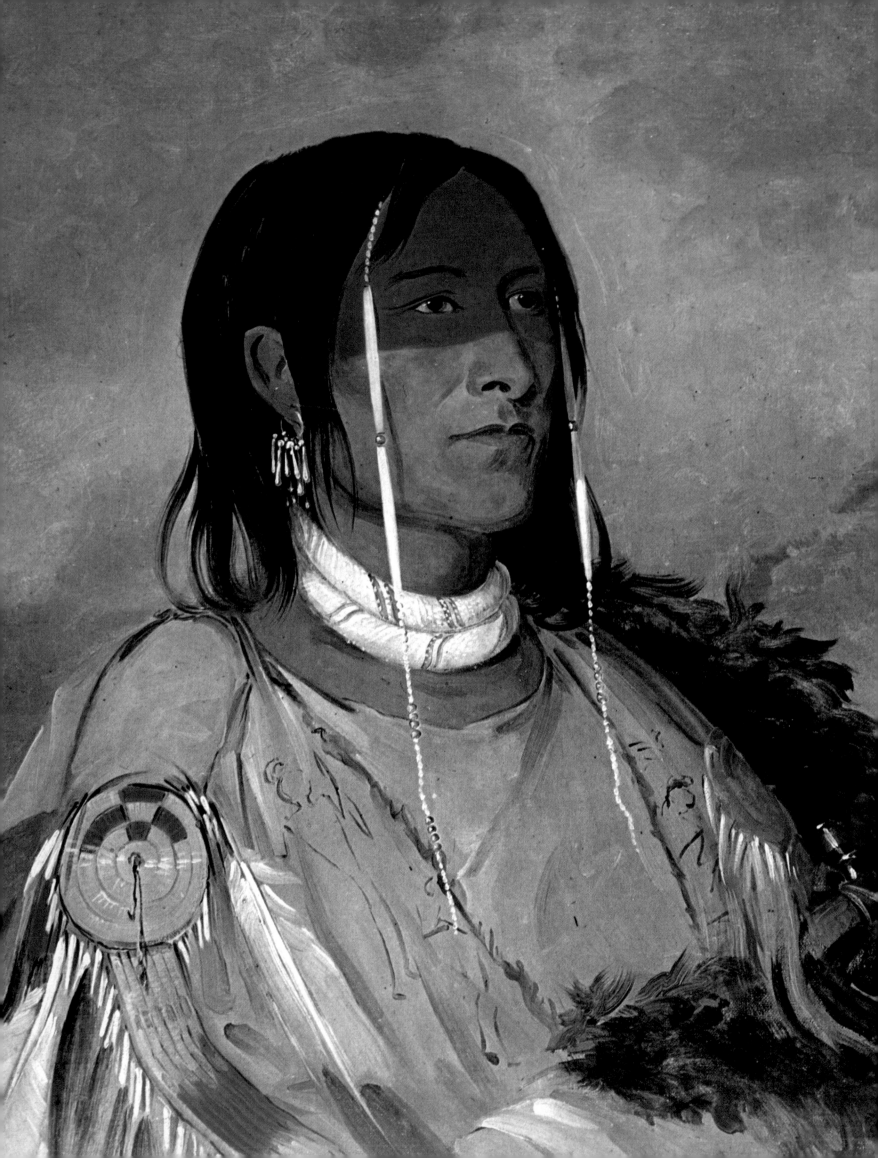

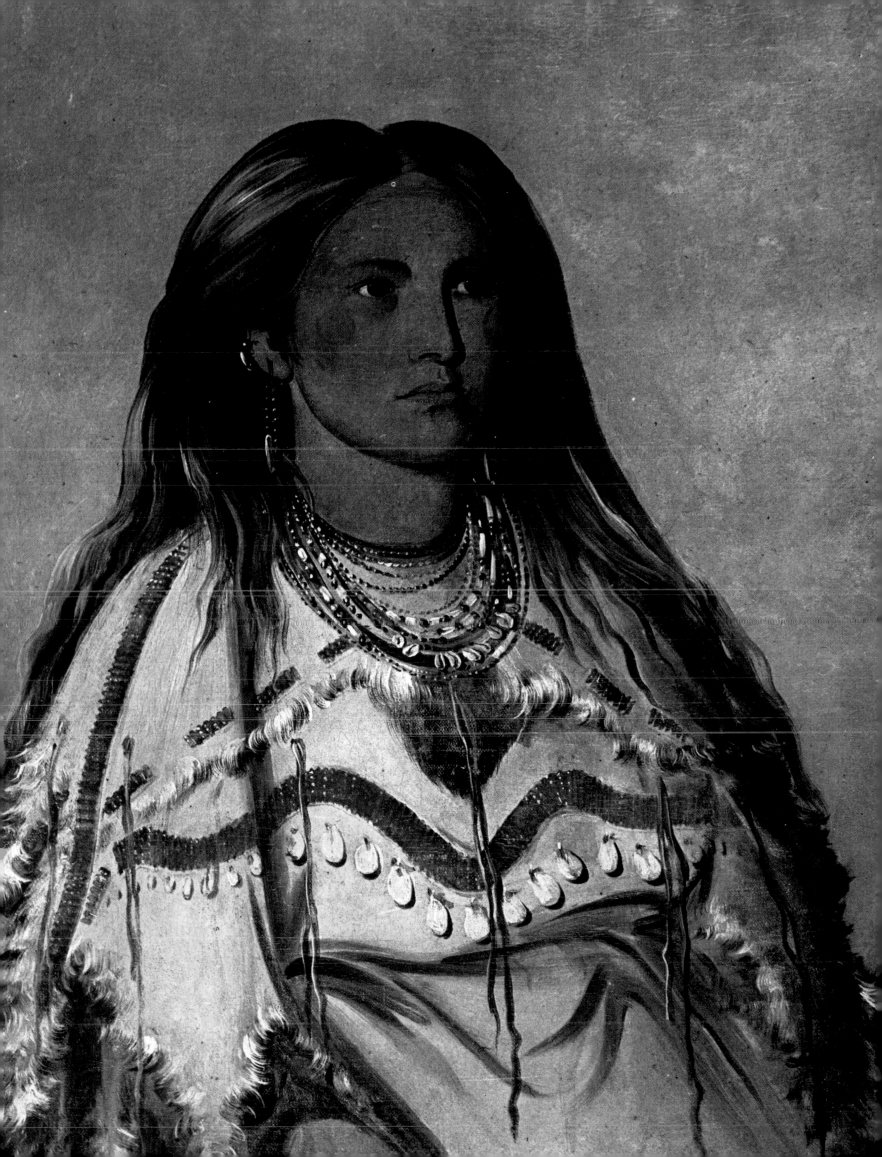

MASTER DRAFTSMAN
ON THE
UPPER MISSOURI

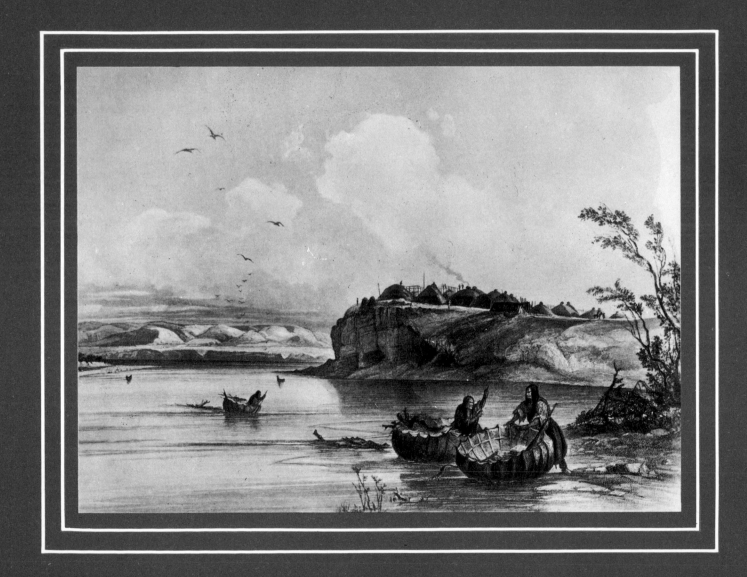

Karl Bodmer

*M*ih-Tutta-Hang-
Kush, a Mandan Indian
Village. Bodmer. 1833.
Engraving. Smithsonian
Institution (left)

Dance of the Mandan
Buffalo Society. Bodmer.
1834. Aquatint. Rare Book
Division, New York
Public Library (overleaf)

Early in the spring of 1833, two artists, one an amateur and the other a professional, closely examined a small collection of George Catlin's oil paintings at the home of General Clark's nephew, Benjamin O'Fallon, near St. Louis. The amateur was a short, stocky, bespectacled, middle-aged German scholar. His companion was a young, thoroughly trained Swiss artist whose work was as yet unrecognized in America. Both were intensely interested in Catlin's portrayal of the plains and its Indians, for they were soon to embark upon their own explorations of the Western wilderness.

The amateur was Alexander Phillip Maximilian, prince of the small German principality, Wied-Neuwied, north of Coblenz on the Rhine River. He had become Major-General in the Prussian Army during the Napoleonic Wars. But he preferred the discipline of the scholarly life. He had gained wide recognition as a scientist through his publication in German, French and English of his researches in natural history in Brazil from 1815 to 1817. In Brazil he had executed his own field sketches. But as the time approached for his departure on an exploration of Western North America this scholarly perfectionist felt the need for a full-time artist to prepare on-the-spot drawings to illustrate an account of his travels and observations.

In March 1832, Maximilian had written Professor Schinz, noted zoologist of Zurich, "Perhaps I should take a young artist along." He found the artist he was seeking in Karl Bodmer, who was then making exquisite landscape sketches in the Rhine Valley near Coblenz. Impressed by Bodmer's talent, the prince wrote the professor, "He will surely supply a lovely box of drawings."

Born in Zurich on February 11, 1809, Karl had recently passed his twenty-third birthday. Yet under the tutelage of an uncle, John Jacob Meyer, a painter and engraver, he had developed a remarkable talent for drawing and painting. He had gained some experience in drawing for reproduction, for some of his views in the Rhine and Moselle valleys had been engraved by his older brother Rudolf. Karl may never have dreamed of painting wild Indians in far-off America, but he accepted the prince's offer to become the artist of a three-man expedition, and signed a contract with his new employer at Coblenz on April 25, 1832. Three weeks later, the artist, the princely scientist, and a hunter, Driepodell, set sail for the United States on a journey of exploration that was to last more than two years.

With scholarly thoroughness, Maximilian and Bodmer visited bookshops and museums in the eastern states, searching for books, prints, and original works of art that would provide background for their field studies. In Philadelphia they examined Peale's Museum, talked with Titian Peale, saw the drawings and paintings he and Samuel Seymour had executed on the Long Expedition, and studied the collections in natural history and Indian artifacts Major Long and Lewis and Clark had deposited there. Maximilian also purchased some of Peter Rindisbacher's watercolors. Then, having seen Catlin's paintings at Major O'Fallon's, the Europeans had an acquaintance with the works of all the major artists who had preceded them into the wilderness beyond the Mississippi.

When he arrived in St. Louis in March 1833, Maximilian consulted with General Clark, Major O'Fallon, formerly Indian Agent for the Upper Missouri tribes, and others, and concluded that the Missouri River route offered the best opportunities to meet friendly Indians and to make significant collections in natural history. So he arranged passage

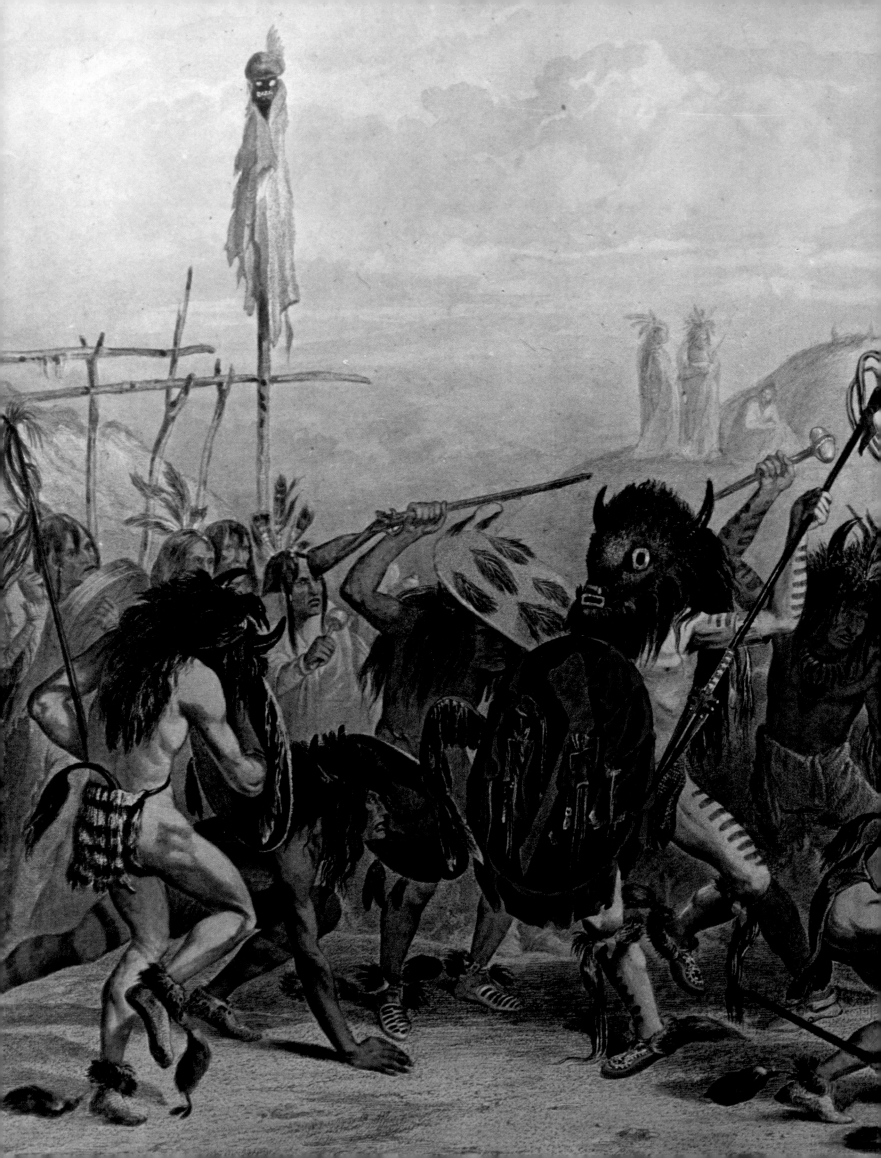

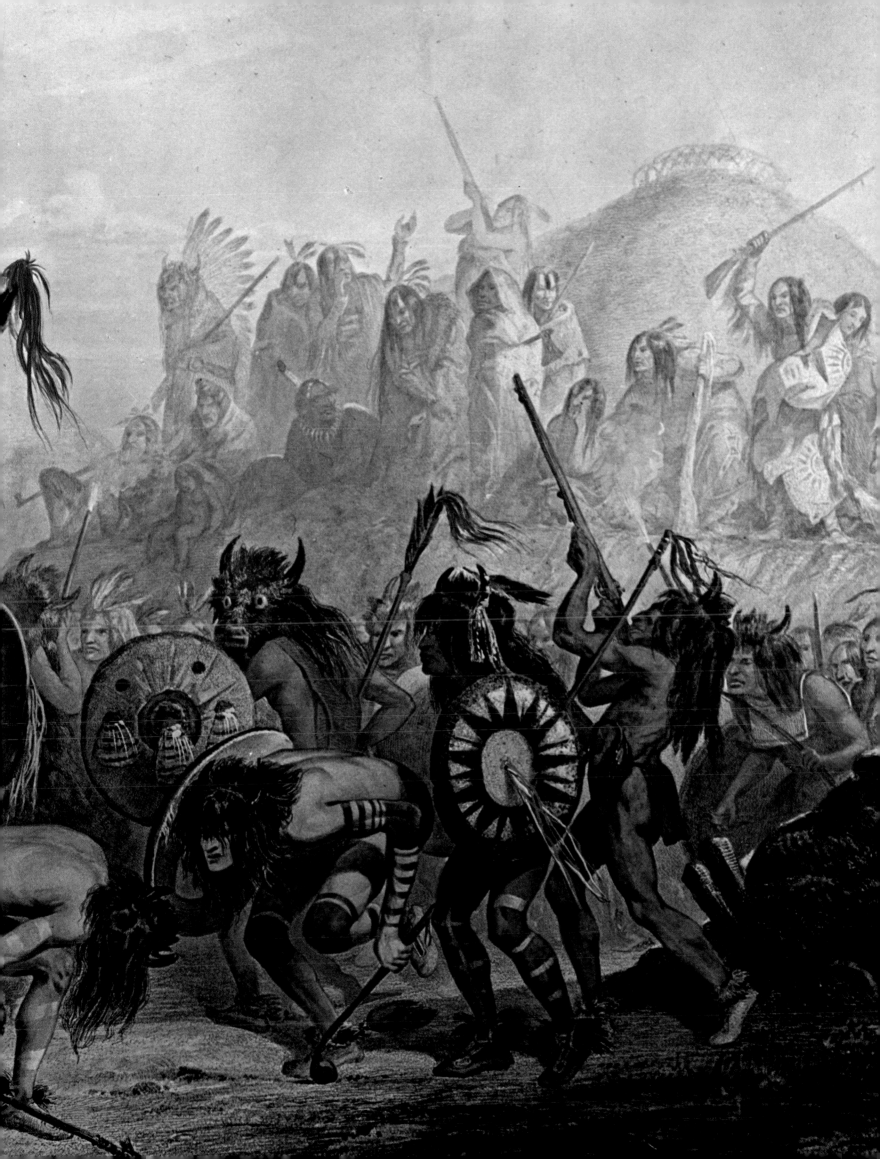

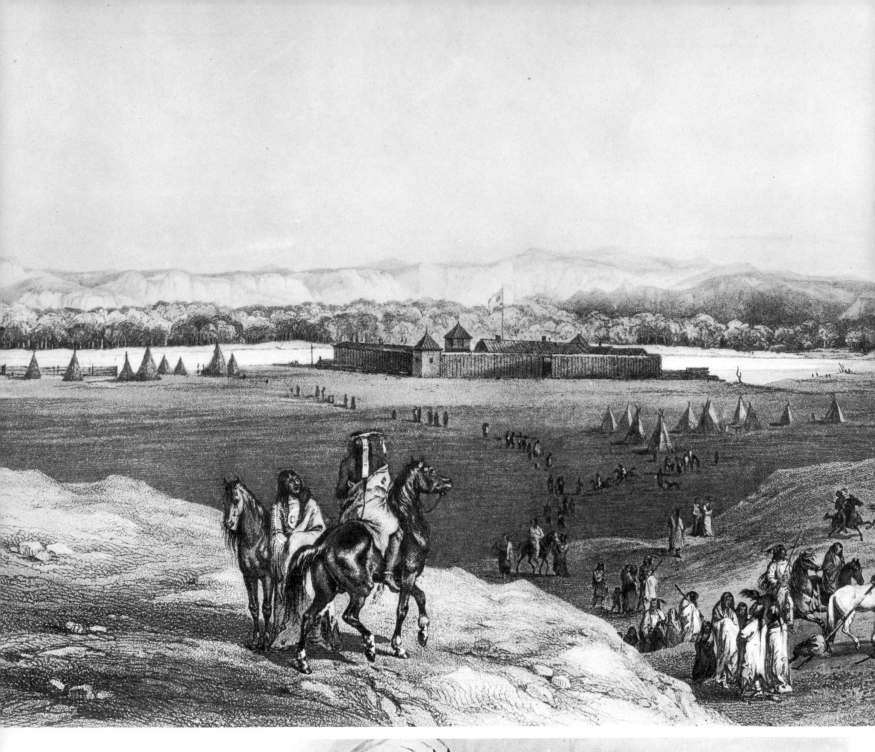

F*ort Union, at the
Mouth of the Yellowstone.
Bodmer. 1833. Engraving.
Smithsonian Institution*

The Artist Fighting a Cheyenne Chief, executed for Prince Maximilian in 1834. Mato-Tope, Mandan Second Chief. Watercolor. Joslyn Art Museum and Northern Natural Gas Company, Omaha

on the American Fur Company's steamboat *Yellowstone*, the same vessel that had carried Catlin upriver the previous year. Meanwhile, General Clark showed the visitors his own museum, the first established west of the Mississippi, and gave Bodmer an opportunity to make watercolor likenesses of the members of a Sauk and Fox delegation who came to his office.

With passports to enter the Indian country, some books, paints, paper, a small music box, and many small articles for bartering with the Indians, the three Europeans left St. Louis on April 10, 1833.

Seven weeks later the travelers reached Fort Lookout, the Sioux Agency, above the mouth of White River. While Maximilian made first-hand observations on the Sioux, Bodmer meticulously drew his first full-length portrait of a Plains Indian warrior, Big Soldier, a Teton Sioux very friendly toward the whites. Big Soldier was clad in his hair-fringed chief's shirt and held a pipe-tomahawk obtained from the whites. The prince marveled that Bodmer's model "remained the whole day in the position required, which, in general the Indians find it difficult to do." And when the artist finished this watercolor next day, his employer pronounced it a "very capital likeness."

At Fort Pierre, principal trading post for the Teton Sioux, Bodmer drew at least four Indian portraits. One showed a handsome Teton woman wrapped in her painted buffalo robe. When it came time to prepare this portrait for reproduction as a copperplate in the Atlas that was to accompany Maximilian's account of the expedition, Bodmer added the figure of a little Assiniboine girl, whose likeness he probably drew at Fort Union.

Proceeding upriver on the steamboat *Assiniboine*, the Europeans reached Fort Clark on June 18th. Some three hundred paces above that trading post was the principal Mandan village of Mih-Tutta-Hang-Kush. Bodmer pictured this Indian town of some sixty earthlodges on a steep bluff overlooking the Missouri. In the foreground he showed three Mandan women with their tublike bullboats of buffalo hides stretched over a framework of willow rods, the only watercraft they used.

Seventy-five days out of St. Louis the travelers arrived at Fort Union, at the mouth of the Yellowstone, then the head of steamboat navigation on the Missouri. From the hills back of Fort Union Bodmer drew a distant view of this important trading post that admirably portrayed its physical setting. Visible in the foreground are some of the many Assiniboine Indians who flocked to the fort when they heard that the steamboat had arrived with a new year's supply of trade goods. They also came with the hope of getting a few presents from the traders.

During the next few days Bodmer painted several Assiniboine warriors. One of them, Noapeh (Troop of Soldiers), wore a headdress of antelope horns which fascinated Maximilian. The prince also observed that this Indian "stood with unwearied patience to the painter, though his relations frequently endeavored to get him away," until Bodmer had recorded his head and horns, his elaborately decorated shirt with its red flannel neck flap, porcupine-quilled breast rosette, black painted stripes on body and sleeves, blue and white beaded sleeve panels, and long hair fringes in minute detail.

The prince also was attracted by a tipi on each side of which a black bear was painted. This lodge doubtless belonged to a member of the bear cult of desperate warriors and awesome healers. Bodmer's watercolor also shows the lean, wolflike dogs that the Assiniboine women harnessed to their travois to carry luggage.

81

The prince was not content to stop at Fort Union, where George Catlin had turned back the previous summer. Obtaining the use of the American Fur Company's keelboat *Flora*, and a stout crew to man it, and joining forces with David Mitchell, a company trader, the travelers pushed on upriver on July 6th. Their keelboat, some sixty feet long and sixteen broad, had a mast and sail. When there was no wind, half the party of fifty-two had to tow her by ropes from the river banks. In low water she was propelled by poles. Hunters on shore rustled fresh meat to feed the entire party en route.

They were following the route traveled by Lewis and Clark in the spring of 1805, and methodical Maximilian compared their published descriptions of the country with his own observations. The party was passing through a region frequently traversed by small war parties on their wide-ranging horse raids upon enemy camps. Maximilian described the conical, timbered war lodges used as overnight shelters by the war parties, but Bodmer apparently did not picture these structures.

Beyond the mouth of the Milk River, the travelers entered extensive badlands affording distant views of eroded rock formations that reminded the Europeans of castles overlooking the Rhine River back home or scenes in Switzerland. While the Prince described these sights in scientific terms, Bodmer recorded them in pencil and watercolor.

At daybreak on August 9th, the travelers saw the American flag waving over Fort McKenzie near the mouth of the river Meriwether Lewis had named the Marias. This strongly-gated, palisaded trading post had been built by the American Fur Company the previous year in the country of the warlike Blackfeet. As the keelboat approached, its occupants were welcomed by salvos from the fort's cannon and by some eight hundred Indians from nearby camps. The prince confided to his journal: "We had happily accomplished the voyage (from Fort Union) in thirty-four days, had lost none of our people, and subsisted during the whole time by the produce of the chase."

During their five-week sojourn at Fort McKenzie, Maximilian and Bodmer, the first scientist and artist to visit the Blackfoot country, exploited their opportunities. The prince collected natural history specimens and Indian artifacts, and took copious notes on the geology, plant and animal life of the region as well as the customs of the Indians and their relations with the traders, who were trying to win them away from their allegiance to the Hudson's Bay Company. Bodmer executed a fine watercolor of Fort McKenzie and at least sixteen portraits of the chiefs, medicine men, warriors and women of the three Blackfoot tribes. Of these, the most interesting historically is his watercolor of Wolf Child, son of a Piegan mother and a Kutenai father. He may have been the Wolf Calf who later claimed to have been a member of the small Piegan party whose dawn attempt to steal Meriwether Lewis' guns and horses on the upper Marias, July 26, 1806, precipitated the only Indian fight of the Lewis and Clark Expedition.

Bodmer and Maximilian also were eye-witnesses to a Blackfoot battle. At daybreak on August 28th, they were awakened by the sound of gunfire. Running to the elevated platform just inside the fort's palisade, they saw the whole prairie covered with Indians afoot and on horseback. At first they thought the fort was under attack, but they soon realized that the attackers, some six hundred Assiniboines and Crees, were intent upon wiping out eighteen or twenty lodges of Piegans outside the fort gate. The little trading party of Piegans had been drinking and singing most of the night and had fallen into a deep sleep toward

T*eton Sioux Woman and Assiniboine Child. Bodmer. 1833. Engraving. Smithsonian Institution*

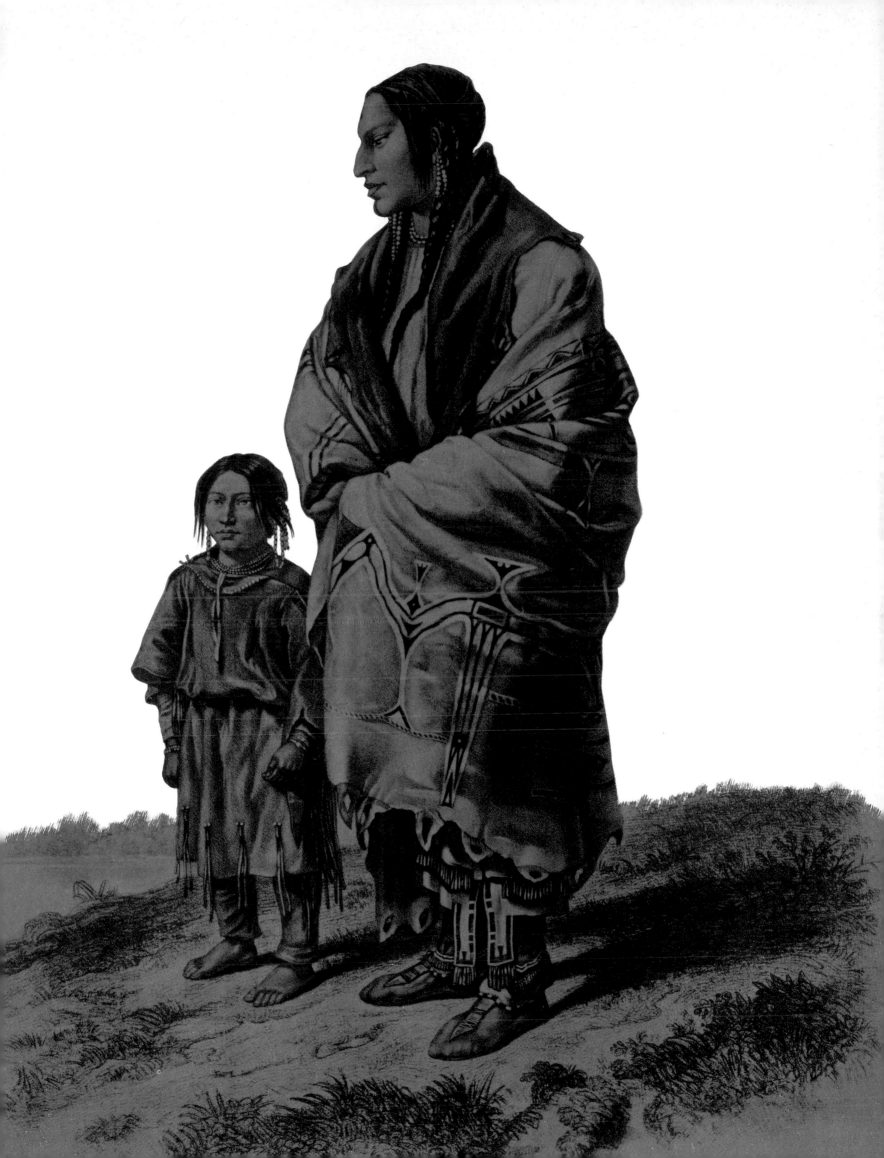

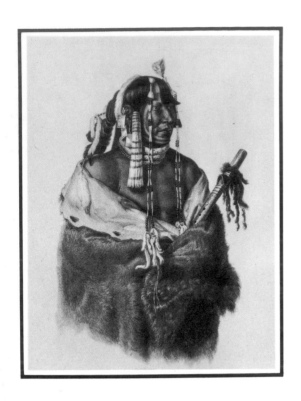

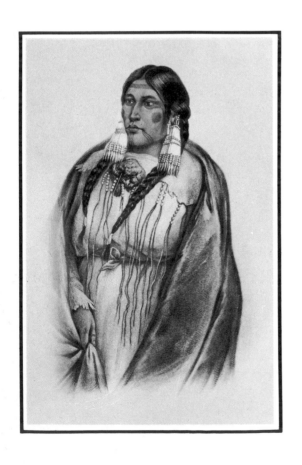

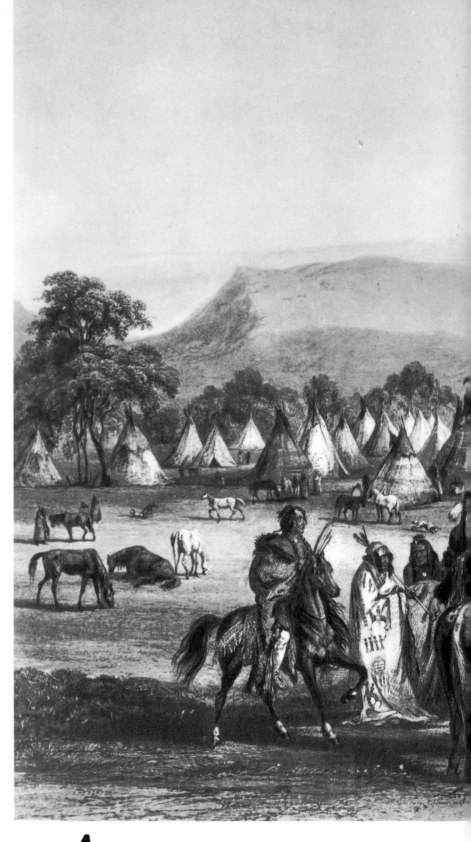

A Mandan Indian
Dandy. Bodmer. 1834.
Engraving. Smithsonian
Institution (top)

*Cree Indian Wife of a
French-Canadian Hunter
at Fort Union. Bodmer.
1833. Engraving. Smith-
sonian Institution*

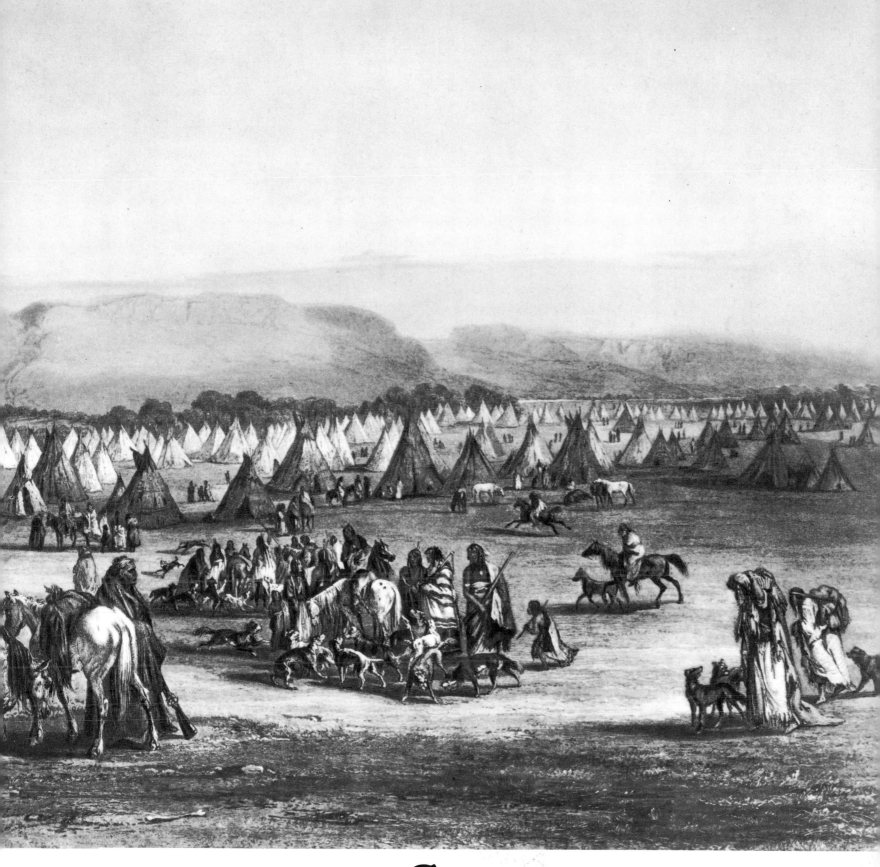

85

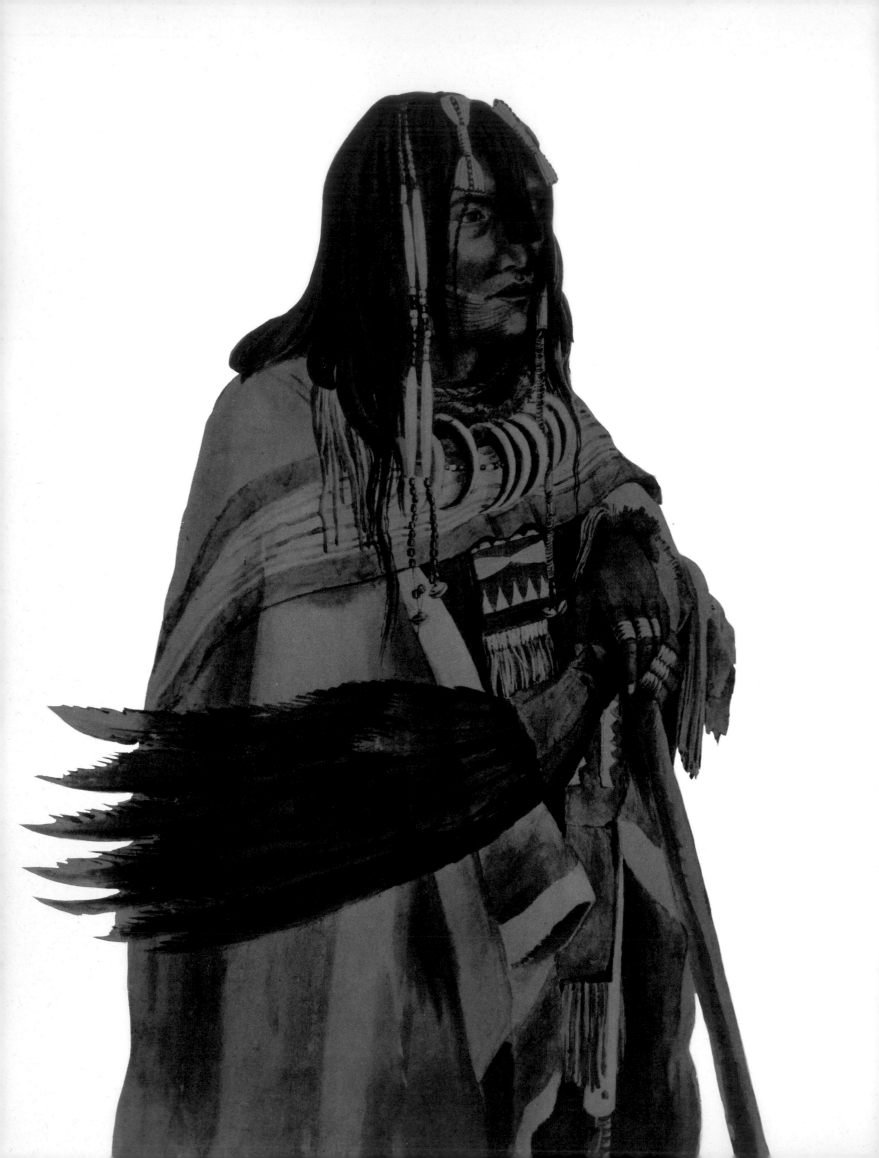

morning. Before they could retreat to the fort, their attackers ripped open their tipis with knives, fired guns and arrows, and killed or wounded several men, women and children. As the defenders fought for their lives, reinforcements came riding to their aid from other Blackfoot camps. Assisted by whites from the fort, they drove the enemy back to the Marias and continued a fire fight until evening, when the attackers withdrew. Traders reported that that old warrior, ex-General Maximilian, took pot shots at the red-skinned attackers from the fort balcony.

Maximilian and Bodmer also saw the Piegans wreak vengeance upon the body of an enemy killed near the fort. The prince observed: "The men fired their guns at it; the women and children beat it with their clubs, and pelted it with stones, the fury of the latter was particularly directed toward the privy parts." Maximilian wanted the dead man's skull for scientific study, but before he could obtain his wish, not a trace of the head was to be seen.

One of Bodmer's most effective prints recreates an early stage in this battle. It vividly depicts the ferocity of the struggle and the variety of weapons employed—bows and arrows, muzzle-loading trade guns, knives and war clubs. No other picture of Plains Indian intertribal warfare is as dramatically convincing as this eyewitness representation by a master draftsman.

After the battle old Bear Chief bragged, according to the prince, that "no ball had touched him, doubtless because Mr. Bodmer had taken his portrait a few days before." Bodmer's medicine was considered as good by the Blackfeet as Catlin's had been deemed bad by the Sioux.

Shortly thereafter Bodmer sketched the great camp of the Piegans, comprising about four hundred lodges, pitched close together because the enemy was believed to be still near. Unlike most artists who pictured Plains Indian camps, Bodmer shows tipis of various sizes, reflecting differences in family wealth and number of occupants of these dwellings.

Maximilian had hoped to pass the winter in the Rocky Mountains, but the traders and Indian visitors at Fort McKenzie convinced him that this would be folly in a region of warring and thieving Indian tribes. While employees of the fort built them a Mackinaw boat for their down-river voyage, Maximilian and Bodmer made daily trips to the heights above Fort McKenzie. From this vantage point, the artist executed a panorama of the Bear Paws in the distance to the northeast. He also painted the mountains to the west, which the prince termed "the Rocky Mountains," but which probably were the much nearer Highwoods. These watercolors were made under considerable tension, while a sharp lookout for hostile Indians was being maintained at all times. On some days false alarms sent them scurrying back to the fort before they had done any art work. But when the pictures were completed the prince was satisfied that these westernmost of Bodmer's landscapes gave "a correct idea of the country."

On September 14th, the European explorers bade goodbye to their friends of five weeks at Fort McKenzie, and started downstream in a boat loaded with cages of bears, small mammals, and bundles of natural history specimens and Indian artifacts. Aided by the strong current, they returned to Fort Union in thirteen days. On the way Bodmer made more landscape sketches and several impressive watercolors of the wildlife they saw on shore. Buffalo were especially plentiful, and one of Bodmer's panoramas depicts a great herd of them descending to the river to drink.

While at Fort Union in October the explorers joined the hunters of the post on a buffalo hunt; and Bodmer pictured the Assiniboine and

Wolf Child, a Piegan Warrior. Bodmer. 1833. Watercolor. Joslyn Art Museum and Northern Natural Gas Company, Omaha

Cree Indians who came to the fort to trade or to beg. But Bodmer's best picture of that month was of the Cree Indian wife of François Deschamps, a French-Canadian hunter at the fort. She epitomizes the mature Plains Indian woman, who had the strength and stamina to dress heavy buffalo hides, set up and dismantle tipis, rustle baggage, and perform the other hard tasks that fell to these Indian women.

Carrying a letter from Kenneth McKenzie to James Kipp, the factor at Fort Clark, authorizing "Baron Braunsberg" (the name Prince Maximilian used during his wilderness travels) and his staff to spend the winter there, the three travelers and five hired boatmen left Fort Union on October 30th, and reached Fort Clark ten days later. They stayed with Kipp's family while a new building was hastily constructed within the fort for their use. By late November they were in their new quarters, a large, one-story room with glass windows which provided good light for drawing, small tables and benches of poplar, and three shelves against the walls which served as beds. This all-purpose room served the travelers well during their winter's stay at Fort Clark. Frequently Indian visitors spent the night on the wooden floor.

While the prince questioned James Kipp and old Toussaint Charbonneau, the Indian interpreter who had served with Lewis and Clark (and is best remembered as the husband of the remarkable Sacajawea), as well as a host of Indians about the history and customs of the Mandans, Hidatsas, and Arikaras, Bodmer busied himself with his pencils and watercolors. The Mandans were moving from their exposed summer villages atop the bare river bluffs to winter homes in the tree-sheltered river bottoms. But Bodmer prevailed upon one of them, Dipauch, to remain in his large summer earthlodge for several days while he slowly sketched its interior construction and varied furnishings in minute detail. The print developed from this field sketch is one of the most satisfying and informative pictures ever made of an Indian subject. As a work of art it is a superlative study in light and shadow. As an historical and ethnological document it is filled with accurate detail.

As the winter advanced and the subzero cold penetrated numerous cracks in the walls of his studio, Bodmer's colors and pencils froze so that he could not use them without heating them in water. Yet he continued to work on many subjects. He accepted the difficult challenge of recording elaborate Indian ceremonies by making quick sketches of the entire group in action and detailed watercolors of the principal performers wearing their ceremonial garb and holding the objects they carried in the performance. From these graphic references he later developed

Indian Artifacts. Bodmer. Lithographs published in Maximilian's "Travels in the Interior of North America," 1843. Rare Book Division, New York Public Library, Astor, Lenox and Tilden Foundations

the elaborate compositions which convey the action and setting of each ceremony and at the same time accurately depict its essential details. Thus Bodmer graphically recorded the Hidatsa scalp dance, and the dances of the women's society and of the men's buffalo society among the Mandans. The last is an outstanding example of Bodmer's technical skill in rendering the human figure in action as well as his genius for composing an exciting, unified, meaningful scene. It is as revealing to the serious student of Indian culture as it is fascinating to the casual viewer.

Throughout the long winter months, Mandan and Hidatsa Indians visited Bodmer's studio to pose for him in their finest clothes. The artist amused them with the tunes from a portable music box which the Indians believed contained a small spirit and was a powerful medicine. One Indian who had been painted in less than his best outfit returned to the studio and insisted upon the destruction of his likeness. Bodmer left the room with the portrait, quickly copied it, returned and tore up the copy before the protestor's eyes, thus silencing his critic.

Shortly after Bodmer witnessed the colorful dance of the Hidatsa Dog's Society, he induced Pehriska-Ruhpa, one of its leaders, to stand for several days while he drew and painted him in the elaborate feather headdress and other garments he had worn in the dance. The prince described this picture as "a very admirable likeness" and the colored print developed from it remains an outstanding representation of the beauty and intricacy of primitive Plains Indian ceremonial costume.

90

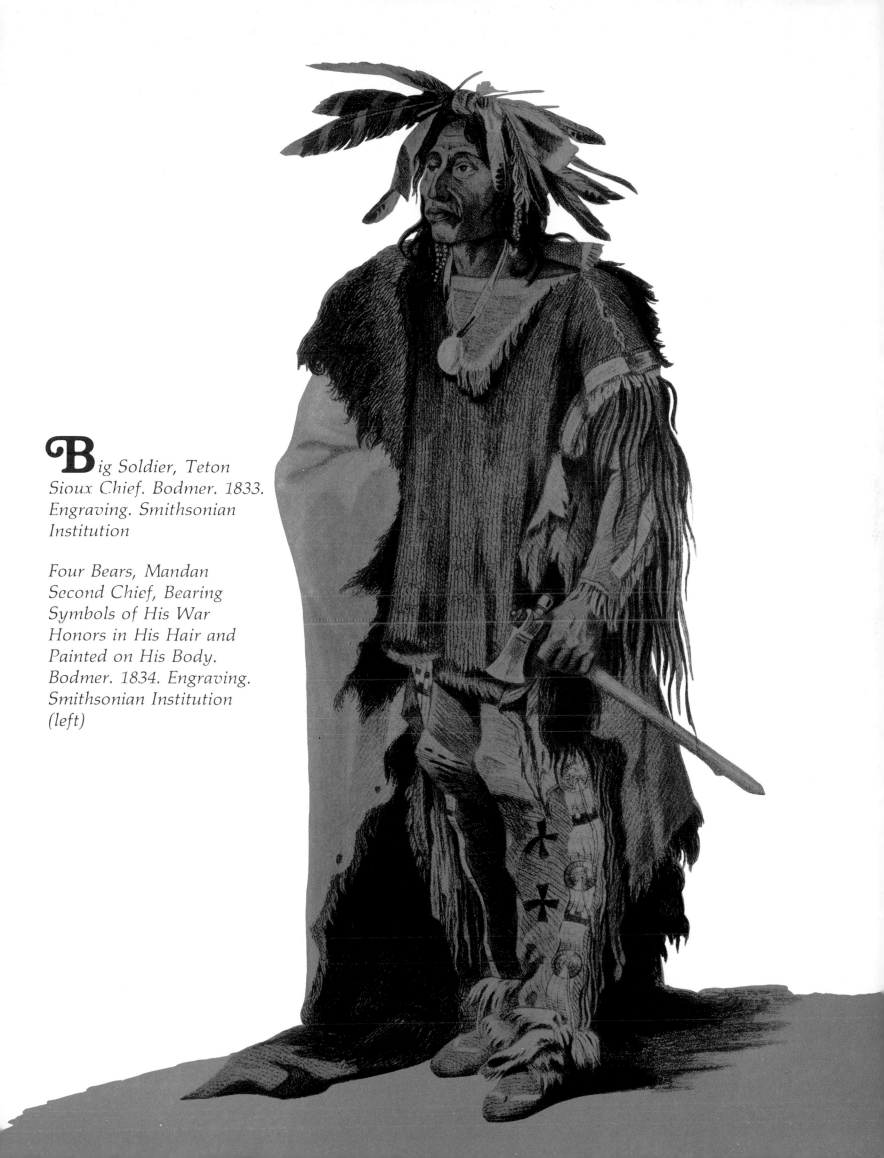

*B*ig Soldier, Teton Sioux Chief. Bodmer. 1833. Engraving. Smithsonian Institution

Four Bears, Mandan Second Chief, Bearing Symbols of His War Honors in His Hair and Painted on His Body. Bodmer. 1834. Engraving. Smithsonian Institution (left)

Catlin's hero, Four Bears, the Mandan second chief, and Yellow Feather, son of a chief of that tribe, were the most frequent visitors to Bodmer's studio. Both posed for him as they had for Catlin two summers before. They were keenly interested in Bodmer's drawing and painting methods for they liked to paint too. To encourage these fellow artists Bodmer gave them pencils, watercolors, and paper. The Maximilian-Bodmer Collection at the Joslyn Art Museum in Omaha contains several watercolors by these Mandan artists. These earliest known examples of Plains Indian painting in the white man's medium show an earnest striving for realism and detail that had been lacking in the crude picture-writing of Mandan artists in earlier years. It is fair to assume that this new trend in Mandan art was inspired by the work of George Catlin and Karl Bodmer. So these artists may be regarded as missionaries of a new artistic tradition among the Mandans as well as interpreters of Mandan culture.

Unfortunately, Yellow Feather was killed in battle soon thereafter, and Four Bears wasted away and died in the small-pox epidemic that decimated the Mandans in 1837. Karl Bodmer was the last white artist to picture this most remarkable tribe of the Upper Missouri before that devastating plague. The Mandans never regained cultural leadership among the tribes of the region.

After bidding farewell to their many Indian friends in the vicinity of Fort Clark, Maximilian and Bodmer began their homeward journey on April, 18, 1834, and reached St. Louis thirteen months after they had left it. The close association between mature scientist and young artist had been exceedingly productive. Bodmer had been permitted to concentrate his rare talents upon picture making. He had worked steadily but unhurriedly. If a subject merited particular care he had devoted several days to it.

The key to this versatile artist's success in depicting Indians, Indian life, landscapes and wildlife may be found in his great skill as a draftsman. Before he applied colors to his work he rendered an exquisite pencil drawing of his subject. With infinite pains he developed every detail of the picture. He was as concerned with recording the exact form, color, and texture of a garment as with portraying the likeness of the man or woman who wore it. Students of the arts and crafts of the Upper Missouri tribes can rely upon Bodmer's accuracy in rendering porcupine-quilled decorations on shirts, leggings and moccasins; of painted designs on buffalo robes, shields or rawhide containers; and of the minute details of hair, ear, or neck ornaments. The same close observation and precise execution is evident in Bodmer's scenes in Indian villages, at trading posts, and of Indian burial and sacrificial places. His landscapes faithfully record the varied character of the country through which he passed, its tree-bordered rivers, broad plains, eroded badlands, and imposing mountains.

No other report of explorations in the Great Plains has been as painstakingly and beautifully illustrated as was Maximilian's great work, *Reise in das Innere Nord-America in den Jahren 1832 bis 1834*, first published in Coblenz in 1839–1841, and reprinted in both French and English. Bodmer himself worked with some of the best Parisian artists to insure that the eighty-two copperplate engravings that accompanied the text in the form of a separate volume of illustrations, would be a superb artistic achievement. In the text of that work Prince Maximilian paid tribute to Bodmer for his representation of "the Indian nations with great truth," and prophesied that "his drawings will prove an

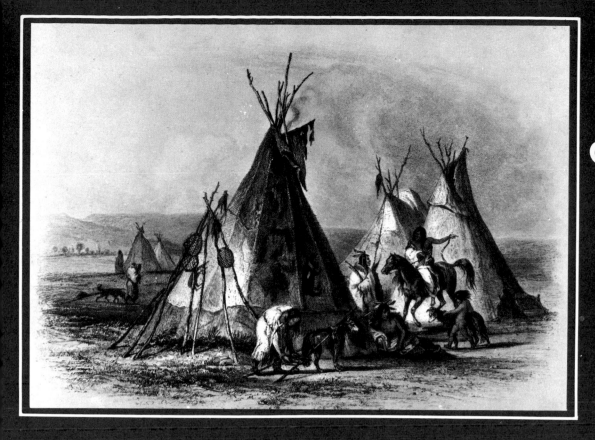

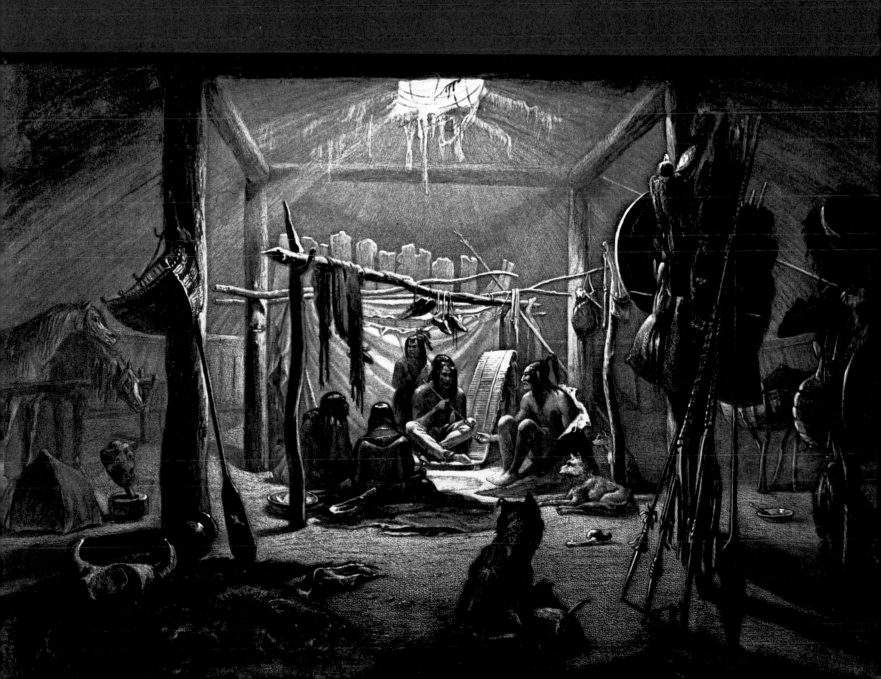

Assiniboine Indian Tipis. Bodmer. 1833. Engraving. Smithsonian Institution (top)

Interior of a Mandan Indian Earth Lodge. Bodmer. 1833. Aquatint. Rare Book Division, New York Public Library (bottom)

Assiniboine Tree Burial near Fort Union. Bodmer. 1833. Engraving. Smithsonian Institution (left)

Distant View of Fort Clark. Bodmer. Winter of 1833–34. Engraving. Smithsonian Institution (right)

important addition to our knowledge of this race of men." Modern anthropologists concur in this high appraisal of Karl Bodmer's contribution to both science and history.

Karl Bodmer never again returned to America. He made his home in France and became a citizen of that country. His art works, which generally depicted wildlife and forest scenes, were exhibited in Paris, Vienna, and other European art centers. He won honors and awards for his entries in the Paris Salon and other important exhibitions. In 1876, he was made a Chevalier of the Legion of Honor. He also contributed to such leading French art magazines as *L'Illustration* and *Le Monde Illustré*.

During his later years Bodmer was one of the famous group of Barbizon artists. He lived across the street from Jean François Millet, and these two became close friends. In mid-century they collaborated in preparing a series of prints interpreting the border warfare of the American Middle West, in which, curiously enough, Millet executed the Indians and settlers and Bodmer the dense forest settings. Bodmer died in Barbizon in his eighty-fifth year, on October 13, 1893. He was buried beside his friend Millet in the neighboring village of Chailley en Biere.

Inevitably, Bodmer's paintings of the Upper Missouri have been compared with those that George Catlin made only a year earlier. Certainly in temperament, background, and methods of work these two artists were poles apart. Impatient Catlin, eager to catch a likeness of his sitter, or to suggest the action of a scene, often sacrificed detail, but

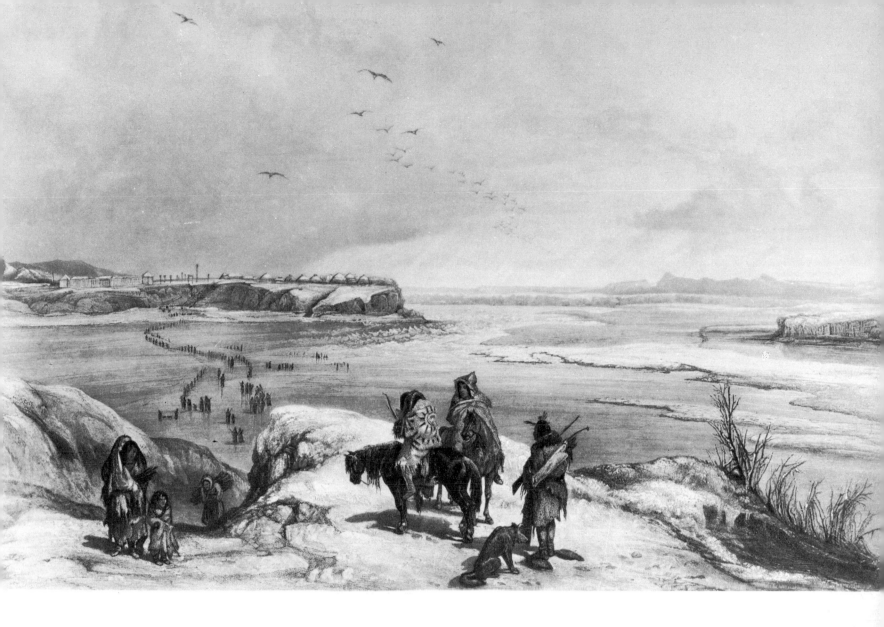

managed to create impressionistic pictures possessing a considerable appeal to the emotions and the imagination of the beholder. Calm, disciplined Bodmer, intent upon rendering every detail of his subject, left little to the imagination, but commanded respect for his superb craftsmanship.

Actually, there are few duplications of subject matter in the works of these two artists. Catlin did not visit the Blackfoot country nor winter among the Mandans. Bodmer did not see the summer ceremonies among the Mandans, the sacred pipestone quarry, nor was he ever on the plains southwest of St. Louis. Only a few of the same Indians of the Upper Missouri tribes posed for both artists.

Together the achievements of Catlin and Bodmer on the Upper Missouri in the years 1832–1834 represent a uniquely important contribution to the pictorial history of the Americas. They provide the most colorful and most comprehensive series of portraits and scenes from life of any group of Indian tribes before their traditional ways were modified greatly by contact with the white man. Some Indian subjects by both artists began to appear in Parisian magazines during the 1840's. Small but fine engravings of Bodmer's Indians were offered in this country by *Graham's Magazine* in 1845. Both artists' works were shamelessly copied or rendered in thinly disguised variations by a host of stay-at-home book and magazine illustrators. No other artists played more influential roles in establishing the Plains Indian as the typical American Indian in the minds of millions of Americans and Europeans.

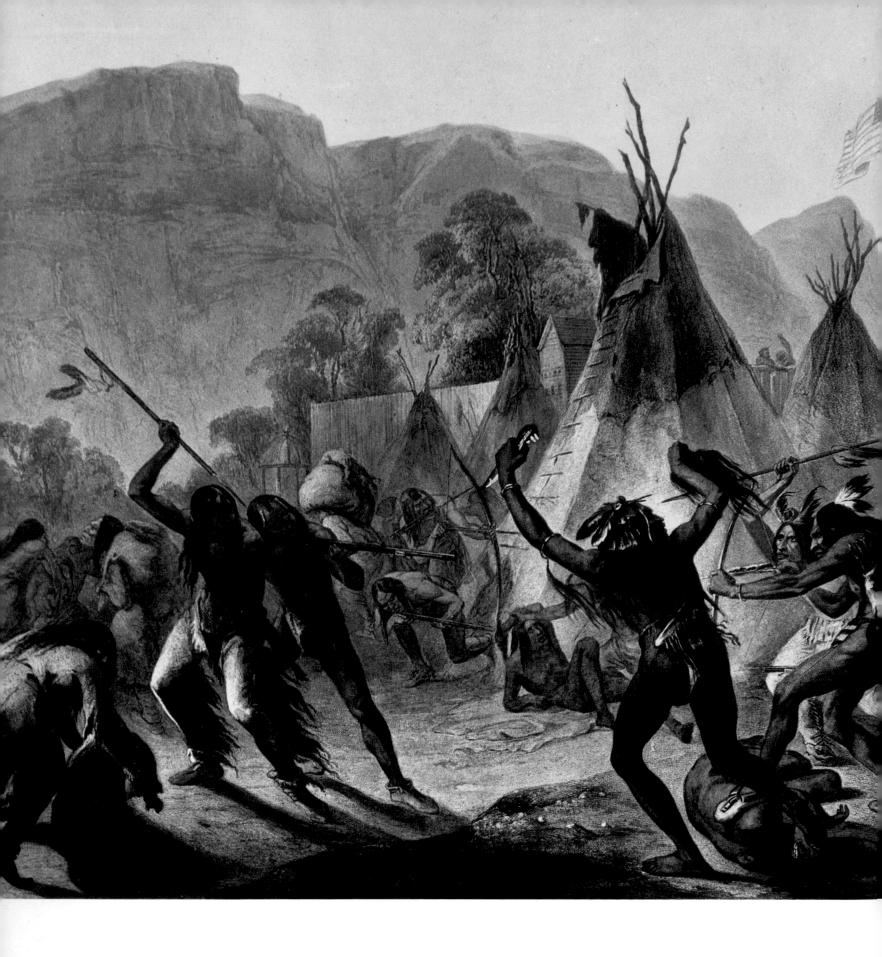

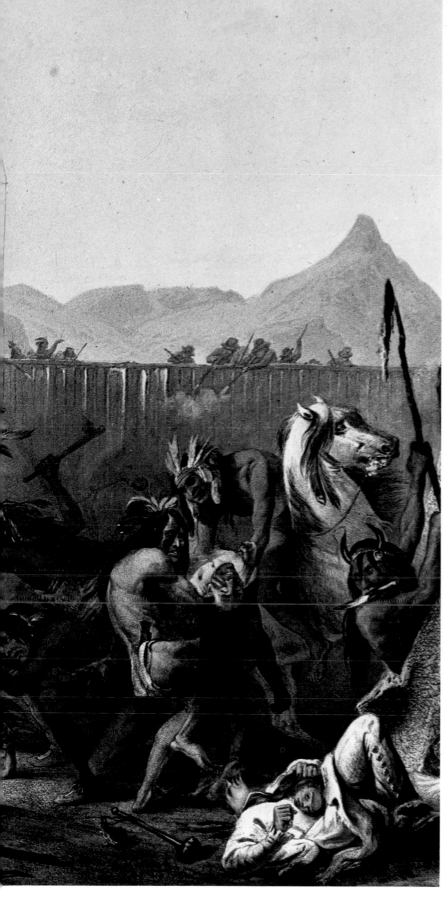

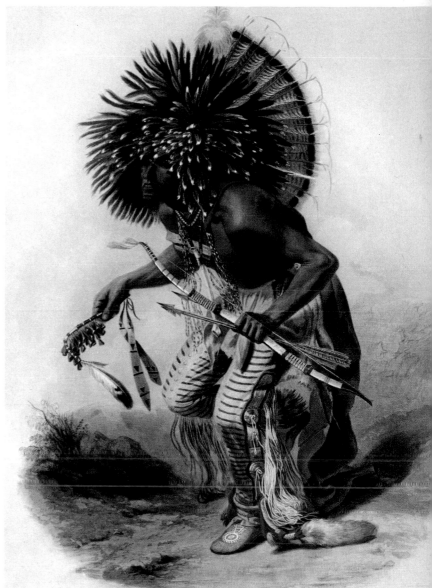

*D*ance Leader of the
Hidatsa Dog's Society.
Bodmer. 1834. Aquatint.
Rare Book Division, New
York Public Library
(above)

Assiniboine-Cree Attack
on a Piegan Camp outside
Fort McKenzie. Bodmer.
August 28, 1833. Aquatint.
Rare Book Division, New
York Public Library (left)

AMONG THE
MOUNTAIN MEN

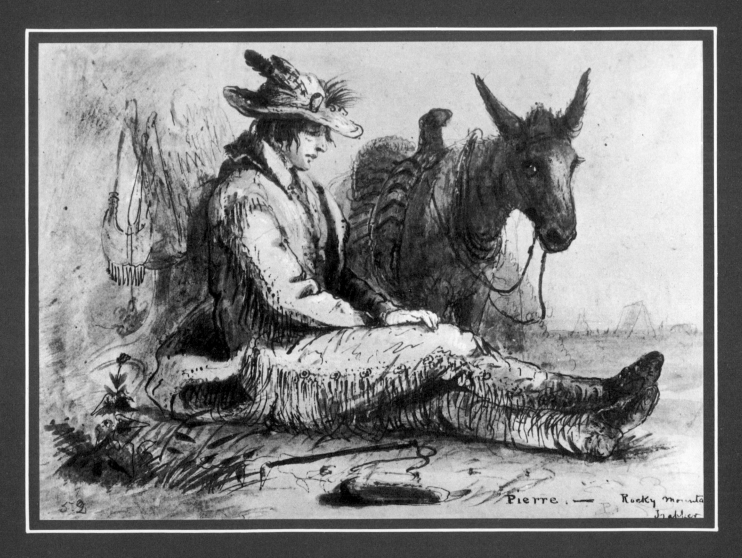

Alfred Jacob Miller

Samuel Seymour had sketched the front range of the Rocky Mountains in 1820. But seventeen summers passed before an artist penetrated the mountain fastness to picture their swift-flowing streams and quiet lakes as well as their towering, snow-capped peaks.

Meanwhile, the high country of present-day Colorado, Wyoming, and Montana had become the domain of some of the most colorful characters in Western history—the mountain men. To obtain the materials for the beaver hats worn by fashionable men and women in eastern and European cities and towns, these rugged adventurers crossed the grassy plains and ascended the mountain streams to trap beaver in the still waters of the highland meadows. Theirs was a hazardous occupation. Repeatedly small parties of mountain men had to fight off surprise attacks from Blackfoot raiding parties. Some trappers met ferocious grizzly bears in desperate encounters. All of them suffered from the bone-chilling cold and heavy snows of the mountain winters. Working in small, isolated parties throughout most of the year, these men looked forward to the mid-summer rendezvous with fellow white trappers and friendly Indians at a great encampment in a "hole," or broad valley in the mountains. There they sold their year's catch of furs to agents of the large trading companies and bought the powder and shot, the traps and the few supplies they needed to carry them through another long, lonely, and precarious winter. Mostly they lived off the land. Their food and the skins for their clothing came from the buffalo, deer, elk, antelope, and mountain sheep they killed. At the summer rendezvous they freely indulged in the social delights so long denied them—swapping tall tales of their adventures, drinking, gambling, fighting among themselves, and making love to Indian girls. Many of them quickly squandered their year's profits on alcohol, and on liberal purchases of gaudy presents to delight comely, dark-eyed, demanding Indian women. After a few days they sobered up, waved goodbye to their comrades, and returned to their work of trapping beaver.

During the decade of the 1820's, the Rocky Mountain fur trade expanded rapidly. But after the middle 1830's, when the popularity of silk hats cut down the demand for beaver pelts, the trade declined almost as quickly. By 1842, the brief era of the mountain man was over. Fortunately, one artist knew these men both at their annual rendezvous with their Indian allies, and in a portion of their wilderness domain. His first-hand pictorial impressions comprise a unique and colorful record of life in the Rocky Mountains in 1837.

Alfred Jacob Miller was born in Baltimore, Maryland, on January 10, 1810. His well-to-do parents recognized and encouraged young Alfred's talent for drawing and painting. During 1831 and 1832, he studied under the able American portrait painter, Thomas Sully. A year later his family sent him to Europe to continue his art education. Alfred studied at the famed Ecole des Beaux-Arts in Paris. He copied the works of the masters in the Louvre, and painted in Rome and Venice. Apparently he also painted in the Swiss mountains.

In 1834, Miller returned to Baltimore where he pursued his career with only moderate success. Compelled to make his own living after his father's death, he moved to New Orleans in the fall of 1836 and set up his studio over a drygoods store at 132 Chartres Street.

One spring day in 1837, a tall, well-dressed stranger entered this studio, critically examined the paintings and left without making a purchase. A few days later he returned, handed the artist an engraved card that read "Capt. W. D. Stewart, British Army," and brusquely

Pierre, Rocky Mountain Trapper. Miller. 1837. Sepia. Gilcrease Institute of American History and Art, Tulsa

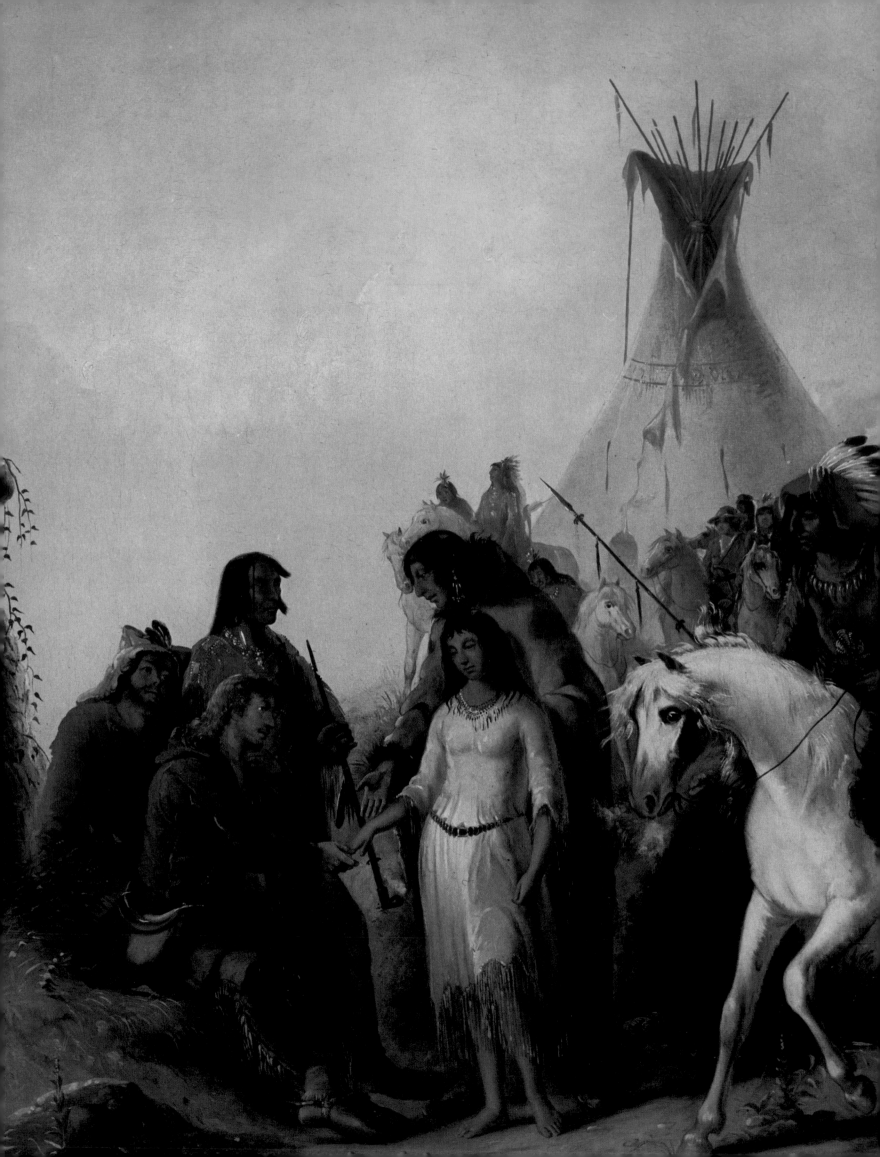

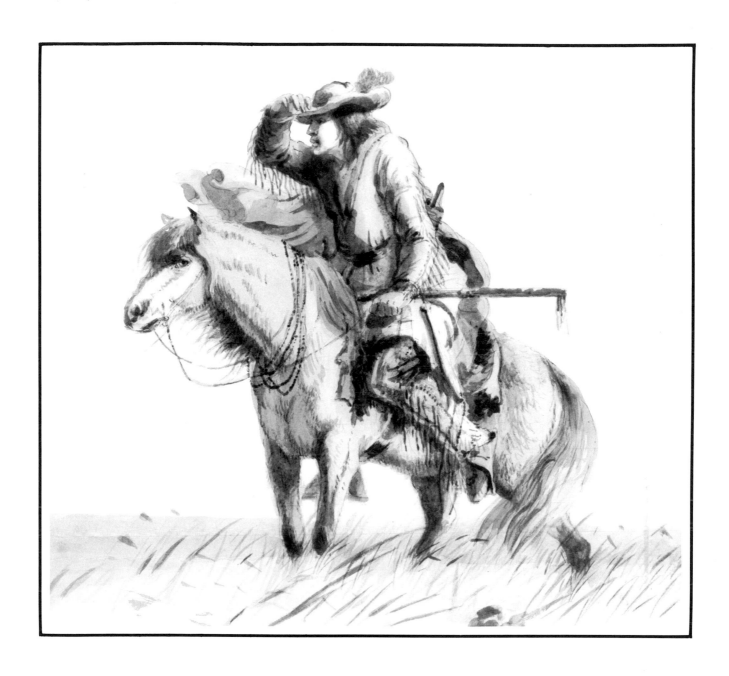

The Lost Greenhorn. Miller. 1837. Sepia. Joslyn Art Museum, Omaha

The Trapper's Bride. Miller. Undated. Oil. Joslyn Art Museum, Omaha (left)

informed him that he was planning a journey to the Rocky Mountains and that he wanted Miller to accompany him as an artist.

Miller soon learned that this visitor was not just an eccentric ex-soldier who liked the way he rendered sky, water, and mountain landscapes. He was William Drummond Stewart, the second son of a wealthy Scottish nobleman, who had served heroically under General Wellington at Waterloo. Seeking adventure after his retirement from the British Army, Stewart had found it in repeated trips to the Rocky Mountains since 1833. He had made money selling American cotton to English mills. Now, at the age of forty-six, this vigorous Scotsman was eager to return to the Rockies with an artist whose on-the-scene sketches would remind him of the West and of the life of his friends, the mountain men and the Indians.

So it was that in the spring of 1837 in his twenty-seventh year, city-bred Alfred Jacob Miller entered the service of a Scottish adventurer

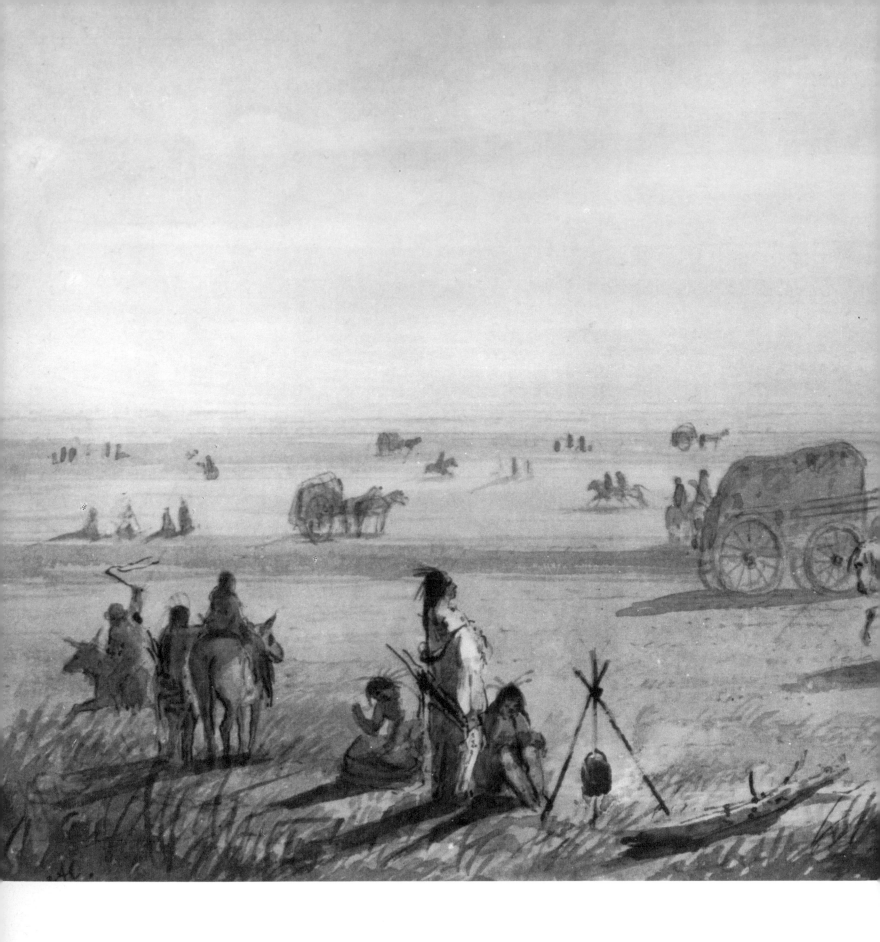

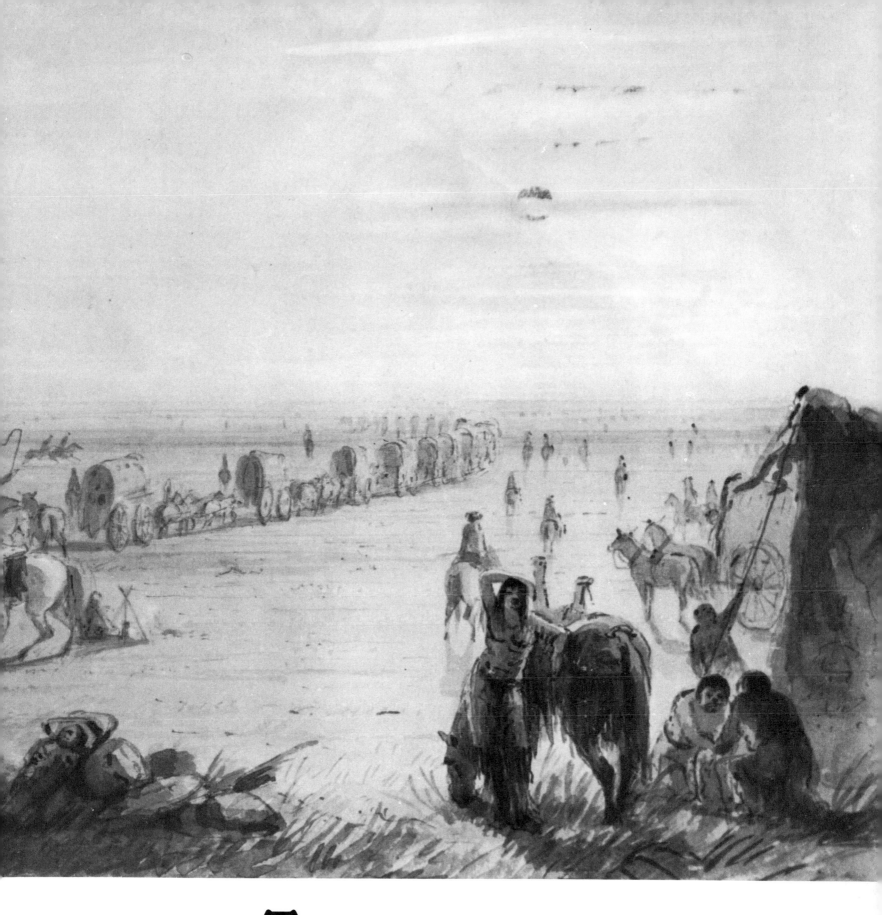

The Caravan Starting
at Sunrise. Miller. 1837.
Watercolor. Joslyn Art
Museum, Omaha

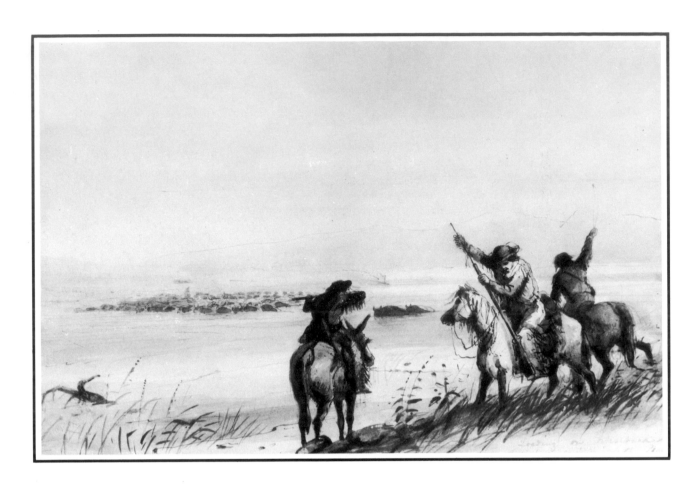

bound for the Rocky Mountains. Captain Stewart bought his supplies, including a variety of luxurious foods, in St. Louis. He also arranged for his party of ten men to join the large caravan of Pratte, Chouteau and Company, which was transporting supplies for the trappers and goods for the Indian trade to the summer rendezvous on the Green River.

About the middle of May the expedition left Westport (near present Kansas City) under the joint leadership of Thomas Fitzpatrick, veteran mountain man, and Captain Stewart. In addition to Stewart's two sturdy covered wagons, each drawn by four mules, the train consisted of the fur company's twenty two-wheeled charettes, each pulled by two horses in tandem. The entire party numbered about one hundred whites and some twenty Delaware Indians who hoped to find work in the mountains as hunters and guides.

After fording the Kansas River, the wagon train moved northwestward through the territory of the friendly Kansa Indians. The travelers met the clever old chief, White Plume, whose portrait Charles Bird King had painted in Washington some sixteen years earlier.

Continuing northwestward, the caravan passed through the Pawnee country, as had Long's Expedition seventeen years before. But instead of following the South Platte, the Fitzpatrick-Stewart party crossed to the north fork of the Platte and marched up its broad valley toward the setting sun. Now Miller was in territory where no white artist had preceded him. He was the first to picture the movement of a wagon train on what was to become the most famous overland migration route in Western history—the Oregon Trail, and he did so four years before the first immigrant train rumbled up the valley of the Platte on its way to

Buffalo Hunters on the Platte. Miller. 1837. Sepia. Bienecke Rare Book and Manuscript Library, Yale University

California. In subsequent years more than a quarter of a million men, women, and children were to travel this dusty trail toward South Pass and new homes in Oregon, California or Utah.

Miller's field sketches in watercolor or sepia ink, and his notes on them provide a graphic account of the daily routine of the men of this early wagon train crossing the plains. As the party proceeded through the territory of the warlike Oglala Sioux, its experienced leaders imposed a semimilitary discipline upon their employees. Everyone rose at daybreak. While the cooks prepared breakfast of meat and coffee, others took down the tents, wrapped them and put them in the wagons. After breakfast the horses were driven in, the draft animals harnassed and riding horses saddled, and the long-drawn-out train got quickly under way, with Fitzpatrick, Stewart, and the hunters in the lead.

At noon the caravan halted. The horses and mules were allowed to rest and feed, while the men lunched and most of them napped, leaving a few on guard. Toward the end of the the afternoon, scouts were sent ahead to find a spot for the evening's camp, near water and with good grass for the horses. When the train reached the selected campground, the wagons and charettes were formed in a large circle about five hundred feet in circumference, the horses and mules unhitched and unsaddled. Toward sundown these animals were driven inside the wagon circle and carefully picketed. After supper of meat and coffee the men retired for the night. Generally the teamsters slept under their wagons. Two night guards were posted, one until midnight, the other until dawn.

Miller himself was relieved of all duties except the care of his horse, so that he could move freely and make sketches of any activity that interested him. In the buffalo country he liked to ride out with the hunters who supplied the camp with meat. He became especially fond of Antoine Clement, Captain Stewart's half-breed hunter, who killed about 120 buffalo on the westward journey.

Buffalo hunting was no sport for amateurs. One day Captain Stewart's boastful English cook prevailed upon his boss to let him go hunting alone. He started out early in the morning, but failed to return at night. Next day searchers from the wagon train found him. He had encountered buffalo, but failed to kill any. And on the grassy plains he had become as hopelessly lost as a landlubber adrift in a small boat in mid-ocean. One of Miller's lively sketches depicts this lost greenhorn desperately scanning the plain for some landmark to guide him.

More than 550 miles beyond Westport the party began to pass some of the natural landmarks frequently mentioned in the diaries of later travelers on the Oregon Trail. The first of these was Chimney Rock, a tall, slender column resting upon a conical base and rising about five hundred feet above the level of the river. Miller was the first of more than a score of artists who depicted this landmark prior to 1875. Thirty-five miles upriver Miller drew massive Scott's Bluff, named for a trapper who had died there less than a decade earlier.

Some fifty miles farther west the wagon train halted at Fort William, built by William Sublette on the Laramie River only three years earlier. Miller was the first artist to picture this famous post, and the only one to show it as it was originally built of vertical log palisades, with rectangular bastions at two corners, and a log blockhouse overhanging the main gate. Later better known as Fort Laramie, this remained a busy center for trade with the Cheyenne and Sioux Indians for twelve more years. Then it became a military post for the protection of overland immigrants in the year of the California gold rush.

Fort William (later known as Fort Laramie). Miller. 1837. Watercolor. Joslyn Art Museum, Omaha (overleaf)

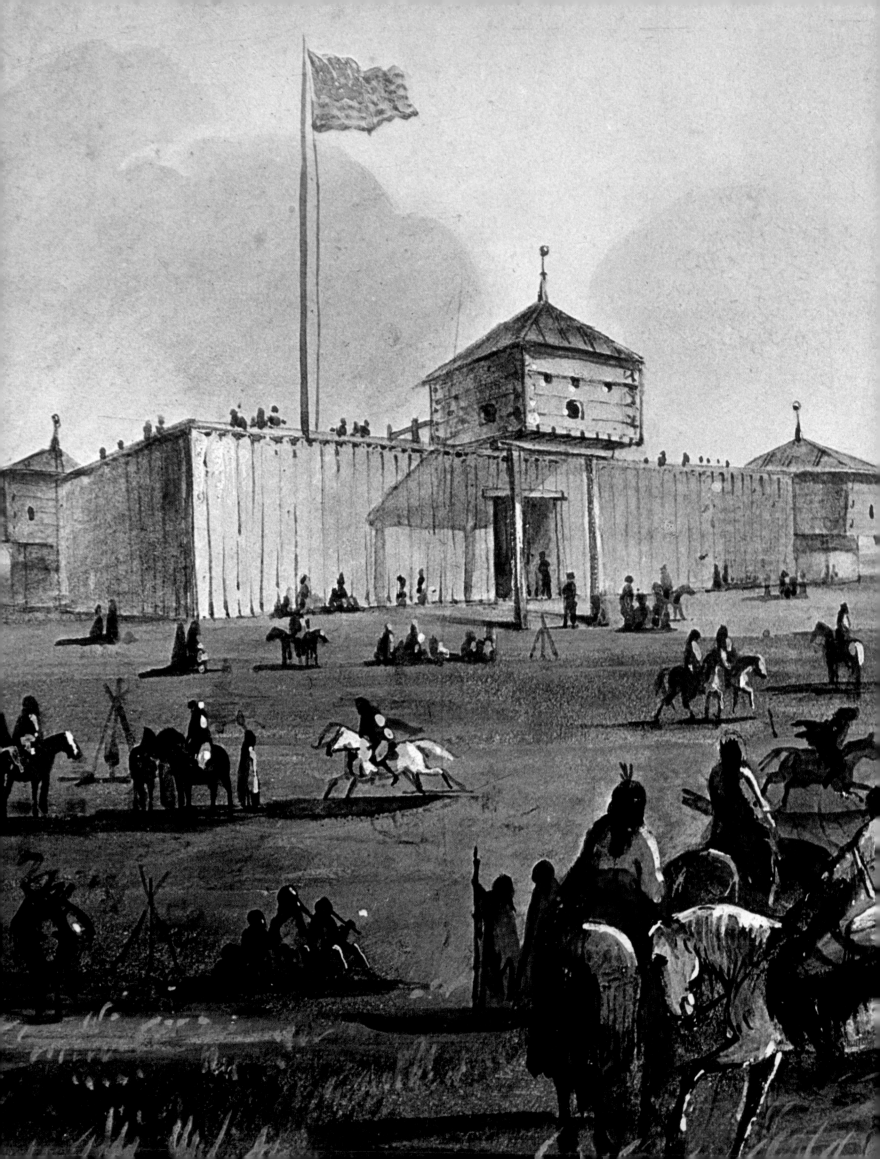

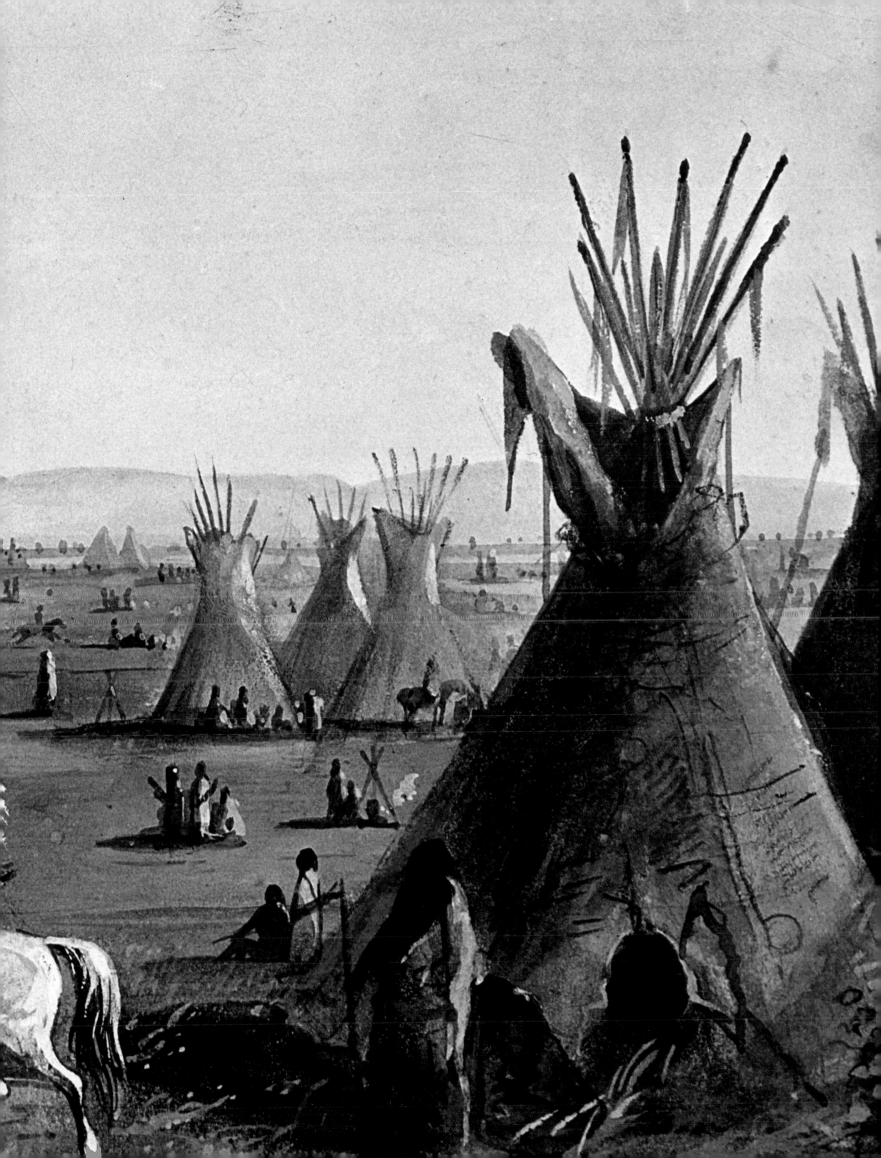

At this man-made oasis on the long trail westward the caravan left supplies and told the isolated traders news of St. Louis and the States. After a day or more of rest, the train moved out again. Nearly 150 miles farther west, it crossed from the valley of the Platte to that of the Sweetwater, and passed Independence Rock, which Miller likened to a huge tortoise sprawling on the prairie. His sketch of this landmark shows antelope running nearby.

Gradually gaining altitude, the wagon train crossed the Continental Divide through the South Pass. This was the easiest of all passages of the Rocky Mountains and was less than 7,500 feet above sea level. A broad valley, gently sloping to the east and west, South Pass bore little resemblance to a narrow mountain pass. One of Miller's sketches, titled *Crossing the Divide*, may show South Pass with the Fitzpatrick-Stewart wagon train vaguely suggested in the distance. It had been only five years since Captain Bonneville had shepherded the first wagons over this pass to a rendezvous of the mountain men.

The thirteenth annual rendezvous of the mountain men and their mountain Indian allies was held that summer in the broad valley of the Green River, some twelve miles south of Horse Creek. As the wagon party approached the site in mid-July they were enthusiastically greeted by many of the trapper fraternity. Soon a large party of Shoshoni Indians came in. Dressed in their finest clothing, mounted on their best horses, and led by their chief Ma-wo-ma, they paraded in honor of their old friend Captain Stewart. Immensely impressed by this show of savage might and finery, Miller recorded it in watercolor.

While encamped for a month at this gathering of some three thousand mountain Indians—Shoshoni, Crow, Bannock, Nez Percé, and Flathead—and several hundred white trappers, Miller made scores of watercolor and sepia sketches of life among the trappers and Indians of the Rockies that are unique in the pictorial record of the West. Miller did not date his sketches, and it is not always possible to determine which of his pictures were based upon his first-hand observations and which he reconstructed from the stories he heard around campfires at night. Surely he never witnessed the battles with and escapes from the dreaded Blackfoot Indians he portrayed in some of his lively sketches, and his pictures of Indians driving buffalo over cliffs differ so markedly from detailed descriptions of Indian buffalo drives that it does not seem possible that he witnessed such an action. Whether or not Miller had an opportunity to see trappers setting their beaver traps in a stream, which was the subject of another of his most popular scenes, is also questionable. However, the notes he took show that he knew how that work was performed. The trap was baited with castoreum from the musk glands of the beaver, hidden under the water, and attached to a pole driven firmly on or near the bank, at a locality where fresh foot prints of beaver in the mud or sand ashore provided "sign" to the trapper that beaver were near.

Nevertheless, many of Miller's Rocky Mountain sketches must have been based upon on-the-spot impressions. Through Captain Stewart he came to know Jim Bridger, Joseph Reddeford Walker, Fitzpatrick, and other famous mountain men, as well as leading Shoshoni chiefs. He witnessed and pictured an Indian council. He took pains to observe the domestic life of the mountain tribes, whom neither Catlin nor Bodmer had visited. And he recorded the friendly relationships between the white trappers and those Indians—their exchanges of conversation through the sign language, their smoking the pipe together in camp, and an Indian girl offering a thirsty trapper a drink from a buffalo horn.

Shoshoni Indian. Miller. 1837. Watercolor. Joslyn Art Museum, Omaha

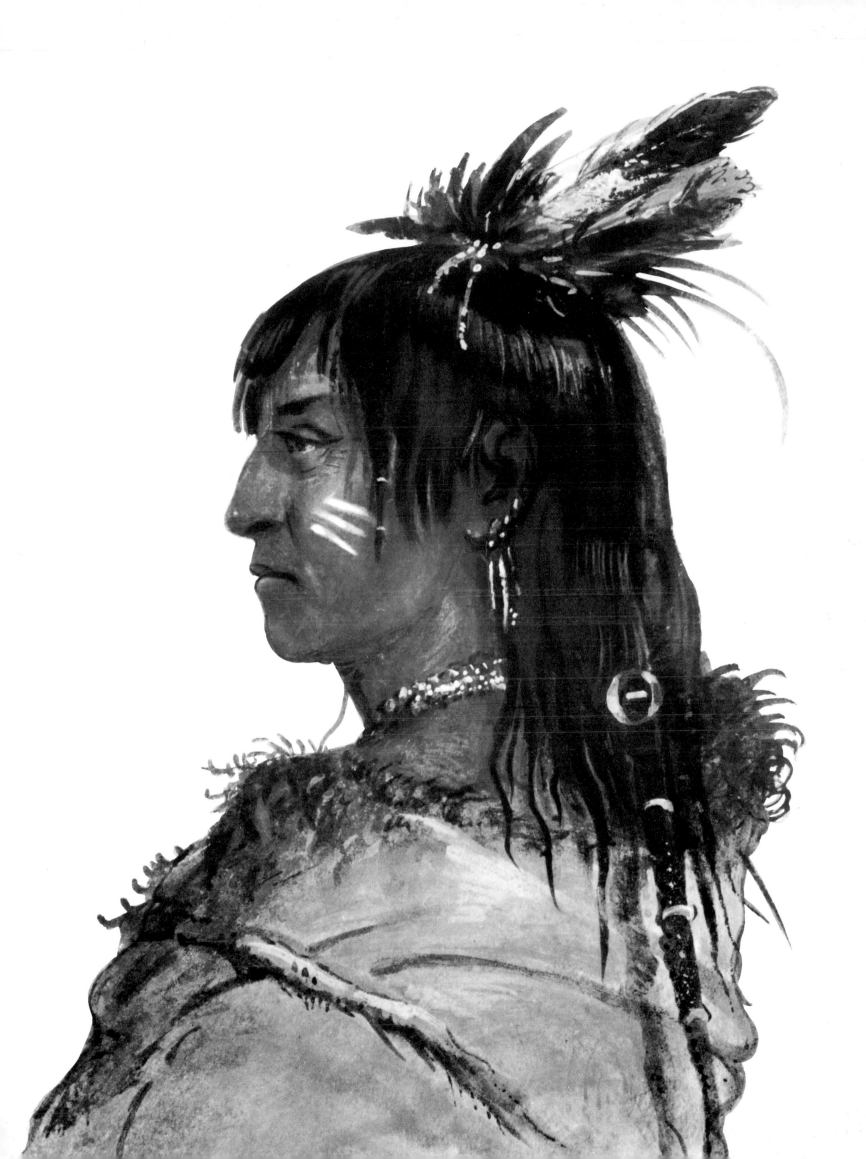

Wind River Mountains. Miller. 1837. Watercolor. Joslyn Art Museum, Omaha (above)

Joseph R. Walker, a Leader among the Mountain Men. Miller. Undated. Oil. Joslyn Art Museum, Omaha (opposite)

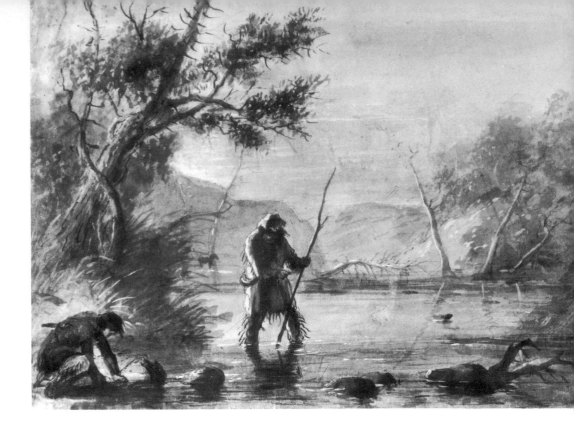

Setting Traps for Beaver. Miller. 1837. Watercolor. Joslyn Art Museum, Omaha (top)

Chasing Wild Horses. Miller. 1837. Sepia. Joslyn Art Museum, Omaha (bottom)

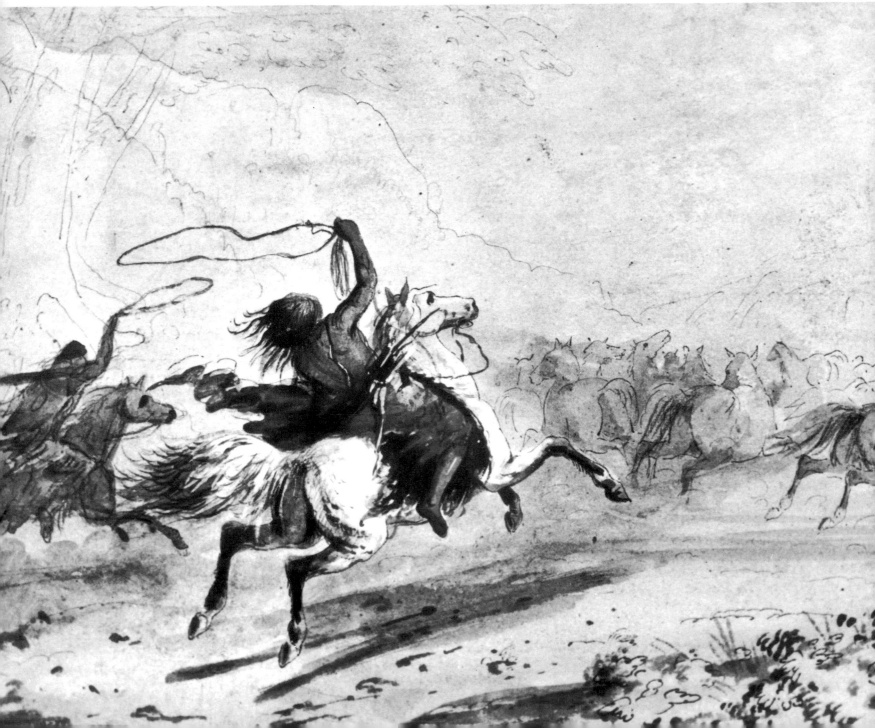

One of Miller's most popular paintings, which he repeated many times in later years, *The Trapper's Bride*, pictured a simple marriage he had witnessed, in which a half-breed trapper bought an attractive Indian girl from her father for some six hundred dollars in trade goods.

When the camp at the rendezvous broke up, Miller accompanied Captain Stewart on a brief hunting trip in the Wind River Mountains. He executed numerous views of rugged wilderness scenery at the heads of the eastern tributaries of the Green River. Miller found the mountain lakes "as fresh and beautiful as if just from the hands of the Creator" and more exciting than any he had seen in Europe. He predicted they would one day attract "a legion of tourists."

One of Miller's most striking mountain views shows snow-capped Fremont's Peak towering 13,730 feet high above long Lake Fremont. Actually the artist saw and painted this scene five years before the "Great Pathfinder" dramatically planted the American flag on the mountain summit and gave it his name. Miller himself could not resist the temptation to gild the lily. Instead of portraying the lake and peak in bright sunlight against a clear blue sky, he insisted on veiling them in the mystery of reds and browns.

By mid-October Miller and Stewart were back in St. Louis, having accompanied the fur company's wagon train eastward from the Rockies. The artist took his field sketches on to New Orleans and there began the laborious task of developing some of them into large oil paintings for his patron. Handicapped by attacks of rheumatism resulting from exposure while he was in the Rockies, Miller worked slowly. During the summer of 1839, he exhibited a group of oil paintings of Western scenes at the Apollo Gallery in New York, where they were well received by the critics and broke attendance records.

Meanwhile, the artist's patron inherited the title Sir William Drummond Stewart and the estate of Murthly Castle in Scotland. For more than a year, beginning in September 1840, Miller served as an artist in residence at Murthly Castle, painting large oil versions of some of the Western subjects that Sir William liked best, such as *The Trapper's Bride*, as well as a small oil depicting Captain Stewart's remarkable coolness when captured by Crow Indians during his first trip to the Rockies in 1833.

In 1842, Miller returned to America. Until his death in 1874, he lived in his native Baltimore, making a comfortable living as a painter of portraits. Although he never returned to the West, Miller followed Catlin's practice of making numerous replicas in oils or watercolors of his most popular Western subjects.

During his historic expedition to the Rocky Mountains in 1837, Alfred Jacob Miller may have executed little more than two hundred sketches. Yet more than six hundred examples of Miller's Western pictures are extant. The largest collection consists of two hundred watercolor duplicates, which Miller executed for William T. Walters from 1858 to 1860. It is in the Walters Art Gallery in Baltimore. When compared with known field sketches, it is evident that the artist made alterations in the works he finished in the studio.

Miller's most important Western portrait is known only in the form of a large oil painting. It portrays Joseph Reddeford Walker, a leader among the mountain men, whom Miller came to know and to respect at the Green River rendezvous in 1837. Perhaps the young artist idealized this Rocky Mountain hero in his rendering of the handsome, sensitive, almost Christ-like head. Miller's Walker does not seem like the type of

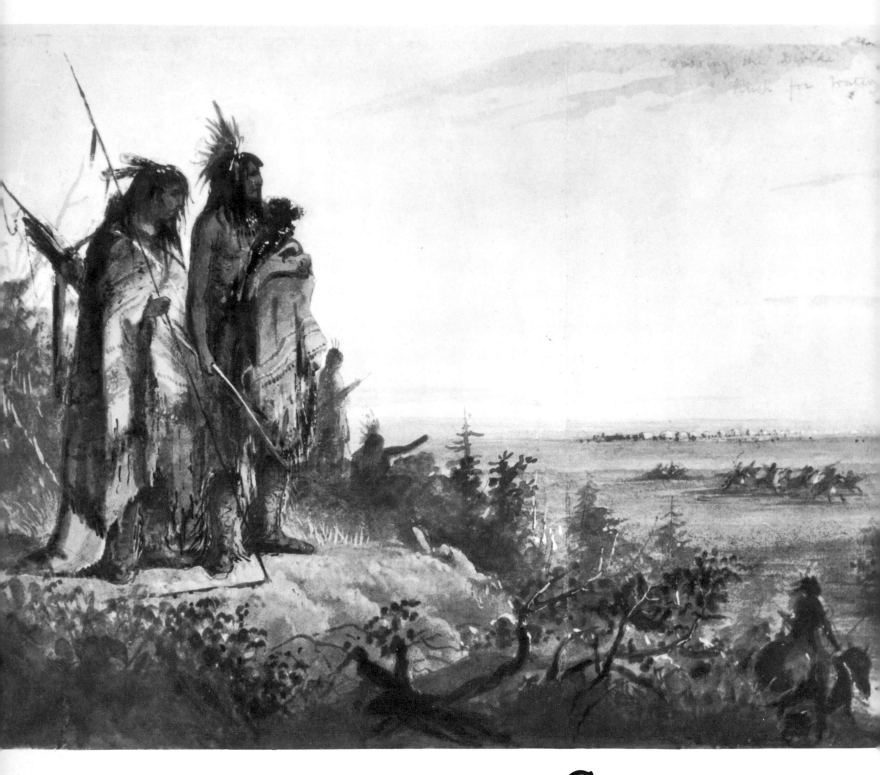

Crossing the Divide.
*Miller. 1837. Watercolor.
Joslyn Art Museum,
Omaha*

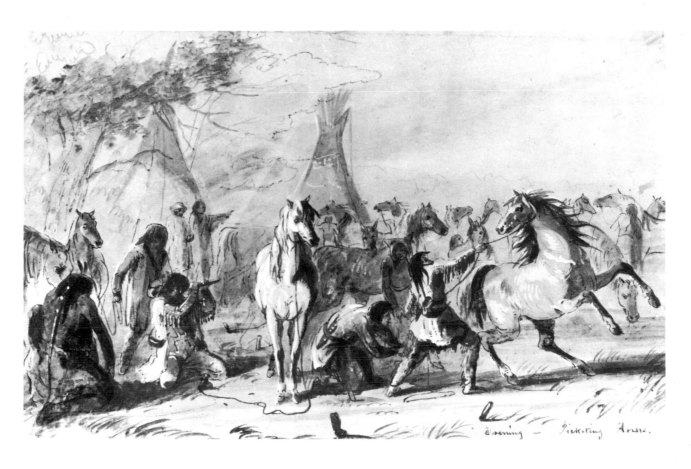

Evening—Picketing Horses. Miller. 1837. Watercolor. Joslyn Art Museum, Omaha

physically and mentally tough man who would have led the first party of American trappers across the hot deserts and over the High Sierras to California and back to the Rockies in 1833–34, killing poorly-armed, impoverished Paiute Indians along the way. Similarly, some of Miller's portraits of Indians are surely idealized.

Miller's oil paintings of scenes in trapper and Indian life appear labored and lifeless when compared with his fresh, vigorous, rapid field sketches of the same subjects in watercolor or sepia. The latter are the work of an artist who was excited by the immediate contact with his subject matter and a master of his media. In them he sacrificed detail to achieve impressive action and expressive feelings about the scenes he saw. Ethnologists decry his failure to define the details of Indian costumes, weapons, utensils, riding gear and other objects as precisely as did Karl Bodmer or Peter Rindisbacher. Miller also possessed little skill in picturing Western wildlife; his bears, for example, being crude caricatures. On his one brief journey into the West he saw the mountains, the mountain men, and the Indians through the eyes of a city-bred romanticist.

Nevertheless, he was the first artist to travel the historic Oregon Trail and the only one to know the Rocky Mountains during the brief reign of the mountain man, and many of his works are not only unique in their subject matter but leave a powerful and lasting impression. Were it not for Alfred Jacob Miller's vivid pictures, the significance of the Rocky Mountain fur trade in the development of the West would be much more difficult for us to visualize. As explorers, trappers, and Indian traders, the rough mountain men represented the first wave of white expansion into the Rocky Mountain region.

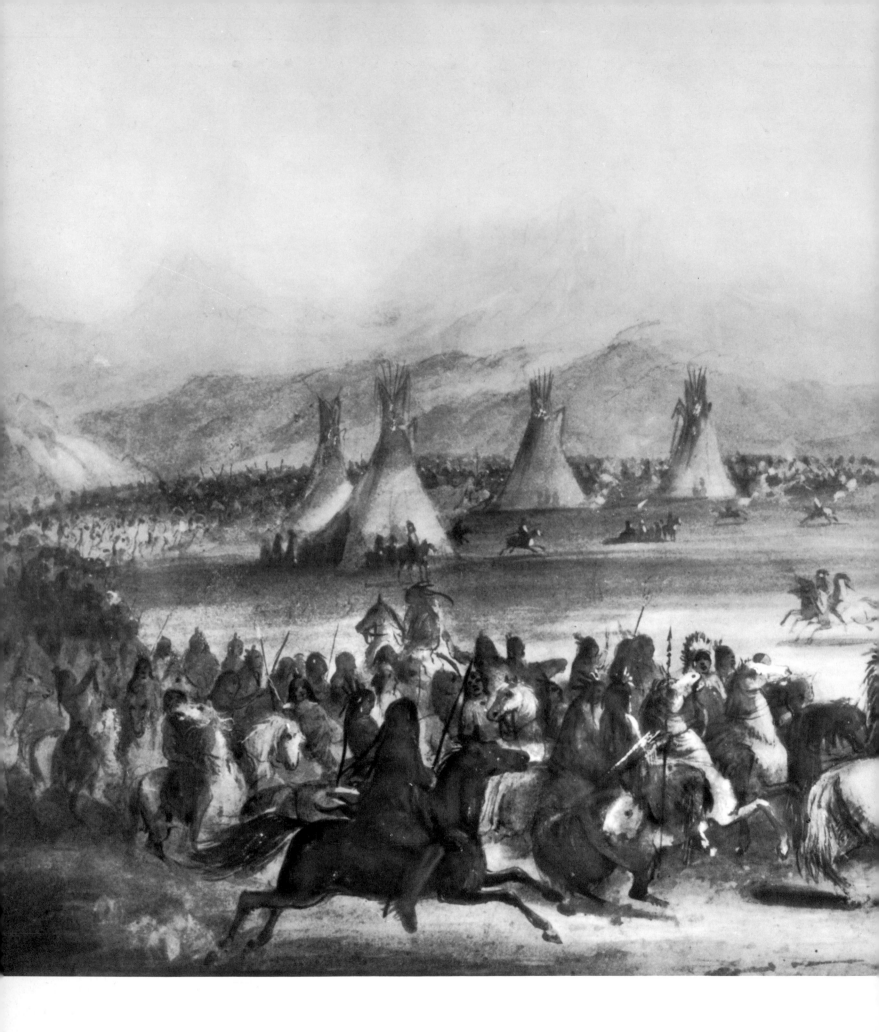

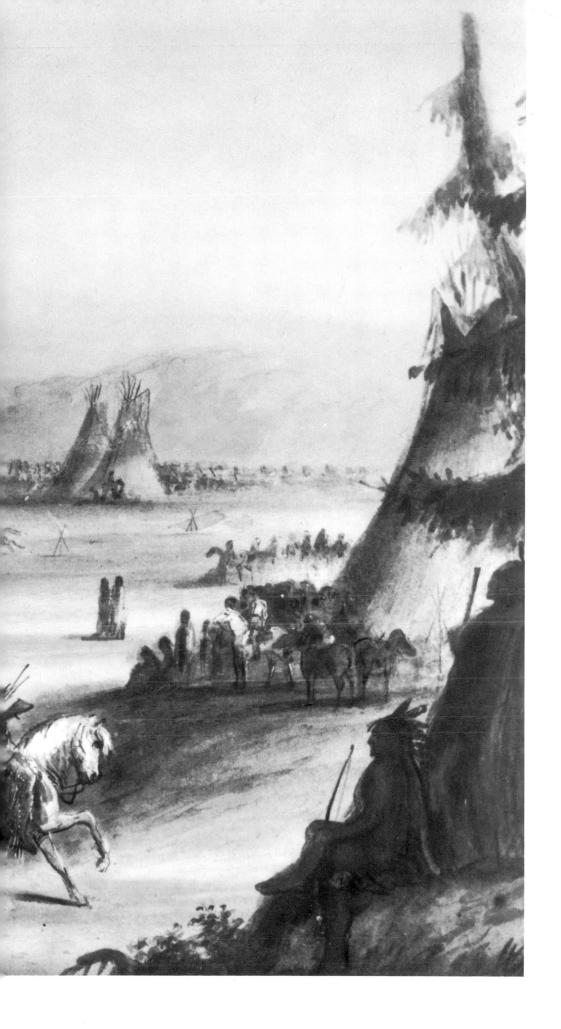

Shoshoni Indian Procession at the Trappers' Rendezvous on Green River. Miller. 1837. Watercolor. Gilcrease Institute of American History and Art, Tulsa

AMONG THE FUR TRADERS AT THE MOUTH OF THE YELLOWSTONE

Rudolph Friederich Kurz

James Kipp, Trader in Charge of Fort Berthold. Kurz. July 15, 1851. Pencil. Historical Museum, Berne (right)

Californians. Council Bluff. Kurz. May 18, 1851. Pencil. Historical Museum, Berne (left)

In his *Observations and Reflections on Upper Louisiana* (1809), Meriwether Lewis not only forecast a bright future for the American fur trade on the Upper Missouri, but he pointed to the mouth of the Yellowstone River as a likely site for an important trading post. In this the explorer proved himself a wise prophet. Fort Union, built by the American Fur Company near the mouth of the Yellowstone in 1828, was for three decades the largest, handsomest, and busiest trading post on the Missouri. In the middle of the nineteenth century it was still the most populous outpost of the white man's civilization in the vast Upper Missouri country.

George Catlin and Karl Bodmer visited Fort Union in the early 1830's. John James Audubon, noted artist-naturalist, spent two months there in the summer of 1843. But no other artist knew Fort Union, its resident traders and its Indian customers as well as did a young Swiss, who worked there as a clerk during the winter of 1851–52.

Rudolph Friederich Kurz was born in Berne, on January 8, 1818. In the journal of his travels in America he recalled: "From my earliest youth primeval forest and Indians had an indescribable charm for me. In spare hours I read only those books that included descriptions and adventures of the new world." When he chose art for a career Kurz determined to devote his talents to "the portrayal of the aboriginal forests, the wild animals that inhabited them, and the Indians."

Impatient to visit the land of his dreams, Kurz would have set out for America in 1839 had not his friend Karl Bodmer advised him to continue his studies of drawing and painting until he could record "the prominent characteristics of an object" with a few swift strokes of his pencil or brush. For three years Kurz studied in Paris. During the first eight months he worked steadily from seven in the morning until ten at night, resting only on Sundays. At the end of that time he was so discouraged with his progress that he tied a stone to his collection of studies and threw it into the Seine.

But this moody perfectionist persevered until he was satisfied that he was artistically prepared for his great adventure. In the autumn of 1846, Kurz embarked from Le Havre, planning to go to Mexico to sketch wild Comanche Indians. But when he reached New Orleans he found that the war between the United States and Mexico would prevent him from traveling farther west. So Kurz turned northward and spent the next year in the Mississippi Valley between New Orleans and Galena, Illinois, only rarely finding opportunities to draw Indians.

Kurz wintered in St. Louis, and in the spring of 1848 journeyed up the Missouri as far as the new town of St. Joseph. For three years he lived in that vicinity, drawing numerous pencil sketches of nearby Indians—Kickapoo, Potawatomi, Iowa, Osage, Oto, and Pawnee. He even married a fourteen-year-old Iowa girl after the Indian fashion; but she left him in less than a week.

Although St. Joseph was the point where wagon trains and smaller parties formed to make the long journey across the plains to the Mormon settlements in Utah and the California gold fields, Kurz showed little interest in their activities until the spring of 1851. Then, for a time, he was tempted into following the trail westward to Great Salt Lake. At that time he sketched a small group of rough, California-bound adventurers with their pack animals near Council Bluff. However, Kurz was in need of money to finance his field studies. So he seized an opportunity to ascend the Missouri on the packet boat *Saint Ange* hoping to find a job at one of the American Fur Company's upriver trading posts.

Hidatsa Indians Sweat-Bathing during the Cholera Plague at Fort Berthold. Kurz. August 19, 1851. Pencil. Historical Museum, Berne (below)

Horseguard at Fort Berthold. Kurz. August 1851. Pen and ink. Historical Museum, Berne (right)

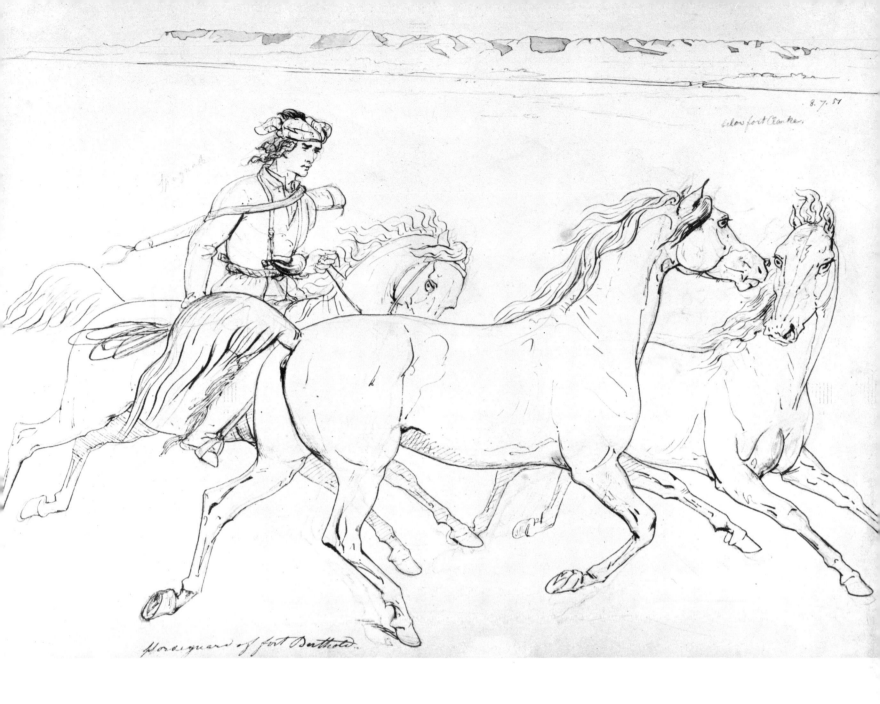

Horse-guard of Fort Berthold.

In the nearly two decades after Catlin and Bodmer had pictured the Indian tribes of the Upper Missouri, no white women and few white men other than fur traders had ascended that river. During the interval, the Mandans, whom those early artists had considered the most remarkable tribe on the river, had been decimated by smallpox. Kurz found a pitiful remnant of this once prosperous tribe, which formerly had conducted picturesque ceremonies in two sizable villages, occupying but seven earthlodges above Fort Clark. Together with members of their tribe living among the Hidatsa, the Mandan numbered only about 150 persons in 1851.

Their old neighbors the Hidatsa also had been greatly reduced by the ravages of the smallpox in 1837. They had moved upriver and built a village called Like-a-Fishhook, containing some eighty earth-covered lodges, below the mouth of the Little Missouri. The American Fur Company had established a small post, Fort Berthold, near this Hidatsa village. When the steamer reached Fort Berthold on July 9th, Kurz went ashore. He was welcomed by James Kipp, a veteran of nearly thirty years in the Indian trade of the Upper Missouri; he had founded and managed

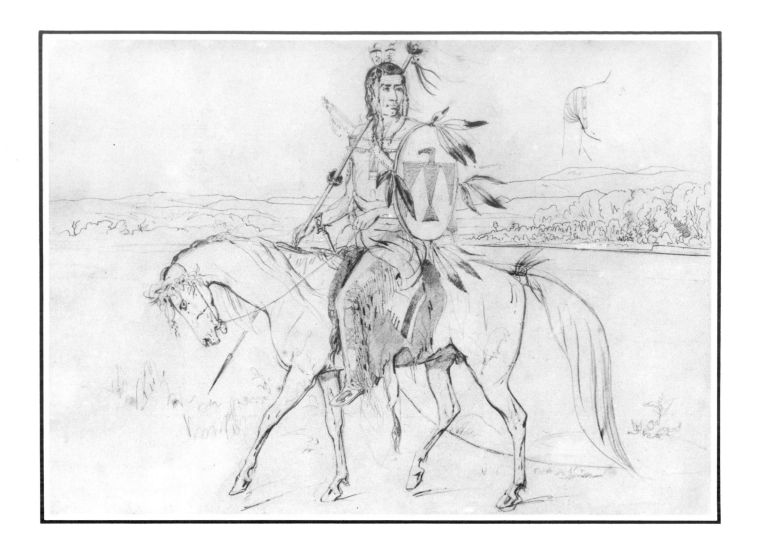

various important posts before his fondness for drink had relegated him to the management of this minor one. To the artist's delight Kipp offered him a position as clerk and set him to work compiling a dictionary of the Mandan language following Kipp's fluent pronunciation. There were swarms,of fierce mosquitos and a host of bedbugs in his small, dimly-lit quarters, but Kurz threw his buffalo robe on the floor, slept on it, and confided to his journal: "How fortunate I am placed! What favorable opportunities for studying the Indians!"

The artist's good fortune was short-lived. Soon after his arrival at Fort Berthold, cholera broke out among the Hidatsa. The superstitious Indians, recalling the smallpox epidemic that had followed Catlin's and Bodmer's picture-making among them, began to look upon Kurz's drawings as "bad medicine" bringing pestilence and death to the red men who posed for him. By mid-August so many Indians had protested his work that Kipp ordered Kurz to put his drawings away and to allow no Indians to see them. Shortly thereafter most of the able-bodied Hidatsa abandoned their village, leaving only their aged and sick near the fort. Surreptitiously Kurz sketched these unfortunate sufferers trying to cure their high fevers by taking sweatbaths in willow-framed, buffalo robe-covered sudatories outside the fort.

Deprived of his Indian subjects, Kurz turned to sketching the common activities of white employees at Fort Berthold. In a country where

Crow Warrior on Horseback. Kurz. October 26, 1851. Pen and ink. Historical Museum, Berne

Indians prided themselves on their cleverness as horse thieves, the horses belonging to trading posts had to be constantly guarded. One lively pencil sketch by Kurz depicts the horse guard at Fort Berthold exercising the horses in his care. Another drawing portrays a small party returning from a hunt, their pack animals loaded with fresh buffalo meat, the major item in the diet of both Indians and whites in the Upper Missouri country.

By the end of August alarming reports of Hidatsa losses from cholera —more than fifty Indians had died—reached Fort Berthold. Some of the survivors were angry with Kurz for still living at the fort, and he had good reason to fear for his life. So when Kipp proposed that Kurz move on to Fort Union, 170 miles to the northwest, in company with Bellangé, a French-Canadian, who was to bring back medicines from that larger post, the artist willingly consented.

So on September 1, 1851, Kurz and Bellangé left Fort Berthold. They were mounted on the poorest horses from the post, and carried loaded, double-barreled guns across their saddles and scalping knives in their belts. Kurz reveled in the prospect of adventure: "Constant danger from lurking enemies, the vast prairie, bounded only by sky and sea; buffaloes and bears in prospect; perhaps a violent storm by way of variety; fine health and tense anticipation—what more could I desire?" Four days of hard riding brought the two travelers to Fort Union, three miles above the mouth of the Yellowstone.

Fort Union was the key point in the American Fur Company's control of the Indian trade of the Upper Missouri. There the Assiniboines, Plains Crees, River Crows, and some Chippewa Indians traded. From Fort Union trade goods and supplies were dispatched to upriver posts— Fort Benton among the Blackfeet at the mouth of the Marias, and Fort Alexander in the Crow Country of the Middle Yellowstone Valley. To Fort Union each spring, from these distant posts, came bales of furs and buffalo robes for reshipment downriver to St. Louis.

For a wilderness trading post, Fort Union was a complex and substantial structure. Rectangular in outline, it extended 220 feet along the river front and 240 feet back onto the prairie. Its main gate was only twenty-five steps from the Missouri River. Enclosing the rectangle were strong, hewn-cottonwood palisades, twenty feet high and fitted into heavy beams resting upon a limestone foundation. At the two opposite corners were twenty-four-feet-square bastions rising to a height of thirty feet. Their stone walls were three feet thick and were whitewashed on the outside. Loaded cannon and ample firearms were kept in these bastions. The fort was deemed virtually impregnable.

The most imposing structure within the palisades was a seventy-eight-foot, two-story wooden building across the parade ground from the main gate. Visitors from civilization were surprised to find this fine building with its picket fence, high front porch, red-painted shingle roof, boarded white sides, and green shutters in the heart of the Indian country. Here the bourgeois, or post manager, Edwin T. Denig, son of a Pennsylvania physician, lived with his two Indian wives and mixed-blood children. Here also was the post's business office, and the mess hall where the manager, clerks and visitors ate at one table, the engagés, or common laborers, at the second one.

A long, single-story building extending to the west side of the parade ground housed the other employees of the fort. A similar structure on the east side of the central space contained the store in which merchandise was sold to company employees and visiting whites, the warehouse

for Indian trade articles, and the storeroom for the robes, furs and peltries received from the Indians. The latter room was large enough to store thirty-thousand buffalo robes.

Behind these three major buildings were cooper's shops, a henhouse, milk house, kitchen, and stables for as many as fifty horses. Inside and west of the main gate was a building that served in part as a blacksmith, gunsmith and tinner's shop, and in part as a reception room for Indians coming to trade. This room was decorated with colorful Indian artifacts, stuffed birds and wild animals, some of which served as models for Kurz to sketch.

Denig, the post manager, a man of many talents, had worked his way up during eighteen years' able service in the Upper Missouri fur trade. He was a keen observer of Indian customs and was becoming the most able and prolific writer on the Indian tribes of the region. As a practical business man, he managed his crew of fifty men with a firm hand that would have been the envy of his seafaring Danish ancestors. His crew included Americans, Canadians, Frenchmen, Scotsmen, Germans, Swiss, Italians, Creoles, Spaniards, Negroes, mulattoes, and half-Indians. They were clerks, interpreters, hunters, artisans, and common laborers. Most of the laborers, who worked for one hundred dollars a year, were rascally braggarts who were neither industrious nor skilled. When they neglected their work, Denig cut down on their food. When they worked hard, he rewarded them with such diversions as balls, in which the men danced with gayly dressed Indian women while Denig himself played the fiddle. When his men suffered accidents or were injured in their not infrequent brawls, he patched up their wounds.

Denig assigned Kurz a room of his own near that of Charles Morgan, a well-educated Scot who was labor foreman at the post. And Denig lost no time putting Kurz to work earning his meals and lodging. With shaving brushes, the only kind available, Kurz painted the picket fence, the exterior of the main building, the reception room, and the sideboard in the mess hall. Then Denig kept him busy at tasks which offered a greater challenge to his talents—painting from a medal a likeness of Pierre Chouteau, Jr., head of the company in St. Louis, on the gable over the gallery of the house; painting life-size eagles on cotton cloth to

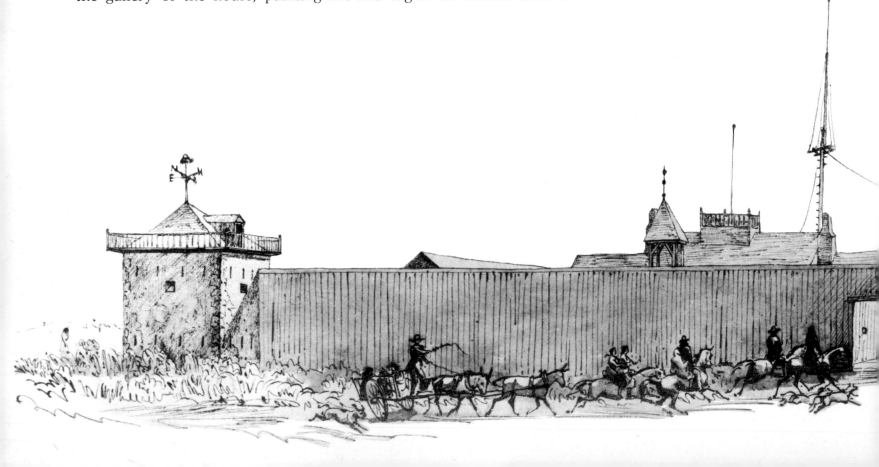

An Engagé at Fort Union. Kurz. 1851–52. Pen and ink. Historical Museum, Berne (opposite)

Interior of Fort Union Looking toward Main Building. Kurz. February 4, 1852. Pen and ink. Historical Museum, Berne (below)

Fort Union at the Mouth of the Yellowstone. Kurz. 1851–52. Pen and ink. Historical Museum, Berne (bottom)

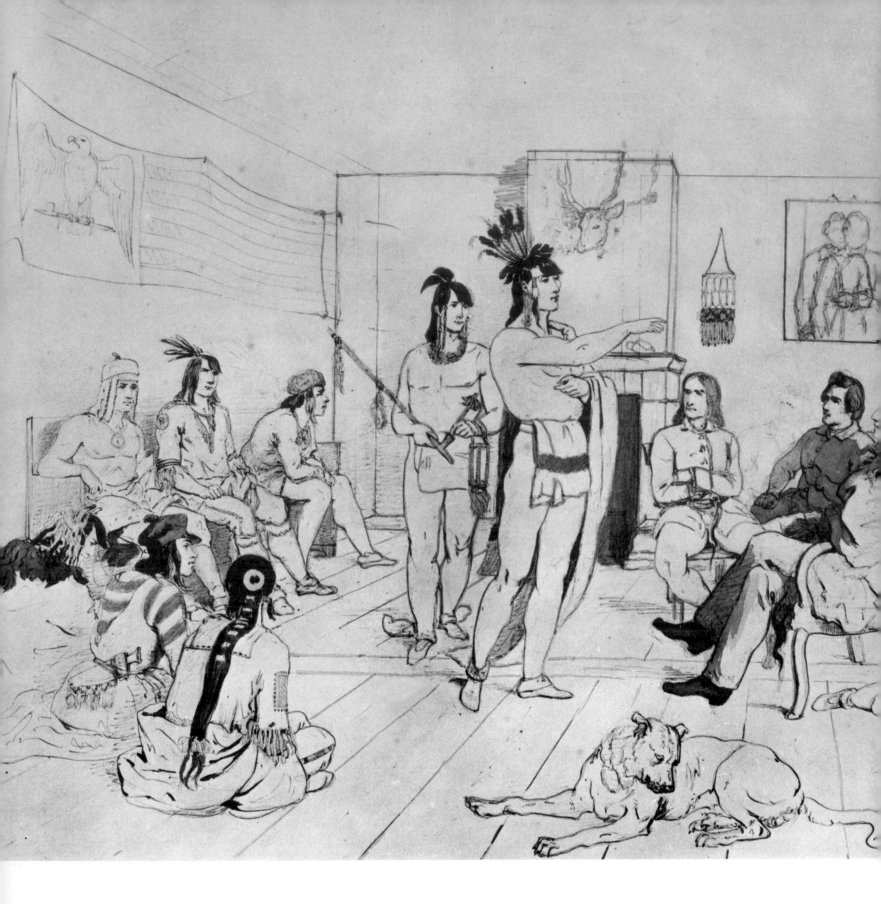

Cree Indian Council with Trader Denig at Fort Union. Kurz. October 19, 1851. Pen and ink. Gilcrease Institute of American History and Art, Tulsa

which red and white stripes were added to make flags for trade with prominent Indians (for twenty buffalo robes each); and painting a knee-length portrait of Denig to hang in the office where it would impress visiting Indian chiefs.

On October 19th, Denig invited Kurz to attend a council in the office with the Cree chief, Le Tout Pique, and some of his followers, who came to the fort to smoke with Denig and to bargain for the trade of his band of more than fifty lodges. A drawing by Kurz of this meeting shows the chief standing and addressing the bearded Denig, while Kurz, himself, sits in the chair between Denig and the interpreter, Battiste. On the bench at the left and on the wooden floor sit the men and women who accompanied Le Tout Pique to the fort. The picture also shows the office furnishings, including one of the Swiss artist's recently completed trade flags and his portrait of Denig.

Happy to be usefully employed, Kurz viewed his move to Fort Union as "the most fortunate event of my life in this country." When Alexander Culbertson, supervisor of all company trading posts on the Upper Missouri, returned from Fort Laramie, where he had helped the United States to conclude a very important treaty with the Indian tribes along the route of the Oregon Trail, he was so pleased with the artist's likeness of his friend Denig that he had Kurz paint his portrait also. Kurz would have painted Culbertson's beautiful Blood Indian wife as well, had she not cut her long black hair in mourning the death of one of her brothers in battle.

Before he left Fort Union, Culbertson agreed to the employment of Kurz as a clerk. "Am now an employee not a visitor," the artist wrote in his journal on November 2. A clerk drew a salary of eight hundred dollars a year. Kurz recognized that if he was to save money he "must be content with the fare at the fort, indulge in no dainties or feasting, and never allow myself to come within ten feet of the Indian women," whose demands of their white lovers for fine clothes and ornaments kept many a fur trader broke.

In his new job Kurz was responsible for keeping a record of the merchandise on hand and for its issuance to employees and to Indians. At that time Fort Union, far beyond the frontier of white settlement, played a role, however small, in world trade. Its stock of Indian trade goods included metal bells and mirrors from Leipzig, clay pipes from Cologne, French calicos, English woolen blankets and guns, sugar and coffee from Latin America, and powder and shot from the Mississippi Valley. Kurz also performed such menial tasks as cutting the tongues from buffalo heads and packing those delicacies in casks, opening the main gates to the fort, and firing the cannon in salute to approaching bands of Indians bringing robes and furs to trade.

Of all the tribes who traded at Fort Union, the Crows from the Yellowstone Valley were the most remarkable. Many families among this wealthiest tribe of the Upper Missouri owned more than fifty horses. Their tipis were the largest and best made. Kurz noted that their men were the proudest and handsomest; their women the best-dressed and most skillful craftsworkers. Unlike neighboring tribes, the Crows were teetotalers who exchanged their expertly-dressed buffalo robes only for substantial goods.

Parties of River Crows visited Fort Union repeatedly during the winter of 1851–52. Kurz drew a haughty Crow warrior, probably the head chief, Rottentail, astride his favorite horse and carrying his painted

127

Four Rivers, a Young
Crow Chief. Kurz. November 25, 1851. Pencil. Historical Museum, Berne
(above)

Cree Woman Wearing
Old-Style Dress. Kurz.
1851–52. Pen and ink.
Historical Museum, Berne
(top right)

Crow Woman in Dress
Decorated with Elk Teeth.
Kurz. 1851–52. Pen and
ink. Historical Museum,
Berne (bottom right)

shield and weapons. A young Crow chief, Four Rivers, who slept in Kurz's room when the fort was crowded with prominent Indians, also sat for his portrait. Kurz drew young Crow braves in handsomely beaded costumes, and pictured the wife of a wealthy Crow wearing the most expensive type of dress known to the region. Its upper portion was lavishly decorated with pendant incisor teeth of elk. A woman's garment of finely-dressed bighorn skin ornamented with three hundred elk teeth was worth twenty-five buffalo robes. An entire ensemble exceeded in money value a year's wages of one of the common laborers at the fort.

The Assiniboines and Crees from north of the Missouri who traded at Fort Union were poor in horses. They did much of their hunting on foot and transported most of their meagre camp equipment by dog power. Kurz sketched members of these less richly clothed tribes when they came to trade a few buffalo robes at the fort. One of his drawings depicts a Cree woman wearing a skin dress supported by narrow skin straps over her shoulders, a simple garment which probably was the aboriginal dress among the women of the region. It was worth at most a single buffalo robe.

One of the most frequent Indian visitors to Fort Union that winter was Ours Fou (Crazy Bear), chief of the Little Girls Band of the Assiniboines, whom the government had chosen head chief of the entire tribe at the council near Fort Laramie. This able chief had been spoiled by the lavish gifts and attentions he had received there, and seemed to think that all Americans should support him liberally, whether or not he had robes to trade. For a time Ours Fou lived in the artist's quarters, and Kurz executed several pencil portraits of him.

As the winter wore on Kurz came to devote a great part of his free time to sketching the wild animals of the region and the domesticated ones at the fort. Two of these drawings are especially noteworthy. One illustrates the transport commonly employed by horse-poor Indians of the northern plains—the dog travois and skin packs, one of which was suspended from each side of the dog's back to balance the load. His drawing of a saddled Blackfoot Indian pony may be the most faithful representation of the Indian pony executed by any artist. This typically heavy-headed, big-bellied, small-limbed little horse was no handsome beast, especially in winter when its hair was shaggy. But it was tough, long-winded and smart. Fed on cottonwood bark and whatever grass it could rustle, it survived northern winters that killed the best bred, grain-fed, larger horses. Young men favored the hair-stuffed pad saddle, such as Kurz showed on this pony, for both hunting and warfare.

As spring approached, the artist's supplies of drawing materials ran out and the demands of his clerk's work became more and more oppressive to him. On April 13th, he hoped that he would "soon be delivered from this place." Six days later he bade his friends farewell and boarded a small keelboat for the first leg of his long journey homeward. He was convinced that "my studies in this country are now completed. From this time forward my thoughts are to be concentrated upon the painting of pictures. One half of my work accomplished at middle life and at the expense of my health."

Kurz reached home in Berne in September 1852, after an absence of six years. He died there nineteen years later without realizing his ambition to transform his field sketches into a series of paintings of the landscapes, wild animals, and especially the peoples of the Upper Missouri. A prolonged illness, and inability to select subjects and combine them into harmonious compositions, and the need to make a living all

Saddled Blackfoot
Indian Pony at Fort Union.
Kurz. 1851–52. Pen and
ink. Historical Museum,
Berne (top)

Transporting Belongings
by Dog Travois and Packs.
Kurz. 1851–52. Pen and
ink. Historical Museum,
Berne (bottom)

militated against the attainment of his goal. The few watercolors he produced in Europe appear to be romantically unreal compared with his own pencil and pen-and-ink field sketches. From 1855 on he was master of design at the cantonal school in Berne.

The primary contribution of Rudolph Friederich Kurz to the pictorial history of the West is found in the hundreds of small pencil and pen-and-ink drawings that he made from life on the Upper Missouri. They are preserved in the crowded pages of his field sketch book in the historical museum in Berne, and in separate drawings in the Gilcrease Institute in Tulsa. These deftly-drawn, realistic studies comprise a unique and well-documented pictorial record of life among the traders and their Indian customers on the Upper Missouri in the mid-nineteenth century. That was fully a decade before settlers began to pass Fort Union on their way to the newly discovered Montana gold fields at the eastern base of the Rockies. It was fifteen years before the traders abandoned stout old Fort Union.

131

LIFE ON THE MISSOURI FRONTIER

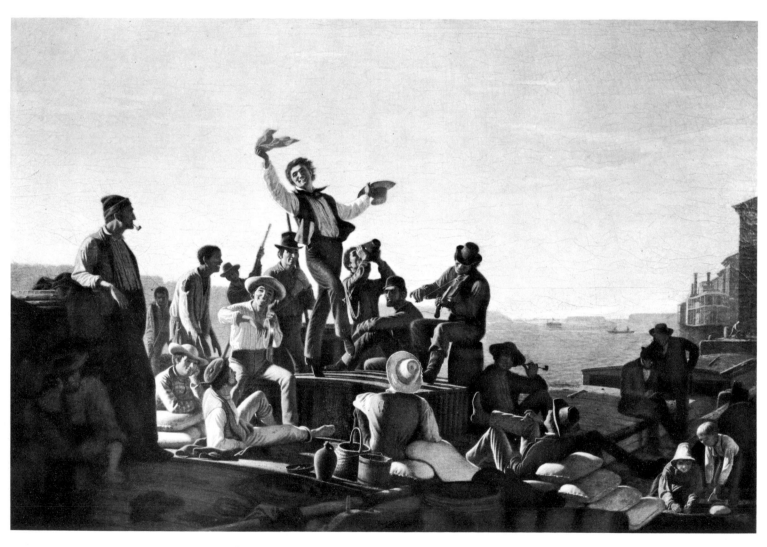

George Caleb Bingham

When the men of the Long Expedition ascended the Missouri during the summer of 1819, they found white settlements bordering the lower course of the river on lands which but a few years before had been Indian country. Two hundred and five miles above the river's mouth, they visited the new town of Franklin on the north bank. Seat of the land office and business center in the Boone's Lick region, Franklin then boasted a population of 1,000. It had thirteen stores, four taverns, a two-story log prison, a post office, and a weekly newspaper, even though the majority of its homes were single-story log cabins. Most of the Boone's Lick settlers came from the south, and they found the soil in their new homeland more fertile than the best lands in Kentucky.

Among the new settlers who reached Franklin during that year was the family of Henry Bingham, a tobacco farmer from Virginia who had lost his farmland as surety on a friend's note. The elder Bingham opened a "house of entertainment" in Franklin and also re-entered the tobacco business. He died in 1823, leaving his widow Mary and six children. The family moved to a farm three miles from Arrow Rock, where Mary Bingham, with the aid of a collection of books, sought to educate her own and other children.

One of the Bingham children was George Caleb. Born March 29, 1811, on a farm on the South River in the Blue Ridge Mountains, he was only eight years old when his family moved westward. Farm life held little appeal for him and, when he was about sixteen, his mother apprenticed him to a cabinetmaker in Booneville on the Missouri. Little is known of the process by which this teen-aged worker in wood was transformed into a promising painter of portraits by his twenty-third year. Legend has it that he was inspired and possibly instructed by an itinerant portraitist. But there is no confirmation of this story. Rather he appears to have been self-taught, with the guidance of such art instruction books and reproductions of the works of Sully and other famous portraitists as he could borrow or acquire.

By 1834 he had executed portraits of several prominent citizens in Columbia and Arrow Rock, which prompted the local paper to compare his works with the best of George Catlin's portraits and to proclaim him a "meteor of the art." The following spring, "G.C. Bingham, Portrait Painter" invited the people of St. Louis to avail themselves of his services. In St. Louis he saw paintings by such other artists as Rindisbacher and Catlin. He also copied for sale some buffalo hunting scenes from originals which may have been by Rindisbacher or Catlin or both.

Within the next two years Bingham married a Missouri girl and built a home at Arrow Rock. He did not want for sitters in his home state. But he knew that if he was to perfect his art he needed further study and broader knowledge of the works of the best artists. In 1838 Bingham spent several months in Philadelphia and New York drawing from casts and models and viewing examples of the best works by eastern painters. That fall he exhibited *Western Boatmen Ashore*—probably his first genre painting—at the Apollo Gallery in New York. This painting, now lost, roused little interest at the time, and Bingham remained primarily a portraitist and a painter of political banners until 1845.

It is not certain what factors led Bingham to concentrate upon genre painting during the middle years of the century. Possibly the popularity of the new daguerreotype turned his attention away from portraiture. Or perhaps he realized that he could make a unique contribution by portraying some of the familiar scenes of his youth on the Missouri frontier. The boatman's life had fascinated farm boys living on shore who

The Jolly Flatboatmen in Port. Bingham. 1857. Oil. St. Louis Art Museum

133

saw these river men ascending and descending the great river and spending their leisure time ashore. What stirring adventures these men must have had in the far-off Indian country! And what fun they had in port!

Bingham's *Fur Traders Descending the Missouri* (1845) portrays a not uncommon scene—a gaunt free trapper and his son or young companion calmly floating down the river in a small pirogue, with a bear cub chained in the bow and a cargo of a few bales of precious furs. The artist's detailed rendering of the two adventurers and their boat contrasts sharply with the river haze that blurs the distant, tree-lined shore. In this picture Bingham demonstrated that at the age of thirty-four he had achieved maturity as an artist, both as a draftsmen and as a painter who could solve difficult problems of light and atmosphere.

This was the first of a series of paintings that Bingham created over a period of twelve years and that established his reputation as the master painter of the boatmen on western waters. Among the best known of these works are *Raftmen Playing Cards* (1847), *The Wood Boat* (1850), and *The Jolly Flatboatmen in Port* (1857). Most popular was *The Jolly Flatboatmen*, purchased by the Art-Union in 1846 for $290. More ambitious in composition and more lively in action than *Fur Traders Descending the Missouri*, this painting was a deliberate grouping of several carefully rendered individual boatmen: an animated dancer snapping his upraised fingers, flanked by two lively music-makers, a fiddler tapping his foot and a boy beating time on a metal pan or skillet. They are pictured amidst a larger number of relaxed onlookers, atop a flatboat in mid-river. The Art-Union selected this happy and immensely appealing scene as one of the two pictures to be engraved and distributed to its subscribers in 1847. Thus 18,000 prints of this painting were seen and enjoyed by thousands of people who never saw a Bingham original. They greatly enhanced the Missouri artist's reputation far beyond the borders of his home state.

Meanwhile Missourians praised the truthfulness of Bingham's interpretations of "their" colorful rivermen. In 1847 the *Missouri Republican* of St. Louis commented, "To look at any of his pictures is but to place yourself on board one of the many crafts which float upon our streams."

During his most active years as a genre painter, Bingham also portrayed other figures of the Missouri frontier. In the mid-1840's, some years after hostile Indians had ceased to threaten white settlements in Missouri, he painted two canvases which harked back to the earlier period of the Indian Wars in this region. Doubtless Bingham had heard stirring accounts of Indian attacks and captures from the lips of men and women who had experienced them, and his paintings seem to perpetuate the old settlers' view of the Indian as a treacherous and inscrutable enemy. The artist's *The Concealed Enemy* (1845) is much less interesting than his *Captured by Indians* (1848), which achieves a tensely dramatic effect by placing five static human figures in semi-darkness, lighted only by a flickering campfire. The heroic white woman occupies the center of the canvas. Her little boy has fallen asleep with his head in her lap, and two of their three Indian captors have dozed off. The artist lets the viewer speculate on the fate of the captives. Women rarely appeared in Bingham's genre paintings, and perhaps this is his tribute to the courageous women of the frontier.

In *The Squatters* (1850) Bingham portrayed other frontier figures who had already passed into history. His family of poor squatters outside its small log cabin symbolizes a restless element of the early migrations. These were people who occupied remote parts of the Public Do-

*S*tudy for Fiddler in "The Jolly Flatboatmen in Port." Bingham. 1857 or ante. Pencil. St. Louis Mercantile Library Association, St. Louis, Missouri

*C*anvassing for a Vote. Bingham. 1852. Oil. Nelson Gallery–Atkins Museum, Kansas City, Missouri (Nelson Fund) (overleaf)

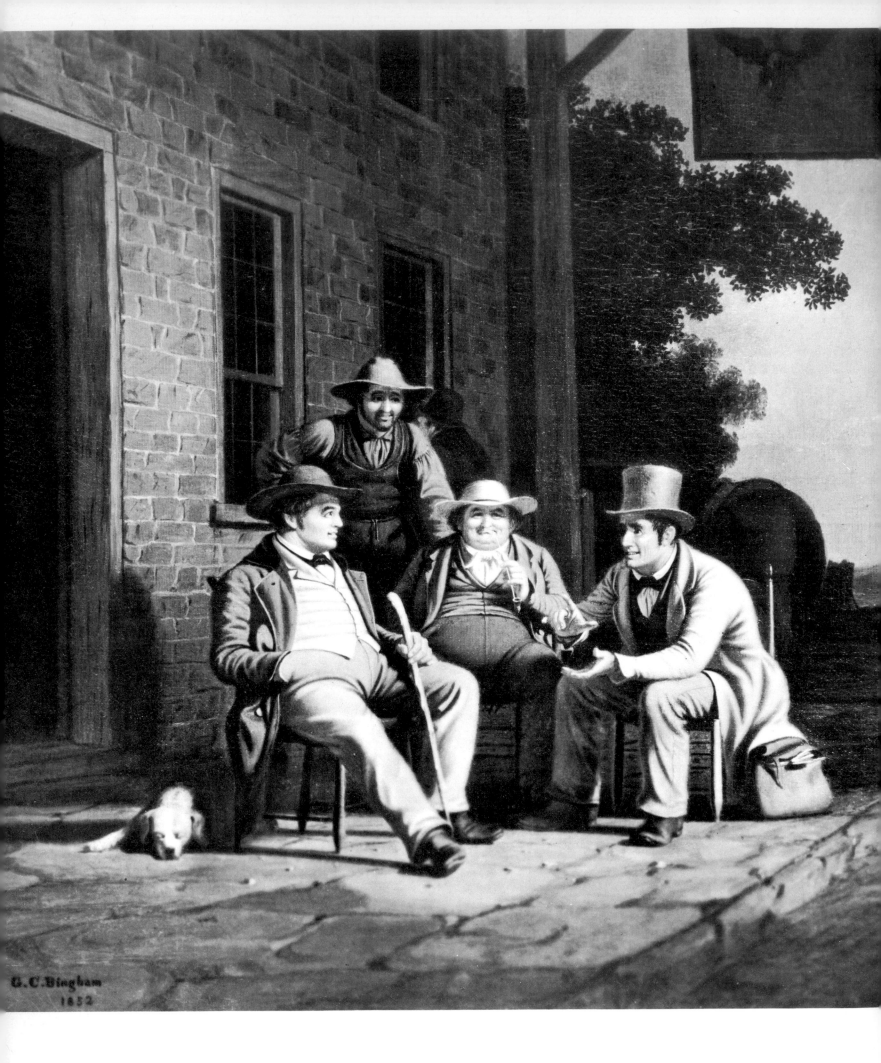

main, people who lived primarily by hunting for a few years in one locality, then selling their land to more stable farmers and moving westward, following what Bingham called "the receding footsteps of the Savage."

In *Shooting for the Beef* (1850) Bingham paid tribute to a common trait of the frontiersman—his pride in marksmanship. He pictured several backwoodsmen gathered in a clearing near a combined post office and grocery store to compete in a rifle match. Often the target was but a nail driven partway into a board at a distance of forty yards or more. A witness to one of these contests in the 1830's noted that some riflemen could hit the nail on the head and drive it farther into the board twice in every three shots. Bingham depicts both the setting and the action of this popular frontier sport. While one man takes steady aim with his long rifle, the next competitor hesitates in the act of ramming home the charge in his muzzle-loader. The eyes of some of the others are fixed on the distant target. At the far left stands the ox—the prize of the contest.

Four of Bingham's best-known paintings portray democracy in action in rural and small-town Missouri—a theme he was well-qualified to interpret. His association with politics went beyond supporting candidates and painting campaign banners and portraits of political heroes. He himself had run for public office. He had both lost and won close elections before he attempted to put politics on canvas. In 1846 he had been the Whig nominee to represent Saline County in the state legislature. He lost on a re-count after he thought he had won. Two years later he defeated the same opponent by a margin of only twenty-three votes.

Bingham knew that vigorous campaigning was needed to win votes, and two of his four political scenes show candidates on the campaign trail. *Canvassing for a Vote* is an intimate view of the candidate dressed in his best suit and plug hat, trying to convince three older citizens of the logic of his positions on the issues. His listeners appear to be attentive without revealing any agreement with the speaker. They are surely "from Missouri."

In *Stump Speaking* the candidate stands on a makeshift platform debating his rival before a motley crowd. Bingham must have enjoyed creating this scene, for he wrote to a close friend while this unfinished work was still on his easel, "In my orator I have endeavored to personify a wily politician, grown gray in the pursuit of office and the service of his party. His influence upon the crowd is manifest, but I have placed behind him a shrewd clear-headed opponent, who is busy taking notes and who will, when his turn comes, make sophisms fly like cobwebs before the housekeeper's broom."

In *County Election* a red-shirted Irishman stands atop the courthouse steps, being sworn in as a voter. Voting was then verbal and not secret, yet few members of the all-male crowd seem to take much interest in the voter's decision. All elements of the population except women are represented in the throng—rich and poor, businessmen and laborers, sober and intoxicated—,a fascinating cross section of the electorate. Meanwhile in the foreground two small boys concentrate on their game of mumble-the-peg.

A contemporary St. Louis reporter commented on this painting, "All who have ever seen a country election in Missouri are struck with the powerful accumulation of incidents in so small a space, each one of which seems to be a perfect duplication from one of these momentous occasions in real life."

Bingham intended his *Verdict of the People* to cap the climax of his

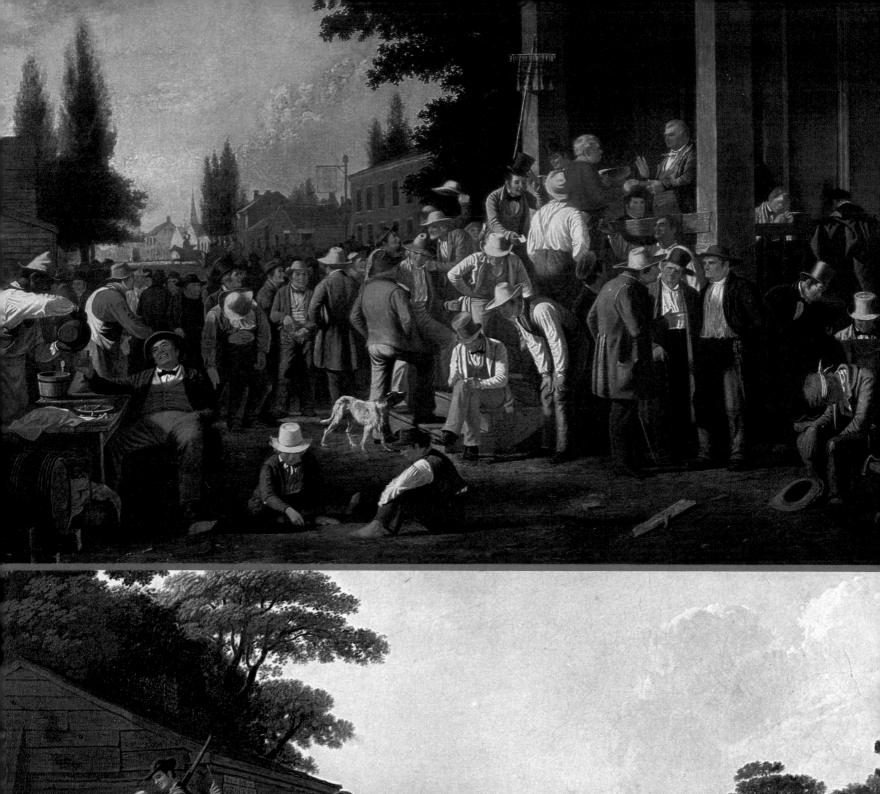

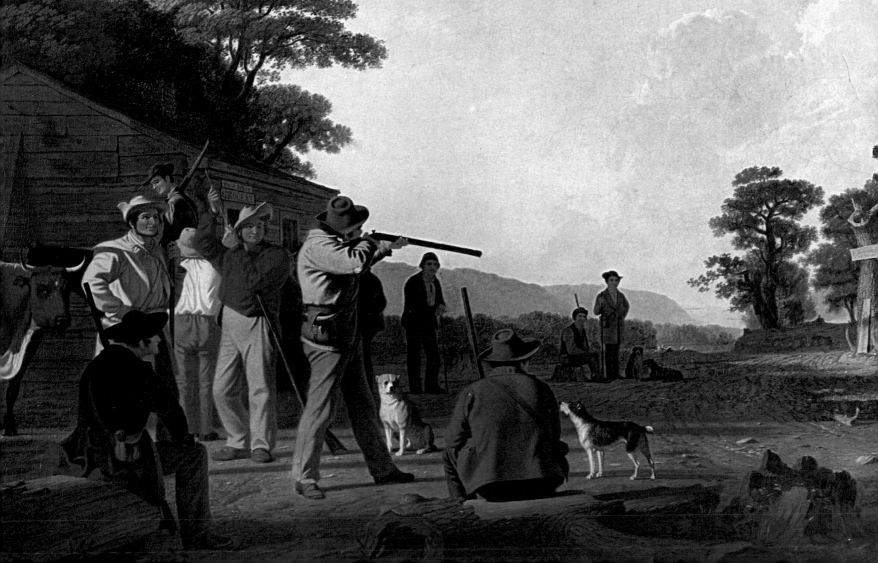

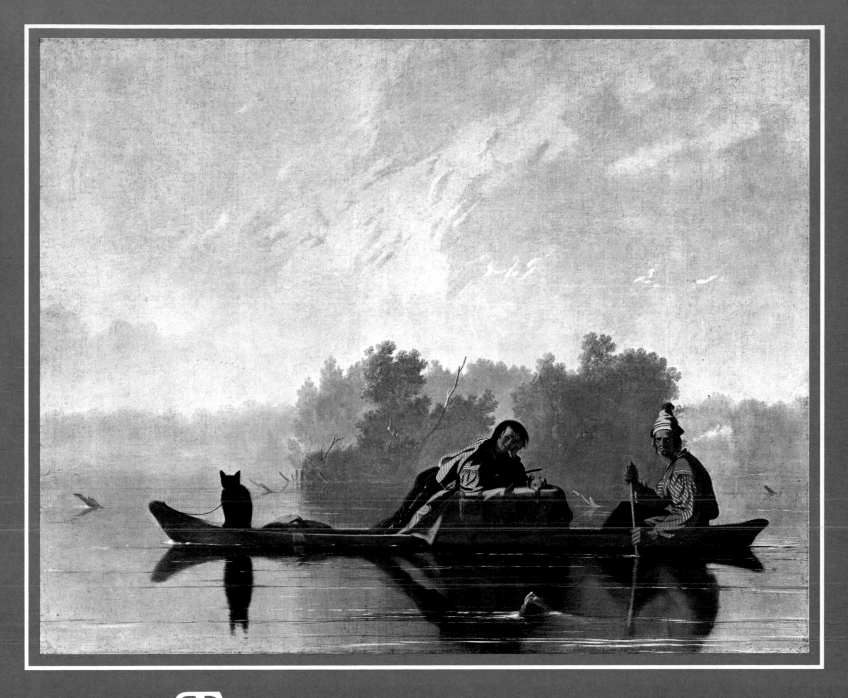

*F*ur Traders Descending the Missouri. Bingham. 1845. Oil. Metropolitan Museum of Art, Morris K. Jesup Fund, 1933 (above)

The County Election. Bingham. 1851–52. Oil. St. Louis Art Museum (top left)

Shooting for the Beef. Bingham. 1850. Oil. Brooklyn Museum, Dick S. Ramsay Fund (bottom left)

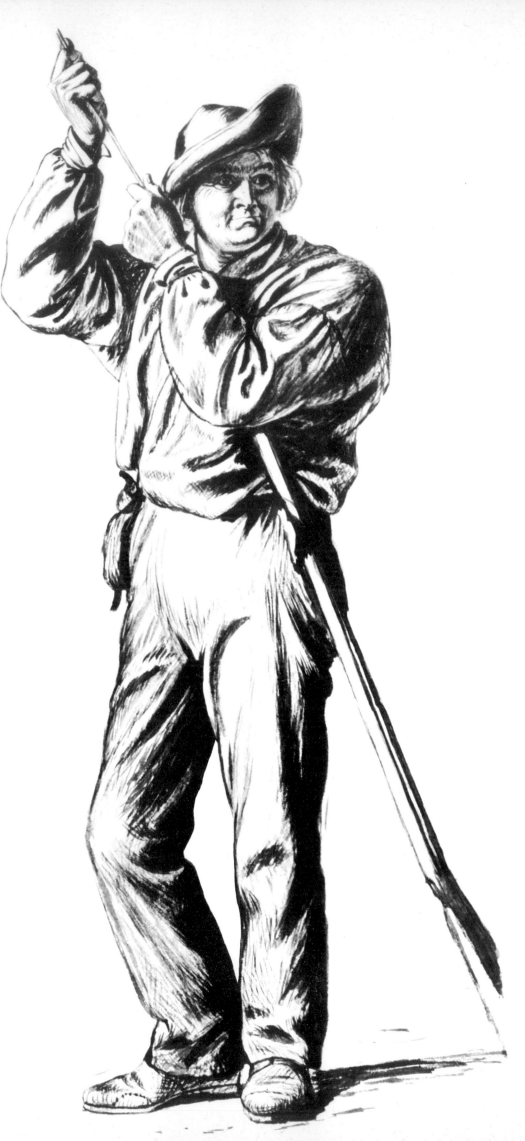

Study for Rifleman in
"Shooting for the Beef."
Bingham. 1850 or ante.
Pencil. St. Louis Mercantile
Library Association, St.
Louis, Missouri

political series. The crowd gathered around another courthouse porch to hear the election results is larger than the election day assemblage in *County Election*, yet the range of clearly-defined individuals is no greater, so that to admirers of *County Election* this rather similar composition may appear a bit of an anticlimax. Even so, both paintings were widely distributed in the form of engraved reproductions.

Although Bingham painted many portraits and some landscapes and repainted a few of his more popular scenes of western life in his later years, his most productive period of genre painting ended in the fall of 1857. Thereafter he traveled widely abroad and in his own country and remained actively involved in politics. In 1877 he was appointed the first professor in the newly established department of art at the University of Missouri. George Caleb Bingham died of cholera morbus in Kansas City, July 7, 1879.

The emergence of an artist of such stature on the trans-Mississippi frontier has puzzled art historians who tend to think of art history in terms of schools in which budding artists are influenced by a master, or in which groups of artists influence one another. In recent years E. Maurice Bloch has taken pains to point out that, through the use of instruction books and studies of the reproduced works of the best artists of the East and of Europe, even the young Bingham was influenced by the aims and accomplishments of the best artists of his own and earlier times. Nevertheless, Bingham contributed creative imagination and a willingness to work hard, as well as a strong ambition to improve and to succeed at his art. He developed a marked ability to draw the clothed man and boy from all angles, which proved to be a basic ingredient in his most successful genre paintings. His discovery of the common man on the western frontier inspired his best paintings. Bingham anticipated by nearly a century the works of the midwestern regional painters of the 1930's: Thomas Hart Benton, Grant Wood, and John Steuart Curry.

Missourians have long been proud to claim Bingham as "the Missouri artist." They first recognized his unique ability to portray both accurately and sympathetically their rivermen, woodsmen, and small-town folks. The great majority of Bingham's known drawings and paintings are still preserved in the museums, historical societies, and libraries of that state, from St. Louis to Kansas City.

Bingham's works have received recognition as unique pictorial documents in the history of life in America. His political scenes especially seem to transcend both place and time. They have come to symbolize the strength and vitality of grass roots democracy in this country.

IN THE CALIFORNIA MINES

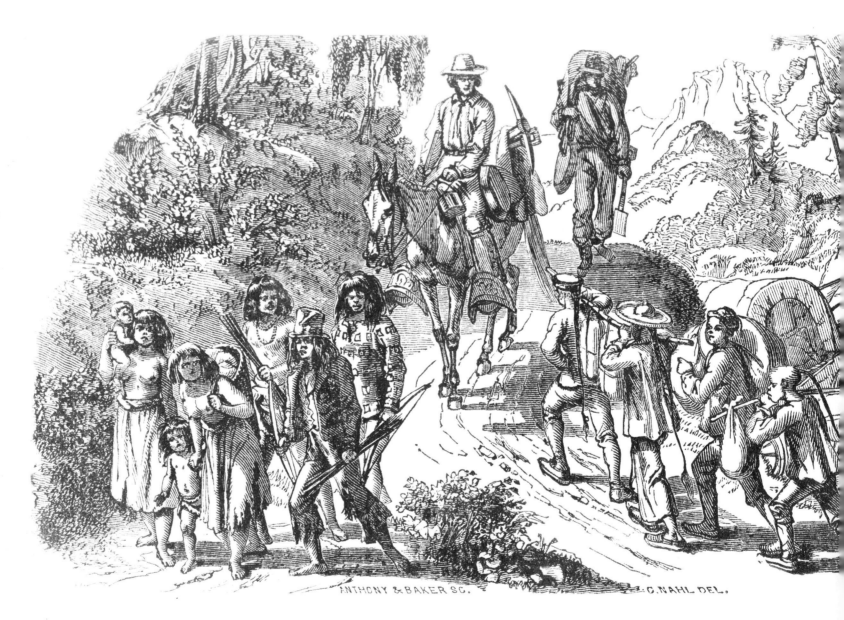

Charles Nahl and Thomas A. Ayres

On the Way to the Mines. Nahl. Undated. Engraving after a drawing. Henry E. Huntington Library and Art Gallery, San Marino, California

The search for gold in the American West began with the Spanish explorers of the sixteenth century. In 1541, Coronado marched from the Pueblo Indian Villages on the Rio Grande northeastward over the buffalo plains in quest of Quivera, in which (so an Indian said) "everyone had their ordinary dishes made of wrought plate, and the jugs and bowls were of gold." Coronado found only a collection of grass-covered huts of Wichita Indians near the big bend of the Arkansas River, in which no trace of gold or silver appeared. For three centuries the Spaniards and Mexicans searched in vain for an El Dorado in the American West. Then, ironically enough, it was discovered by an American carpenter in the isolated foothills of California just nine days before Mexico formally ceded California and the Southwest to the United States.

On January 24, 1848, James Marshall found glittering yellow particles in the tailrace of a new sawmill he was building at Coloma on the American River. He promptly reported his find to his employer, John A. Sutter, an enterprising Swiss who had obtained a Mexican land grant of nearly fifty thousand acres. Sutter's tests indicated that Marshall had discovered gold. Despite the efforts of both men to keep the find secret, the news spread—first to the other California settlements and to Oregon, then to Latin America, the Orient, eastern United States and far-off Europe. By 1849, the greatest gold rush in history was luring thousands of excited fortune hunters to the western foothills of the Sierras. California's population expanded from about twenty thousand to nearly one hundred thousand during 1849. And as stories of the richness of the mines and of fortunes made from them circulated widely, more and more gold-seekers swelled the migration during the early 1850's.

Most California-bound gold-seekers from the eastern interior of the United States traveled overland by the North Platte Valley and South Pass, the route Alfred Jacob Miller had followed in 1837 to the Rocky Mountain trappers' rendezvous, and thence across the Great Basin and over the Sierras. Others took a more southerly trail westward through Santa Fe.

Many Europeans and easterners who could raise enough money for ship passage sailed the long sea route around Cape Horn at the southern tip of South America to San Francisco—a voyage of five months or more. Still others followed a middle course—by sea and land—in which the ocean voyage was broken by a seventy-five-mile crossing of the Isthmus of Panama.

Among the argonauts who took the last-named route in 1850 were two Germans—thirty-one-year-old Charles Christian Nahl and his teenaged half-brother Hugo William Arthur Nahl. Their ancestors for three centuries had been artists of ability. Johan August Nahl, their great-grandfather, was perhaps the most inventive artist of the German rococo. Charles's father, Georg Valentin Friederich Nahl, was an etcher and engraver. So when Charles was born at Kassel, October 13, 1818, his parents must have taken it for granted that he too would become an artist. Young Nahl attended the Art Academy at Kassel and in 1846 went to Paris to study under Horace Vernet, painter of heroic battle scenes. Nahl's paintings were exhibited in the Paris salon in 1847 and 1848. Following the downfall of King Louis Philippe (who may be remembered as a patron of George Catlin) in the Revolution of 1848, the Nahl brothers immigrated to New York with their mother and sister. There Charles made a living by painting; he also exhibited at the American Art Union.

In 1850, the restless Nahl brothers caught the gold fever and set sail

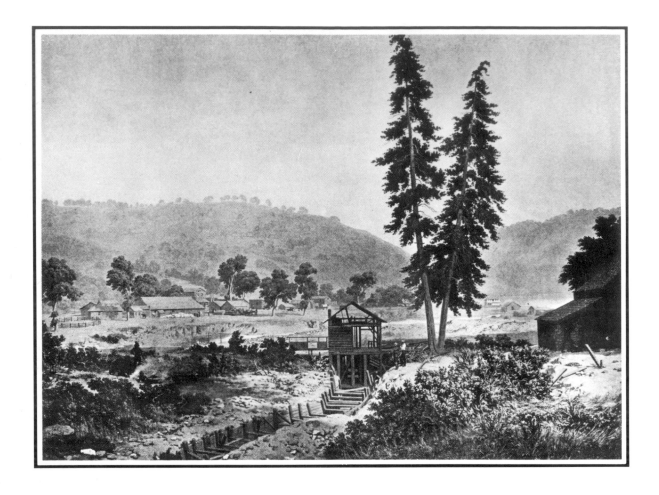

for California by way of the Isthmus of Panama. The journey across the Isthmus, forty-four miles up the narrow, winding Chagres River to Cruces by small boat, thence on muleback over the Continental Divide to Panama on the Pacific side, much of it through lush tropical jungle, was in itself an exciting adventure for Charles Nahl. He made field sketches of the scenery and his experiences along the way.

San Francisco was the port through which nearly all gold-seekers who came by sea entered California. When the Nahls arrived there its fine harbor was crowded with sailing ships from many Atlantic and Pacific ports. Since 1848 San Francisco had become a cosmopolitan city of twenty thousand where United States citizens mingled with Latin Americans, Europeans, Hawaiians, Australians, and Chinese — fortune-seekers from the far corners of the earth who had responded to the siren call of gold.

Like most of the other new arrivals, the Nahl brothers headed inland toward the mining region. For a time they worked in mines at Rough and Ready Camp on the Yuba River in Nevada County, northeast of Sacramento. There Charles participated in mining camp life and sketched his fellow miners at work and play. In 1851, he visited Sutter's Mill at Coloma, the birthplace of the California gold rush, and made sketches there which he later developed into a large oil painting notable for its detail and accuracy.

That year the Nahls moved to Sacramento, where Charles apparently executed miners' portraits — in exchange for gold dust — and some genre

*S*utter's Mill—Where
Gold was Discovered in
California. Nahl. 1851.
After an oil. John Howell
Books, San Francisco

*Mining with the Long
Tom. Nahl. Engraving
after a drawing. "Hutch-
ings' California Illustrated
Magazine" (below)*

subjects for display in local barrooms. The following year a fire that swept Sacramento destroyed Charles Nahl's sketches of life in the mines and the studies he had made during his crossing of the Isthmus of Panama. But the fire could not erase his vivid memories of his experiences in the mining region.

After the Sacramento fire of 1852, the Nahls moved again—this time to a permanent home in San Francisco. There Charles soon found a market for his knowledge and talents, executing numerous drawings of aspects of the gold rush for engraved or lithographic reproduction. Many of his drawings appeared as illustrations for newspapers, magazines, and books.

Among his most popular works were those prepared for two books of mining anecdotes by Alonzo Delano, who had crossed the plains to the mining region of the Feather River in '49. Although some of these drawings are almost farcical, Nahl never sacrificed good draftsmanship for comedy. In *Pen Knife Sketches, or Chips of the Old Block. A Series of Original Letters Written by One of California's Pioneer Miners* (Sacramento, 1853), the publisher introduced Nahl as a man "whose reputation for genius, talent, and success in his profession, is not surpassed by that of any artist in the country." Nahl's twenty-three illustrations, engraved by English-born Thomas Armstrong, won the admiration of miners as authentic representations of humorous and pathetic incidents among the men in the flats and gulches of the mining country.

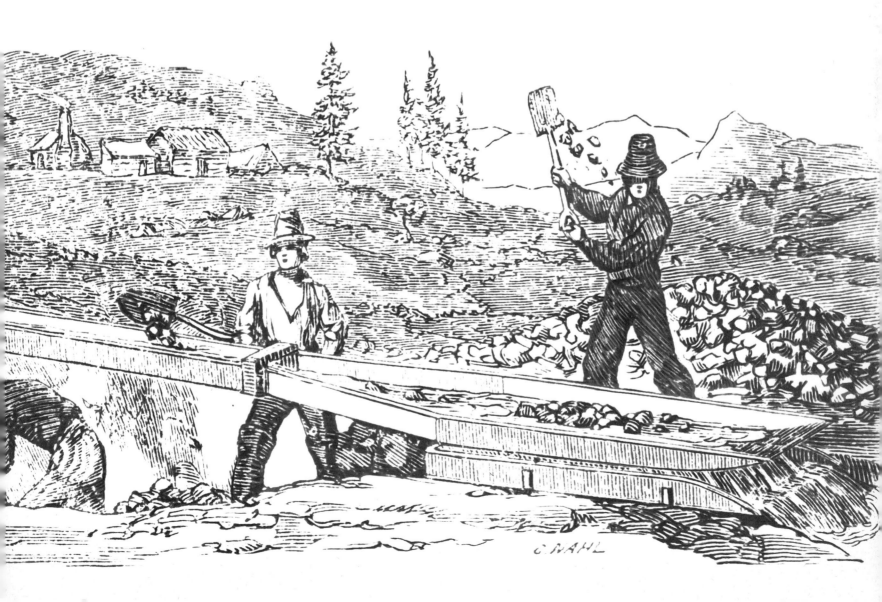

Nahl's reputation was acknowledged in the title of Delano's second volume of gold rush anecdotes, *Old Block's Sketch Book, or Tales of California Life. Illustrated with Numerous Elegant Designs by Nahl, the Cruikshank of California* (Sacramento, 1856). Both of Delano's little books have become collectors' items.

The black-and-white illustrations Nahl published during this period chronicle many aspects of life in gold rush days. One composition portrays the variety of peoples a traveler might encounter on an upland trail to the mines: barefooted Indians of the foothills, most of them half-naked but one dressed in filthy, cast-off miner's clothes; sandaled and pigtailed Chinese with their burdens slung from long poles over their shoulders; white miners—one afoot and one riding a bony horse, packing their picks and shovels; and a wagon with a four-horse team such as was used to haul supplies and provisions to the mining camps. Other Nahl drawings show more affluent travelers helping to push a stagecoach up a steep incline on a road to the mines, and a mounted expressman carrying mail—at prices as high as four dollars a letter—in his saddle pouches.

Most of the gold-seekers who converged upon the California foothills were greenhorns who had no mining experience and little conception of the hard manual labor required to separate the gold from the dross. Yet this was the very heart of life in the mines. In a single composition Nahl illustrated the variety of mining methods employed in California during the first four years of the rush, when more than $125,000,000 in gold was recovered. Placer mining—that is, extracting loose bits of gold from sand, gravel, earth, and boulders from stream beds or hillsides—predominated in those early days. A lone prospector with his flat-bottomed, sheet-iron pan could "strike it rich" only if he found gold in sufficient concentrations. Most miners found it more profitable to work in small groups, using rudimentary wooden devices fitted with metal screens and hoppers to separate the precious metal from the quantities of waste materials. Two men could handle a simple "rocker" or "cradle"; from two to five men were needed for a twenty-foot "long tom"; and five or more men could operate a long "sluice" or "flume." In the background other miners are digging into a hillside to recover gold from geologically older beds, a practice initiated in the Nevada County mines by experienced Cornish miners in 1850.

The mining camps were a man's world, peopled largely by bearded men in flannel or calico shirts and wool or duck trousers tucked into sturdy boots. In some camps the appearance of a woman created a stir, and in all of them the arrival of mail was eagerly welcomed by homesick men. Nahl depicted such aspects of camp life with sympathetic understanding.

After a hard six-day week, many of the miners would "blow off steam" over the weekend, drinking, fighting, and gambling much like the earlier Rocky Mountain trappers at their summer rendezvous. Nahl depicted these activities in a number of his black-and-white illustrations and in his paintings. Although few of his oil paintings have survived, two of them are especially noteworthy. His *Saturday Evening in the Mines*, painted in the 1850's, hung first in a Sacramento barroom and then in the California State Capitol before it was acquired by Stanford University. The scene is a crudely furnished miner's cabin, in which two men are closely watching a third one weigh the week's gold dust on delicately-balanced scales. A fourth slumps in his chair affectionately holding a bottle from which he has apparently partaken rather freely.

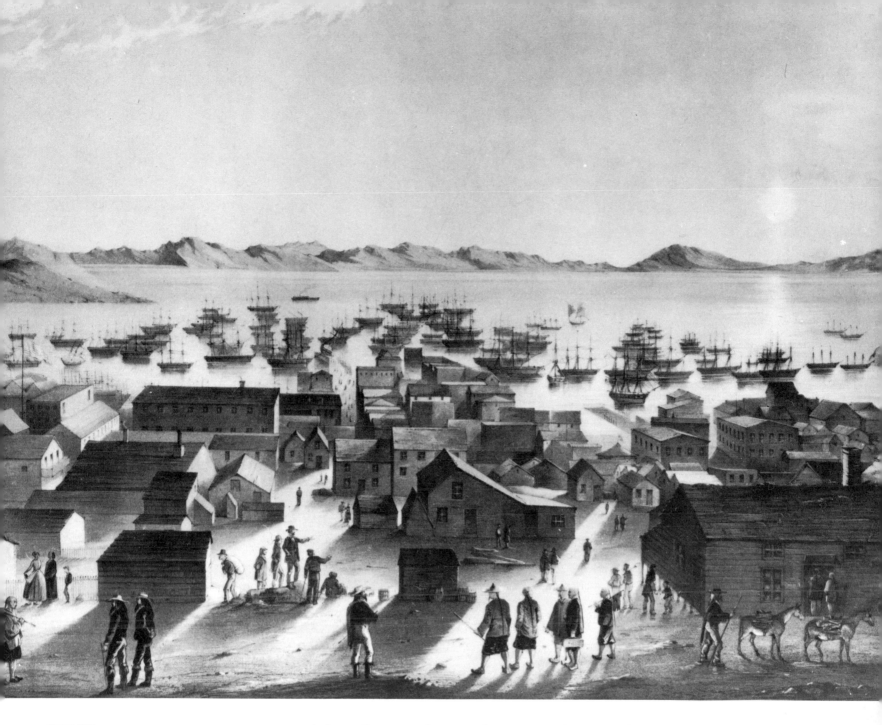

View of San Francisco. Marryat. 1850. Lithograph after a watercolor. New-York Historical Society

A beardless youth is cooking over the open fire, while a sixth man is asleep in an upper bunk.

Nahl's masterpiece of mining camp genre is *Sunday Morning in the Mines*, painted for Judge Crocker of Sacramento in 1872. Into this six-by-nine-foot canvas the artist has crowded a great variety of Sunday activities. On the left is a drunken brawl (background), four men racing their horses, and others trying to restrain a drunken youth from throwing away his packet of hard-earned gold dust. Inside the crude cabin sheathed with split shakes a man is writing a letter. Two miners are listening to a third reading from a book, probably the Bible, and others are doing their weekly washing. Art critics may decry the busyness, the literal detail and the anecdotal quality of this composition. But there is a vitality about it, an unacademic, authentic Western exuberance that captures the relaxed, rowdy spirit of the place. Moreover, the very wealth of accurate detail makes this painting of absorbing interest to students of the gold rush.

For many years the Nahl brothers operated an art and photographic studio and gallery in San Francisco. Charles designed the bear on the

147

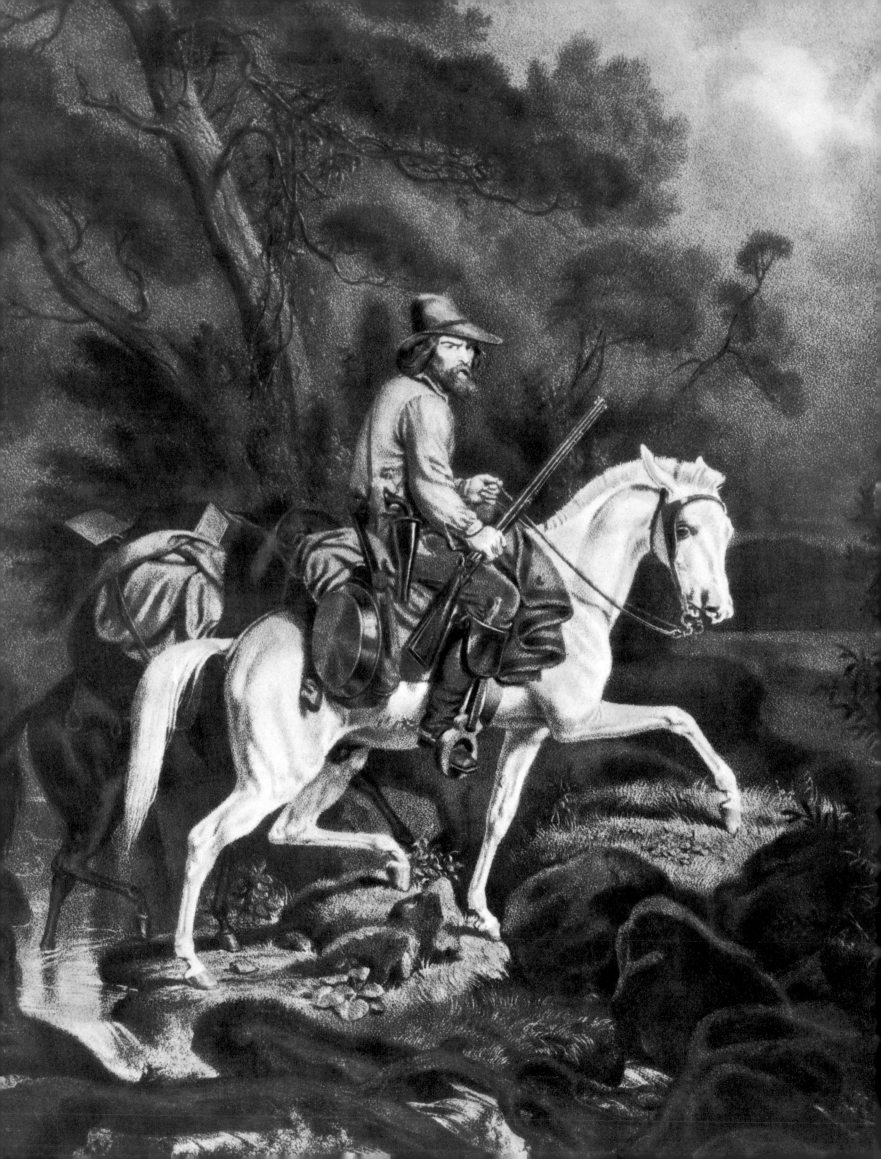

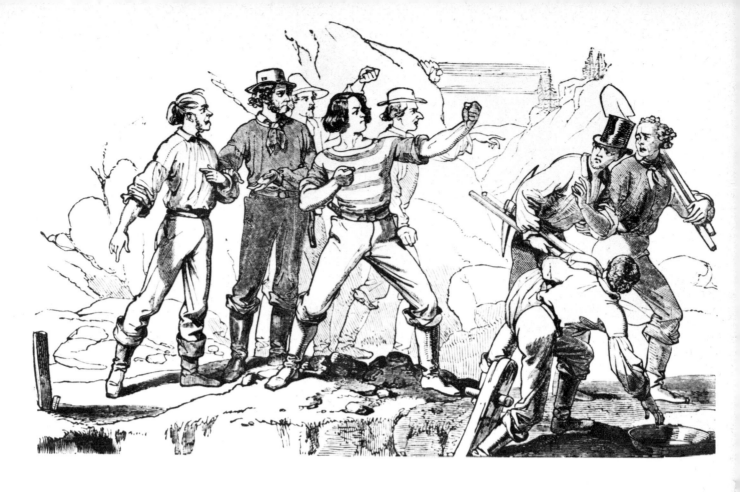

The Lone Miner. Nahl and Wenderoth. 1852. Lithograph after a drawing. Bancroft Library, University of California (left)

Ejecting the Squatters. Nahl. 1856. Engraving after a drawing. Rare Book Division, New York Public Library (above)

California State flag, and his half-brother the State seal. A shy bachelor, Charles lived with his mother and sister in a modest home on Bush Street until his death in 1878, at the age of fifty-nine. In its obituary the *San Francisco Evening Bulletin* mourned the loss of this "man of genius" whose "mining scenes were probably as good as any ever executed here." Charles Nahl's first-hand knowledge of mining camp life, his technical skill, his passion for accuracy in portraying miners as active, interesting human beings, and his productivity, make him the leading pictorial interpreter of the gold rush.

An unexpected bonus from the gold rush was the rediscovery of one of the West's unique scenic treasures—the Yosemite Valley. During the fall of 1833, Joseph Reddeford Walker, Alfred Jacob Miller's hero among the mountain men, had led a party of hardy American trappers over the high Sierras to California. They skirted the northern rim of this deep, then nameless valley, and probably were the first white men to gaze upon its natural wonders. However, the great overland migration to California during the 1840's followed other and easier routes, and the rediscovery of the valley came only as a result of Indian resistance to the influx of miners into the foothills region. Early in 1850, Indians attacked James D. Savage's trading post and mining camp on the Merced River—some fifteen miles below the entrance to the Yosemite Valley. Their continued plundering of mining camps led the whites to organize a volunteer force which pursued the Grizzly (Yosemite) Indians into their upriver, mountain valley stronghold.

Late in March 1851, Major Savage led his Mariposa Battalion into the valley only to find that the troublesome Indians had withdrawn from it. Even so, some of the volunteers were profoundly impressed by the vista of distant mountains, seen through a mile-wide valley framed by precipitous granite walls from the tops of which waterfalls, many times higher than Niagara, cascaded to the valley floor. Around their evening campfire the whites tried to find a fitting name for this wonderland. "Paradise Valley" was considered first, but they finally named

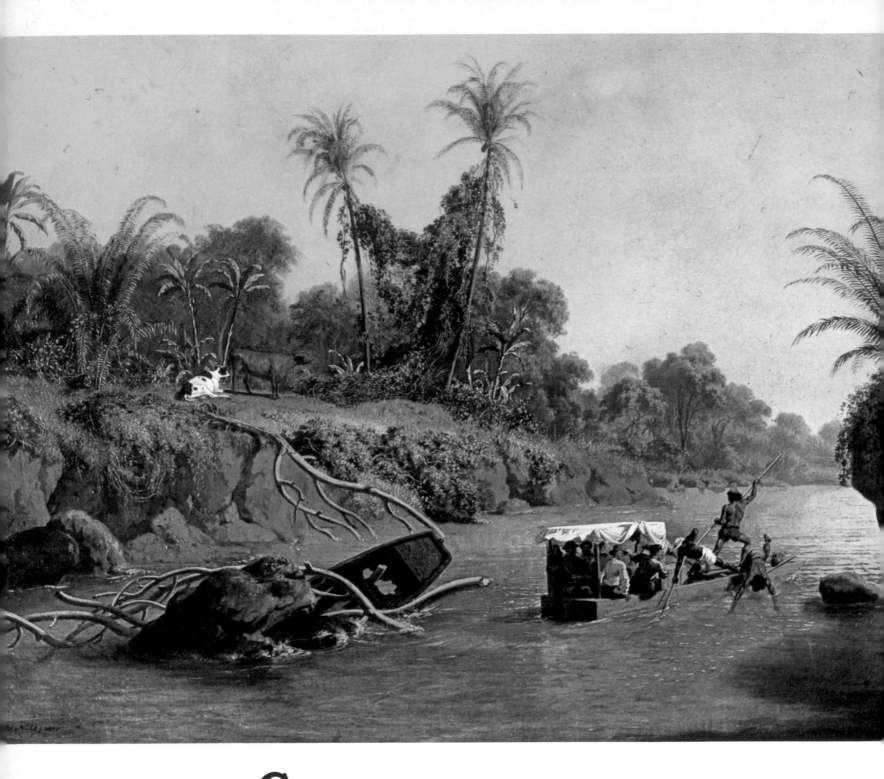

Crossing the Isthmus of Panama by Way of the Chagres River in 1850. Nahl. Oil. Bancroft Library, University of California (above)

Saturday Evening in the Mines. Nahl. 1856. Oil. Stanford University Art Gallery (top right)

Detail from "Sunday Morning in the Mines." Nahl. 1872. Oil. E.B.Crocker Art Gallery, Sacramento, California (bottom right)

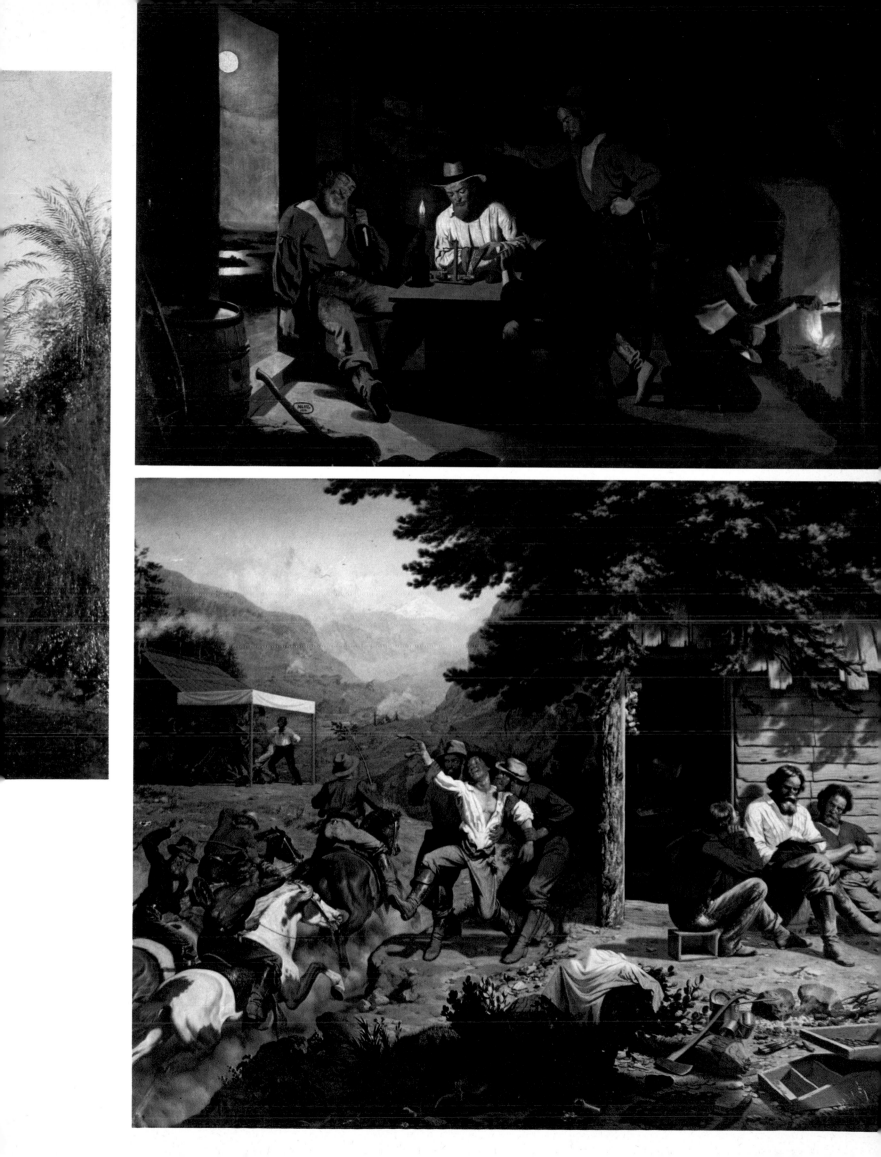

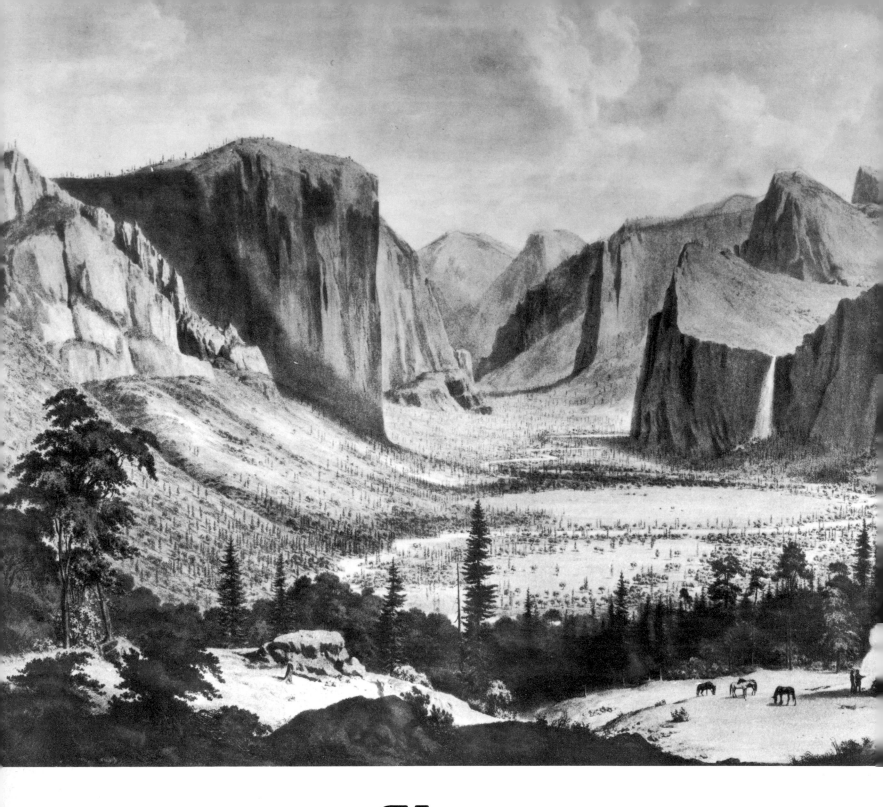

*Y*osemite Valley
from Inspiration Point,
the First Panorama of the
Yosemite Valley. Ayres.
1855. Lithograph after a
drawing. Print Division,
New York Public Library

it "Yosemite" after the small Indian sub-tribe whose home it had been.

After the Indian troubles subsided, tales of "thousand-foot-high waterfalls" continued to reach San Francisco—some 140 miles distant. They fascinated James Mason Hutchings, who was planning to publish an illustrated magazine in San Francisco. In 1855, he organized the first party to visit the Yosemite Valley in order to describe and picture its scenic attractions. Hutchings engaged Thomas A. Ayres, a landscape painter who had executed scenes in and near San Francisco in 1854, as the artist for his four-man expedition. A native of New Jersey, Ayres had started for the California mines early in 1849. Like the Nahl brothers he turned to his art after an exposure to the miner's life. He traveled widely through interior California between 1850 and 1854 sketching scenes in the mining camps and on the Indian reservations.

Led by Yosemite Indian guides, Hutchings' group rode the old Indian trail from Mariposa by way of Wawona to the Yosemite Valley. The party spent five days in the valley during which Ayres drew detailed and literal pencil sketches of the imposing vistas and closer views of some of the major features of the area. His first drawing, and the earliest known picture of the Yosemite Valley, was a panoramic view from Inspiration Point. The millions of tourists who have followed Hutchings' party into this magnificent valley can testify to the fidelity of the artist's delineation of the granite precipice of El Capitan (in the left middle distance), narrow, ribbon-like Bridal Veil Falls and the massive projections of the Three Brothers (on the right), as well as flat-faced Half Dome in the distance. Among other sketches by Ayres was a view of "The High Falls" (Yosemite Falls).

Hutchings wrote the first published description of the Yosemite Valley (in the *Mariposa Gazette* of July 12, 1855), but words alone could not convey an adequate conception of this wonderland to one who had never seen it. Hutchings had the drawing by Ayres of Yosemite Falls (the highest waterfall in North America, descending 2,425 feet in three leaps) drawn on stone and published in San Francisco that same year, and he incorporated four drawings by Ayres in the account of his Yosemite experiences printed in the very first issue of his *California Illustrated Magazine*. From his Yosemite sketches Ayres painted a panorama "Yosemite Valley and Fall," which was exhibited for an extended period in Sacramento.

During a second trip to Yosemite in 1856, Ayres executed a series of views which he exhibited the following year at the Art Union in New York. The success of that showing won him a contract with Harper and Brothers to illustrate a series of articles on California. He returned to the West Coast and, after completing some sketches in southern California, boarded the *Laura Bevan* at San Pedro en route to San Francisco. In a heavy storm off Point Dume on April 26, 1858, the ship went down, taking with it the lives of all aboard.

Unfortunately, Thomas A. Ayres did not live to see his beloved valley protected as a public trust by the State of California in 1864, and established as part of Yosemite National Park in 1890. More gifted artists—among them Albert Bierstadt and Thomas Moran—would later interpret the Yosemite Valley, but it was Ayres, the argonaut of gold rush days, who executed the pictures that first drew America's attention to that wonder of nature.

BROTHERS AMONG THE SOUTHWEST INDIANS

Edward M. and Richard H. Kern

Restoration of the Pueblo Hungo Pavie (Crooked Nose). R.H.Kern. Lithograph after a water-color. "The Simpson Report," 1850. Library of Congress (preceding page 154)

Chapaton, Chief of the San Juan Navajos. Drawn by E.M.Kern from a sketch by R.H.Kern. September 8, 1849. Wash drawing. Academy of Natural Sciences, Philadelphia (preceding page 155)

St. Michael. Bernardo Miera y Pacheco. New Mexico, eighteenth century. Carved and painted figure. Smithsonian Institution (right)

Buffalo Dance. R.H.Kern. Lithograph after an original sketch made in 1851. "The Sitgreaves Report," 1853. Smithsonian Institution (far right)

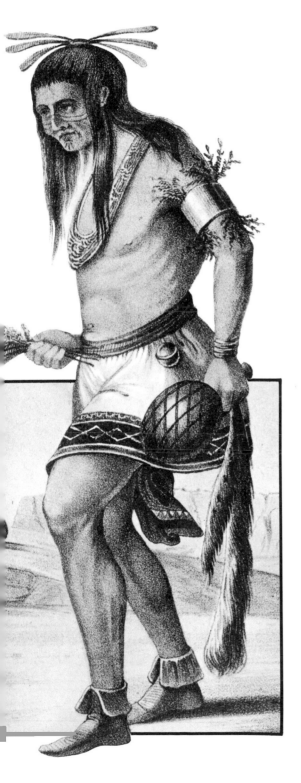

At the time of the Mexican Cession no other portion of the American West had been known to white men as long as had the arid Southwest. Even so, nearly three centuries of Spanish exploration and settlement and a quarter century of Mexican rule had produced no pictorial record of the region and its native peoples—Indians whose life styles differed markedly from those of other western tribes. These Indians had accepted some Old World food plants and domesticated animals—horses, mules, and sheep—but they remained aloof from or openly hostile to Spanish and Mexican domination of their lives. Spanish priests built churches in the Indian villages of the sedentary tribes and decorated the church interiors with carved and painted representations of Christian saints, but the Indians did not abandon their traditional religious beliefs, arts, and ceremonies. Our cultural heritage from the Spanish and Mexican periods in New Mexico and Arizona is rich in examples of religious art. But if secular drawings and paintings were created to depict aspects of the daily lives of the people, they have not been preserved.

During the summer of 1849, two young Philadelphia artists were stranded in the old town of Santa Fe. They were the brothers Kern— Edward Meyer (born 1823) and Richard Hovenden (born 1821). Their father had been a customhouse collector for the port of Philadelphia. Both sons had shown an early talent for art, and though they may have been largely self-taught, both had works accepted for exhibition by the Artists' Fund Society while still in their teens. Richard later taught some of that Society's drawing classes and made scientific illustrations for biological studies.

Friends had helped Edward to obtain a much-coveted appointment to the post of artist on the famous explorer John C. Frémont's third expedition into the West in 1845. He continued to serve as officer under Frémont in California during the Mexican War. Edward's great enthusiasm for western exploration encouraged both Richard and their older brother, Benjamin, to join him on Frémont's fourth expedition in 1848. Eager to redeem himself after his recent army court-martial, Frémont, the impetuous pathfinder, unwisely attempted to lead his party over the high San Juan Mountains on his approach to Taos and Santa Fe in December. Caught in heavy snows, ten of his men perished from exhaustion, starvation, and cold. The three Kerns were among the survivors who straggled into Taos in January. From there Frémont impatiently pushed on to California, leaving the remnant of his party to shift for themselves.

In March Benjamin Kern and the noted mountain man Bill Williams returned to the mountains to try to recover papers and other belongings abandoned in the winter snows by the Frémont party. Both were killed, probably by Ute Indians. Shocked by their brother's death, and completely disillusioned with their former hero, Frémont, the two surviving Kern brothers still refused to turn away from the challenge of western exploration. In Santa Fe they met Lieut. James H. Simpson of the Army's Corps of Topographical Engineers, who needed two artists of their abilities and experience to assist him in surveying a still unmapped region farther west.

So it was that these three explorers with a scientific bent came to accompany a punitive expedition against the Navajo Indians led by Col. John M. Washington, Military Governor of New Mexico. The Navajos had engaged in guerilla warfare with their Spanish, Mexican, and Pueblo Indian neighbors for generations, and they were thought to possess livestock and captives taken from their old enemies since the United

157

States acquired New Mexico. The expedition mustered in mid-August 1849 near the Indian pueblo of Jemez on a tributary of the Rio Grande 57 miles west of Santa Fe. Although their ancestors had numbered several thousand people residing in several villages less than two centuries earlier, the Jemez had been reduced to a single settlement of two-storied adobe apartments occupied by fewer than 400 Indians. On August 19th Edward Kern witnessed and sketched the traditional green corn dance at Jemez in which elaborately costumed and painted male dancers were accompanied by singers and seated musicians who "produced a sound much like that of grinding corn on a metate" by drawing knotched sticks across smooth ones.

Two days later Francisco Hosta, the Governor of Jemez, who was also to accompany the expedition, guided Simpson and the Kerns on a tour of the Catholic mission church and then into two traditional pueblo sanctuaries—dimly-lighted, underground chambers (kivas), entered by ladders, with colorful mural paintings on their walls. Evasively Hosta told them that the murals were only "for ornament," but he permitted Richard Kern to make the earliest known white artist's drawings of these fine examples of Pueblo religious art—naturalistic and conventionalized animals, birds and plants of the region, and more abstract symbols of the powers of nature such as sun and moon, rain, and both good and destructive lightning. Richard also executed a full-length watercolor portrait of Hosta wearing his war costume, holding his decorated circular shield and lance, with a portion of Jemez Pueblo in the background.

Col. Washington's infantry and artillery, reinforced by New Mexican militia and sixty Indian allies from six Rio Grande Pueblos, was guided by the Mexican, Carravahal, northwestward from Jemez toward the Navajo stronghold, Canyon de Chelly. On August 26th they crossed the Continental Divide, reached the westward-flowing Chaco River, and saw in the distance "a conspicuous ruin." Simpson and the Kerns approached this site with "high expectations" which were exceeded upon closer examination. They were amazed to find the remains of a single great structure with some fifty-four ground floor apartments and three or more ceremonial kivas. They were most impressed by the masonry walls of precisely cut and fitted blocks of sandstone, which Simpson recognized as "a combination of science and art which can only be referred to a higher stage of civilization and refinement than is discoverable in the works of Mexicans or Pueblos of the present day."

Pueblo Pintado, as their Mexican guide named this ruin, was but the first of many similar—and some even larger—ancient apartment houses in the Chaco valley. After the command reached the Chaco Canyon, Simpson gained permission from Col. Washington to leave the main column in company with Richard Kern, Assistant Surgeon John F. Hammond, interpreter James Collins, guide Carravahal and an escort of seven mounted Mexicans. Together these men made the first recorded exploration of that unique concentration of ruins of prehistoric stone apartment houses which are now preserved in Chaco Canyon National Monument, and which are still known by the Mexican or Indian names Carravahal gave them. As the explorers proceeded westward through the canyon on August 28, 1849, they examined each ruin in turn, took measurements of some of them and found painted pottery and other artifacts.

Time did not permit excavation or detailed comparisons of the architectural and construction details of these huge buildings. But Simpson credited Richard Kern with the suggestion that, while the buildings'

Mariano Martinez, Chief of the Navajo Indians. Drawn by E.M.Kern from a sketch by R.H. Kern. September 8, 1849. Wash drawing. Academy of Natural Sciences, Philadelphia

outer walls were vertical, they were terraced on the inner or court side, as pictured in Richard's restoration drawing of Hungo Pavie, in which he "unwittingly" omitted one of the four stories. The exploration party determined that Pueblo Bonito was both the largest and the best preserved of the ruins they came upon. They estimated its ground floor rooms at about two hundred, the circuit of its outer wall at some 1,300 feet, and its original height at "at least four stories."

Toward sundown they reluctantly hurried on to rejoin the main column. Two days later the command began to meet small parties of Navajos on horseback, the women riding astride, wearing blankets confined at the waist by girdles, leggings and moccasins. Some of the men wore "helmet-shaped" skin caps with pendant eagle feathers, as pictured in Richard Kern's watercolor of a Navajo warrior with his weapons. Yet these small parties appeared more curious than hostile. The marchers passed "very extensive and luxurient" cornfields and learned that their fine corn was due to the Navajo practice of planting the seeds deeply—a foot or more below the surface—to take advantage of subsurface moisture.

On August 31st, Col. Washington met Narbone, the aged Navajo head chief, in council, presented his demands for the return of all Mexican captives, murderers of Mexicans, and stock taken from the Mexicans by the Navajos since the United States established jurisdiction in New Mexico, and obtained the chief's agreement to make a treaty between the Navajo Nation and the United States later in Canyon de Chelly. Richard Kern drew a portrait of Narbone.

Several hundred Navajos were gathered round the participants in the parley. Soon thereafter, a Mexican in Washington's command pointed to a horse in the possession of a Navajo that had belonged to him. When that Indian refused to give it up and the Navajos started to ride away, Col. Washington ordered the guard to open fire. Narbone and six of his men were mortally wounded.

From this point on, the command moved cautiously, with skirmishers riding the flanks. While their Pueblo Indian allies kept watch from the heights above, the main body passed through a narrow defile which Simpson named Pass Washington on his map.

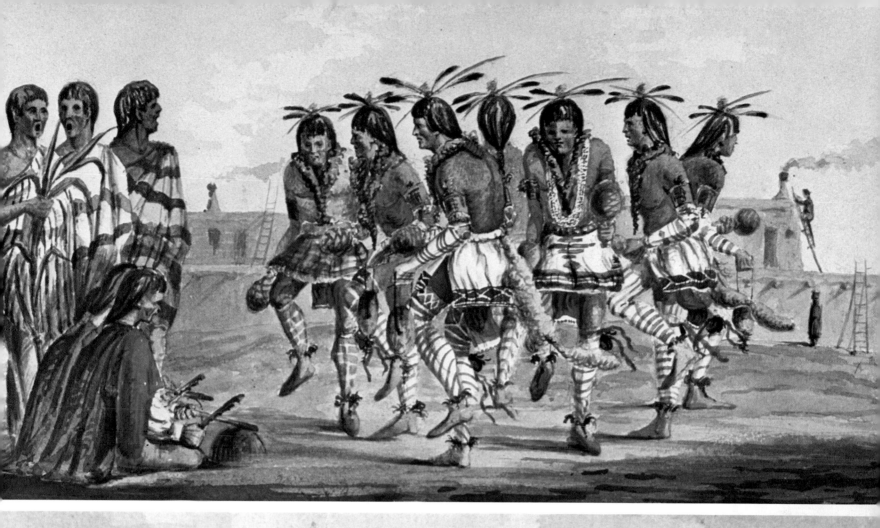

On September 8th, Simpson and the Kern brothers explored the Navajo stronghold, Canyon de Chelly, a narrow, winding gorge with towering red sandstone walls rising to heights of more than 800 feet. The brothers found ruins on the canyon floor and more spectacular ones built into great chasms in the canyon walls. Richard Kern's watercolor of one of the latter is the earliest known drawing of a southwestern cliff dwelling. It is now known as the White House, because one wall was covered with white plaster. Kern's rendering closely resembles modern photographs of this ancient ruin—one of the major points of interest in Canyon de Chelly National Monument.

The next day, September 9th, Col. Washington and Indian Agent for New Mexico James S. Calhoun negotiated the first ratified treaty of peace between the United States and the Navajo Indians, the strongest and most aggressive tribe in the Southwest, estimated at 7,000 to 14,000 persons. Richard Kern's signature is on the treaty as a witness. He also drew portraits of the two Navajo chiefs who signed the treaty—Head Chief Mariano Martinez, dressed in Mexican style, and Chapitone, Chief of the San Juan Navajos, wearing a broad woven headband and a striped sleeveless jacket over a shirt. After the treaty council Navajo warriors traded fine Navajo blankets, dressed skins, and peaches with the soldiers.

Believing he had accomplished his mission, even though there was little hope that the warlike Navajos would comply with the terms of the treaty, Col. Washington led his troops southeastward toward Santa Fe. On the way they stopped at the large Pueblo of Zuni on the Zuni River, and at Inscription Rock (now El Morro National Monument), where Simpson and Richard Kern copied some of the many signatures left on the soft sandstone by passing Spanish officials and priests during the long colonial period. Richard also drew a distant panorama of the

Buffalo Dance of the Zuni. R.H.Kern. Lithograph after an original sketch made in 1851. "The Sitgreaves Report," 1853. Smithsonian Institution (right)

Women Grinding Corn. R.H.Kern. Lithograph after an original sketch made in 1851. "The Sitgreaves Report," 1853. Smithsonian Institution (below)

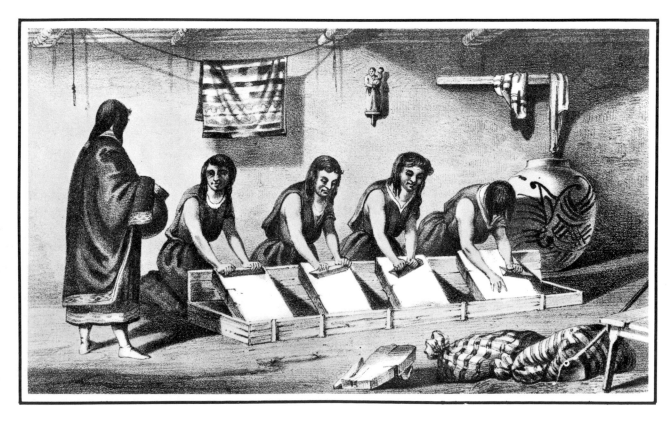

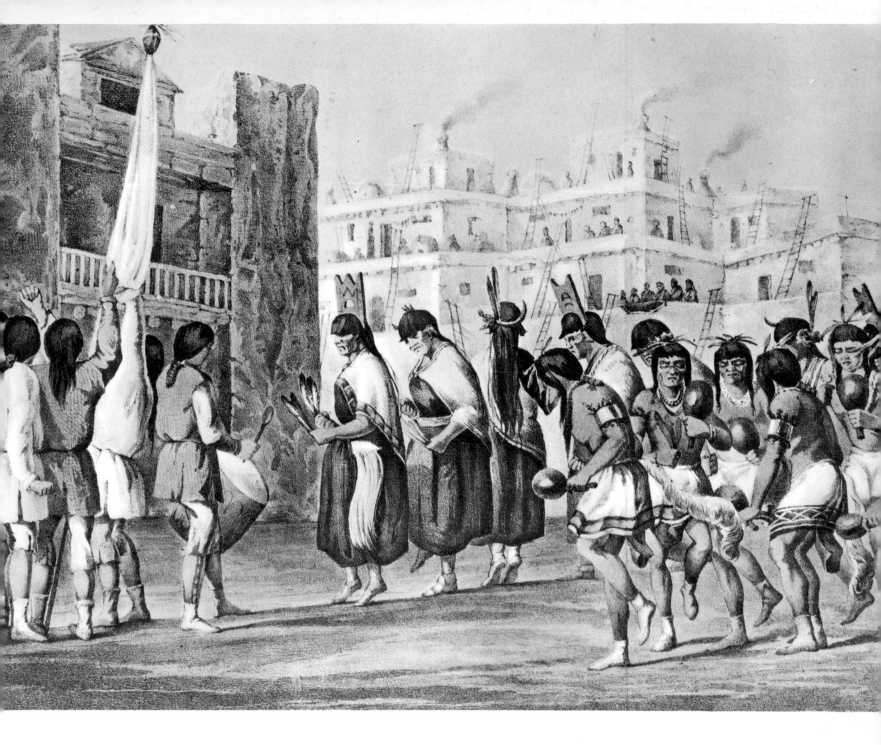

sprawling Pueblo of Laguna, population about 750, less than 50 miles west of Albuquerque. On September 26th the command reached Santa Fe and the historic expedition against the Navajo Indians ended.

Throughout the remainder of the year the Kern brothers assisted Lieut. Simpson in preparing his report of the exploration. In its official publication as a Senate Document in 1850, Simpson credited Edward with "the topography and other artistical work displayed upon the map," and Richard with nearly all of the "sketches of scenery, &c." He praised them both for their ingenuity in making do with the inadequate paper available to them in Santa Fe, even after "ransacking almost every store in the place" to obtain their supplies.

Washington officials must have been impressed by the general interest as well as the scientific value of Simpson's report. It was published within a few months of its receipt, with seventy-five numbered black-and-white illustrations and colored plates. Three thousand additional copies were printed, and two years later Lieut. Simpson had another edition privately printed in Philadelphia.

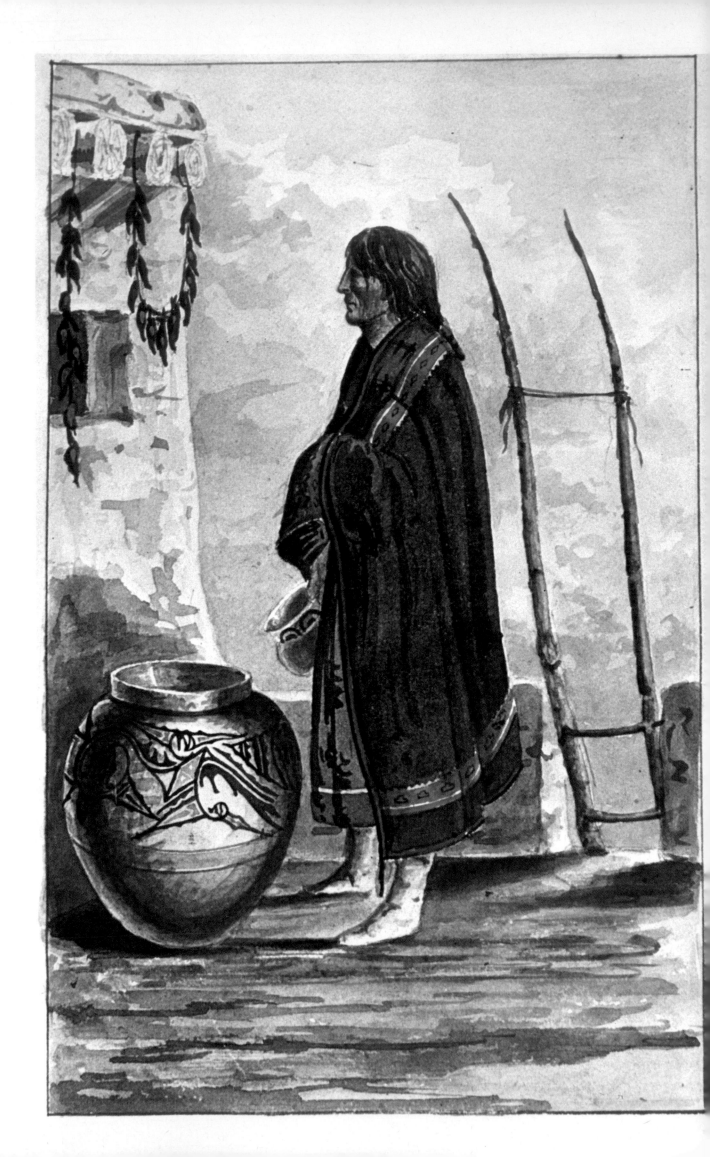

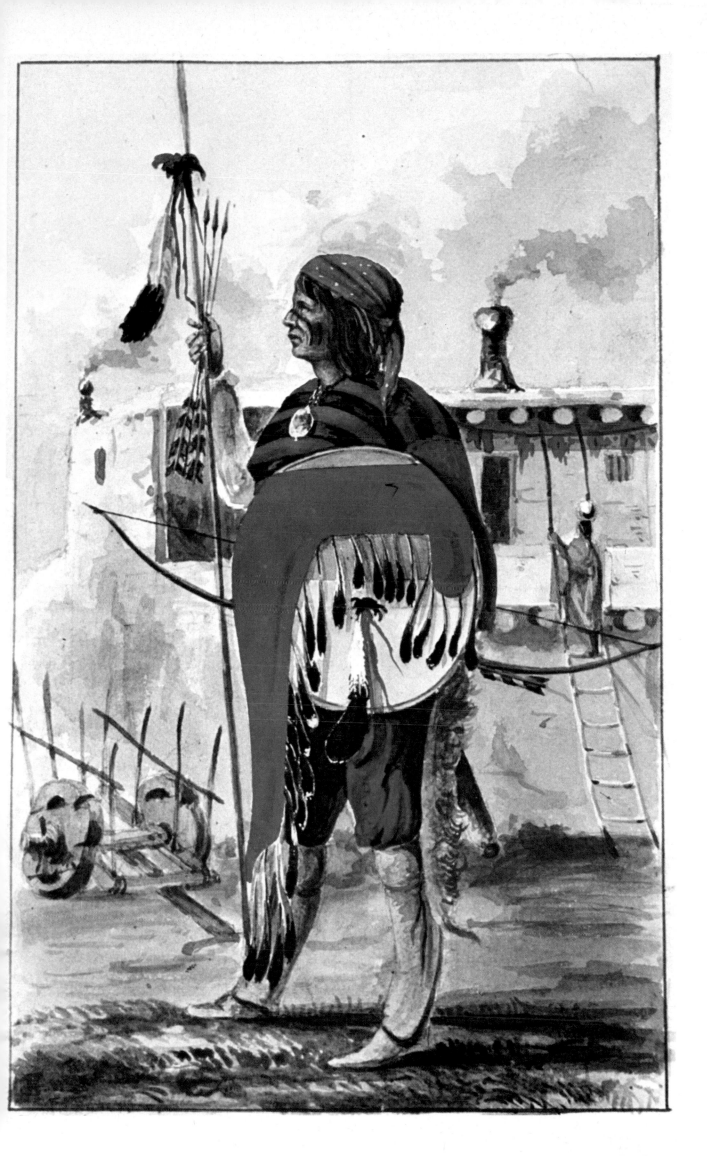

Simpson recommended that the region westward from Zuni to the mouth of the Colorado River should be officially explored and mapped, and Richard Kern was selected as the sole artist and cartographer for that expedition. On September 1, 1851, he reached Zuni with Capt. Lorenzo Sitgreaves of the Army Corps of Topographical Engineers, the party's leader. With them were the experienced mountain man Antoine Leroux as guide, and Dr. S. W. Woodhouse, physician and naturalist. There were also fifteen American and Mexican packers and muleteers and the mules needed to carry the expedition's supplies and equipment.

Men and mules tarried more than three weeks at Zuni waiting for the escort of fifty-five soldiers who would protect them from hostile Indians. As the days passed, Sitgreaves fretted over the diminishing supplies and the inadequate forage for his mules near Zuni. While collecting birds two miles from the pueblo, Dr. Woodhouse was bitten by "a fine specimen" of a rattlesnake. He followed an old western remedy Kern suggested—getting drunk on more than a quart of brandy. The doctor survived both bite and treatment, but carried his bitten left hand in a sling throughout the exploration.

During this unplanned delay, Kern explored Zuni, then the largest occupied pueblo in the Southwest, with an estimated 1,500 Indian occupants. Their terraced apartments of plastered stone rose to a height of five stories. The cornfields and peach orchards extended for miles down the valley of the little Zuni River. In small gardens close to the village, women grew onions, beans and chili peppers.

Kern saw and sketched men and women at their daily indoor tasks. In one room he pictured four women on their knees and side-by-side, grinding corn on primitive stone slabs with stone mullers. In another he showed a woman weaving cotton on an upright loom suspended from the roof beams. In a third he pictured men working iron at a forge in which the fire was regulated by air from large hide bellows.

Three centuries of Spanish influence had altered Zuni lifeways but slightly. Men had learned the art of blacksmithing. Carved and painted figures of Christian saints decorated their apartment walls. But painted pottery storage jars and food bowls of traditional types stood on the floors of their sparsely furnished rooms. In the open plaza before the old mission church Kern pictured a ceremonial buffalo dance such as the ancestors of the Zuni may have performed before the first missionaries came among them. Women wore upright wooden tablitas on their heads; the male dancers wore embroidered cotton kilts. With their rattles they kept time to their movements and to the accompaniment of a single drummer and a small group of male singers.

On September 21st Sitgreaves' expedition left Zuni on a 68-day, 658-mile march to Camp Yuma near the Mexican border. It proved a grueling ordeal for both men and mules, through a region which their leader termed almost entirely "barren, and without general interest." After he followed the Zuni River to its junction with the Little Colorado, and down that stream for two weeks on a northwesterly course, he decided that his supplies were getting too low and his mules too weak to risk following the long and tortuous river valley. So he turned westward overland to strike the Colorado well below its Grand Canyon. For a full week water was so scarce that the men could not wash their faces and hands. Hostile Indians harassed the party and stole some mules. On November 3rd their guide was severely injured by stone-headed arrows from the bows of Indians who were concealed behind

Whar-Te (The Industrious Woman), Wife of the Governor of Jémez. R.H.Kern. August 20, 1849. Watercolor. Academy of Natural Sciences, Philadelphia (preceding page 164)

Hos-Ta (The Lightning), Governor of the Pueblo of Jémez. R.H.Kern. August 20, 1849. Watercolor. Academy of Natural Sciences (preceding page 165)

Wash-U-Hos-Te (Big White Bead), A Pecos Indian. Thought to be drawn by R.H.Kern. 1849. Pen and ink. Academy of Natural Sciences, Philadelphia

rocks, and at daybreak on the 9th, Dr. Woodhouse received an arrow through the leg. Eight days later fifty or more Yumas attacked the party and mortally wounded a soldier of the escort before they were driven off by rifle fire.

Peaceful meetings with Indians were brief and few. Even so, Kern managed to picture members of three sparsely-clothed tribes of the Arizona desert: Yampais (Yavapais), Cosninos (Havasupais), and Mojaves. He portrayed the Mojaves as taller and more athletic people than the Zunis. The men wore breechclouts and protected their legs, arms and bodies from the hot sun with painted decorations. The women's only garment was a knee-length skirt of willow-bark strips. During the last ten days of their journey Sitgreave's men ate little but fresh mule meat. They were thankful to end their exploration at Camp Yuma on November 30th.

Although Sitgreaves' Report was also published as a Senate Document, it was much more meagre in text and illustrations than had been Simpson's Report of his more interesting and less harrowing explorations

in 1849. Captain Sitgreaves pointed to the map of the arid region his party explored as his major contribution. It was drawn by Richard Kern. Many of the illustrations pictured birds, animals and plants collected by Dr. Woodhouse on the plains *east* of New Mexico. But there were also more than a dozen Kern landscapes and detailed drawings of desert rodents, snakes, and strange four-legged reptiles from the region west of Zuni. Of greatest interest were Kern's revealing scenes of Zuni Indian life; there were also more stilted pictures of Indians of the Arizona desert. Even these may have been somewhat altered by eastern lithographers in copying the drawings for publication.

Neither Richard nor Edward Kern participated in southwestern explorations after 1851. Even so, Richard's experience in that region encouraged him to study and prepare a map of Coronado's travels through that region more than three centuries earlier, and to advocate a southwestern route in the growing controversy over the most practical railroad route from the Mississippi River to the Pacific Coast. He had hoped to explore the Southwest further, but the Corps of Topographical Engineers assigned him to work as "topographer and artist" for Captain J. W. Gunnison on the survey of a more central route farther north, across the plains of Kansas and the Colorado Rockies. Gunnison's party crossed the Rockies through the 10,032-foot Cochetopa Pass in southern Colorado and continued westward into Utah. On October 26, 1853, twelve members of the party were exploring the vicinity of Sevier Lake when they were attacked by Indians. Eight of them were killed, including Captain Gunnison and Richard Kern.

Edward Kern was at sea when his older brother was killed. In June 1853 he had joined Navy Captain Cadwalader Ringold's North Pacific Exploring Expedition as cartographer and photographer. During the next seven years he made scientific drawings of coastlines, and scenes in exotic ports from Kamchatka to Japan, China, and South America. After serving briefly with the Union forces during the Civil War, Edward Kern

Copies of Paintings upon the Walls of an Estufa at Jémez. R.H.Kern. August 20, 1849. Watercolors. Academy of Natural Sciences, Philadelphia (left)

Pouched Mouse. E.M.Kern. Lithograph after an original sketch made in 1851. "The Sitgreaves Report," 1853. Library of Congress (right)

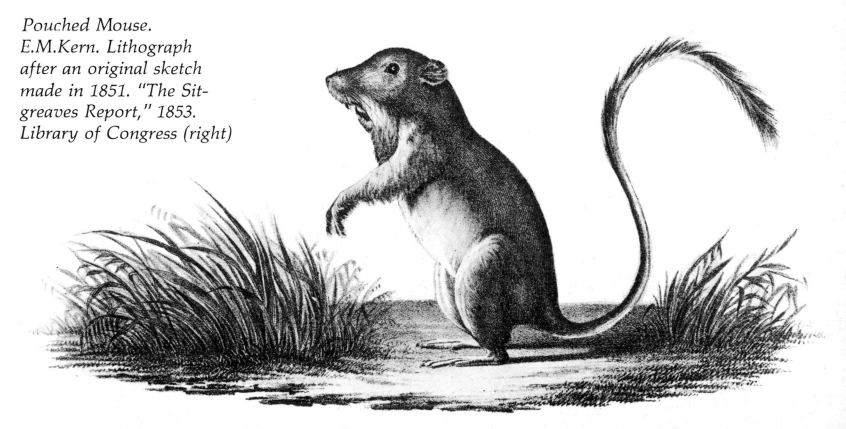

No ## 15

R H Kern delt.
Laguna Sept 2 1849

2

R H Kern delt.
Water Jug. Juni —

3

R H Kern delt.
Water Jug. Juni

died in Philadelphia on November 23, 1863, at the age of forty. His memory is perpetuated in the name of a river, a county and a town in California, the scene of his explorations with Frémont in 1846.

Who was the more able and versatile artist—Edward or Richard Kern? In the spring of 1851, at a time when Richard declined an offer from the Southern Boundary Commission, he strongly recommended his brother for the post: "He is my superior in topographical drawing and portrait painting, and my equal in the other departments of the art." But Lieut. Simpson considered them both "good portrait painters and most excellent topographers." On their exploration with Simpson they worked closely together; in some cases one redrew the other's work in preparing it for publication. Even so, Richard was credited with the very great majority of illustrations for the report, and his services were in greater demand on later explorations of the Corps of Topographical Engineers. An oil portrait of Richard by Edward in the Smithsonian Institution reveals that Edward did possess a considerable talent for portraiture.

Both brothers were artist-scientists in the Charles Willson Peale and Titian Peale tradition. Both became members of the Academy of Natural Sciences in Philadelphia in 1847. Richard literally gave his life to scientific field explorations, but Edward was no less willing to face the hazards of overland exploration beyond the Rockies in the mid-nineteenth century. They were both willing to devote their artistic talents to the tedious work of map-making and scientific illustration. Truth to nature was their goal; style and technique were but means to that end.

The Kern brothers' most important contributions to the pictorial record of the West were made on their expedition to the Navajo country with Simpson in 1849. Among their pictorial "firsts" were the first known portraits of Navajo Indians, whose descendants comprise this country's largest Indian tribe. Their pioneer pictures of Zuni and Jemez Indians and of their daily and religious life are of even greater importance to ethnologists. They anticipated the Indian works of more famous painters of the Taos Art Colony by a half century.

Richard's drawings of the prehistoric ruins in Chaco Canyon and the cliff dwelling in Canyon de Chelly are important documents in the history of American archaeology. They anticipated by a quarter century more intensive studies of these ruins which have been continued to the present day. Tree-ring dating of the timbers used in their construction has revealed that they were built during the Golden Age of Pueblo Indian culture, between 1000 and 1300 A.D., and were abandoned soon thereafter. Both climatic and social factors may have been involved in their abandonment: a prolonged drought, and floods robbing them of the crops needed for their subsistence; perhaps in the case of Pueblo Bonito, the largest prehistoric apartment house in the United States, factional bickering caused one group of occupants to leave before the other. Some of their descendants may have been living among the historic pueblos visited and pictured by the Kerns in 1849.

In view of the scientific importance of the Kern brothers' western pictures, it is fitting that the major collections of their field drawings and sketches should be preserved in museums of science and anthropology: the Academy of Natural Sciences in Philadelphia, of which both artists were members, and the Peabody Museum of Archeology and Ethnology at Harvard University.

ARTIST
AND TRAIL BLAZER
IN THE
NORTHERN ROCKIES

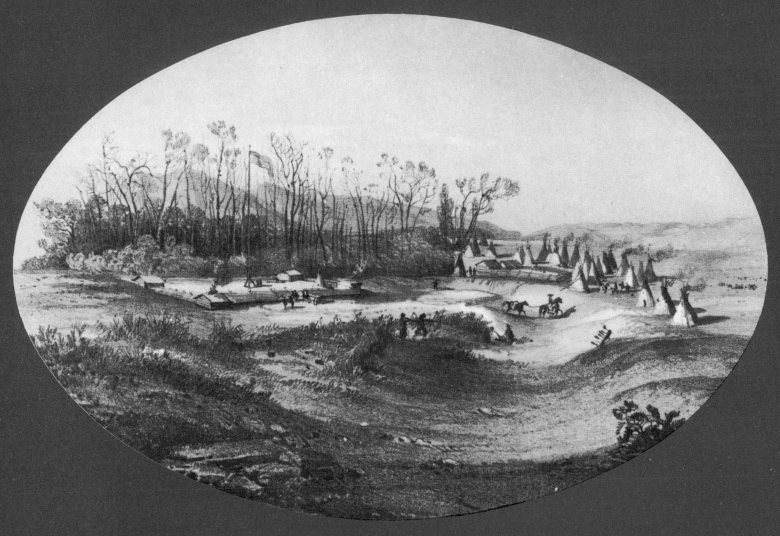

Gustavus Sohon

For forty-eight years after Lewis and Clark made the first recorded crossing of the Rocky Mountains from the headwaters of the Missouri to those of the Columbia in 1805, no other official exploring party passed through that rugged beautiful portion of the Western wilderness. Meanwhile the small tribes of mountain Indians whom Lewis and Clark met and described learned to bargain with white traders for fine furs and beaver pelts, and to listen to a few courageous missionaries who sought to save their souls. But half a century after Lewis and Clark, when these tribes made their first treaties with the United States, there were still no white settlers on their lands.

The great migrations of settlers and prospectors across the Great Plains and the Rockies to California, Utah, and the Oregon country during the decade of the 1840's followed more southerly routes—the well-worn trail up the North Platte and over the South Pass, or other trails still farther south. As the white population of the Pacific Slope grew rapidly, so did the demand for a railroad to connect these settlements with the eastern states. However, strong differences of opinion existed as to the route such a railroad should follow and the locations of its eastern and western terminals. Seeking to find a solution to this hotly debated problem, Congress, in 1853, authorized the War Department "to ascertain the most practical and economical route for a railroad from the Mississippi River to the Pacific Ocean."

Military expeditions, amply staffed with engineers, scientists, and cartographers, were organized and outfitted promptly and sent to explore a northern, a central and a southern route, and to prepare reports which would enable Congress to select the most favorable one.

The most challenging of these explorations was the survey of a northern route, between the forty-seventh and forty-ninth parallels, from the Mississippi River to Puget Sound. Major Isaac I. Stevens, an experienced military engineer who had been appointed the first governor of the newly created Territory of Washington, extending from the crest of the Rockies to the shores of the Pacific in the northwest, was placed in charge of this exploration. He left St. Paul on the Mississippi in June 1853, with a party which moved westward across the plains. Stevens also ordered Lieutenant Rufus Saxton, Jr., to proceed eastward from Fort Dalles on the Columbia and to establish a provision depot at the Flathead Indian village of St. Mary's in the Bitterroot Valley, west of the Continental Divide.

Among the eighteen enlisted men of Saxton's command was a black-haired, hazel-eyed, dark-complexioned German immigrant named Gustavus Sohon. Although he was only a private, this man was to play a significant role in the exploration of the Northwest. Born in Tilsit, Germany, December 10, 1825, Sohon had received a good education in his native land when, at the age of seventeen, he migrated to the United States to avoid compulsory service in the Prussian Army. But, after a decade of residence in Brooklyn as a bookbinder—and a maker of wood carvings—he volunteered for service in the army. Sohon enlisted in July 1852, and a few days later his Company K, Fourth Infantry, boarded the steamship *Golden West* for service on the Pacific Coast.

When Saxton's little force reached Fort Owen, the trading post for the Flathead Indians in the Bitterroot Valley, in late August 1853, Sohon was twenty-seven years of age. A gifted linguist, who spoke German, French, and English fluently, possessed of a keen, inquisitive mind, a marked talent for drawing, and a knack for making friends, Sohon soon made himself invaluable to the survey.

Cantonment Stevens in the Bitterroot Valley. Sohon. 1853. Lithograph after drawing. New-York Historical Society

By the time Governor Stevens reached the Bitterroot Valley, after crossing the Rockies by way of Cadotte's Pass in late September, he was convinced that his most critical problem was finding the most practical and economical route for a railroad over the Rocky and Bitterroot ranges. The only mathematical data and maps available for this area were those compiled by Lewis and Clark in their hasty travels. He needed much more detailed scientific information. So he decided to leave a small party in the Bitterroot Valley through the winter to take precise meteorological observations and to explore and survey the intermountain region, with special emphasis upon the examination of the entrances to the mountain passes.

Stevens ordered Lieutenant John Mullan to take charge of these critical investigations, and he assigned Private Sohon and fourteen other men to Mullan's command. They proceeded to erect four log huts some ten miles south of Fort Owen on the Bitterroot River. Named Cantonment Stevens, this little settlement served as a weather station and winter quarters for Mullan's explorations.

With remarkable rapidity Sohon learned to speak the Salishan languages of the nearby Flathead and Pend d'Oreille Indians, both of which sounded strange to American ears. Sergeant Ordway, of the Lewis and Clark Expedition, had observed when that party met the Flatheads forty-eight years earlier: "They have the most curious language of any we have seen before. They talk as though they lisped or have a burr on their tongue. We suppose that they are the Welsh Indians if there is any such from the language." Sohon became Mullan's interpreter and aided him in obtaining from those Indians valuable informa-

Alexander, Head Chief of the Pend d'Oreille Indians. Sohon. April 21, 1854. Pencil. Smithsonian Institution (above)

Aeneas, Iroquois Guide to Father De Smet. Sohon. May 16, 1854. Pencil. Smithsonian Institution (right)

tion on the trails and general geography of the region. He also accompanied explorations of the intermountain region southward as far as Fort Hall on the Snake River and northward to the Kootenay River. They crossed the Continental Divide six times and measured the snowfall in the various mountain passes. Sohon also executed landscape sketches depicting the country traversed, its landmarks, Cantonment Stevens, and the party on the march. Some of these drawings were reproduced as colored lithographs in the published report of the survey.

Sohon quickly made friends with members of the Flathead tribe who lived near Cantonment Stevens. This small tribe, numbering about three hundred persons, had had a peculiar attraction for all white men who had come to know them since Lewis and Clark first encountered them on their way West in 1805. Fur traders, missionaries, and explorers were unanimous in their praise of the courage and morality of these Indians, and their constant friendship for the whites. In and near their Bitterroot Valley homeland they hunted deer, elk, bear, beaver, and wild fowl, fished in the mountain streams, and gathered edible roots and berries in season. But they also made semi-annual excursions over the Rockies to hunt buffalo in the country of their powerful and aggressive enemies, the Blackfeet. In numerous battles and skirmishes with the Blackfeet the Flatheads lost many warriors. Yet they stoutly insisted upon their right to hunt on the buffalo plains.

Early in the nineteenth century some Iroquois Indians, who had followed the westward expanding fur trade as canoemen and trappers, settled among the friendly Flatheads. In their original homeland in the St. Lawrence Valley these Iroquois had been converted to Christianity;

they introduced among the Flatheads some of the concepts and simple rituals they had learned from the Catholic fathers, such as the offering of daily prayers, and the observance of Sunday as a day of rest. They urged the Flatheads to join them in seeking missionaries who would bring them the blessings of the Christian life. Repeated deputations of Iroquois and Flatheads to distant St. Louis in quest of "black robes" culminated in 1841 with the founding by Father Pierre Jean De Smet of the first Catholic mission in the Northwest, Saint Mary's, among the Flathead in the Bitterroot Valley.

The primitive Flatheads eagerly presented themselves for baptism in the new faith. Their warriors looked upon baptism and the wearing of crosses as potent war medicines which would protect them and bring them success in their frequent battles with the dread Blackfeet. But when Father De Smet tried to convince them that warfare was evil, that they should abandon their hazardous buffalo-hunting excursions to the plains, and that they should be content to remain in their own valley, raise crops and livestock, and become a farming people, these Indian warriors and hunters were not impressed. When the missionaries also insisted that they give up gambling (which they dearly loved), abandon polygamy, and the enforcement of law and morality by flogging the bare backs of offenders, they simply refused to do so. The missionaries were surprised to find that these friendly Indians, whom they thought would be so amenable to civilization, resisted all economic and social practices which were at odds with their own cultural experiences. The priests failed to recognize that nothing was more dear to the Flatheads than their independence. These Indians insisted upon their right to live their own lives. When they prayed to the white man's God they generally asked "to live a long life, to kill plenty of animals and enemies, and to steal the greatest number of horses possible," as Father Mengarini, one of the priests, acknowledged.

During the spring and early summer of 1854, Gustavus Sohon executed a series of pencil portraits of the Flathead chiefs. Even in their visored caps and cloth shirts, these were handsome, stalwart Indians. Figuratively speaking, none of them wore the white man's collar. Sohon's portraits provide a unique record of the appearance of these remarkable Indian leaders, who were some of the first converts to Christianity in the northern Rockies.

During the same period Sohon sketched the only known likeness of the two most prominent Iroquois still living among the Flatheads. Pierre Gaucher (also known as Iroquois Peter), and Aeneas (a Flathead corruption of the name Ignace) had played historic roles in the introduction of Christian missions among the tribes of the Northwest. In 1839, they had comprised the deputation to St. Louis which had secured the first priests for the Flatheads. In 1840, Aeneas had guided Father De Smet on the first of his many journeys across the Rockies, while Pierre went ahead alone to break the news of their coming to the Flatheads. Aeneas was a restless wanderer whose knowledge of the Rocky Mountain region was very useful to Lieutenant Mullan. Pierre, after the missionaries brought seeds and cattle, became the best farmer in the Bitterroot Valley. Yet his success in growing wheat, oats, and potatoes, and in raising livestock never persuaded the Flathead buffalo hunters to imitate him.

That spring Sohon also drew portraits of the principal chiefs of the Upper Pend d'Oreilles, allies and northern neighbors of the Flatheads in the beautiful Flathead Lake-Kootenay River region. Hardly more numerous than the Flatheads, this tribe had also welcomed Christian mission-

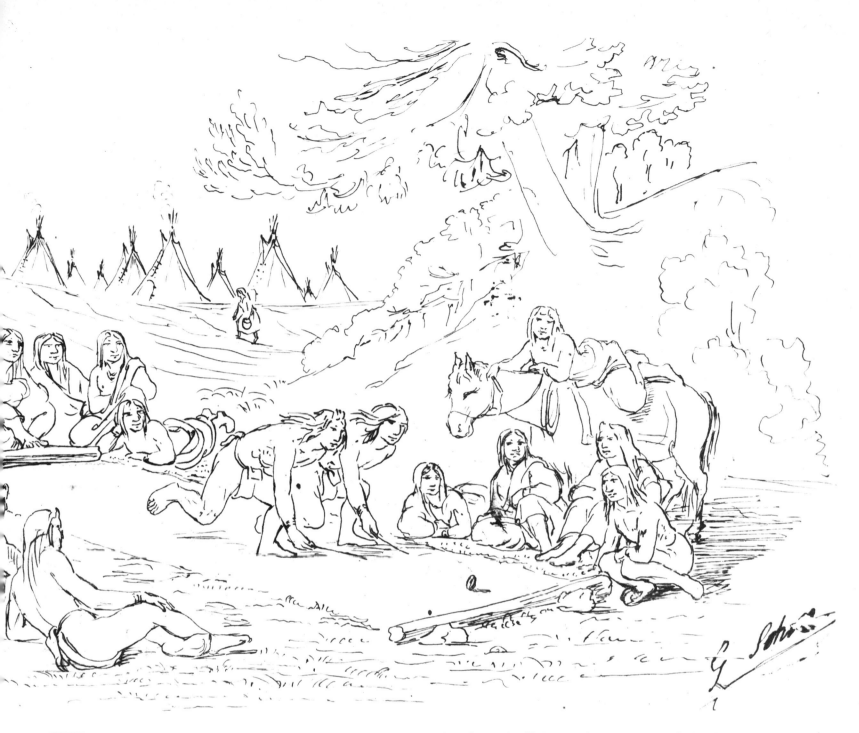

Flathead Indians Gambling. Sohon. Undated. Pen and ink. Smithsonian Institution

aries, but continued to hunt buffalo in the country of the hostile Blackfeet. Outstanding among them was No Horses, baptized Alexander, who had been head chief of his tribe for twenty years. Although Sohon's portrait shows him wearing a cross on his chest, Alexander was a proud war leader and a stern disciplinarian who did not hesitate to use his whip on unruly young men of his tribe.

In the fall of 1854, after a year of exploratory work in the mountain valleys, Lieutenant Mullan led his little party westward to rejoin Governor Stevens at Fort Dalles. The governor was so favorably impressed by Sohon's work that he arranged for his transfer to detached duty with him. Before Stevens set out on a march eastward to obtain additional field data for his railway survey and to make the first treaties for the United States with the northwestern tribes, he paid tribute to Private Sohon as "a very intelligent, faithful and appreciative man who . . . had shown great taste as an artist, and ability to learn the Indian language, as well as facility in intercourse with the Indians." Governor Stevens'

son, Hazard, who accompanied this expedition, wrote of Sohon as "the artist, barometer carrier, and observer . . . an intelligent German, a clever sketcher, and competent to take instrumental observations."

In late May 1855, on a tributary of the Walla Walla River, Sohon was present at one of the largest gatherings of Indians in the history of the Northwest. During it Governor Stevens negotiated treaties with the Walla Walla, Cayuse, Umatilla, Yakima, and Nez Percé tribes of the Columbia Valley in which they ceded to the United States an area larger than the entire state of New York. Sohon made pencil sketches of the mounted parade of some 2,500 Nez Percé arriving at the council ground, the feast given the Indians by the Commissioners, a general view of the council in session, and the exciting scalp dance by Nez Percé braves on the day after the treaty was signed. He also drew portraits of the chiefs who signed the treaty, and sketched a group of young Nez Percé, who had been taught to write by Presbyterian missionaries, as they recorded the proceedings in their own language.

In mid-July, Governor Stevens negotiated the first treaty with the Flathead, Upper Pend d'Oreille and Kutenai tribes at a council ground northwest of present-day Missoula, Montana. Sohon's panoramic view of this council shows why the Indians still refer to this site as "where the trees have no lower limbs." Sohon also served here as one of the official interpreters; the negotiation resulted in the cession of 25,000 square miles of Indian land.

The Stevens party then continued eastward over the Rockies. After reaching the plains Sohon sat down and painstakingly drew the first panoramic view of the lofty main chain of the Rocky Mountains in present Montana, extending from Chief Mountain, near the Canadian border, southward as far as the eye could see. Redrawn by John Mix Stanley for publication as a colored lithograph in the official reports of the railroad surveys, this is a magnificent view of the "shining mountains." Farther eastward Sohon made the earliest known drawings of the Great Falls of the Missouri, the passage of which had been so arduous for the westward-bound Lewis and Clark exploration.

Sohon participated in the council on the Missouri River at the mouth of the Judith in October 1855, when Governor Stevens negotiated the first treaty with the warlike Blackfoot tribes and the Gros Ventres. He interpreted for the Flathead and Pend d'Oreille chiefs who eloquently argued their traditional right to hunt buffalo on that northwestern portion of the Great Plains which Stevens marked on his map as the exclusive domain of the Blackfoot tribes. He drew the only known view of that historic council and a fine series of portraits of the principal Blackfoot and Gros Ventres chiefs, including the Piegan head chief, Lame Bull, the first signer of the treaty.

When a mounted courier brought word to Stevens that the tribes with whom he had treated recently on the Walla Walla had broken out in open warfare, he purchased arms and ammunition for his party at Fort Benton and pushed on westward, over the Rockies, the Bitterroots, and the Cœur d'Alenes, and through the country of the hostiles, reaching Fort Dalles by the end of the year. Sohon sketched the pack train crossing the snowcovered Bitterroots on this long forced march.

Private Sohon spent the remainder of his enlistment—until July 2, 1857—working over his field sketches and preparing maps and meteorological data. During his final months of military service he helped to prepare the first reasonably accurate map of the Western United States in the Topographical Engineers' office at Benicia, California.

Lame Bull, Head Chief of the Piegans (first signer of the first treaty between the Blackfoot tribes and the United States). Sohon. October 1855. Pencil. Washington State Historical Society

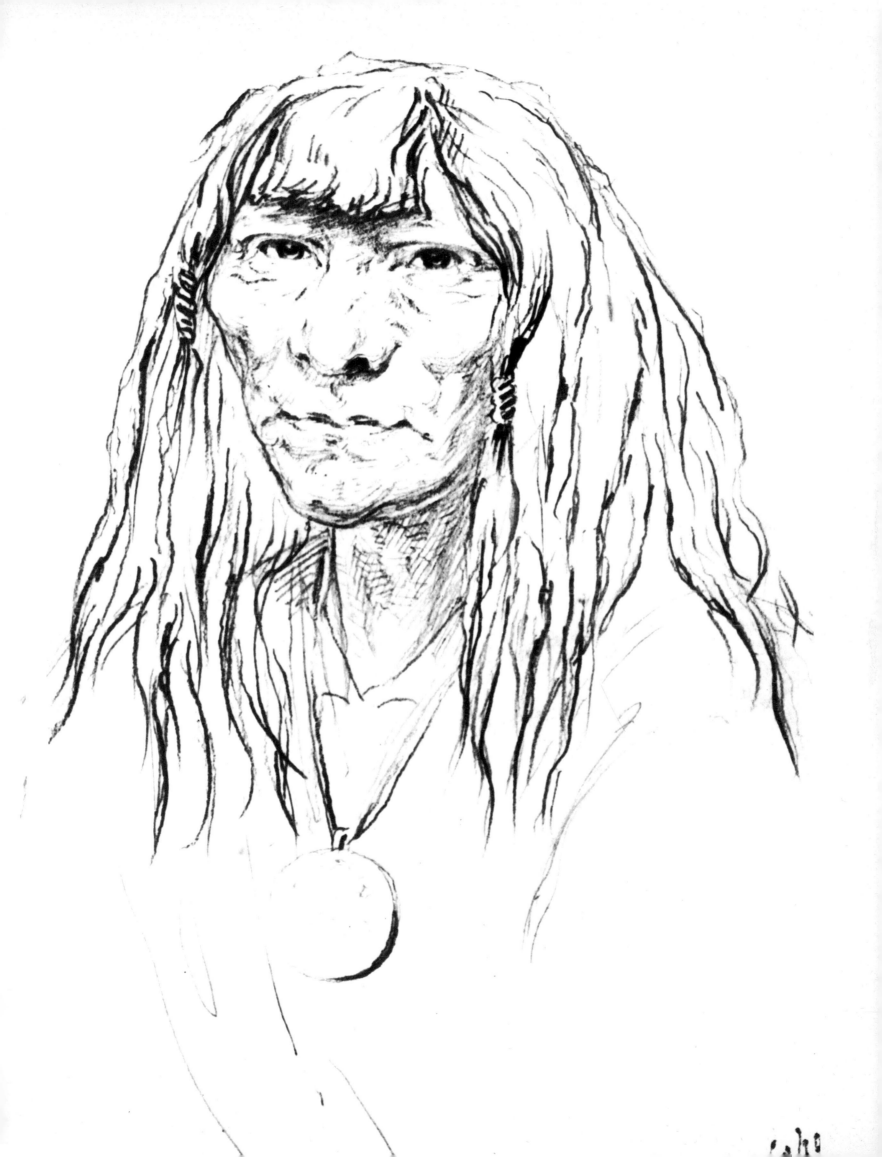

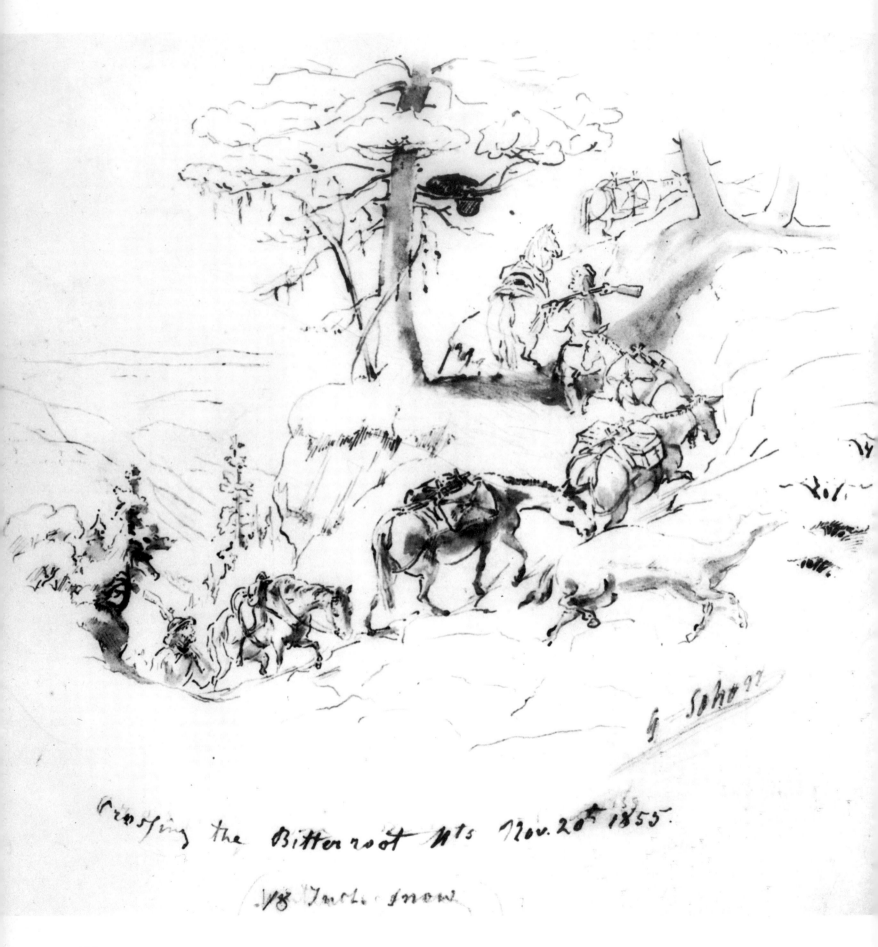

Crossing the Bitterroot Mts Nov. 20th 1855.

1/8 Inch snow.

By the spring of 1858, Sohon was back in the Northwest working as a civilian "guide and interpreter" for his former commanding officer, who had been placed in charge of constructing the first wagon road over the Northern Rockies, from Fort Benton on the Missouri to Fort Walla Walla on the Columbia. Sohon's title is no true indication of his contribution to the success of this difficult enterprise. Not only did he negotiate with the Indians through whose country the road was to pass, but he led the advance party that marked out the route through the wilderness, and over mountain passes. He guided the first wagon train in a two-months' trip over the new road.

For two more years Sohon worked with Mullan making improvements and short cuts in the wagon road. A few sketches drawn by Sohon during this period provide an idea of the rugged country through which the road passed and the difficulties in its construction. When completed, after more than four years of work, it was 624 miles long and from twenty-five to thirty feet wide. It could be traveled by wagons in fifty-seven days, by pack trains in thirty-five. Popularly known as the Mullan Road, it served as a military wagon road and as a highway for travelers and settlers and for the transport of freight to the Northwest until the completion of the railroads across the northern Plains and Rockies two decades later.

At the close of the 1862 field season, Sohon accompanied Lieutenant Mullan to Washington to help in preparing the text, maps, and illustrations for the official *Report on the Construction of a Military Road from Fort Walla to Fort Benton* (published in 1863). It contained ten colored lithographic reproductions of original drawings by Gustavus Sohon. Two maps in this report give the name Sohon Pass to the crossing of the Cœur d'Alene Mountains through which Sohon had literally blazed the trail for the mountain road.

Sohon never returned to the scene of his nine years of activity in the Northwest. For a brief period in the middle 1860's he had a photographic studio in San Francisco. Thereafter, he ran a shoe business in Washington, D.C., and he died in that city on September 3, 1903.

It is doubtful if any other nineteenth-century artist contributed in so many ways to the development of the West, or possessed a more intimate knowledge of the Indians or the landscape he pictured. It may have been that Private Sohon's artistic background had nothing to do with his assignment to duty with the northern railway survey in the year 1853, but it was a fortunate circumstance for the pictorial history of the American West. Sohon extended the pictorial record geographically westward from the mouth of the Marias, across the Rockies and Bitterroots to the valley of the Columbia with the same regard for accuracy in drawing that Karl Bodmer had shown on the Upper Missouri.

More than one hundred of Sohon's pencil or pen-and-ink drawings executed in the Northwest from 1853 through 1862 are preserved in various collections. They are characterized by clean, sure lines, and a very realistic three-dimensional quality, whether the subjects are landscapes, historic councils, Indian activities, or portraits. Hazard Stevens, who was present when Sohon drew many of his Indian portraits at the treaty councils of 1855, observed that Sohon "had great skill in making expressive likenesses." At his best, in his portraits of the Flathead leader, Adolphe, and the two Iroquois living among the Flatheads in 1854, Gustavus Sohon demonstrated a talent for portraiture that justifies ranking him among the most able artists who interpreted the plains and the Rockies during the nineteenth century.

Crossing the Bitterroot Mountains. Sohon. November 20, 1855. Pen and ink. Smithsonian Institution

SCENES OF
ROCKY MOUNTAIN
GRANDEUR

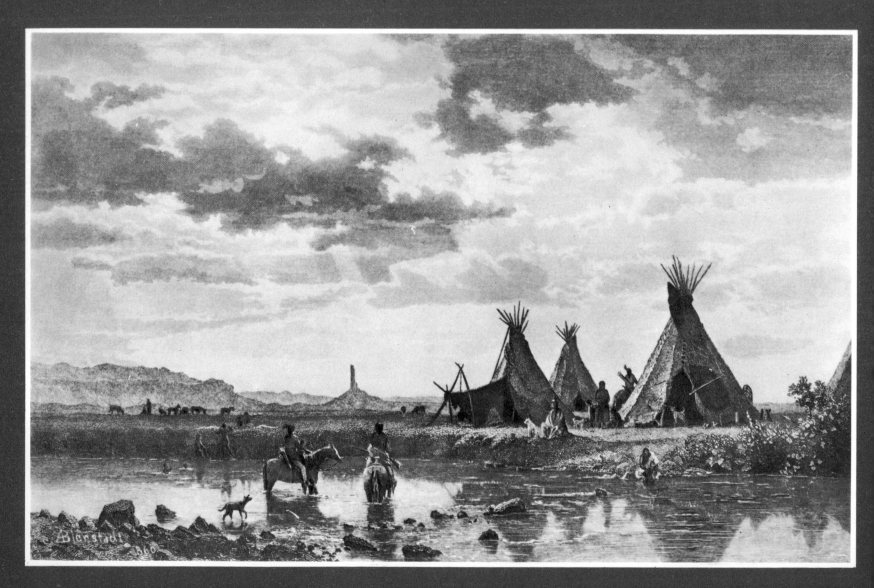

Albert Bierstadt and Thomas Moran

The year 1859 was a memorable one in the history of the Rocky Mountains. More than 100,000 excited gold-seekers hurried across the grassy plains to the Pikes Peak region. In that year, too, a little-known German-born artist got his first sight of the Rockies. Very few of the prospecting horde found any precious metal, but the lone artist found inspiration in the Rockies that brought him international fame and fortune. Just as there had been isolated, little-publicized gold discoveries in the Rocky Mountain region before the rush to Colorado in 1859, so had there been earlier painters of Rocky Mountain scenery—Samuel Seymour in 1820, Alfred Jacob Miller in 1837, Gustavus Sohon and other artists of the Pacific Railway explorations in the middle 1850's. But none of their small pencil sketches or watercolors became as widely-known as Bierstadt's large oils, which achieved popularity within five years of his first acquaintance with the Rocky Mountains.

Albert Bierstadt was born in Solingen, near Düsseldorf, January 7, 1830. Two years later his family moved to New Bedford, Massachusetts, where Albert received his basic education. His mother, a cousin of the German painter, Hasenclever, tried to dissuade her son from becoming an artist. He was twenty-one years of age before he painted his first work in oils. In 1853, he returned to Germany for more than three years of intensive study in Düsseldorf, an important art center. Then he traveled widely in Europe, sketched in the Alps and Apennines, and wintered with the colony of American artists in Rome. When he returned to the United States in 1857, he was thoroughly trained in the Düsseldorf techniques of field sketching in oils, pencil and charcoal.

Early in 1859, a government expedition, led by a civil engineer, Frederic W. Lander, headed westward to improve the mountain portion of the wagon road from Fort Kearney, through the South Pass and on to the eastern border of California near Honey Lake. Albert Bierstadt and S. F. Frost of Boston gained permission to accompany Lander's party to the Rockies at their own expense. By May, Bierstadt was on the same route Alfred Jacob Miller had traveled twenty-two years before—up the Platte and Sweetwater valleys to the South Pass. In the intervening years this had become a well-worn emigrant road, the Oregon Trail. As the Lander party moved up the Platte east of its fork, they met thousands of discouraged gold-seekers returning eastward and declaring that the Pikes Peak gold rush was a complete humbug. Lander induced many of them to turn their wagons west again toward more distant lands of opportunity—California or Oregon. They swelled the number of emigrants over this trail in 1859 to some 13,000, with 1,400 wagons and 30,000 head of stock.

Bierstadt had a fine opportunity to observe the overland emigration in one of its heaviest years since the California gold rush a decade earlier. One of his small paintings, *Nooning on the Platte*, shows a family wagon, with its associated oxen and hogs during a typical heat-of-the-day rest period on the long journey. Late in May, the Lander party met an encampment of some three hundred peaceably inclined Oglala Sioux Indians. Bierstadt both sketched and took steriopticon views of these Indians with some photographic equipment he carried with him. Seven years later a fine engraving of his 1860 studio painting of a portion of this Sioux camp with the famous Oregon Trail landmark, Chimney Rock, in the distance was published in the *Ladies Repository*.

Nearer the Rockies he painted a view of Lander's wagons against a distant mountain background. By June 6th, the party reached Fort Laramie, converted ten years before from an Indian trading post into the

Chimney Rock in the Platte River Valley with Oglala Sioux Village in Foreground. Bierstadt. 1859. Engraving after a painting. "The Ladies Repository," January 1866

most important military post for the protection of travelers on the Oregon Trail. From a ridge a few miles west of that fort the travelers caught a fine view of Laramie Peak some forty miles westward; it was to become the subject of one of Bierstadt's best-known paintings.

By June 24th, the party reached South Pass and soon thereafter Bierstadt, Frost, and a muleteer, with a single springwagon, six mules and some saddle horses, left Lander's group to make their own explorations in the vicinity of the Wind River and Shoshone Mountains of Wyoming. On July 10, 1859, Bierstadt wrote a letter from the Rocky Mountains to *The Crayon*, which disclosed the artist's genuine enthusiasm for the Rocky Mountain West:

I am delighted with the scenery. The mountains are very fine; as seen from the plains they resemble very much the Bernese Alps. . . . They are of granite formation, the same as the Swiss mountains and their jagged summits, covered with snow and mingling with the clouds, present a scene which every lover of landscape would gaze upon with unqualified delight. . . . The color of the mountains and of the plains, and indeed that of the entire country, reminds one of the color of Italy; in fact, we have here the Italy of America in a primitive condition.

Bierstadt found:

. . . the figures of the Indians so enticing, travelling about with their long poles trailing along the ground, and their picturesque dress, that renders them such appropriate adjuncts to the scenery. . . . The manners and customs of the Indians are still as they were hundreds of years ago, and now is the time to paint them, for they are rapidly passing away. . . . I think that the artist ought to tell his portion of their history as well as the writer; a combination of both will render it more complete.

Camping out in the midst of such inspiring subjects for his brush was an exhilarating experience for Bierstadt. He ate antelope, mountain grouse, sagehens, and other wild game, slept under the starry sky, and woke with the dew on his face. "I enjoy camp life exceedingly," he assured his readers. "I never felt better in my life."

Returning eastward in late summer, Bierstadt set to work with enthusiasm, developing many of his small field sketches into the huge oil paintings he thought were needed to interpret the great out-of-doors in its true proportions. For him a big country required a big canvas. When his *The Rocky Mountains* was completed on more than sixty square feet of canvas, its first showing in New York was advertised on street banners outside the gallery. It was really two pictures in one, reflecting Bierstadt's dual interest in scenery and Indians. When viewed from a distance it had the appearance of a mountain valley spectacularly framed by a background of rugged and magnificent peaks. But upon moving closer the viewer was attracted by the detailed rendering of the small encampment of Shoshoni or Bannock Indians in the valley foreground. Bierstadt may have relied upon his field photographs for some of these details. Certainly his portrayals of costumes, riding gear, weapons, tipis, and numerous articles of household equipment are much more sharply defined than those in Alfred Jacob Miller's watercolors of Indian encampments in the same region. Some critics thought this profusion of foreground detail incompatible with artistic unity in so large a canvas. But the public loved it. And their enthusiasm for Bierstadt's huge paintings was shared by men of wealth who eagerly sought his outsized oils for museum or private collections. His *Lander's Peak* (Wyoming) was sold to a London collector for $25,000, a record for a painting by an American artist at that time.

G*reat Spring of the Firehole River. Moran. 1871. Watercolor. Yellowstone National Park (top)*

Grand Canyon of the Yellowstone. Moran. 1872. Oil. U.S. Department of the Interior (bottom)

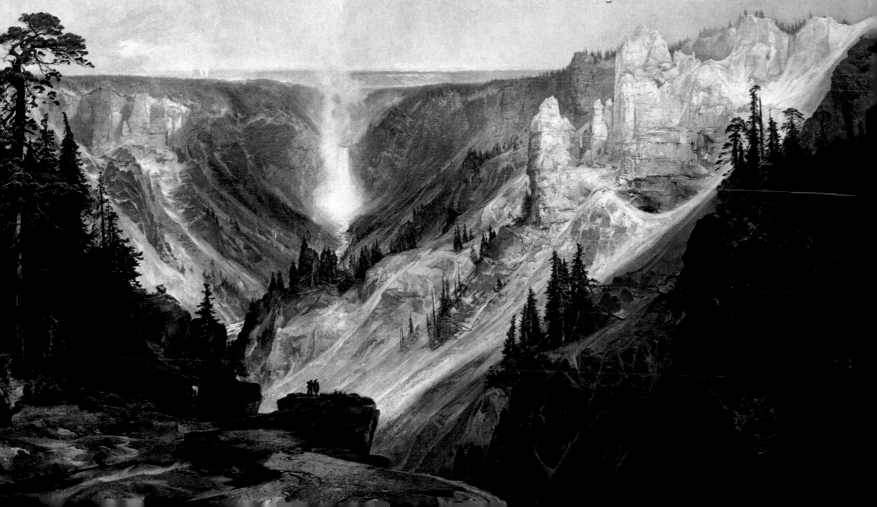

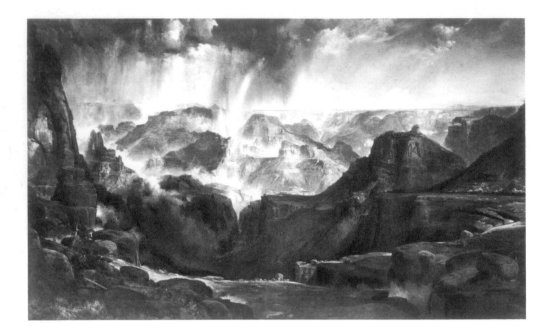

Another popular work from Bierstadt's studio following his first trip West was an allegorical interpretation of the great overland migration, entitled *The Oregon Trail*. Even though Bierstadt had been an eyewitness to this movement, this painting does not seem to represent any actual site along the trail or any specific wagon train. But it does record the heroic spirit of that epic trek.

In 1863, Bierstadt extended his travels westward beyond the Sierra Nevada, painting for several weeks in the beautiful Yosemite Valley of California. During the late 1860's and early 1870's, he painted Rocky Mountain scenes in Colorado, at first on his own, and later as a guest at the hunting lodge of the enthusiastic British sportsman, the Earl of Dunraven, in Estes Park. Among his interpretations of the Colorado Rockies were paintings of Grand Lake and of Longs Peak. Two of Colorado's scenic attractions still bear Bierstadt's own name—14,045-foot-high Mount Bierstadt in the Front Range near Mount Evans, and gem-like Bierstadt Lake in Rocky Mountain National Park.

By the decade of the 1870's, Albert Bierstadt had become the most widely known active American painter. His works found a place in the Hermitage in St. Petersburg, the Imperial Palace in Berlin, and in the homes of wealthy families in England and America. The United States commissioned him to execute two historical paintings for the Capitol in Washington.

Nevertheless, in 1889, a committee of New York artists selecting paintings for the Paris Exposition refused to hang his large, melodramatic landscape with figures, *Last of the Buffalo*, because its style was out of step with the newer ideals in French painting. Albert Bierstadt's later years were plagued by ill health as well as the decline in his reputation. On February 18, 1902, at the age of seventy-two, he suffered a heart attack and died.

Probably no other artist in American history has been both such a beneficiary and such a victim of changing values in art criticism. When his vast canvases of Rocky Mountain scenery first appeared, each carefully developed in the studio from numerous small field sketches, their grand scale helped to impress the beholder with the grandeur of our

The Rocky Mountains. Bierstadt. 1863. Oil. Metropolitan Museum of Art, New York (overleaf)

186

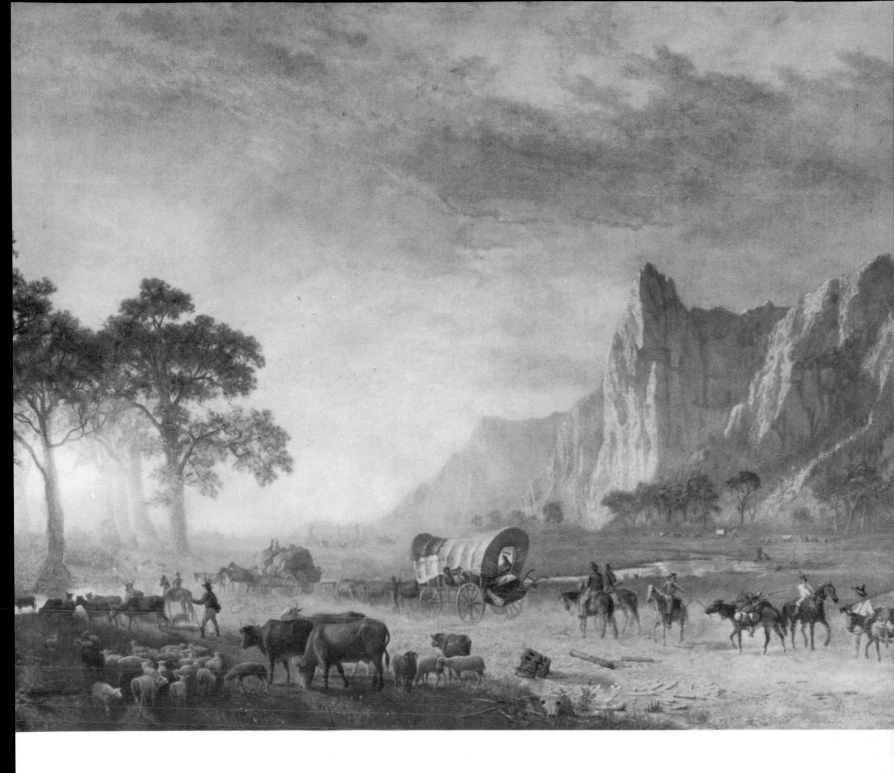

The Oregon Trail.
Bierstadt. About 1865. Oil.
The Butler Institute of
American Art, Youngs-
town, Ohio (above)

The Chasm of the Colo-
rado. Moran. 1876. Oil.
United States Department
of Interior Museum (left)

Western wilderness. That Bierstadt tended to gild the lily and to rely upon formulae to achieve dramatic effects became more obvious as his huge canvases increased in numbers. By placing a lone horseman or one or more wild animals in the foreground he emphasized the solitude of the wilderness and the immensity of the landscape. By breaking foreground and background he achieved theatrical effects of distance. By filling his skies with ominous stormclouds or a colorful rainbow, and by exaggerating the heights of trees, waterfalls, or towering peaks, and the depths of mountain valleys, he tended to overstate his case. Our Rockies are not really the equivalent of the Swiss Alps, for the Rockies rise from a much loftier land mass.

Meanwhile, the critics had become increasingly aware of the brilliant colors and fluid brush techniques of the French impressionists. By comparison Bierstadt's Düsseldorfian concern with minutiae appeared meretricious, his colors dull, his forms static, his application of paint

187

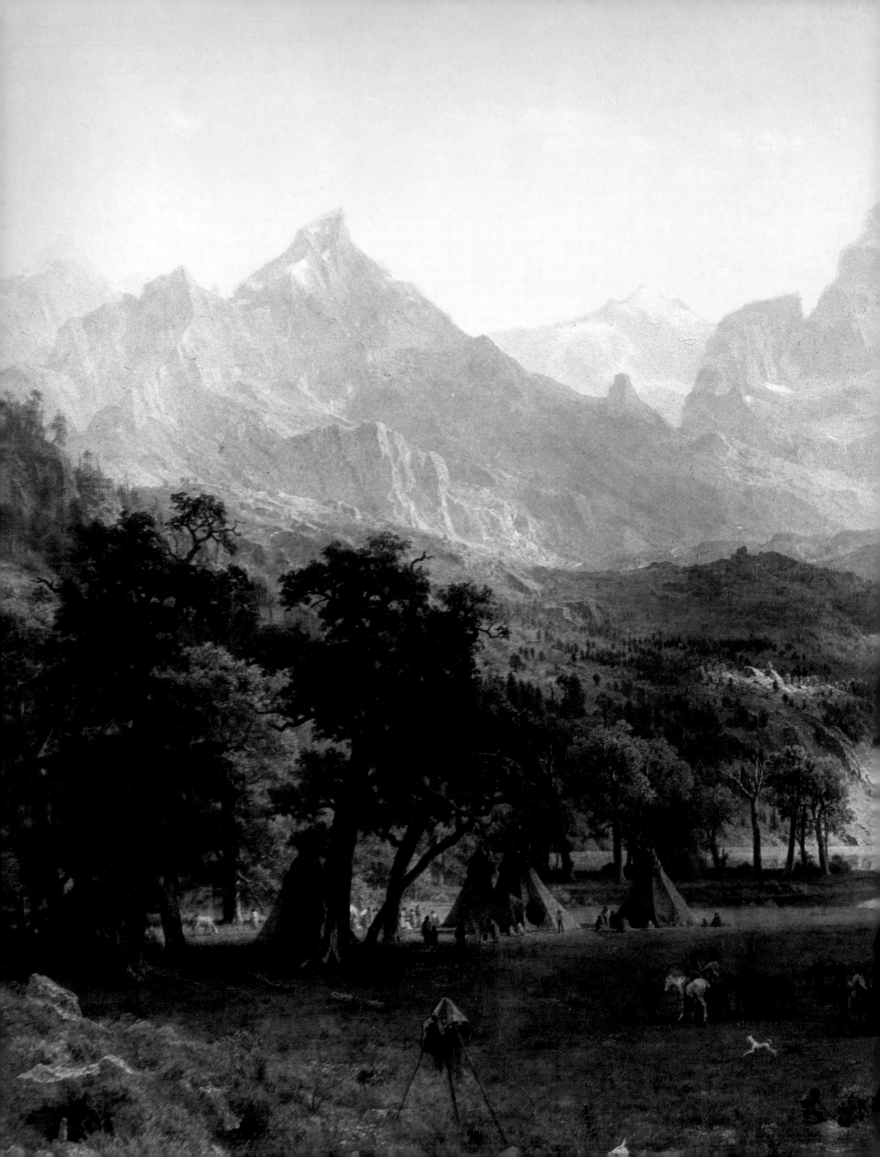

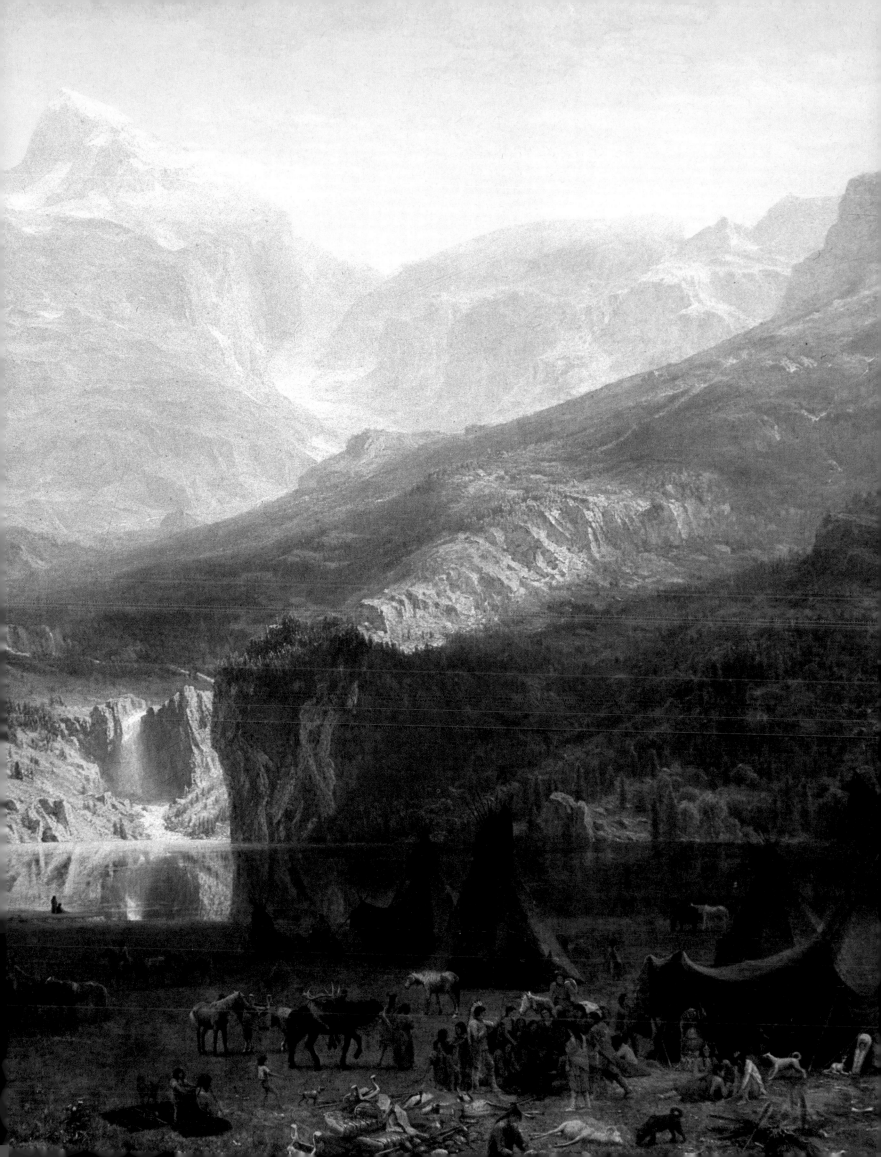

heavy-handed. His obituaries referred to his great popularity of "forty years ago." Charitably, the *Outlook* of March 1, 1902, observed: "The defects of his works are very obvious and they have been felt so keenly that his work is now probably undervalued." Viewing his huge canvases after the passage of another half-century we are likely to decide that they are neither so able nor so inept as the extremist critics of earlier generations rated them.

In recent years even those critics who decry the immobility of his studio paintings have praised Bierstadt's small oil-on-cardboard field sketches. They reveal a keen observation, skilled draftsmanship, and spontaneous appreciation of basic forms that mark a creative artist rather than a mere craftsman.

Albert Bierstadt had achieved an international reputation as the foremost painter of our Western mountains by the time Thomas Moran first saw the Rocky Mountains in 1871. Moran, like Bierstadt, was born abroad and raised in this country, and gained rapid recognition for the pictures based upon his first Western field trip. In other respects the resemblances between the two leading artists of the so-called Rocky Mountain School were few.

Thomas Moran was born in Bolton, Lancashire, England, January 12, 1837. His parents brought him and their six other children to America when Tom was seven years old. They settled in Philadelphia where the boy attended public schools until the age of fifteen. Apprenticed in his sixteenth year to the firm of Scattergood and Telfer, wood engravers, young Tom quickly demonstrated skill in drawing on the wood block. He began to make small watercolors on his own, the firm found a market for them, and he gained a sureness of touch and an interest in drawing

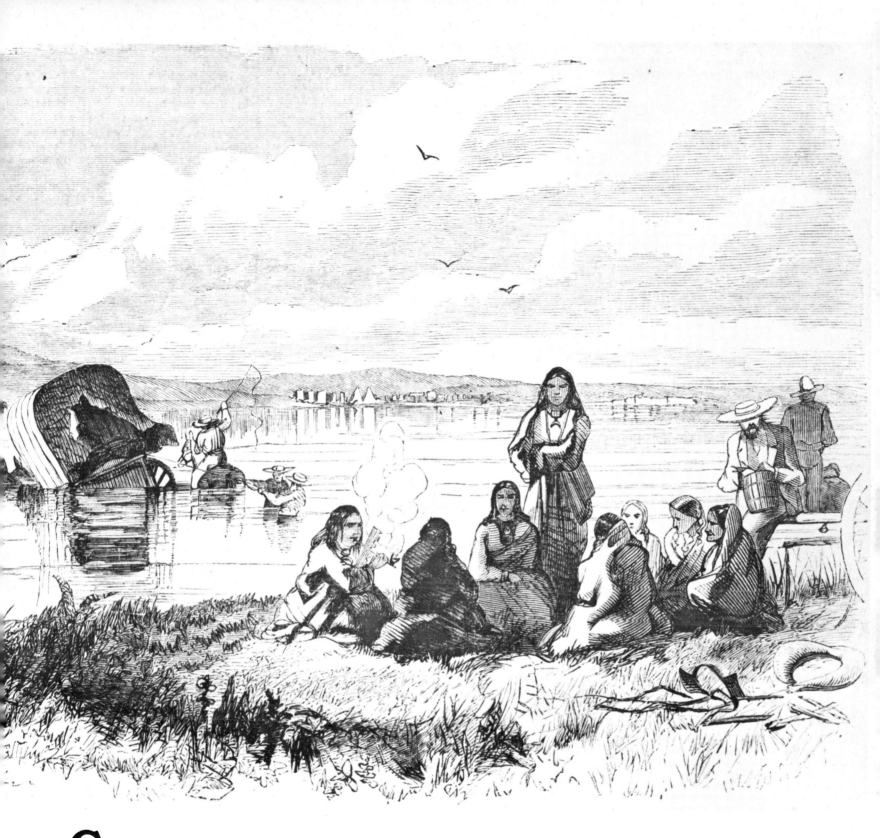

Crossing the Platte.
Bierstadt. 1859. Engraving
from a field sketch. "Har-
per's Weekly," August 13,
1859 (above)

A Pike's Peaker. Bierstadt.
1859. Engraving from a
field sketch. "Harper's
Weekly," August 13, 1859
(left)

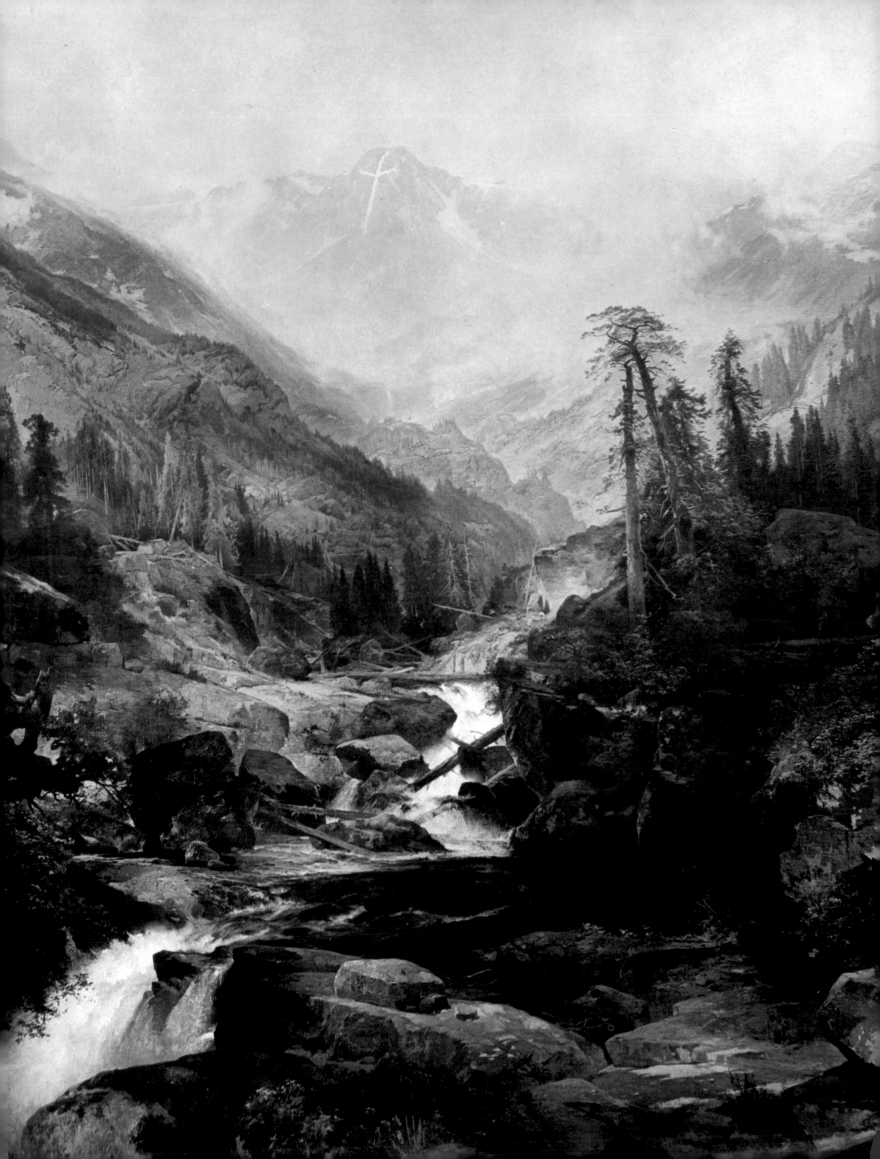

for reproduction which was to serve him well in later years as an etcher and lithographer as well as a painter.

After three years the youth fell seriously ill and was released from his apprenticeship. Upon his recovery he entered the studio of his older brother, Edward, an able marine painter. Although he profited from his close association with his brother, and from the encouragement of James Hamilton, another painter of marine subjects, Thomas Moran was largely self-taught. Experimenting with various media, he made his first etching in 1856, his first lithograph in 1860. In his twenty-first year he exhibited a watercolor at the Pennsylvania Academy of Fine Arts. Fascinated by color, he sought inspiration in the imaginative and dramatic works of J. M. W. Turner, and in 1861, a decade after Turner's death, Moran went to London to study and even to copy some of Turner's original works. Six years later he studied the works of old masters in Europe. The great paintings of the past stirred Moran's sensitive imagination and inspired his quest for ideal beauty and color in nature. By 1870, his own works had been exhibited in the Paris Salon and he had won membership in the Pennsylvania Academy of Fine Arts.

A peculiar chain of circumstances attracted Thomas Moran to the American West. The natural wonders of the mountain region around the headwaters of the Yellowstone River had become one of the most persistent legends of the West. John Colter, who had left the Lewis and Clark Expedition during its return journey in 1806 in order to hunt and trap on the Yellowstone, had traversed part of the headwaters region in 1807. Later fur trappers discovered the great geysers of the Firehole River, and as late as the 1860's old Jim Bridger insisted that the mountain men's tall tales of spouting natural fountains, boiling hot springs, and a huge mountain of glass (obsidian) were not yarns invented for the benefit of gullible greenhorns. But not until after the gold rush to Montana in the 1860's did influential men become interested in exploring the Yellowstone headwaters to determine if its natural resources were worthy of economic exploitation. Late in the summer of 1870, nineteen men led by Henry Dana Washburn, Surveyor-General of Public Lands in Montana, and Lieutenant Gustavus C. Doane explored the fabulous region and found the geysers, hot springs, and other natural formations even more awe-inspiring than they had been pictured in the words of the old trappers. They returned to Montana as enthusiastic propagandists for a revolutionary idea: this wonderland must not be permitted to pass into private ownership; it must be preserved by the federal government for the enjoyment of all the people.

That winter Nathaniel P. Langford, a member of the expedition, lectured in Washington and New York on the natural marvels of the region and wrote an article for *Scribners*, *The Wonders of the Yellowstone*, which Thomas Moran was invited to illustrate. Working entirely from descriptions, Moran became the first pictorial interpreter of the Rocky Mountains to try to portray some of its distinctive local features *before* he saw them. This experience stirred Moran's imagination and his desire to see the region. Dr. Ferdinand V. Hayden, in charge of the Geological Survey of the Territories, heard Langford's enthusiastic lecture in Washington on January 10, 1871, and decided to shift his next summer's scientific explorations to the Yellowstone region. Moran borrowed money so that he could join Hayden's group as guest artist.

Moran was then thirty-four years old. He was slight and frail, had never ridden a horse, and lacked experience in rough wilderness life. He joined Hayden's thirty-five-man expedition in Virginia City, Montana,

Mountain of the Holy Cross, Colorado. Moran. 1875. Oil. Huntington Hartford Collection, Gallery of Modern Art, New York

early in July 1871, after a hard, five-day stagecoach ride from Ogden, Utah. Yet he quickly adapted himself to the rigors of horseback travel and camp life. In William H. Jackson, the party's pioneer Rocky Mountain photographer, he found a sympathetic colleague. An amateur artist, Jackson respected Moran's talent and sought his advice in composing his own field photographs. Moran did not regard the literal, monochrome products of Jackson's camera as a threat to his own colorful watercolor sketches. A close friendship between artist and photographer developed quickly and lasted until Moran's death nearly fifty-five years later. Indeed, the best appraisal of the modest artist's contribution to that first scientific exploration of the upper Yellowstone was penned by Jackson. He recalled Moran's "picturesque appearance when mounted. The jaunty tilt of his sombrero, long yellowish beard, and portfolio under his arm marked the artistic type, with something of local color imparted by a rifle hung from his saddle horn."

With a military escort from Fort Ellis in the Gallatin Valley to protect them from possible Indian attacks, the expedition marched some thirty miles eastward to the Yellowstone Valley, then up that valley about ten miles to the Boteler brothers' ranch. Leaving their wagons and carrying their supplies and equipment on pack horses, they followed the Yellowstone to the mouth of Gardiner's River. Ascending the latter on July 21st, they saw the first of many amazing examples of nature's handiwork in the Yellowstone region—the white-terraced, steaming springs (now known as Mammoth Hot Springs) down which poured waters of brilliant colors. Jackson noted that this "was a wonderful revelation of contrast and color for Moran, who transferred much of its detail to beautiful water color sketches."

Soon thereafter Moran sketched the fantastic towers and pinnacles along turbulent Tower Creek and the majestic Tower Falls, which plunged over a 130-foot precipice into a rounded limestone basin. On the 27th, the party reached the deep gorge of the Grand Canyon of the Yellowstone, whose "beautiful tints" Moran said, "were beyond the reach of human art." He found in the variegated colors of the pinnacled walls of this deep chasm and its distant 350-foot-high waterfall the most fascinating challenge to his artistic abilities, and returned to it again and again in later years.

During the remainder of the thirty-eight days Moran spent in the Yellowstone country that summer, he sketched Yellowstone Lake from its outlet with its wooded islands and the snow-capped Absaroka Mountains in the background. He also made a brief sally into the Firehole region and executed the earliest known sketches of some of those natural fountains that spout boiling water high into the air at regular intervals—the Yellowstone geysers.

Jackson recalled that Moran left the base camp at Botelers' Ranch with his memory as well as his portfolio and sketch books "stored with abundant material, eager to get back to his studio and begin work on those wonderful creations that were to bring fame and fortune in the years to come." But they also did much for the American people. Moran illustrated Hayden's timely article on the Yellowstone region in *Scribners* for February 1872, in which the geologist urged Congress to "at once pass a law setting it apart as a great public park of all time to come." Moran's colorful watercolors and Jackson's sharp photographs provided visual proof to the committees of Congress who considered that measure. On March 1, 1872, President Grant signed the bill establishing Yellowstone National Park, the first such national reserve in the world.

*D*etail of Indian En-
campment from "The
Rocky Mountains." Bier-
stadt. 1863. Oil. Metro-
politan Museum of Art,
New York

True, thirty-one years earlier George Catlin had suggested that the entire Great Plains be declared a national park to preserve both its buffalo and its Indians, but in those days of rapid national expansion his plea had fallen upon deaf ears.

Somewhat in the Bierstadt tradition Moran painted a huge canvas of the Grand Canyon of the Yellowstone, based upon his field sketches, which he sold to the government for $10,000. And still later, at the time of the World's Columbian Exposition in Chicago he executed an even larger oil painting of the same subject, which William H. Holmes, first director of the National Gallery of Art, and himself a painter of Western scenery, regarded as the masterpiece of "the greatest master in landscape that America, and indeed the world, has produced."

In 1876, Louis Prang issued a portfolio of fifteen large chromolithographs by Thomas Moran under the title *The Yellowstone Park, and the Regions of Idaho, Nevada, Colorado, and Utah* with a text by Dr. Hayden extolling the quality of the color work and declaring that "the wealth of color in which nature has clothed the mountains and the springs of that region constitutes one of the most wonderful elements of their beauty."

Meanwhile, Moran extended his artistic explorations into other areas of the West. He was in Utah and in the Yosemite Valley in 1872. Next year he accompanied Major John W. Powell's survey party in Utah and Arizona and made his first sketches of the Grand Canyon of the Colorado. Its broad panorama of many-colored rocks, intricately sculptured in a multitude of imposing shapes, inspired and fascinated the artist. In 1876, he completed a large oil, *Chasm of the Colorado*, which Congress purchased; it hung for many years in the Senate wing of the Capitol, and is now in the museum of the Department of the Interior.

During the summer of 1874, Moran made a trip into the Colorado Rockies to sketch spectacular Holy Cross Mountain, first photographed by his friend Jackson the previous year. He then finished a large oil, *Mountain of the Holy Cross, Colorado*, which won him popular acclaim and a gold medal at the Centennial Exposition of 1876. In this work Moran showed that he could render the gray granite and green foliage of the Colorado high country as effectively as the assembly of warmer colors in the softer formations of the Yellowstone and Grand Canyon regions. However, Moran painted the foreground and background from quite different altitudes, which may account for a certain lack of feeling of distance in the peak with its 1,500-foot-high snowy cross.

As early as 1872, the Hayden Survey party had honored Moran by giving the name Mount Moran to a massive 12,100-foot peak in the Grand Tetons. Unfortunately, Moran never saw this peak from its most spectacular east side, across the blue waters of lovely Jackson Lake. Not until 1879 did Moran make his only approach to the Tetons, traveling with a military detachment from Fort Hall, Idaho, on a twelve-day horseback trip. Moreover, smoke from fires in the mountains limited his opportunities to sketch what he called "perhaps the finest pictorial range in the United States." But he did return with enough sketches to provide the bases for two fine studio landscapes, *Teton Range* (painted in 1897) and *Mount Moran* (dated 1903).

Thomas Moran grew old gracefully and remained active into his eighties. In 1924, he was still sketching his beloved Grand Canyon in the field, and worked four hours a day at his easel in his Santa Barbara, California, studio that winter. Beloved by a host of admirers, he died in his ninetieth year, on August 25, 1926.

*S*urveyor's Wagon in
the Rockies. Bierstadt.
1859. Oil. City Art Muse-
um of St. Louis

Moran lived to see many of his favorite sketching locations in the mountainous regions of the West preserved in the National Park system. In Yellowstone, Grand Canyon, and Yosemite National Parks his favorite sketching stations bear the name of Moran Point. Devil's Tower, a 600-foot-high naturally-fluted column of volcanic origin above the Belle Fourche River in northeastern Wyoming was established in 1906 as the first national monument; that was just twelve years after Moran and Jackson had made a wagon journey from the little town of Gillette to sketch and to photograph this natural wonder.

The works of Thomas Moran, like those of Albert Bierstadt, have been both extravagantly praised and condemned by professional art critics. Moran had little interest in art fads and decried both poor drawing and ugliness in art. He also insisted, "I place no value upon literal transcripts from Nature. My general scope is not realistic; but my tendencies are toward idealization." Yet he was a careful student of rocks and liked to draw and to paint them. Some eastern critics condemned his riotous use of color despite the fact that he was interpreting some of the most colorful scenery in the world; others the liberties he took with natural forms in developing his idealized landscapes. Yet Moran has numbered among his greatest admirers leading geologists who have known both the forms and the colors of the areas he portrayed far better than have his art critic detractors.

Both Moran and Bierstadt were obviously less interested in literal representation of the topographical features of the Western mountains than were most of their predecessors. Perhaps the introduction of photography in the recording of the Western landscape after mid-century stimulated the search these artists made for an ideal beauty that the camera could not achieve. Nor could the old wet plates of that day reproduce the rich colors of the Rockies. Through their colorful works Bierstadt and Moran awakened American pride in the grandeur of the West and a national interest in preserving many uniquely beautiful parts of that region for the inspiration and enjoyment of future generations. Thanks in part to them many of the places they pictured have remained almost unchanged to this day.

197

ARTISTS
OF THE
PLAINS INDIAN
WARS

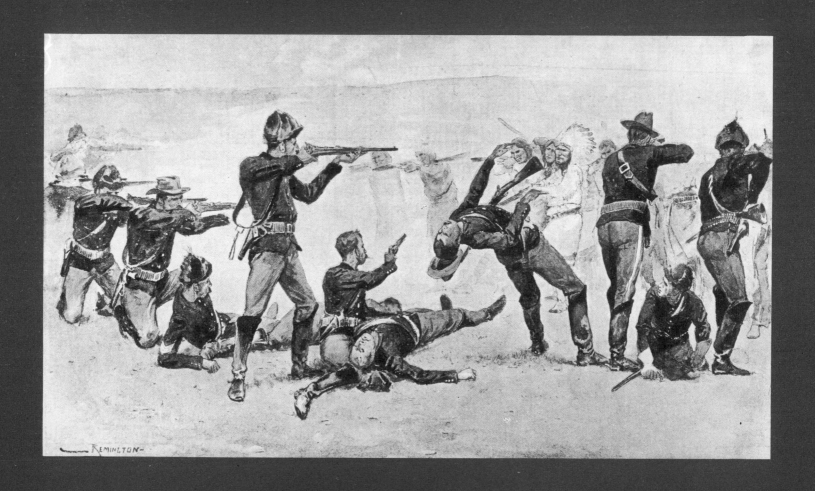

Theodore R. Davis and Frederic Remington

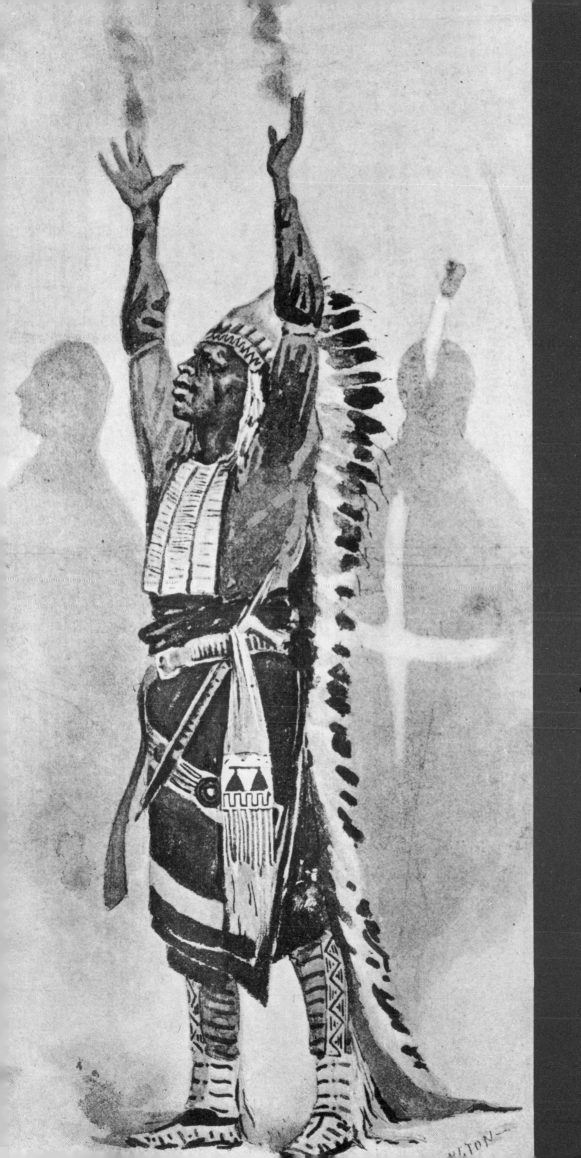

The Medicine Man's Signal to Begin Firing at the Fight at Wounded Knee. Remington. After a drawing from a description of the action. "Harper's Weekly," January 24, 1891 (left)

Opening of the Fight at Wounded Knee. Remington. After a drawing from a description of the action. "Harper's Weekly," January 24, 1891 (far left)

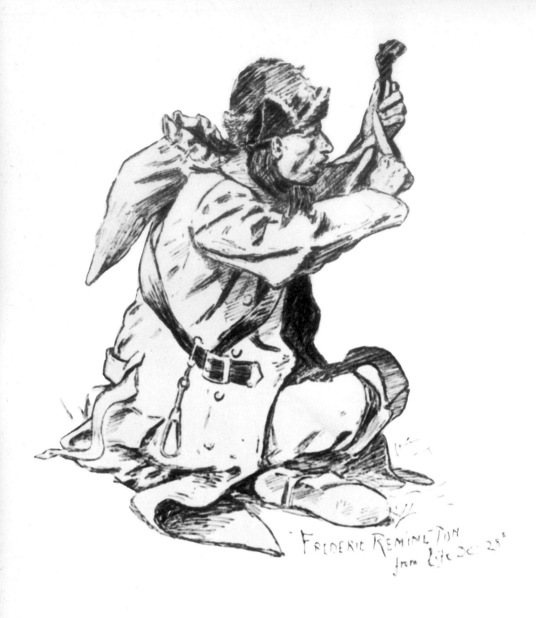

The Indian Wars of the Great Plains during the period 1854 to 1890 produced some of the most dramatic and colorful action in the history of the West. The pictorial record includes many striking photographs of Indian and white leaders in this conflict. But the slow-shuttered cameras of those times could not have captured the swift action even had they been carried into the thick of the fighting. A few competent artists rendered eyewitness observations of minor actions. But the artists were not present when the Plains Indians scored their greatest victories or made their determined last stands against the whites.

This inadequacy in the pictorial coverage of the Plains Indian Wars may appear strange to those who know that the majority of the most decisive battles on the plains took place after the Civil War, the first American war to be well-documented pictorially. Throughout the Civil War such weeklies as *Harper's* and *Leslie's* and even the *Illustrated London News* filled many pages with illustrations based upon the field sketches of special artists at the front. These pictures enabled readers of widely circulated magazines to follow the war's progress and visualize its battles only weeks after they were fought.

No combat artist made a greater contribution to the pictorial record of that conflict than did Theodore R. Davis. Born in Boston in 1840, and trained in drawing in New York, Davis joined the staff of *Harper's Weekly* in 1861. He was at the front throughout the war and, although twice wounded, produced more field sketches than did any other Civil War combat artist.

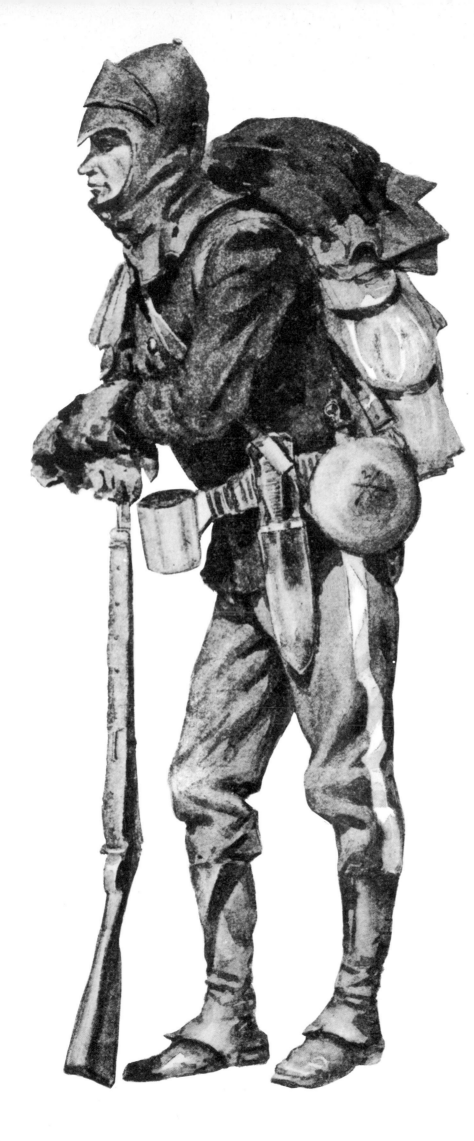

A United States Infantry Soldier in Winter Uniform. Remington. After a field sketch. "Harper's Weekly," January 24, 1891 (left)

Cheyenne Scout Eating a Beef Rib. Remington. After a field sketch. "Harper's Weekly," January 31, 1891 (far left)

201

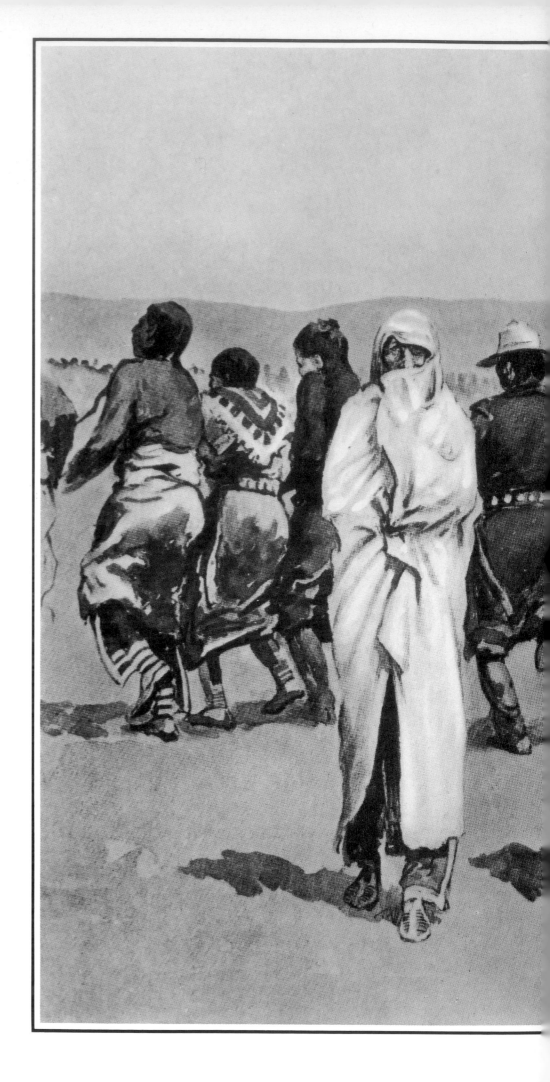

Ghost Dance of the Oglala Sioux on Pine Ridge Reservation, South Dakota. Remington. After a field sketch. "Harper's Weekly," December 6, 1890

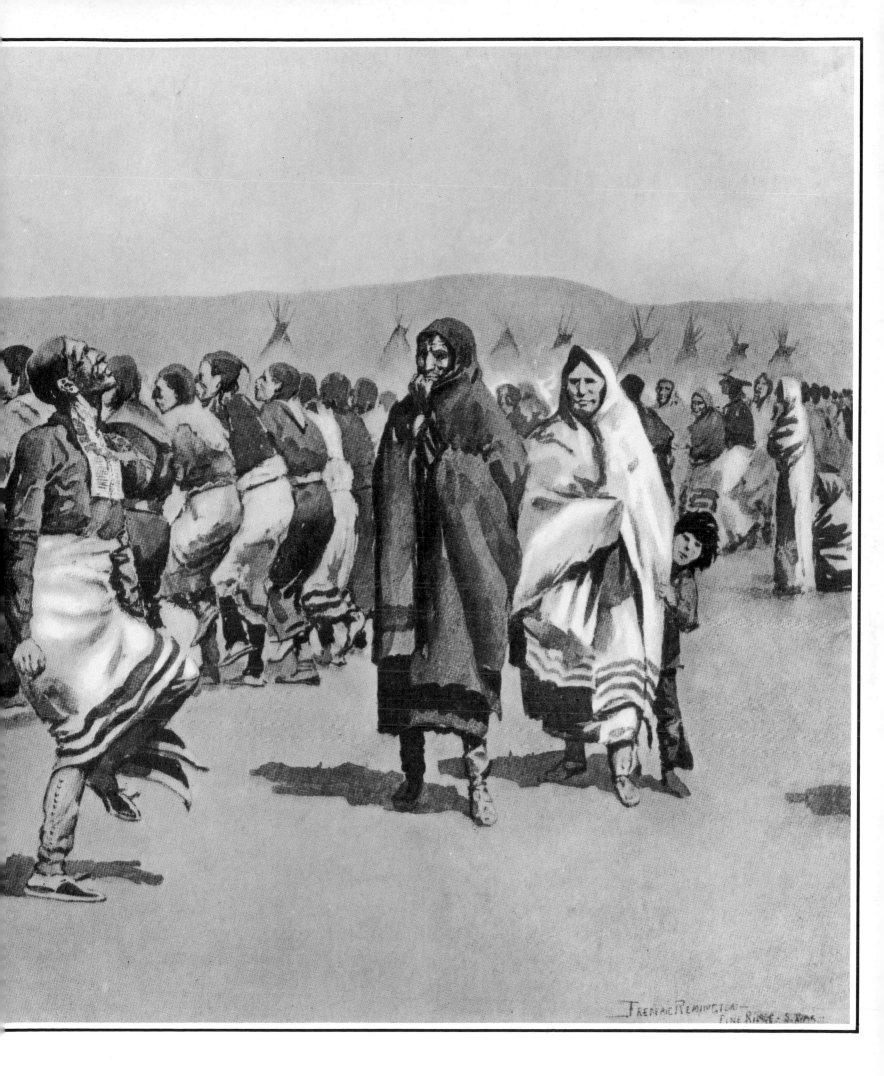

As he moved about the battlefields searching for picture-worthy actions, Davis was sometimes a target for enemy sharpshooters, and once had his sketchbook shot out of his hands. He developed the good reporter's eye for newsworthy material. When he selected a subject he quickly sketched the scene, penciled hastily the terrain, trees and foliage, gun positions, and groups of fighting men, and added written notations to aid his vivid visual memory. Very soon thereafter, often in his tent at night, he developed his field sketch, and promptly mailed it to the New York office where expert wood engravers prepared his illustration for printing in the magazine. Davis' own notebooks, filled with drawings of men of all ranks and services, firearms, horses and riding gear, guns and gun carriages, wagons, flags, tents, pontoon bridges and all other paraphernalia of war, served for filling in the details of his field drawings. By the war's end he must have established a relationship with his engravers which enabled them to reproduce his drawings with a minimum of change and distortion. Years later he published some of his rough layouts and detailed notebook sketches. They reveal his working methods and the high quality of his reference drawings.

In the fall of 1865, *Harper's* sent Davis westward to picture the mining camps and boom towns of Colorado. At Atchison, Kansas, he boarded a Butterfield Overland Dispatch coach bound for Denver. At 2 P.M. on November 24th, this mule-drawn Concord coach was nearing the Smoky Hill Spring stage station when alert Davis spied some mounted Indians charging toward them. Shouting to the driver and his fellow passengers, he opened fire on the most gaudily dressed among the attackers. While the driver urged his mules on, his four passengers peppered the Indians—they were Cheyennes—with rifle and pistol fire, wounded two of them and drove them off. Arrows and pistol balls penetrated the coach but did no serious damage. After reaching the stage station the travelers were besieged by Indians until a cavalry detachment came to their rescue. Under a strong army guard the coach drove on to Denver. Davis commented, "Cooper might have *his* Indians; we did not care for their company."

On February 17, 1866, *Harper's Weekly* offered a full-page engraving of Davis' drawing of the attack, along with his own description of the experience. In their enthusiasm the engravers may have added some Indians to the attacking force. The incident is the prototype of the Indian attack on the overland stage, so often re-enacted for later generations in Buffalo Bill's Wild West Show, on motion picture and television screens that it has become a hallmark of life in the Old West.

Continued Indian depredations and the always present threat of a more general Indian War on the plains caused the Army to organize an expedition in Kansas and Nebraska in the spring of 1867. Major General Winfield Scott Hancock, an able corps commander in the Civil War, was ordered to impress the Indians with his large force, confer with the chiefs of the hostile tribes and tell them that if they wanted a fight they would have it. One of his officers was Lieutenant Colonel George Armstrong Custer, of the newly formed Seventh Cavalry, young, courageous, and ambitious to gain recognition as an Indian fighter.

Harper's Weekly encouraged Davis, as their veteran combat artist, to accept General Hancock's invitation to accompany him as artist-correspondent. Davis reached Fort Larned in time to attend Hancock's fruitless council with Tall Bull and other Cheyenne leaders. Although the general complained of Indian killings of whites and interference with travel on the overland routes, the Indians complained just as strongly

Custer Parleying with Pawnee Killer, Sioux Chief, June 1867. Davis. Wood engraving after a field sketch. "Harper's Weekly," July 1867

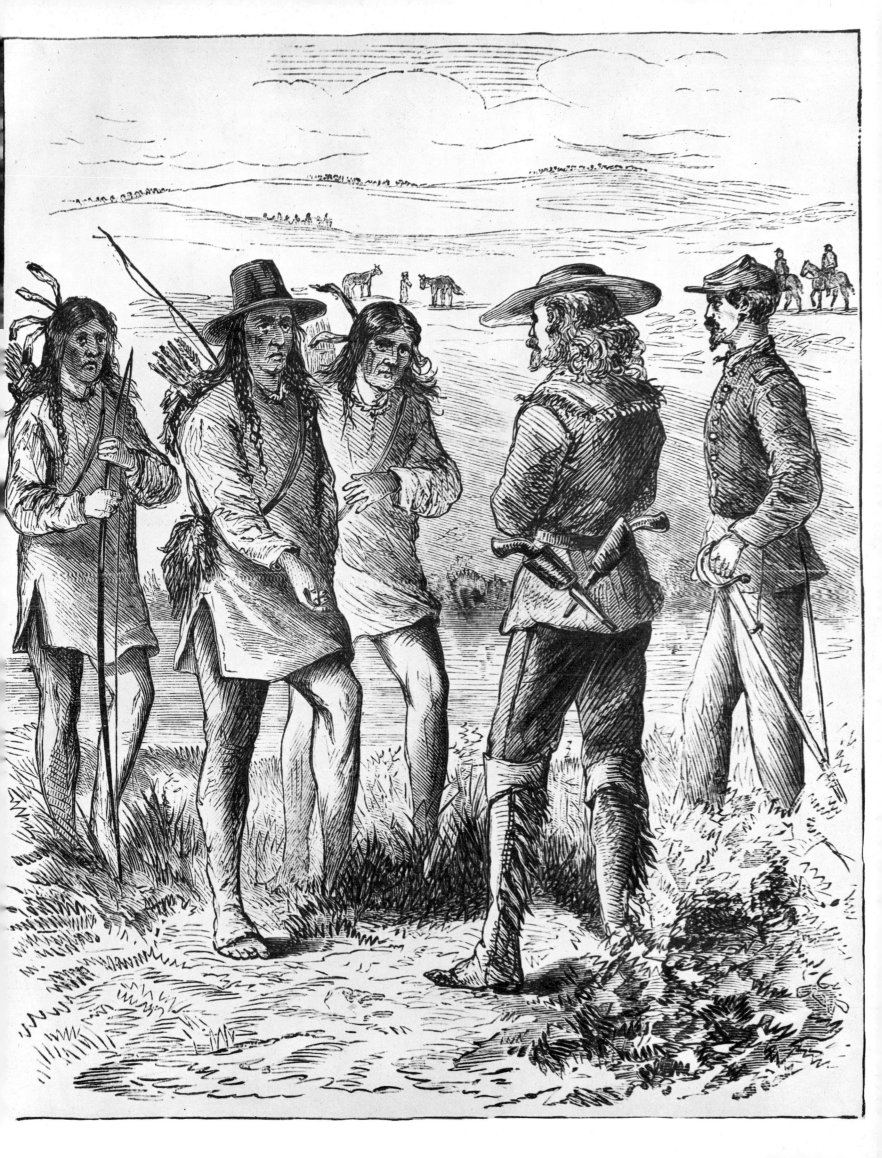

of the railroads being built through their hunting grounds. When Hancock pressed on toward the Cheyenne village, the Indian women and children, and later the warriors, fled, abandoning their village. Doubtless they recalled the massacre of Cheyennes at Sand Creek less than two years before, when troops·had attacked a peaceful village. When Custer's force, in an unsuccessful pursuit of the fleeing Indians, found the Lookout stage station and its three attendants burned, Hancock burned the deserted Cheyenne village. The smoke from the burning lodge poles, hide covers, and household furnishings in this huge bonfire could be seen for many miles over the level plains.

Hancock was soon to learn that he could neither intimidate the Indians by destroying their property, nor buy their friendship through kindness. At a council with Arapaho and Kiowa chiefs at Fort Dodge, he gave the brilliant Kiowa orator and war chief, Satanta, a Major General's coat. A few weeks later Satanta led a raiding party which ran off nearly all the horses belonging to Fort Dodge. Brazenly he doffed his hat to the garrison, and saucily tossed the tails of his fine new coat as he rode away. While at Fort Dodge Davis drew a sketch of the interior of the post trader's store showing the variety of objects he sold to his soldier and Indian customers.

From Fort Dodge, Davis rode northward with Hancock to Fort Hayes, where they found Custer's force weakened by desertions and inactive because their rations had not arrived. On June 1st, he joined the three hundred men and twenty wagons of Custer's cavalry on a futile march of some thousand miles northward to Fort McPherson on the Platte, southwestward to Fort Wallace on the Smoky Hill and eastward to Fort Hayes. They saw many abandoned ranches and some graves bearing the simple legend, "Unknown man killed by Indians."

Among the group of field sketches by Davis reproduced in *Harper's Weekly* that summer was one depicting two of Custer's scouts and two of his couriers. The courier's work was so dangerous that few men cared to hold the job very long. They preferred to ride by night and take their chances on seeing Indians as quickly as the Indians could see them. Another illustration shows flamboyant Custer parleying with the Brulé Sioux chief, Pawnee Killer, and some of his braves, who insolently begged for sugar, coffee, and ammunition just a few hours after they had failed, in a dawn attempt, to run off Custer's horses. Clad in cheap cloth shirt (probably Army surplus) and tall hat, this crafty Sioux chief of the 1860's lacked the picturesque qualities of the Sioux leaders whom Catlin and Bodmer painted in their ornamented dress three decades earlier.

Soon thereafter Captain Louis Hamilton and twenty to twenty-five cavalrymen of Troop C chased a half-dozen Indians, who were lurking around Custer's camp, only to fall into a typical Plains Indian trap. After the redskins lured the troopers several miles from camp, more than forty fast-riding Indians came whooping out of a ravine, shooting their guns and arrows. The soldiers quickly dismounted and formed a circular skirmish line around their horses. Although this was their first taste of Indian fighting, they managed to kill or wound several of the encircling Indian horsemen and the red men gave up the attack. Davis' rather stiffly reproduced sketch shows the essentials of this action. As was common in the Plains Indian Wars the cavalrymen fought on foot, while every fourth man held his own horse and those of three men on the skirmish line.

The most haunting of Davis' pictures based upon his field experiences of that summer is a starkly realistic view of the mutilated bodies of

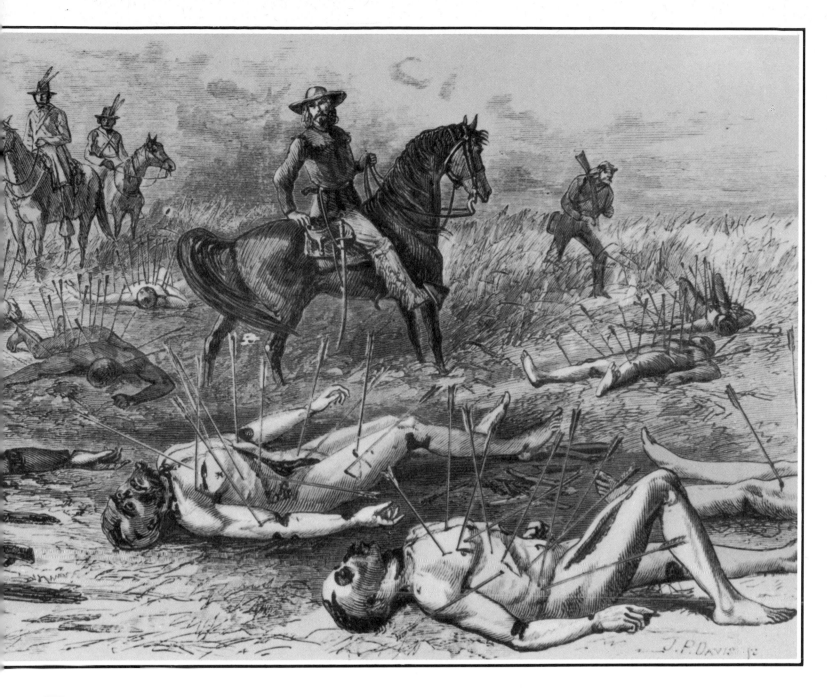

Discovering the Remains of Lieutenant Kidder and Ten Men of the United States Cavalry, Killed and Mutilated by the Sioux, June 24, 1867. Davis. Wood engraving after a field sketch. New York Public Library

Lieutenant Kidder and his men, reproduced in Custer's *My Life on the Plains.* Kidder left Fort Sedgwick with an escort of ten men, including a Sioux guide, Red Bead, carrying dispatches from General Sherman to Colonel Custer. En route a large Indian force attacked them. A few days later circling buzzards attracted Custer's men to their naked, arrow-pierced bodies and broken skulls in the tall grass of a ravine. Since only the Sioux was not scalped, Custer attributed the murders to Sioux warriors—possibly led by their ammunition-begging chief, Pawnee Killer. No other picture so clearly illustrates the horrors of Indian fighting on the plains; it was this that gave rise to the warning to soldiers: "Save your last bullet for yourself."

Before he boarded the eastward bound train from Fort Harker, then the western terminus of the railroad in Kansas, Davis drew a portrait of himself, holding his Ballard rifle and wearing the buckskin garments in which he had ridden nearly three thousand miles with the army on the plains.

Although Hancock's summer campaign in Kansas and Nebraska was a costly failure, special artist Davis' part in it was a success. He recorded

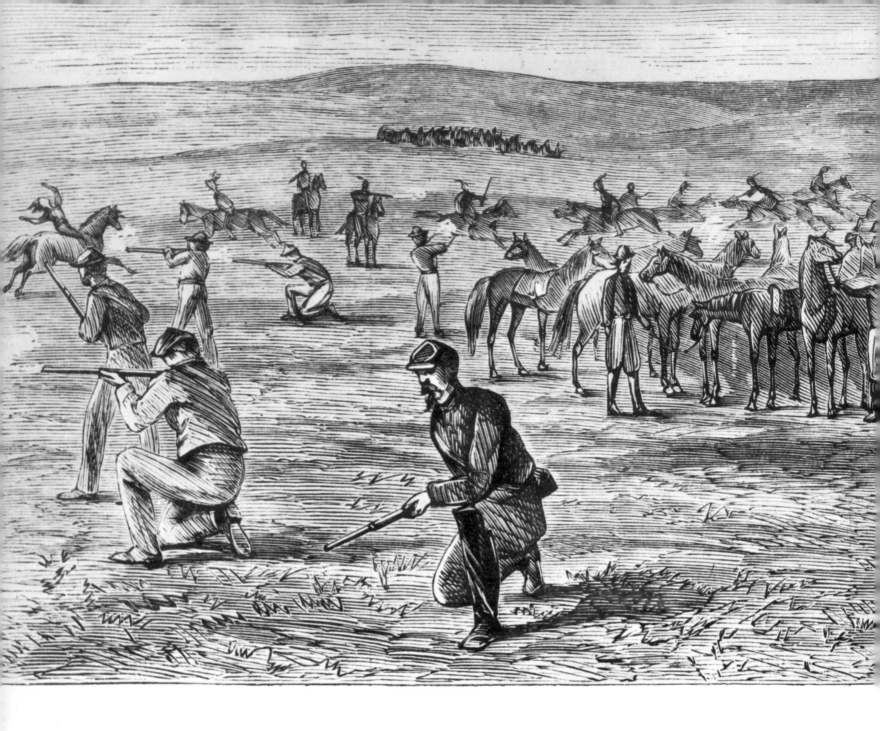

the first and best eyewitness pictures of the realities of the Plains Indian Wars. Unfortunately his original sketches are not preserved, for much of their spontaneity, if not some of their detail, must have been lost in the process of engraving them for reproduction. Davis continued occasionally to draw Western scenes for *Harpers Weekly;* these must have been based upon his memories, the descriptions of others, or his imagination, for he is not known to have made another western trip. Theodore R. Davis, the most experienced combat artist of his generation, died in his fifty-fourth year at Asbury Park, New Jersey, November 10, 1894.

For a decade after Hancock's summer campaign of 1867, the Indian Wars of the plains dragged on, marked by alternating periods of quiet and conflict. General Sherman recognized it as "an inglorious war, not apt to add much to our fame or personal comfort, and for our soldiers . . . it is all danger and extreme labor, without one single compensating advantage." The white soldiers were pitted against an enemy small in numbers and widely scattered over the grasslands. These Indians possessed a thorough knowledge of their own country, superior skill and

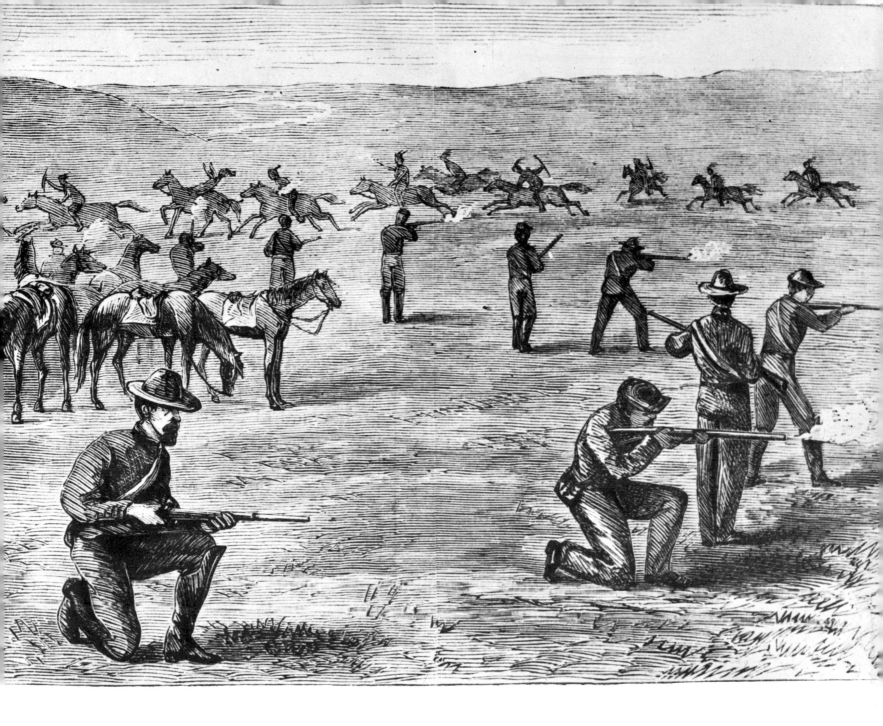

great mobility as horsemen. They also had had experience in bitter inter-tribal warfare, in which they had perfected their skills in scouting, and genius for keeping their enemies off balance through harassing surprise attacks and ambushes. It took time for the generals who had distin-guished themselves in the Civil War to develop techniques for conquer-ing the red-skinned will-of-the-wisps of the open grasslands. In fact, it was the extermination of the buffalo, the Indian's commissary, as much as superior numbers and equipment that helped the West Point generals eventually subdue these Indians.

Very little of this dramatic warfare was recorded by artists. Hermann Stieffel, a German-born private of the Fifth Infantry, crudely portrayed an Indian attack upon General Marcy's wagon train near Pawnee Fort, Kansas, September 23, 1867, in which the infantry escort formed a circle around the wagons and fought off the attackers much as had the un-mounted cavalrymen in the drawing by Davis. The illustrated magazines occasionally published a battle scene allegedly based upon a sketch by an anonymous "officer in the field." Custer's tragic last stand on the Little

Sioux Indians Attack-ing a Company of the 7th Cavalry, June 24, 1867. Davis. Wood engraving after a field sketch. "Har-per's Weekly," August 17, 1867

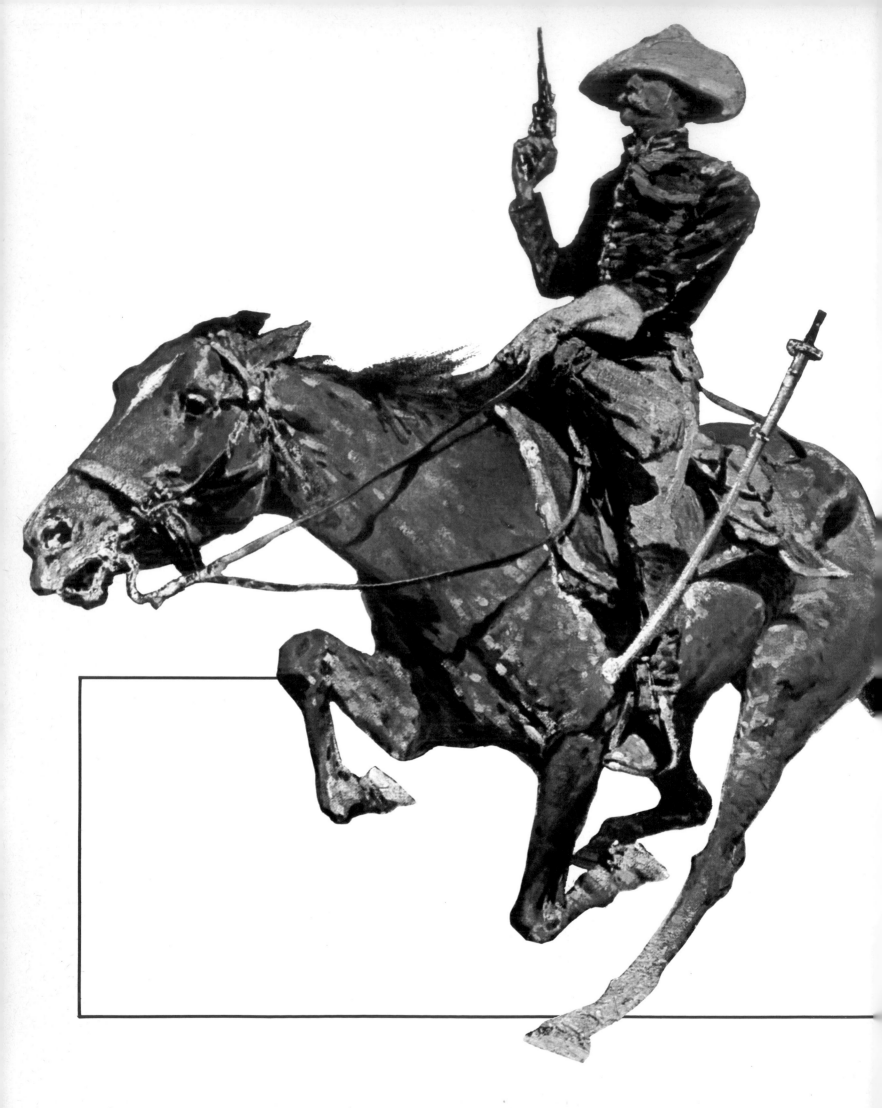

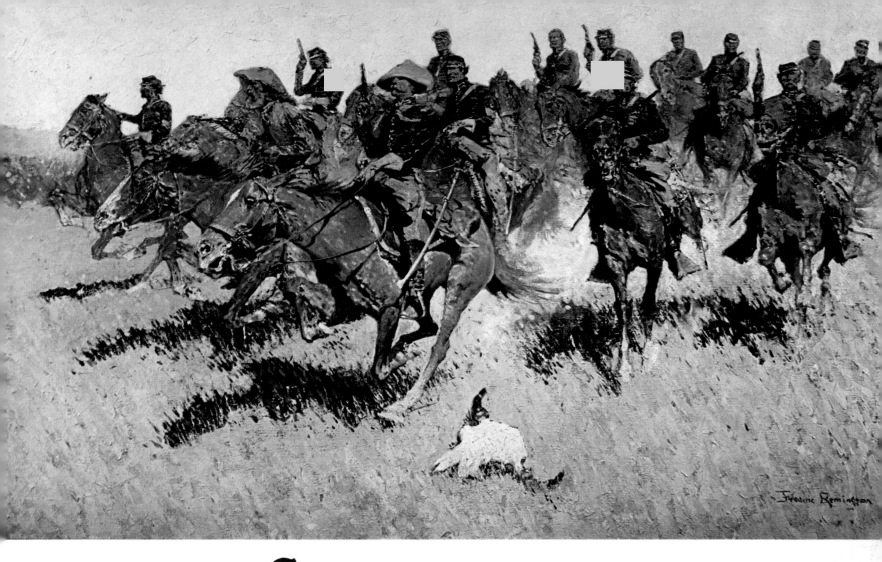

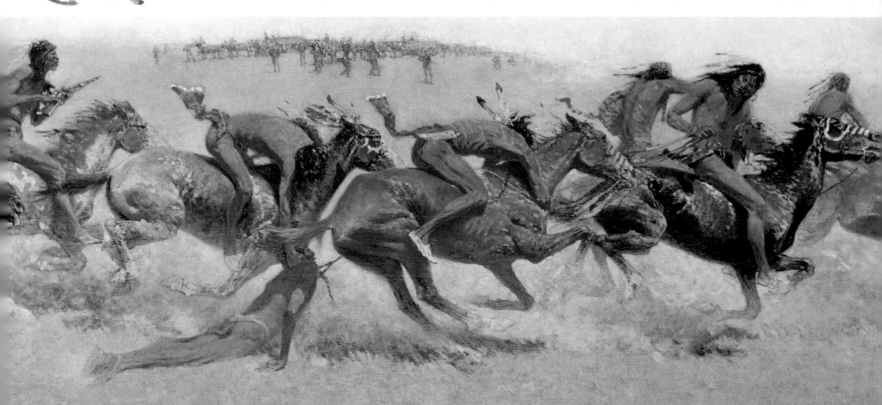

Cavalry Charge on the Southern Plains. Remington. 1907.
Oil. Metropolitan Museum of Art, New York (above)

Indian Warfare. Remington. 1908. Oil. Gilcrease Institute
of American History and Art, Tulsa (below)

Detail from "Cavalry Charge on the Southern Plains."
Remington. 1907. Oil. Metropolitan Museum of Art, New York (left)

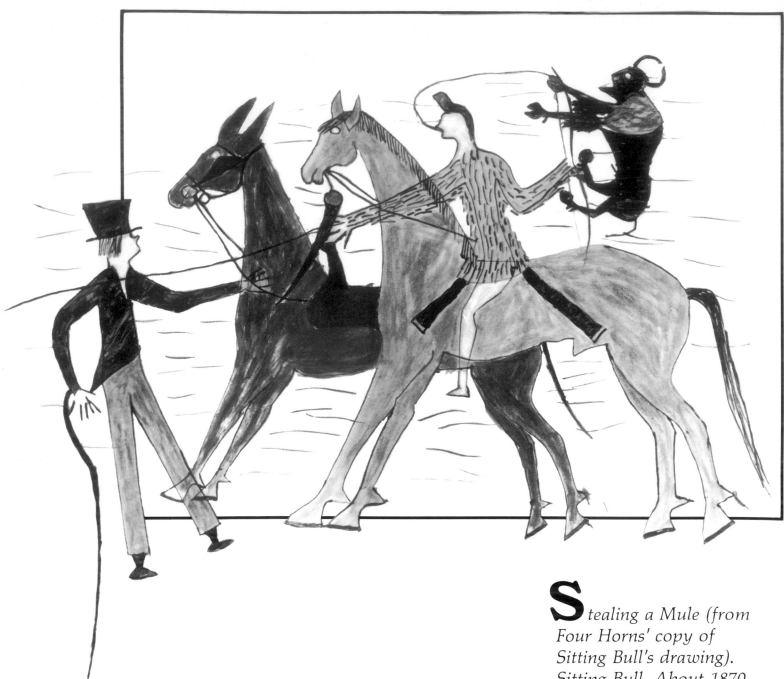

tealing a Mule (from Four Horns' copy of Sitting Bull's drawing). Sitting Bull. About 1870. Drawing. Smithsonian Institution

Bighorn during the summer of 1876 inspired many artists who never saw an Indian battle to draw or paint dramatic, highly imaginative but realistic-looking scenes of that little-known action. That battle was the high-watermark of Indian resistance on the plains. Sitting Bull and his followers fled into Canada, while the other hostiles were forced to give up their arms and ponies and return to their reservations.

Numerous pictures drawn by Indians in pencil, crayon, and watercolors on the pages of old ledger books, notebooks, and loose sheets of paper during the last quarter of the century reveal the Indians' view of these wars. Such drawings follow the Indian tradition of recording warfare in terms of the winning of individual honors. Some of these works are interestingly designed and quaintly realistic, but they offer little information about complex battlefield actions. In 1870, the Sioux leader, Sitting Bull, drew a pictographic record of some of the 63 coups (war honors) to which he was entitled for his brave deeds in fighting enemy tribesmen as well as white men. In each of these he identified himself by a line extending from his mouth to a figure of a buffalo bull.

When a tired and sullen Sitting Bull rode into Fort Buford on the Missouri on July 19, 1881, at the head of 186 followers, to surrender to the United States authorities, no trained artist was present. However, next day, when Sitting Bull formally turned over his Winchester to Major Brotherton with the reported remark, "I wish it to be remembered that I was the last man of my tribe to surrender my rifle," Major Guido Ilges, who was in the room, made a quick pencil sketch of that die-hard chief. Promptly published on the front page of the *Saint Paul Daily Pioneer Press* this crude but authentic portrait depicts the chief with his eyeglasses on his forehead and a calico handkerchief around his head. This was a far cry from the feather-bonneted star of Buffalo Bill's Wild West Show who would later sell his signed photograph to thousands of awe-struck members of the audience.

Just twenty-one days after Sitting Bull's surrender, the *Plaindealer* in the little town of Canton, New York, briefly noted, "Fred Remington, son of the late Col. S. P. Remington, expects to start on Wednesday of this week for Montana. We understand that he intends to make a trial of life on a ranch." Not yet twenty years old (he had been born October 4, 1861) this strapping fellow's greatest achievement had been playing two seasons as a forward on the Yale football team captained and coached by Walter Camp. He had been studying art at Yale for a year and a half when his father's death forced his withdrawal from college. Since then he had been unsteadily employed. Remington's love of horses and outdoor adventure, as well as his failure to convince the father of the young lady who was later to become his wife that he was worthy of her, shaped his decision to go West that summer. And when Remington first saw the West in 1881 it was the beginning of another life-long romance.

Although he lived only two winters beyond the Mississippi (1883 to 1885) while he tried his hand at sheep ranching in Butler County, Kansas, was cheated of his share in the ownership of a Kansas City saloon, and made a long trip through the Southwest, Remington made repeated summer excursions into the West during the decade of the 1880's. He absorbed impressions of the Western country, especially of its horses and its people—Indians, Mexicans, cowboys, officers and enlisted men at frontier military posts. He carefully noted the differences between the small, grass-fed Indian pony with its "neck joined like the two parts of a hammer," and the larger but less rugged, grainfed cavalry mount. In those years Remington was more interested in form than in color and he employed his tremendous energies in developing his talent for rapidly rendering horses and humans in realistic poses.

During the latter half of the 1880's, Remington spent some summers with the army in the southwestern desert pursuing the elusive Apaches. His first illustration published by a national magazine, *Harper's Weekly* for January 9, 1886, was titled *The Apache War—Indian Scouts on Geronimo's Trail*, and his pictures of that war in later issues of that magazine helped him to obtain other illustrating assignments. Within two years he was swamped with requests for illustrations.

In the Southwest Remington may have smelled some powder, and certainly he made warm friends among the soldiers. In 1890, rumors of a possible Indian War on the plains drew Remington to South Dakota and Montana. The Western Sioux had then been living on reservations at peace with the whites since the late 1870's save for Sitting Bull's renegades who held out until 1881. Since the buffalo had been exterminated in the early 1880's these Indians had made little progress as farmers or cattlemen. The sizeable conservative group considered it degrading for a

A Sioux Indian Drawing of the Battle of Little Bighorn, June 25, 1876. Smithsonian Institution (overleaf)

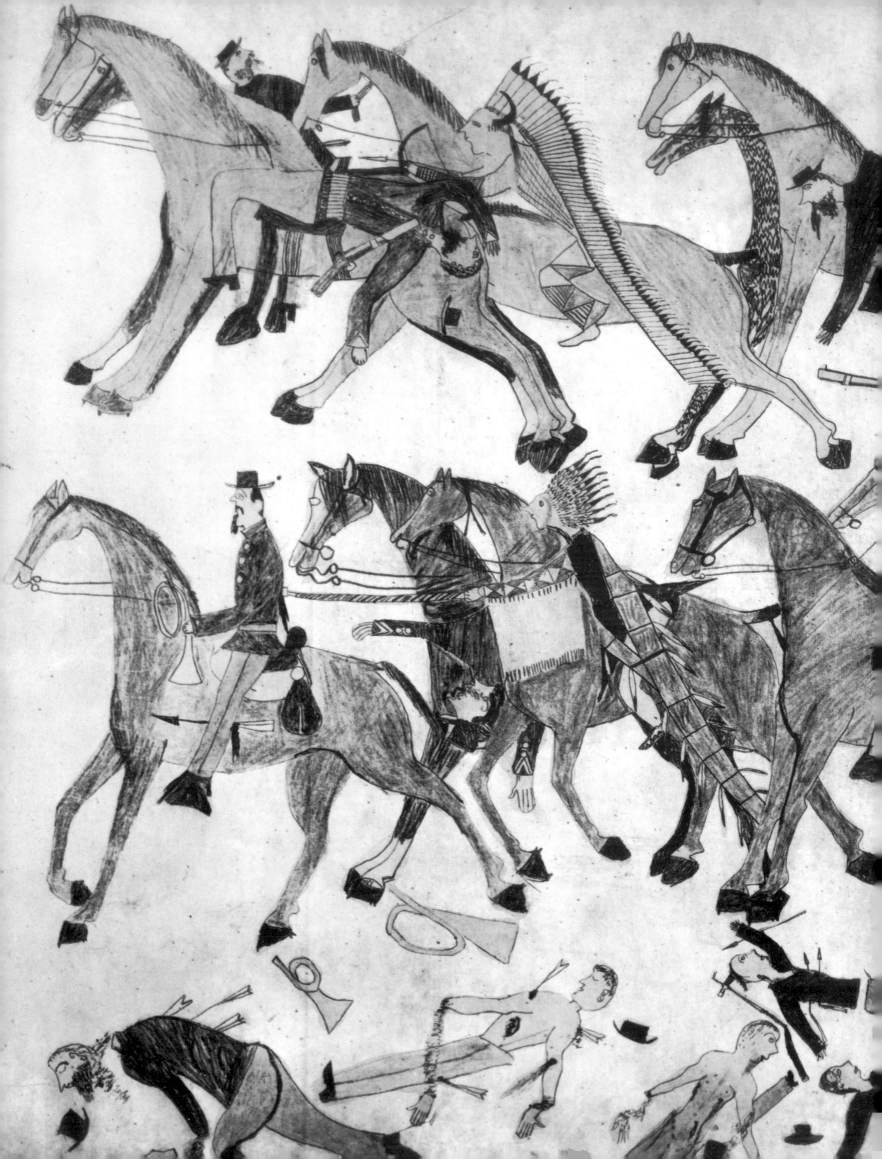

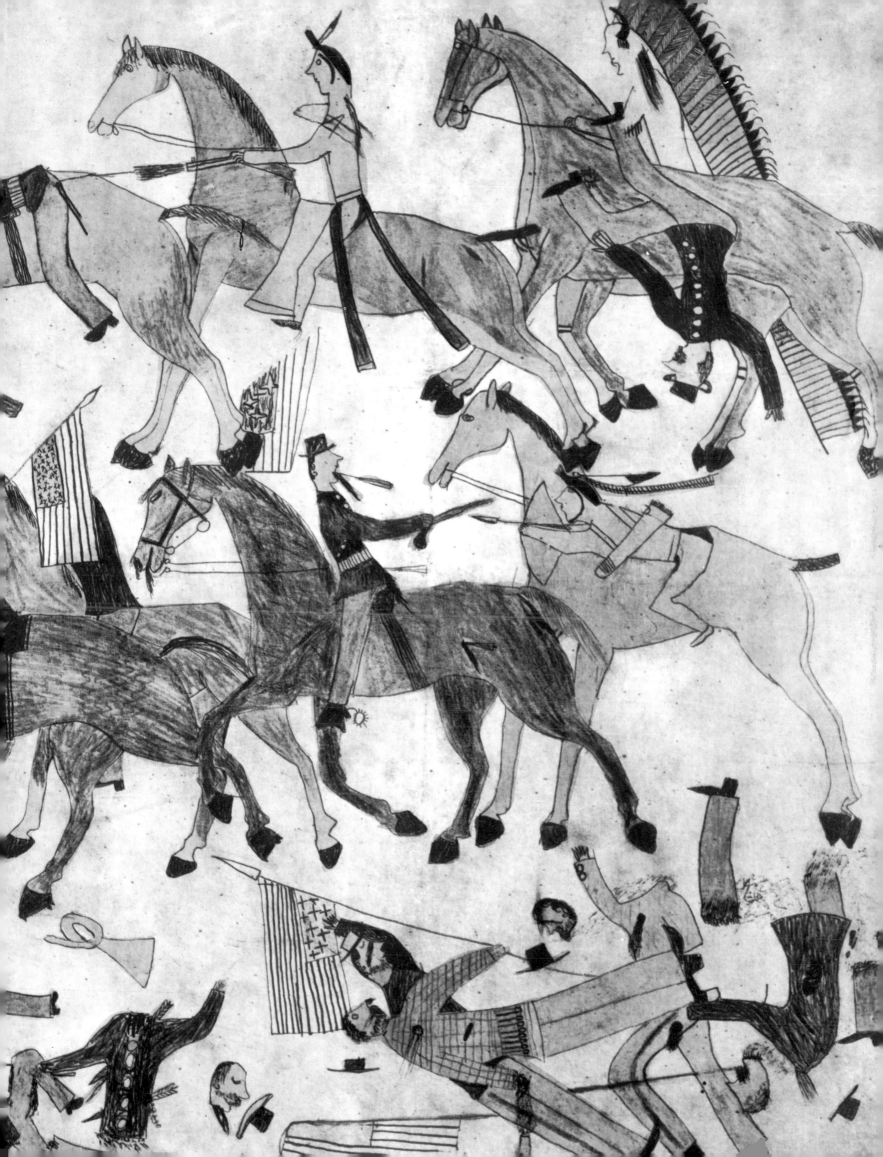

man to earn his living by grubbing in the earth. So these former warriors and buffalo hunters subsisted largely upon government rations, and dressed in government issue white men's garments. Unsuccessful in adopting the white man's way, many of these proud people longed for their old days of independence.

Then, in 1889, they heard of a new religion expounded by Wavoka, a Paviotso Indian in Nevada, which seemed to offer new hope. A Sioux delegation to Wavoka brought back some of the elements of his religion to their people. It taught them that by practicing the new Ghost Dance and other rituals they could cause the whites to disappear, the buffaloes to return and the Indians to be reunited with their dead relatives in the old way of life. The paraphernalia included "ghost shirts" of cotton bearing mystical painted symbols which the Indians believed would make their wearers impervious to bullets.

Unhappily, dissatisfaction with a new land cession, and partial crop failures, as well as an ill-timed reduction in rations, made the new religion still more attractive to those of the Sioux who found adjustment to reservation life most difficult. As they slipped away to perform the Ghost Dance rites in isolated areas far from their agencies, rumors spread that they were preparing for an outbreak that would destroy the settlers on ranches and in towns near the reservations.

Harper's Weekly sent Remington West as artist-correspondent in the early fall of 1890. On a plain near the White River on the Pine Ridge Reservation, South Dakota, he witnessed and sketched an Oglala Sioux performance of the Ghost Dance. Then he accompanied Major General Nelson A. Miles, vigorous new commanding general of the Division of the Missouri, on a visit to the Cheyenne Agency on Tongue River, Montana. The artist was impressed by the general's escort—smartly efficient, uniformed Cheyenne Indian scouts, young men of the same tribe that had helped the Sioux to wipe out Custer's command on the Little Big Horn just fourteen years earlier. Now they had become trained light cavalry in the service of the United States.

Neither Remington nor Miles seemed to be fearful that the Ghost Dance offered any real threat to the peace at that time. But as the period of dancing continued, some of the Indians became more insolent; the inexperienced Indian Agent at Pine Ridge lost control of his charges, grew panicky, and on November 15th telegraphed for at least one thousand troops. As the blue-coated soldiers converged upon the Sioux reservations, magazine and newspaper reporters flocked to the trouble area. On November 28th, Miles wrote the Adjutant General in Washington that the Indians were well armed with repeating Winchesters and might "make one final effort in the death struggle of their race." Next day a *Harper's Weekly* editorial gravely predicted "possibilities are that we shall have in the Northwest this winter the bloodiest Indian war ever fought."

No such war occurred. Only a portion of the Sioux, comprising the conservative segment, and some of the young hot-heads presented any real threat, and the army persuaded some of the most dangerous chiefs and their followers to lay down their arms. Nevertheless, the so-called "Sioux Outbreak" did produce the last major battle in the Plains Indian Wars. It occurred on Wounded Knee Creek, December 19, 1890, when some of the young men of Big Foot's camp of Ghost Dancers resisted Colonel Forsyth's attempt to disarm them.

Remington did not see this battle, but he was at nearby Pine Ridge, and the rough sketches he made of the action for *Harper's Weekly* were

based upon descriptions he obtained from army participants soon after the clash. They attempt to show the medicine man, Yellow Bird, throwing dirt into the air as a signal for the young men to throw aside their blankets and fire on the soldiers who were trying to disarm them; the opening of the battle with the soldiers returning fire, and the use of one of the four Hotchkiss cannons in the conflict. Firing up to fifty explosive shells a minute, these light artillery pieces frightened the Indians and accounted for some of the 146 killed and 51 wounded Sioux men, women and children. In the unequal battle white losses were 25 killed and 39 wounded.

Other Remington pictures of that field trip included a full-length portrait of Lieutenant Edward W. Casey, commander of the Cheyenne scouts, on horseback. He was the last officer to be killed in the Plains Indian Wars—ironically by a graduate of Carlisle Indian School, named Plenty Horses. Remington also portrayed General Miles' review of his troops at Pine Ridge two weeks later. In this parade, which Remington called the "grandest demonstration by the army ever seen in the West," the cavalry, infantry, and artillery, some 3,500 strong, clad in their heavy winter uniforms marched through a furious sandstorm which almost concealed them from the sight of the sullen, suspicious former Sioux warriors on nearby ridges.

The Indian Wars were over. But Frederic Remington never forgot them. To the end of his life he found inspiration for many of his most dramatic pictures in Indian War themes. Unfortunately, few of his critics have distinguished between his post-war reconstructions of history and the few pictures he made from first-hand observation before the firing ceased. The latter were primary pictorial documents similar in kind to the works of artists considered earlier in this book who drew and painted what they saw in the field. The former were imaginative reconstructions of history such as have been executed by generations of artists who never saw an Indian War. Such pictorial reconstructions may be realistically rendered, emotionally exciting and even aesthetically pleasing. But their value as historical documents must depend upon the thoroughness of the research upon which they are based. In the pictorial record of the West, artistic realism is no substitute for historical truth.

Unfortunately, Remington, whose prodigious output exceeded twenty-five hundred drawings and paintings, could not do thorough research on every subject he attempted. His exceedingly popular series, *Great Explorers*, published in *Colliers* one each month from October 1905 through July 1906 contains both anachronisms and fanciful details. Witness his Lewis and Clark, dressed in outmoded Revolutionary War uniforms and traveling in Ojibwa birchbark canoes! Perhaps it was his later knowledge of their inaccuracies that caused Remington to burn all but one of that series before his death. Remington's full-page illustrations for a handsome 1892 edition of Longfellow's *The Song of Hiawatha*, won him high praise for their artistic quality, but critical examination reveals that he dressed the ancient forest-dwelling Ojibwa of the Great Lakes region in clothing of the late nineteenth-century Indians he had known on the Western grasslands.

That Remington himself was jealous of the success of competitors in the pictorial reconstruction of the Plains Indian Wars was shown in his scathing criticism in the *New York Herald* of Charles Schreyvogel's oil painting, *Custer's Demand*, as "half-baked stuff." That painting portrayed a meeting between Custer and chiefs of the southern Plains tribes at a time when both Remington and Schreyvogel were only eight years

Sitting Bull, Sioux Chief (as he appeared on his surrender, July 19, 1881). Major Guido Ilges. After a pencil sketch. "Saint Paul Daily Pioneer Press"

old. When drawn into the controversy, Colonel Schuyler Crosby, who was pictured in the painting and was still living in 1903, asserted that Remington was more often wrong than right in his criticisms of costume and equipment in the Schreyvogel painting.

Fellow artists criticized Remington for his use of photographic reference materials. In an interview with Perriton Maxwell, the art critic, in 1907, Remington acknowledged: "I do not employ photography at all now; though I once found it a great help. In a sense I have gotten all the good out of it I can get, and now I want to work entirely away from it." It seems probable that Remington learned about the action of running horses from the classic series of still photographs taken by Eadweard Muybridge and published in his book *The Horse in Motion* in 1882. Those photographs clearly proved that the artists' convention of picturing running horses in a rocking horse pose with both front and hind legs extended was untrue to nature, and showed in profile the true positions of the horse's legs at various stages of action. Some of Remington's side view renderings of horses on the run show leg and even tail positions identical to those pictured in the Muybridge photos. If, indeed, Remington learned from Muybridge, that was nothing to be ashamed of. Remington prided himself upon his knowledge of and ability to picture

218

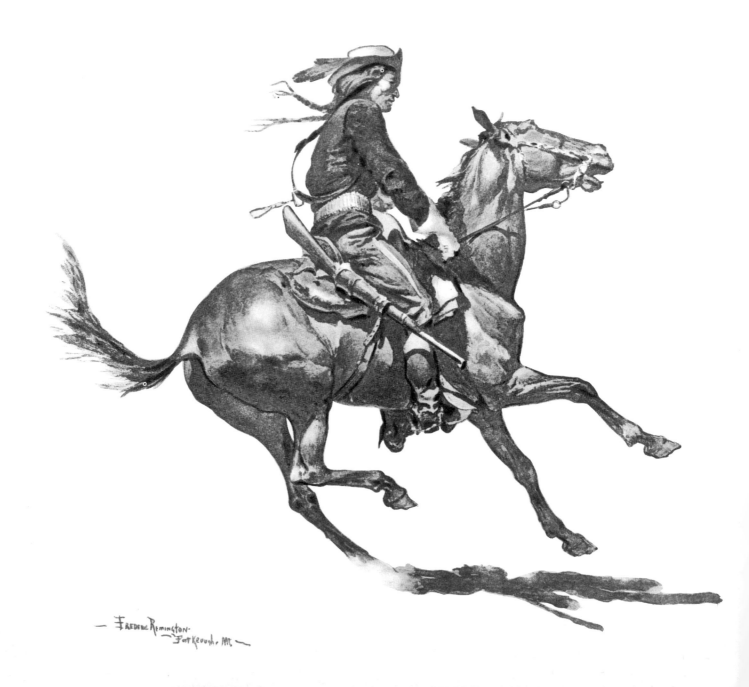

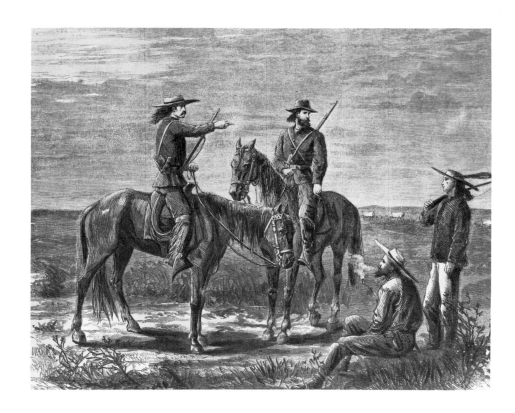

Custer's Scouts and Couriers, Spring 1867. Davis. Wood engraving after a field sketch. "Harper's Weekly," June 29, 1867 (above)

One of the Fort Keogh Cheyenne Scout Corps, Commanded by Lieutenant Casey. Remington. After a field sketch. "Harper's Weekly," December 27, 1890 (left)

horses of different breeds at rest or in motion. He once asked that his epitaph read simply, "He Knew the Horse." And surely his talent for picturing fast-moving Western horsemen helped greatly in perpetuating the image of the Old West as a place of exciting action.

Remington's technical virtuosity in several artistic media was remarkable. He first gained fame as a realistic illustrator in black-and-white, and did not turn to painting until his thirtieth year. In 1895, he took up sculpture and quickly demonstrated his talent for portraying dramatic action of horse and rider in that medium.

Working much of his time in New York, Remington was aware of the influence of impressionism upon many of his fellow artists in his later years. But he insisted on continuing to express himself in his own realistic way, and needled the impressionists with the statement that he had two maiden aunts who could knit better pictures than they could paint. It was not easy for Remington to make the transition from black-and-white to oil painting in color, but his paintings continued to improve in quality. Two paintings of his later years reveal that he was beginning to capture the bright sunlight of the Great Plains in spirited story-telling pictures of the Indian Wars. Both his *Indian Warfare* and his *Cavalry Charge on the Southern Plains* were executed within two years of his death from appendicitis on Christmas night, 1909.

Remington said, "I paint for boys . . . boys from ten to seventy." And his vigorous pictorial re-creations of scenes from the vanished West of the Indian fighters and their desperate red-skinned foes continue to have a strong appeal for men and boys of all ages. There is no denying that Frederic Remington's art works were a powerful force in creating the image of the Wild West. Whether any particular Remington work contains more romance than truth can be determined only by an objective analysis of the details of the work itself.

A MONTANA COWBOY PORTRAYS THE PASSING OF THE OLD WEST

Charles M. Russell

On May 29, 1805, the Lewis and Clark Expedition passed the mouth of a "handsome river" which emptied its clear, cold water into the broad Missouri. Captain Clark named it Judith's River in honor of Miss Julia Hancock, who later became his wife. Fifty years later Gustavus Sohon sketched the solemn council at the mouth of this river during which the warlike Blackfoot tribes signed their first treaty with the United States. And exactly twenty-five years after that, in 1880, an impressionable sixteen-year-old artist entered the fair and fertile Judith Basin. Here during the next decade he witnessed the passing of the Old West—the extermination of the buffalo which had been the old-time Indian's staff of life, the fencing of the early cattleman's open range, and the influx of farmer-homesteaders who broke the prairie sod and converted the natural grasslands into fields of wheat. That wide-eyed, curious youth could hardly have dreamed that he would win lasting fame as the most able pictorial reporter of the end of the frontier on the Great Plains.

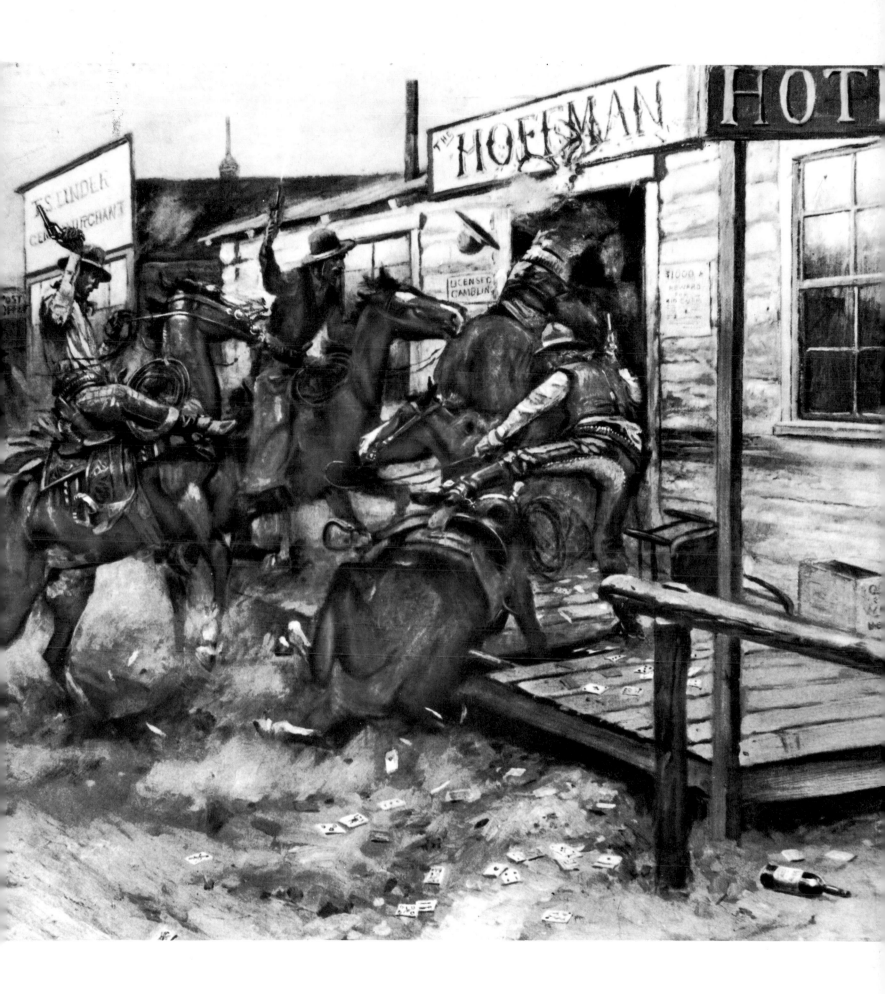

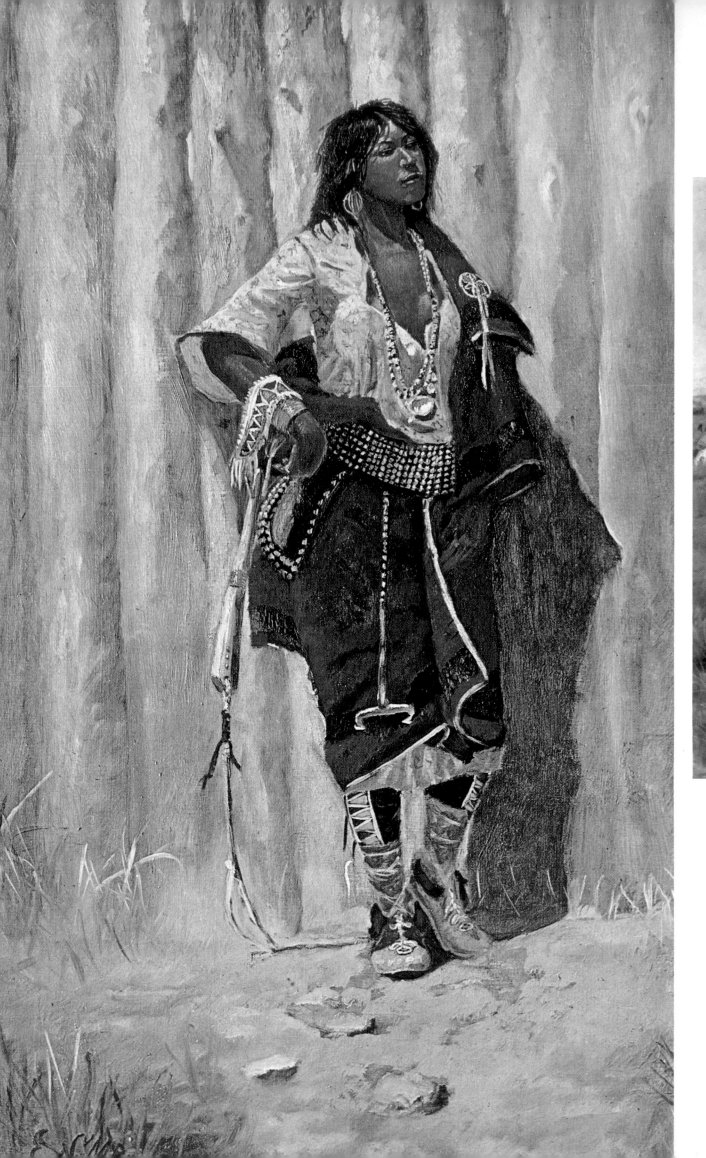

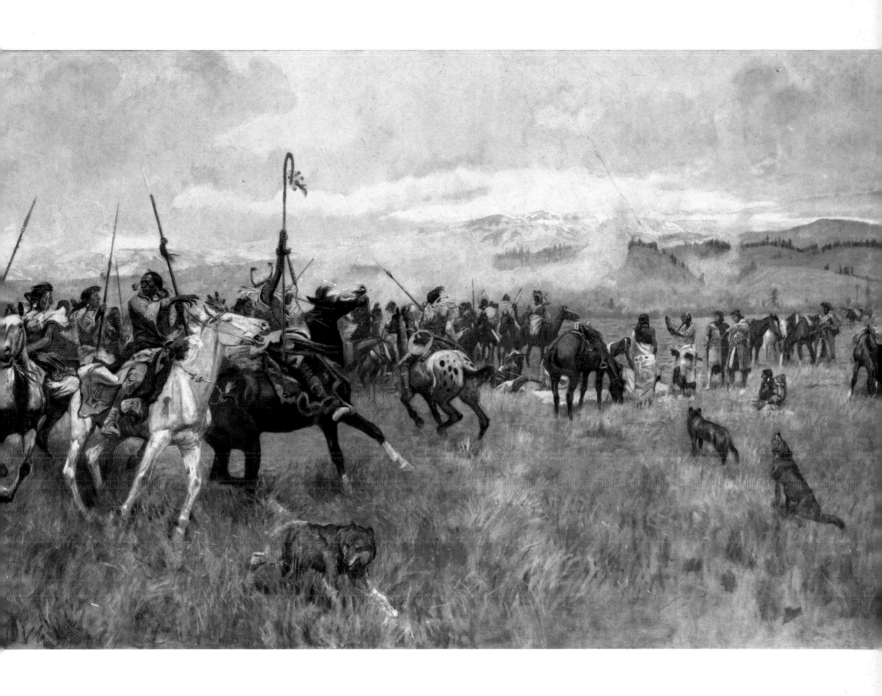

In without Knocking. Russell. 1909. Oil. Amon Carter Museum of Western Art, Forth Worth (preceding page 221)

Lewis and Clark Meeting the Flatheads in Ross' Hole. Russell. 1912. Oil. Historical Society of Montana (above)

Indian Maid at Stockade. Russell. About 1900. Oil. Mr. Walter Bimson, Phoenix (left)

Charles Marion Russell was born in St. Louis, Missouri, March 19, 1864. As a small boy he dreamed of becoming an Indian fighter. He loved to draw, and his earliest known pictures crudely portrayed war-bonneted Indians on horseback. Charlie was an indifferent student. His well-to-do father sent him east to military school in New Jersey at the age of fourteen. At mid-term the boy was happy to escape its rigid discipline and to return home, deficient in all subjects except history. His father then hired a tutor for his son's basic studies, and enrolled him in an art school. The boy became bored, and quit after three days—the only formal art training Charles M. Russell ever received.

Hoping a little first-hand experience would cure his son's romantic infatuation with the West, father Russell permitted Charlie to accompany a family friend, Wallis W. "Pike" Miller, part owner of a sheep ranch on the Upper Judith River, to the still primitive Montana Territory. Shortly after Charlie's sixteenth birthday the two travelers left St. Louis via the Union Pacific and Utah Northern to rail's end at Red Rock, Montana. They rode a stage coach on to Helena, the bustling little capital city of the territory, built on the site of Last Chance Gulch, where gold had been discovered in the year of Charlie's birth.

Montana Territory was larger than all of New England plus the states of New York and Pennsylvania, but its population in 1880 was less than forty thousand, fully a third of them Indians. It had more horses than humans, and on its short-grass plains east of the Rockies domesticated cattle were replacing the diminishing buffalo herds.

During the decade of the 1870's, all of Montana's Indians east of the Rockies had been placed upon reservations north of the Missouri or south of the Yellowstone, opening a broad east-west belt to white cattlemen and sheep raisers through the center of the territory. But as long as buffalo could be found there the Indians left their reservations to hunt them. Until after the middle 1880's, this central belt was also traversed by numerous small parties of Crow and Blackfoot braves on intertribal horse-stealing raids. Riding ahead of his party on the two-hundred-mile journey eastward from Helena to the Judith Basin, young Russell met some twenty or more Crows riding northward to try to overtake and recapture horses stolen from their camp by clever Piegan Blackfoot thieves. The Crows quieted the boy's very obvious fears in his first face-to-face encounter with genuine Plains Indians, but told him not to trust their traditional enemies, the Piegans.

By early April, Russell reached Miller and Waite's sheep ranch in the broad Judith Basin. Since his chance meeting with the picturesque Crows he had sketched from memory the first of the many thousand pony-riding Indians he would draw or paint in his forty-six years as a Montanan. But Russell found little romance in herding meek sheep for Pike Miller. By June, he had lost so many of his charges that Miller not only let the careless boy go but saw to it that he was not hired at the Utica Stage Station, which had an opening for a horse herder.

Alone, broke and hungry on the trail from Utica Station, with little beside his bedroll and two horses he had purchased from a friendly Indian, Russell met Jake Hoover, an able and experienced skin and meat hunter. Jake took pity on the discouraged youth, fed him, and took him to his log cabin on the South Fork of Judith River. Charlie lived with that lone hunter and trapper for the greater part of the next year and a half. He was too tender-hearted to be a successful hunter himself, but he accompanied Hoover in his wide-ranging quest for game through the Judith Basin and in the surrounding mountains. From his own observa-

Waiting for a Chinook. Russell. 1887. Watercolor. Montana Historical Society, on loan from the Montana Stockgrowers Association

tions and the shrewd knowledge of the ways of wild animals Jake passed on to him, "Kid" Russell, as he was becoming known in the basin, learned the coloring, structure and musculature, habits, and actions of deer, buffalo, elk, bear, mountain sheep and the smaller mammals. He spent much of his spare time sketching wildlife or modeling clay miniatures of animals in different poses. From nature he gained a solid foundation for the remarkable grasp with which he later drew, painted, or modeled animals in violent action or at rest.

Seventeen-year-old "Kid" Russell thought himself lucky to land a job as horse wrangler during the fall roundup of cattle in the Judith Basin in 1881. The greenhorn performed his task of managing hundreds of horses well enough to be allowed to accompany the first cattle drive out of the Judith Basin to the railroad that fall. The cattlemen reached the Yellowstone River near Pompey's Pillar, a natural landmark named by William Clark, who passed it on his return from the Pacific Coast in 1806. They crossed the broad river to the Crow Reservation on the south side, where Indians demanded a dollar a head for the privilege of driving cattle through their land. Thirty-two years later Russell recreated this incident in oils in his colorful *Toll Collectors*.

For the next seven years Russell worked as horse wrangler or night herder for some of the big cattle outfits in the Judith Basin. He became intimately acquainted with cowboy life, enjoying the companionship of the rugged men with whom he worked. He swapped tall tales around the campfire, and occasionally visited the cow towns and settlements with their false-fronted saloons and bawdy houses. He knew cowboys from their broad-brimmed hats to their high-heeled boots, how they thought and acted under every kind of condition. He saw the top hands at work and at play—breaking mean broncs to the saddle, rounding up, lassoing and branding cattle, gathered around the chuck wagon at meal time, or relaxing around the fire under the stars after nightfall. He gained a detailed knowledge of the cowboy's limited possessions and of the conformations and actions of cow ponies and cattle. What is more, he came to love the country itself—the grassy ground cover and roll of the plains,

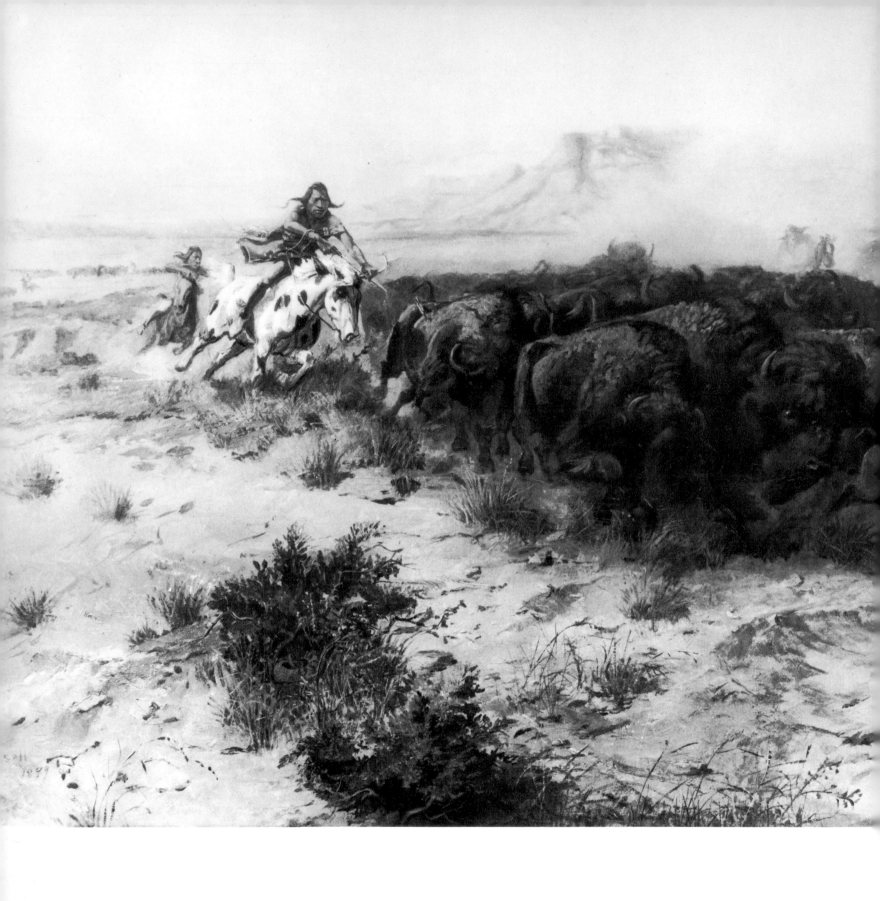

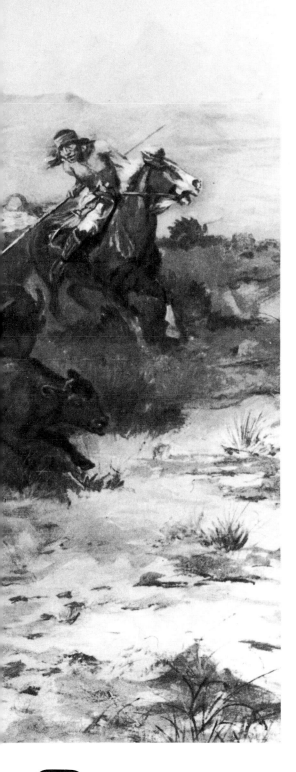

Buffalo Hunt with Rattlesnake. Russell. 1899. Oil. Amon Carter Museum of Western Art, Fort Worth, Texas

the deep, meandering river valleys, the distant buttes and mountains, and the big sky overhead. And he had time to take his colors and brushes from the little tin box in his bedroll and to picture the life and the country. The rough cow hands were the first to appreciate the faithfulness with which young Russell pictured the life they knew well. During this period Russell gave away pictures to any of his comrades who wanted them. His draftsmanship improved, but his effective use of colors developed more slowly.

During the early 1880's, good prices and mild winters made cattle raising on the free lands of the northern plains a booming business, backed by Eastern and even European capital. Between 1880 and the fall of 1886 the number of cattle in Montana nearly tripled, and the range became overstocked. The dry summer of 1886 was followed by a nightmare winter of heavy snows and temperatures of minus forty degrees and lower. Cattle floundered and died in the snow-clogged coulees or starved and froze on the open plains. Russell was visiting Jesse Phelps, owner of the OH Ranch, in February 1887, when the latter received a letter from Louie Kaufman in Helena, asking how his Bar R cattle were doing. While Phelps tried to compose a written reply which would adequately describe the tragic losses on the range, Russell quickly drew a crude, postcard-sized watercolor of a bare-boned, freezing, starving critter standing in the snow while wolves waited nearby to close in for the kill. When Phelps saw this picture he tore up his letter and sent only Russell's graphic portrayal with the pathetic title, *Waiting for a Chinook* —a Chinook being a warm wind.

No words were needed. Many Montana cattlemen were wiped out by that cruel winter. Others suffered such heavy losses that they abandoned the cattle business for less risky investments. For the cattlemen Russell's rough sketch foreshadowed the end of the open range period on the northern plains. Thereafter, reduced herds prevented overgrazing, hardier breeds were introduced, and winter feed and shelter were provided.

At the time, the twenty-three year old artist reaped no monetary rewards from his grimly vivid picture. But it made the name of Charlie (or Charley) Russell, the "Cowboy Artist," known outside of Montana and encouraged him to consider his future in art more seriously.

On May 12, 1888, *Harper's Weekly* published an engraved reproduction of one of Charlie's oil paintings, the first appearance of his work in a national magazine. It was another pathetic winter scene. Entitled *Caught in the Act*, it showed two mounted cowboys confronting a family of destitute Indians butchering a white man's steer. This was a common occurrence in Montana during the early 1880's, when the rapid extermination of the buffalo left the Indians unable to feed themselves and when their government rations were grossly inadequate to prevent starvation. During the winter of 1883–1884, hundreds of Blackfoot Indians starved to death on their Montana reservation. *Harper's Weekly* did not need to point out that the Cowboy Artist's sympathies were with the Indians. But commented, "Anyone acquainted with frontier life will at once appreciate the truthfulness of the picture."

During his years in the Judith Basin, Russell's interest in Indians was only partially satisfied by his limited and fleeting opportunities for acquaintance with individuals or small groups of red men. Meanwhile, the Indians' traditional way of life in large part ended with the extermination of the buffalo by white hide-hunters, and the pressure brought by white authorities against intertribal horse-raiding. Realizing that the old ways of the Indians were gone but not yet forgotten, Charlie rode north

227

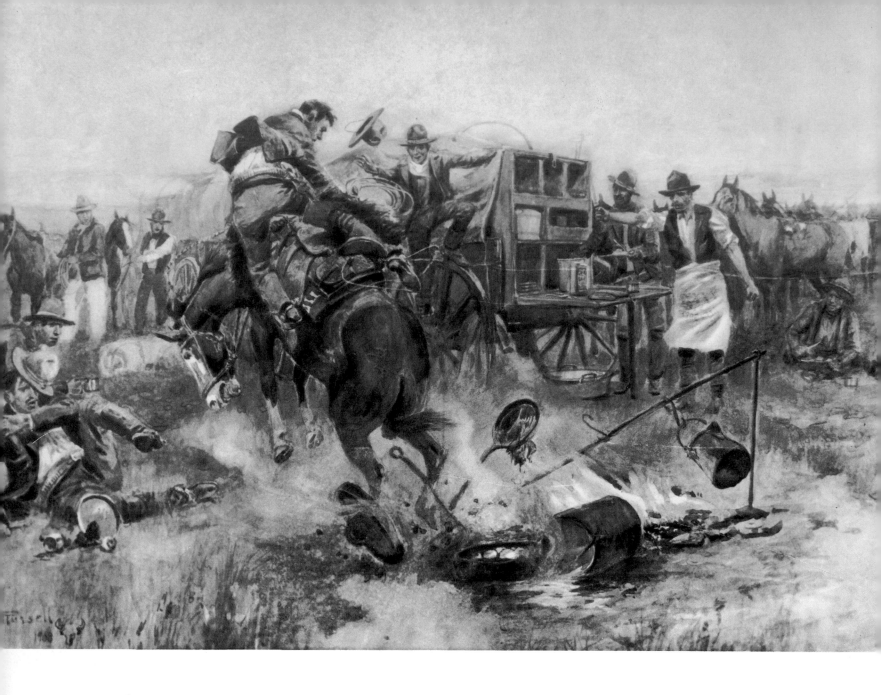

across the international boundary to the Blood Reserve in Alberta in the
fall of 1888, and spent the winter among that Blackfoot Indian tribe. He
witnessed some of their religious ceremonies, studied their arts and
crafts, learned the Plains Indian language of signs, and listened to the
Indians' recitals of fascinating tribal legends and of experiences in hunt-
ing and warfare. Russell is said to have resisted Sleeping Thunder's
invitation to marry into the Blood tribe, but he never ceased to admire
his "red brothers," as he himself termed them. In later years he insisted,
"Man for man, an Injun's as good as a white man any day. When he's a
good friend he's the best friend in the world." This attitude toward
Indians was not popular among cattlemen and other land-hungry whites
in Montana during the frontier years. But the Indians liked Russell both
as a picture-maker and as a sympathetic friend.

In his thousands of watercolors, oil paintings, and pen-and-ink
sketches the Cowboy Artist more often represented Indians than he did
cowboys. The exciting action of the buffalo hunt with bows and arrows,
which he may never have witnessed but must have known through many
detailed descriptions by his Indian friends, was a favorite theme of his,
the subject of at least forty-nine of his works. Numerous other pictures
from his pen or brush depict Indians on the warpath or in battle, moving

228

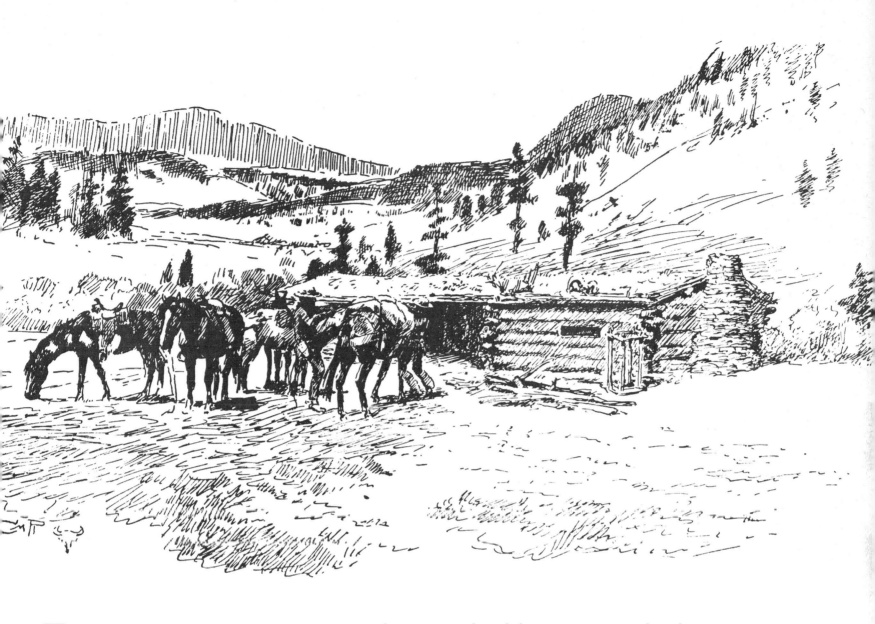

*J*ake Hoover's Cabin.
Russell. Undated. Pen and
ink. Historical Society of
Montana (above)

A Bronc to Breakfast.
Russell. 1908. Oil. His-
torical Society of Montana
(left)

a camp with travois and pack horses, or engaged in domestic activities in their tipi encampments.

Although Russell rarely attempted to portray a white woman, he drew or painted hundreds of Indian women in his scenes in tribal life. His finest oil portrait, *Indian Maid at Stockade*, executed near the turn of the century, clearly reveals the costume changes that occurred among the northern plains tribes in the seventy years after Catlin and Bodmer painted their portraits. Save for her buckskin moccasins (probably soled with rawhide from domesticated cattle, and decorated with floral designs introduced by half-breeds), all of her garments are of white men's cloth. Even her elaborate belt and knife sheath, studded with brass tacks, was of thick, commercially tanned leather. Yet this woman is typically, even savagely Indian, in her poise and pride as well as face and figure.

Back in the Judith Basin in 1889, Russell found that the farmers and sheepmen were taking up homesteads, fencing the open range with barbed wire, and plowing up the natural grasslands. Russell's dislike of sheep had begun with his first experiences trying to herd them in 1880. Now he began to develop a dislike for the nester, the farmer-settler who not only displaced the cowboys in his beloved Judith Basin, but also turned the grass upside down and destroyed the last vestiges of the West

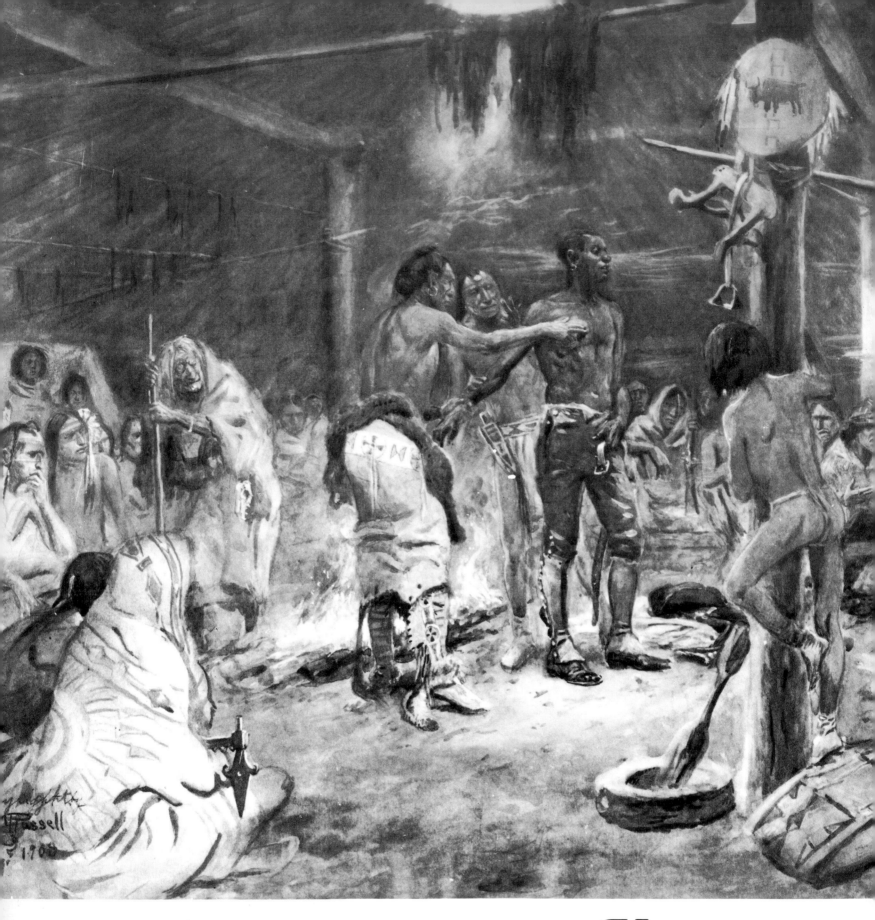

York *(in the lodges of the Mandans). Russell. 1908. Watercolor. Historical Society of Montana*

he loved. To him the farmers were desecrators of God's country, and he never ceased to damn their plows and barbed wire.

For a time the open-range cattlemen found a new refuge north of the Missouri in the Milk River country. In 1888, virtually all of Montana north of the Missouri had been a huge Indian Reservation for the Blackfeet, Gros Ventres, and Assiniboines. But in that year those tribes ceded the greater part of that huge area, larger than many Eastern states, and were confined to three much smaller reservations. This opened a new range for the stockmen, and Russell grudgingly joined the exodus of the cowboys from the Judith Basin, working as a wrangler driving herds north to the Milk River Valley. For three years he worked on this new range and spent his winters painting in Great Falls and Chinook. Meanwhile, in 1890, fourteen of his early oils were published in New York in a small portfolio entitled *Studies of Western Life*. At the same time the Great Northern Railroad was completed across northern Montana, making possible a new influx of agricultural settlers and dooming the last open rangeland in Montana.

In the spring of 1893, Russell moved to Great Falls and for the next three years divided his time between there and Cascade, a small cowtown some twenty-five miles farther west, painting and modeling and enjoying the convivial company of old and new friends in local bars. Saloon keepers, such as Sid Willis at The Mint in Great Falls, were the first collectors of Russell's paintings and sculpture. Indeed, one of the outstanding Russell collections was displayed in The Mint until after World War II. Then, in 1896, Russell married Nancy Cooper, a pretty girl from Kentucky, who not only loved the hard-drinking, pleasure-loving ex-cowboy, but recognized his artistic talents. She inspired him to spend more time at his easel and less with his drinking companions, and she shrewdly found markets for his work with publishers.

In 1903, Charlie moved into a new log cabin studio on Fourth Avenue, North, in Great Falls, where it still stands as a museum. There he drew and painted or modeled many of the more than twenty-five hundred works he produced during his long career. In 1904, he cast his first piece of bronze sculpture—a cowboy on a bucking horse. Many more were to follow. His paintings developed from the colored drawing stage into bold blendings of form and color, revealing a greater awareness of light and shadow and of the effects of brilliant colors.

In 1911, Russell held his first one-man show, "The West That Has Passed," at the Folsom Galleries in New York. The *New York Times*, reporting that exhibition of "a score of paintings and bronze groups of Indians and cowboys and wolves and buffaloes that are making him famous," was as much impressed by the man as by his works, noting that he loved the freedom of the West and genuinely disliked the confinement of big cities. The reviewer observed that "he has been driven by an unquenchable thirst to portray the West before it vanished forever." Encouraged by this New York reception, Russell's wife began asking what he termed "dead men's prices" for his paintings.

The many admirers of Russell's works like to say that their significance derives from their detailed accuracy—the result of his first-hand knowledge of the Montana frontier in the 1880's and 1890's, his keen observation and retentive memory. But the critic who would apply the same standards for judging the accuracy of drawings and paintings as he would to written documents must recognize that it is dangerous to generalize about *all* of Russell's pictures. Like Frederic Remington and various twentieth century interpreters of the West, Russell sometimes

attempted to portray scenes he never witnessed or actions outside the realm of his own experience.

During the last thirty years of his life Russell repeatedly painted his conceptions of early exploration, mountain men, early fur traders on the Missouri, missionaries to the Indians, and the Indian Wars. These pictorial reconstructions of events which took place before he went West, were, of course, based not upon observation but on research and imagination, along with a knowledge of the country itself.

The Lewis and Clark Expedition interested Russell more than any other historical theme. From 1896 to 1918, he executed no fewer than thirteen oils, watercolors, or pen-and-ink sketches dealing with the expedition.

One of Russell's most popular watercolors, simply entitled *York* and executed in 1908, attempted to depict an event that took place in 1805 some eight hundred miles down the Missouri from his Great Falls studio. There, during the winter of 1804–1805, the Hidatsa Indians, who had never before seen a Negro, were puzzled by the dark skin of York, Captain Clark's negro servant. Thinking that his body might be painted black, one of the Indians spat on his fingers and attempted to rub off York's color. Since the *Journals* of Lewis and Clark provided Russell virtually no description of York, the meeting place, or the costumes worn by the whites and the Indians, his portrayal of the structure must have been adapted from Bodmer's masterpiece of 1834, *Interior of the Lodge of a Mandan Chief*; moreover, the headdress of the chief seated between the two white leaders at the far right seems to have been copied from the one worn by Bodmer's well-known *Dog Dancer*. Bodmer's influence may also be seen in the costume of the Indian putting his finger tips to York's skin. Some of the other Indian details, the painting on the hanging skin, the decoration of the willow backrest, the dress of the woman seated at the right, and the belt and knife scabbard of the central standing figure, must have come from Russell's own knowledge of the Blackfoot Indians, for they appear to be late nineteenth-century Blackfoot styles. Certainly the style of the figures painted on the hide and of

232

the woman's dress bear little resemblance to the specimens Lewis and Clark collected during their winter in the vicinity of the Mandan and Hidatsa Indians, which are still preserved in the Peabody Museum of Archeology and Ethnology of Harvard University. As for York he must have been entirely a product of Russell's imagination. Not until 1964, in the first publication of a newly discovered portion of William Clark's *Journal*, was a description of him available. It describes him as a fat man who had considerable difficulty keeping up with Captain Clark on the trail, quite different from the tall, rangy figure Russell portrayed.

The fact that Russell knew the Indians of the 1880's may have been more of a handicap than a help in picturing the Indians of Lewis and Clark's time. For where earlier pictorial source materials were lacking, such as the works of Bodmer, Russell seems to have taken it for granted that there had been little change in Indian costume in the seventy-odd years after the Lewis and Clark expedition. We know now that this was an unwarranted assumption.

Russell's largest oil painting is the huge mural, 25 × 12 feet, that covers an entire wall of the chamber of the House of Representatives in the Montana State Capitol. Painted on commission in 1912, it is larger than any of the Western landscapes executed by Bierstadt or Moran. It is Russell's conception of *Lewis and Clark Meeting the Flatheads in Ross' Hole, September 4, 1805.* Perhaps its size and prominent location, its theme, and the fact that it combines lively foreground action with a fine panoramic background, have caused some critics to regard this painting as Russell's "masterpiece." Yet it contains anachronisms that must grate on every serious student of history who views it. Lewis and Clark mentioned no cloth garments among the Flatheads, and yet the picture shows the blanket capote and red cloth leggings, obviously late nineteenth century Indian costume.

Similarly, at the time of his death, October 24, 1926, an unfinished painting in Russell's log cabin studio, which showed Father De Smet's first meeting with the Flatheads in 1840, twenty-four years before the artist's birth, is peopled with late nineteenth-century Indians.

Russell's standing as the last major interpreter of the Old West does not rest upon such reconstructions, but upon his accurate portrayals of the West of which he was a living part in Montana during the 1880's and early 1890's. From time immemorial Montana has been a fertile field for culture heroes. The "Napi" of Blackfoot mythology was thought of as both the creator of the world and a prankster with some very human frailties. Since his death Charles M. Russell has become a similar kind of culture hero for all Montanans. Stories of his cowboy days, humorous pranks, homespun philosophy (also expressed in illustrated letters to friends), middle-aged nostalgia for the West that had passed, and his dislike for the evidences of technological progress—the plow, barbed wire, railroads, automobiles (to which he applied the Blackfoot name of "skunk wagon"), and "flying machines," are so numerous and varied that it has become difficult to distinguish the man from the legend. There is little doubt that he has become one of the most popular men who ever lived in Montana. Three years after his death the Montana Legislature authorized the creation of a larger than life-size statue of Charles M. Russell to be enshrined in Statuary Hall in the Capitol at Washington, D.C., and in 1959 it was installed. There he stands, seven feet tall, with palette and brushes in hand, his feet encased in cowboy boots such as he always wore, as a symbol of the spirit of Montana's colorful pioneer past.

Whether Russell's vivid and vital story-telling pictures qualify their creator as an artist of unique talent, as his host of admirers contend, or whether he was merely an illustrator, as he modestly called himself, his role as graphic interpreter of the last days of the frontier in Montana will not be forgotten. Most of the nation's staid old art museums have ignored Russell as a contributor to the art of America. But the newer historical museums of the West take pride in exhibiting his works prominently. The historian of the Western frontier cannot ignore him. As K. Ross Toole, former Director of the Historical Society of Montana, where the largest collection of Russell's works is displayed, has observed, "The *real* power of Russell's work does not reside in technique. It resides in the fact that he felt, to the very depths of his being, that an era was dying—and that it meant *something*."

For Charles M. Russell the extermination of the buffalo, the confinement of Indians to reservations, the fencing of the open range, the plowing under of the grasslands, and the pollution of the fresh air with smoke from copper smelters did not spell progress. He sincerely believed that these things desecrated the enchanting West that he loved, and that that West was God's country.

Christmas Card to Malcolm Mackay of Tenafly, New Jersey. Russell. 1914. Historical Society of Montana

Best wishes for your Christmas
Is all you get from me,
'Cause I aint no Santa Claus —
Dont own no Christmas tree.

But if wishes was health and money,
I'd fill your buck-skin poke,
Your doctor would go hungry
An' you never would be broke.

ACKNOWLEDGMENTS

The author and publishers wish to express their deep appreciation of the generous assistance of the following organizations and individuals in the preparation of this book:

Academy of Natural Sciences, Philadelphia; American Philosophical Society Library, Philadelphia, Mrs. Gertrude D. Hess; Historical Museum, Berne, Switzerland; Walter Bimson, Phoenix, Arizona; Brooklyn Museum, Dick S. Ramsay Fund; Butler Institute of American Art, Youngstown, Ohio; University of California, Bancroft Library, Berkeley, Joseph A. Baird, J. Barr Tompkins; Public Archives of Canada, Ottawa; Amon Carter Museum of Western Art, Fort Worth, Texas; E.B. Crocker Art Gallery, Sacramento; National Museum, Copenhagen, Denmark; Miss Ida Edelson, Philadelphia; Gallery of Modern Art, Huntington Hartford Collection, New York; Thomas Gilcrease Institute of American History and Art, Tulsa, Oklahoma, Dean Krakel, Bruce Wear; Harvard University, Peabody Museum of Archaeology and Ethnology, Cambridge, John Otis Brew, Mrs. Katherine Edsall; John Howell Books, Warren Howell, San Francisco; Henry E. Huntington Library and Art Gallery, San Marino, California, Edwin H. Carpenter; Joslyn Art Museum, Omaha, Nebraska, Eugene Kingman, Miss Mildred Goosman; Maryland Historical Society, Baltimore; Metropolitan Museum of Art, Morris K. Jesup Fund, New York; Montana Historical Society, Helena, Michael Kennedy; Museum of the American Indian, Heye Foundation, New York; The National Archives, Washington, D.C., Herman R. Friis; National Park Service (Independence National Historical Park, Philadelphia, Yellowstone National Park, John S. McLaughlin, Yosemite National Park); Nelson Gallery–Atkins Museum (Nelson Fund), Kansas City, Missouri; New-York Historical Society, Miss Shirley Beresford, Miss Carolyn Scoon; New York Public Library, Rare Book Division, Lewis Stark, Mrs. Maud Cole, and Print Division, Wilson Duprey, Miss Elizabeth E. Roth; Historical Society of Pennsylvania, Philadelphia, R. N. Williams II, University of Pennsylvania, University Museum, Philadelphia, Froelich Rainey; City Art Museum of St. Louis; St. Louis Mercantile Library Association, St. Louis, Missouri; Stanford University Art Gallery; Smithsonian Institution, Washington, D.C., Saul Riesenberg, Peter Welsh, William Truettner, Robert Elder, Mrs. Margaret Blaker, Joseph Bowen; U.S. Department of Interior Museum, Washington, D.C.; U.S. Military Academy, West Point, William Kerr; Washington State Historical Society, Tacoma, Miss Francine R. Seders; The White House, Washington, D.C., James R. Ketchum; Henry Francis du Pont Winterthur Museum, Winterthur, Delaware, Milo M. Naeve; Yale University Library, Beinecke Rare Book and Manuscript Library, Western Americana Collection, New Haven, Archibald Hanna.

The author also wishes to thank the librarians of the Smithsonian Institution and the Library of Congress for their many courtesies in facilitating his research. He is especially grateful to Milton Rugoff, Ann Guilfoyle, and Marjorie Rutimann of Chanticleer Press, Inc., for editing the manuscript and for assistance in collecting the illustrations for this volume.

ᴀ SELECTED ʙIBLIOGRAPHY

General Background

Virgil Barker, *American Painting*. New York, 1950.

Wolfgang Born, *American Landscape Painting*. New Haven, 1948.

John C. Ewers, *Plains Indian Painting*. Palo Alto, 1939.

John C. Ewers, "The Emergence of the Plains Indian as the Symbol of the North American Indian." *Smithsonian Institution Annual Report for 1965*, pp.531–544, 1965.

John C. Ewers, "Fact and Fiction in the Documentary Art of the American West." *The Frontier Re-examined*, pp.79–95, Urbana, 1967.

John C. Ewers, "The Opening of the West." *The Artist in America*, pp.42–67. New York, 1967.

E.P. Richardson, *Painting in America. The Story of 450 Years*. New York, 1956.

Robert Taft, *Artists and Illustrators of the Old West: 1850–1900*. New York, 1953.

In the Wake of Lewis and Clark
CHARLES WILLSON PEALE:

John C. Ewers, "Chiefs from the Missouri and Mississippi and Peale's Silhouettes of 1806." *The Smithsonian Journal of History*. Vol.I. No.1, pp.1–26, 1965.

Donald Jackson, editor, *Letters of the Lewis and Clark Expedition with Related Documents, 1783–1854*. Urbana, 1962.

Charles Coleman Sellers, *Charles Willson Peale*. 2 vols. Philadelphia, 1952.

CHARLES B.J.F. DE SAINT-MEMIN:

Theodore Bolton, *Early American Portrait Draughtsmen in Crayons*. New York, 1923.

Luke Vincent Lockwood, "The St.-Mémin Indian Portraits." *The New-York Historical Society Quarterly*. Vol.XII, No.1, pp.3–26, 1928.

First Artists in the Great American Desert

Edwin James, *Account of an Expedition from Pittsburgh to the Rocky Mountains 1819 and 1820*. Philadelphia and London, 1823.

TITIAN RAMSAY PEALE:

Robert Cushman Murphy, "The Sketches of Titian Ramsay Peale (1799 to 1885)." *Library Bulletin, The American Philosophical Society*, pp.523–531, 1957.

Jessie Poesch, *Titian Ramsay Peale (1799–1885)*. Philadelphia, 1961.

SAMUEL SEYMOUR:

Harlin M. Fuller and Leroy R. Hafen, eds. *The Journal of Capt. John R. Bell, Official Journalist for the Stephen H. Long Expedition to the Rocky Mountains, 1820*. Glendale, Calif., 1957.

John Francis McDermott, "Samuel Seymour, Pioneer Artist of the Plains and the Rockies." *Smithsonian Institution Annual Report for 1950*, pp.497–509, 1951.

Portraying Plains Indians for Posterity
CHARLES BIRD KING:

John C. Ewers, "Charles Bird King, Painter of Indian Visitors to the Nation's Capitol." *Smithsonian Institution Annual Report for 1953*, pp.463–473, 1954.

Thomas L. McKenney and James Hall, *History of the Indian Tribes of North America*. 3

vols. Philadelphia, 1836–1844.

Herman J. Viola, "Invitation to Washington." *The American West*, Vol.IX, No.1, pp.18–31, 1972.

JOHN NEAGLE:

Margaret Lynch, "John Neagle's Diary." *Art in America*, Vol.37, No.2, pp.79–99, 1949.

Young Artist on the Red River of the North

Michael Benisovich and Anna M. Heilmaier, "Peter Rindisbacher, Swiss Artist." *Minnesota History*, Vol.32, No.3, pp.155–162, 1951.

Alvin M. Josephy, Jr., *The Artist Was a Young Man. The Life Story of Peter Rindisbacher.* Fort Worth, 1970.

John Francis McDermott, "Peter Rindisbacher: Frontier Reporter." *The Art Quarterly*, Detroit Art Institute, pp.129–144, 1949.

Hunting Indians with a Paintbrush

George Catlin, *Letters and Notes on the Manners, Customs and Condition of the North American Indians.* 2 vols. London, 1841.

George Catlin, *O-kee-pa, A Religious Ceremony and other Customs of the Mandans.* Centennial Edition. Ed. by John C. Ewers. New Haven, 1967.

John C. Ewers, "George Catlin, Painter of Indians and the West." *Smithsonian Institution Annual Report for 1955*, pp.483–528, 1956.

Harold McCracken, *George Catlin and the Old Frontier.* New York, 1959.

Master Draftsman on the Upper Missouri

John C. Ewers, "Early White Influence Upon Plains Indian Painting: George Catlin and Carl Bodmer among the Mandan, 1832–34." *Smithsonian Miscellaneous Collections*, Vol. 134, No.7, 1957.

Alexander Philip Maximilian, Prinz von Wied-Neuwied, *Travels in the Interior of North America.* 1 vol. and Atlas. London, 1843.

Among the Mountain Men

Bernard DeVoto, *Across the Wide Missouri.* New York, 1947.

Mae Reed Porter and Odessa Davenport, *Scotsman in Buckskin, Sir William Drummond Stewart and the Rocky Mountain Fur Trade.* New York, 1963.

Marvin C. Ross, *The West of Alfred Jacob Miller.* Norman, Oklahoma, 1961.

Among the Fur Traders at the Mouth of the Yellowstone

Edwin T. Denig, *Five Indian Tribes of the Upper Missouri.* Ed. by John C. Ewers. Norman, Oklahoma, 1961.

John C. Ewers, "Folk Art in the Fur Trade of the Upper Missouri." *Prologue, The Journal of The National Archives*, Vol.4, No.2, pp.99–108, 1972.

Rudolph Friederich Kurz, "Journal of Rudolph Friederich Kurz . . . 1846 to 1852." *Bureau of American Ethnology*, Bulletin 115. Washington, 1937.

Life on the Missouri Frontier

"George Caleb Bingham, 1811–1879." *Exhibit Catalog, National Collection of Fine Arts*, Washington, 1968.

E. Maurice Bloch, *George Caleb Bingham: The Evolution of an Artist.* Berkeley, Calif., 1967.

John Francis McDermott, *George Caleb Bingham, River Portraitist.* Norman, Oklahoma, 1959.

In the California Mines

CHARLES CHRISTIAN NAHL:

Jeanne Van Nostrand and Edith M. Coulter, *California Pictorial. A History in Contemporary Pictures, 1786 to 1859.* Berkeley, Calif., 1948.

Eugen Neuhaus, "Charles Christian Nahl, The Painter of California Pioneer Life." *California Historical Society Quarterly*, Vol.XV, No.4, pp.295–305, 1936.

THOMAS A. AYRES:

Jeanne Van Nostrand, "Thomas A. Ayres, Artist-Argonaut of California." *California Historical Society Quarterly*, Vol.XX, No.3, September, 1941.

Carl P. Russell, *One Hundred Years in Yosemite.* Berkeley, Calif., 1947.

Brothers Among the Southwest Indians

Robert V. Hine, *Edward Kern and American Expansion.* New Haven, 1962.

Frank McNitt, editor, *Navaho Expedition. Journal of a Military Reconnaissance from Santa Fe, New Mexico to the Navaho Country made in 1849 by Lieutenant James H. Simpson.* Norman, Oklahoma, 1964.

Capt. Lorenzo Sitgreaves, "Report of an Expedition Down the Zuni and Colorado Rivers." Senate Exec. Document, 33rd Congress, 1st Session. Washington, 1853.

Artist and Trail Blazer in the Northern Rockies
John C. Ewers, "Gustavus Sohon's Portraits of
Flathead and Pend d'Oreille Indians, 1854."
Smithsonian Miscellaneous Collections, Vol.
100, No.7, 1948.
Hazard Stevens, *The Life of Isaac Ingalls Stevens*. 2 vols. Boston, 1935.

Scenes of Rocky Mountain Grandeur
ALBERT BIERSTADT:
Albert Bierstadt, "Rocky Mountains, July 10,
1859." *The Crayon*, Vol.6. p.287, September,
1859.
D.O.C. Townley, "Living American Artists.
Albert Bierstadt." *Scribners Monthly*, Vol.
III, No.5, pp.605–608, 1872.
Florence Lewison, "The Creative Core of Bierstadt — the Abstract Basis of His Art." *Exhibition Catalog, Florence Lewison Gallery*. New
York, 1963.
THOMAS MORAN:
Fritiof Fryxell, *Thomas Moran, Explorer in
Search of Beauty*. East Hampton, Long Island, 1958.
Thurman Wilkins, *Thomas Moran, Artist of the
Mountains*. Norman, Oklahoma, 1966.

Artists of the Plains Indian Wars
THEODORE R. DAVIS:
Theodore R. Davis, "A Summer on the Plains."
Harper's Monthly, Vol.XXXVI, pp.292–307,
February, 1868.
Theodore R. Davis, "How a Battle is Sketched."
St. Nicholas Magazine, Vol.XVI, No.9, pp.
661–668, July, 1889.
SITTING BULL:
Matthew W. Stirling, "Three Pictographic
Autobiographies of Sitting Bull." *Smithsonian
Miscellaneous Collections*, Vol.97, No.5,
1938.
FREDERIC REMINGTON:
Harold McCracken, *Frederic Remington, Artist
of the Old West*. Philadelphia, 1947.
Atwood Manley, *Frederic Remington in the
Land of His Youth*. Canton, N.Y., 1961.
Perriton Maxwell, "Frederic Remington — Most
Typical of American Artists." *Pearson's
Magazine*, pp.395–406, October, 1907.

**A Montana Cowboy Portrays the Passing
of the Old West**
Ramon Adams and Homer Britzman, *Charles
M. Russell, the Cowboy Artist*. Pasadena,
1948.
Frank Bird Linderman, *Recollections of Charley
Russell*, Norman, Oklahoma, 1963.
Harold McCracken, *The Charles M. Russell
Book*. Garden City, N.Y., 1957.
Frederic G. Renner, *Charles M. Russell. Paintings, Drawings, and Sculpture in the Amon
G. Carter Collection*. Fort Worth, Texas,
1966.
Frederic G. Renner, *Paper Talk, Illustrated
Letters of Charles M. Russell*. Fort Worth,
Texas, 1962.

Artists of the Old West was
prepared and produced by Chanticleer Press:

Publisher: Paul Steiner
Editor: Milton Rugoff. Associate: Marjorie Rutimann
Art Director: Ulrich Ruchti, assisted by Irva Mandelbaum
Production: Gudrun Buettner, assisted by Helga Lose
Printed by Amilcare Pizzi, S.p.A., Milan, Italy